p

D0196653

89-91
68-71
48
30

AN OUTLINE DICTIONARY

OF

MAYA GLYPHS

With a Concordance and Analysis of
Their Relationships

BY

WILLIAM GATES

With the author's "Glyph Studies" reprinted from
The Maya Society Quarterly

DOVER PUBLICATIONS, INC.
NEW YORK

Published in Canada by General Publishing Company, Ltd., 30 Lesmill Road, Don Mills, Toronto, Ontario.

Published in the United Kingdom by Constable and Company, Ltd., 10 Orange Street, London WC2H 7EG.

This Dover edition, first published in 1978, is an unabridged republication of the work first published by The Johns Hopkins Press, Baltimore, in 1931. The plates on pages 77 and 78 originally appeared in color. "Glyph Studies" by William Gates (from *The Maya Society Quarterly*, Vol. 1, No. 4, September, 1932) has been added to this edition.

International Standard Book Number: 0-486-23618-8
Library of Congress Catalog Card Number: 77-92481

Manufactured in the United States of America
Dover Publications, Inc.
180 Varick Street
New York, N.Y. 10014

INTRODUCTION

The first question one is always asked is: Whether the Maya writing is phonetic? The shortest way to answer that and at the same time give an introduction to the present work, will be to start with the fundamentals.

To communicate our ideas to other persons we have two separate systems at our employ—by signs or by sounds, one received by the eye, the other by the ear. These two methods correspond each to the idea and also to each other; are used together or separately, yet are mutually independent; nor does either *need* the other.

Of signs there are many kinds: pictures of natural things, symbols of actions or of abstract ideas; and even gestures. Each branch of science has its symbols, chemical, algebraic, etc. So has the business world. Among these is the special science of phonetics, which deals with the coordination and use of the hundred or more recognizably distinct vocal elements of speech, as well as with qualifying elements such as tones, accent, etc.; each of these has a specific sign, which we call a letter or diacritic, each allotted to one of the distinct separate products of the vocal organs, and known to, usable by, those who have been taught that representative character. These conventional signs are used to form written words, and convey their *pronunciation;* but they have no relation to the *meaning* of the words so produced. In this lies the basis and definition of phonetics.

As is the case with the sets of phonetic symbols, so with all other systems for the representation or communication of ideas. Each has its status by a developed and understood convention, and consists of a body of discrete elements, used in synthesis, in definite ways and relations. Music has its notes, which are quite different things from the symphony they carry. Many symbols have a 'phonetic' origin, such as the Greek letters used in mathematical formulae, adapted as naked forms to serve the purpose, but with no phonetic value; the symbol **pi** in this connection no longer stands for the sound of that letter, nor has that sound any part in its mathematical use.

With the exception of such artificially adopted signs, and perhaps some philosophical or religious symbols, such as the Tau or the Svastika, it is probable that all symbols go back to an original pictograph of some kind. But that is usually so far back of any form of cultured or civilized use, as to be not only unrecognizable (and wholly foolish to speculate about), but with no longer any effect or value in the current usage.

Before writing existed among any particular people, they spoke words to convey their ideas. And each such spoken word was the *name* of some material or immaterial thing. Every 'thing' of either class has its 'name,' represented on the one hand by the complex of spoken vocal sounds (varying with each language); and on the other hand by its picture or symbol (ideograph), when these latter came into use, the symbol always very far after the 'savage' picture. Pictures may convey meanings, but they are not language; only syntax can supply that.

Every thing has therefore three incidents: its name, or Word, with it from the beginning, and without which connected thought is impossible to men; next the complex of voice elements used by those of any language to utter that name, and passed from tongue to ear; and then the symbol received and apprehended through the eye. These two representatives of the idea are wholly separate, appeal to different senses, and must be learned each for itself.

Green and tree are two 'ideas.' The painted color or the sketched tree will be recognized by all, and called, vocally, differently. The Maya symbol will be called **yax,** * **green, verde, lü,** by a Maya, Englishman, Spaniard or Chinese; neither one will be thinking of the three, five or two vocal elements represented by the separate letters. The fact that two spoken *words* can be joined to give a double idea does not involve phoneticism as the base of the corresponding script. It has been repeatedly urged that the union of the two signs for **yax-kin,** green or new, and sun, into the month name **Yaxkin,** evidences a "phonetic use of the glyphs." It does not. No one will deny that Chinese is purely ideographic; yet their words are pronounced, and similarly joined --both in speech and as characters.

Let us, to illustrate, take the English compound word Greenfields. This may either be a personal proper name, or that of an estate. It may be rendered into Chinese characters in two distinct ways: two characters approximating in sound to the English word may be taken, which to the Chinese reader will indicate the sound of the man's name—only. Or the two characters for green and field may be taken, which will give a translation of the *idea* behind the name of the estate—and that only.

All communication of ideas, by whatever means, by letters, pictographs, symbols, musical notes, the colors and brush strokes of the artist—everything beyond the crudest animal gestures or monosyllables, is by an elaborate complexity of arranged conven-

* **X** in Middle American tongues represents the sound *sh*, having been so used in Spanish of the sixteenth century. Also, in Yucatecan Maya **C** is always hard, as **Cimi** like **kimi,** not **simi.**

tional elements. A comprehensive mathematical formula conveys a 'unit idea' to its users; so do our words, whether spoken or written. Everything used, therefore, for the purpose of language is a symbol, of one or another kind; it either is a symbol of one of the hundred or more distinguishable vocal sounds, in which case we call the symbol a letter—a *phonetic* symbol. Or else the symbol represents the idea directly.

Spelling and its companion, its set of separate phonetic symbols, are very late developments in language. Unlettered people, savage or modern, ignore them. Pictures and symbols far anteceded them. First came the picture; then the ideograph; with each, their *words*. Those words, to make up language, are first main elements, names of things or actions—nouns and verbs. Then come minor elements, in two main classes, either descriptive and modifying the main ideas, or else connective and relational. When we have these we have language; the character of the syntax will follow the basic mode of expression, of the people.

Alphabetic, or properly called phonetic writing, is the latest of all, and results from a double process. The original pictograph is worn to a fragment, and then adapted exactly as Greek letters are for formulae. People can go a long and highly cultured road and never need phonetic symbols, or a specific phonetic science. We have two historically preserved cases of such a development, in Egyptian and in the transfer of Chinese literature and culture to Japan. As is well known, the Japanese read the Chinese books, without being able to *talk* Chinese, but giving their own names to the characters, as **yama** for mountain, instead of **san**. The cultured Japanese will say either Fuji-no-yama, or Fuji-san. To enable the less cultured reader of a Japanese newspaper to pronounce unusual Chinese characters introduced, one sees the *katakana* of 50 syllabic 'letters' run down the side of the character, exactly as we here add the latters **y-a-x** to give the sound of the Maya character for green. But we do not add a particle to our knowledge of the meaning of the passage or compound by thus giving the sounds.

Throughout the following work I have quite often rendered a glyph into the modern Maya that interprets it; but it is only to add a fuller Maya flavor to the work, and to stimulate and show the value and necessity of Comparative Mayance linguistics if we are to advance.

Our first objective is to determine the *meaning* of the glyphs. To that their sound-names are of no value whatever, save as a part of historical linguistic research, into how the different branches came to separate from the common tongue, spoken when

Latin was, as far back as Latin is behind modern French. And deductions based on similarities of spelled words have been the utmost bane of science, bringing all linguistics into disrepute. See below, under glyph **59**, and the three words for moon.

Theory after theory has been propounded, unchecked or verified, been published, and died. Brinton's 'ikonomatic' theory, seeing in the words of the few known glyphs, phonetic assonances with some far distant word as an *explanation* of *why* the thing was so named, was carried out in total disregard of dialectic and historical differences, and the positive evidence of sound mutations.

Another attempted way of reading, quite often heard of and put forth without support, always too by those who have not studied the thing, is that Maya is at least 'in part' rebus writing. Now first, rebus writing is not *written language* at all. The essence of a rebus is an actual picture of some simple known object, whose spoken name is the same in sound as some other word of entirely different meaning. To make a rebus for "Aunt Rose," we must make a picture of an ant and a rose, to suggest the sounds, punningly. No such instances have ever been even brought forth in illustration, as for Maya.

Those who suggest this, say that it is "likely" that Maya was in this "somewhat like the Mexican picture or rebus-writing." But this Mexican itself was not rebus-writing at all; it was a pure pictographic system, in which the abbreviated or partially conventionalized pictures of various objects were used to represent, singly or combined, the objects themselves. Popocatepetl is a picture of smoke and a mountain to represent that idea, that particular volcano, and the two words **popoca** and **tepetl,** Smoke-Mountain. Whereas a rebus uses the picture to represent something not the same as the picture.

Incidentally, this very Mexican system, in which the character represents the thing and not the letters as such (the way our writing does), is a case of exactly the same ideographic combination of two words we have in Maya **Yaxkin,** or in Chinese **Meng-tse, Shan-tung.** Save that the Mexican are still pictures, while the others are conventionally advanced symbols, ideo-*graphs.*

It has seemed necessary to go into the above detail, to clear off the weeds whose growth has only been possible by the complete lack of a general instructed (howbeit very greatly interested) public, such as the Classicists, the Egyptologists, and others, have for their work. The Maya problem is coming more and more to the foreground, as a result of the really magnificent exploration work that has been and is developing; and the question of what their actual culture, their science, and their wonderful written

INTRODUCTION ix

system really are, calls for patient and detailed research into actual materials (of which a lot docs exist), and not for guesswork, esoteric interpretations of this or that stroke in this or that daysign, and imaginative assertions about the most treacherous of all subjects—far past origins. He who transcends history invites a fall.

So what, now, can be said of the Maya system of writing? It is, first, ideographic. It has system, as those who will study the concordance in this work, will see. It has main elements, such as we spoke of above: first names of things, and then quite certainly words of action. In this latter, it quite corresponds to the known Egyptian method of using characters representing action, as a man walking, striking, etc. We cannot yet define many Maya verbs, but when we see a certain glyph always used in the text above a figure carrying something, and usually accompanied by other glyphs showing the very things so seen carried in the pictures; or another where fire is being twirled, we are quite safe in recognizing the act, the *meaning*, even in our still imperfect knowledge of the spoken sounds they used. Which latter come secondary, anyway. To get the latter even well started, we need a polyglot Mayance vocabulary, showing what words are everywhere common (and hence safely archaic); and what vary from region to region—involving equally interesting tribal or ultra-national contacts, migrations, and progressions.

With these well-known 'main elements' we next have quite a number of adjectival glyphs, such as the colors, and then various others which by their changes, repetitions and placements seem to be modifiers—and usually prefixed. (Prefix and superfix being equivalents, also subfix and postfix.) Next we have another set of still minor elements which we have very good reason for regarding as those very necessary parts of written language, determinatives of class or category. Every language has homophones, and once that is so, some form of determinative is necessary. We have three words pronounced tu; a preposition, an adverb, and a numeral—to, too, two; the extra o and the w are simple determinatives as above noted. Hieroglyphic Egyptian has such elements; so has syllabic Tibetan. Where needed in Maya glyph expressions, they are very probably subfixes. See later, under **Cimi**.

Of course we have compound glyphs, two main ideas joined; such exist in all language. Such compounds also approach in syntax value closely to adjective-noun, or adverb-verb compounds; the boundaries between are fluctuating, since adjective and verb are in fact self-substantial ideas.

The above comprises the necessities of a written system; and in their composition the glyphs follow very markedly the known agglutinative, separable and auxiliary type of American languages in general, and the Mayance in particular. That there are any specific conjunctions or prepositions among the glyph forms, I much doubt. I have found no traces to show them. Conjunctions are not indeed necessary; juxtaposition can do the work. Besides that such words in Mayance are in fact nothing but definitive forms of nouns, declined by prefixed possessive pronouns. For 'and' in Maya we have **vetel, avetel, yetel,** my, thy, his accompanying. For 'by, because of' we have **inmenel, amenel, umenel,** my, thy, his activity. These words serve the place of our conjunctions and prepositions, but are not such at all, as we understand them; they are agglutinative adjuncts to the expressions, stating my association with the matter. They are quite parallel in syntactic method with **batab ech,** 'cacique thou,' with no connecting verb. On the way from monosyllabism to declentional systems and subordinations of form (far removed from the ideographic or glyphic collocations of the concepts themselves), this separable, free agglutination is in the natural middle, both historically and logically. And being the normal type of the spoken tongues in America, which we know, that the structure or syntax of the glyphs as written should follow the same lines, is necessary and cannot be avoided. People both talk and write, as they think.

The basis and main purpose of the present work is its concordance and tabulation of the glyph forms, with the most complete cross-indexes possible, that study of the writing may be facilitated. It is in no way an effort to "read the glyphs" by mental processes and speculation. The work was planned out, and the broad arrangement of the glyph-classes, just thirty years ago. The type forms have been drawn and made merely to get a font of Maya type to make publication and study easy. The first type, the simple main elements and affixes by themselves, were produced at that time. Pages 24 and 61 Dresden were set up and printed, with the affixes set around the main element; this took a sheet 15 inches high, and showed it necessary to undertake the designing and making of all compound forms, as found. Some ten years later enough of the Dresden forms and all the Paris had been drawn and cast, to make an edition of the latter possible. Also printed what was in fact the 'first edition' of the present work, in half a dozen copies for my own use. As the years went on, and time and other work allowed, the rest of the Dresden and Madrid

type-forms were completed, with the few possible monumental forms, as yet read—see glyphs **52 to 58**.

The first classification was on bare form, save as for the day and month signs from Landa. From then on the continuous effort has been to put associated forms side by side. For my own use the page, column and line mode of reference (destructive of all text continuity, and making comparative work hopeless) was changed to the ṭolkin system seen herein. Each ṭolkin was put in type and print, by itself, in single columns instead of the two column way. Not until then did the work of arrangement really begin; see the reproductions in the text of the present work.

Out of this, and the involved constant and repeated changes of numbering and arrangement, the associations began to develop general classes both of main glyphs and affix uses, such as between calendric, astronomical, or crop and hunting activities, etc. Pairs of opposites, and of likes, such as earth and sky, food and drink, began to develop, and repetitions and persistent associations, or shifts therein, to develop meanings aided by the pictures beneath. This aid is peculiar to the codices, and lacking in the monumental texts: an excellent reason why the study of the latter has not led to the study of the glyphs as a true system. *It is the combination of the completed concordance and the pictures that has made possible the fixing of the final and critical fact that in the use of the affixes lies the control of the system; in short, its syntax.*

I have given a number of glyph meanings, where they seemed clear, in the corresponding Maya words, but as meanings or descriptions only. I have referred to **Imix** with the snake-rattle prefix as **ṭab-Imix** (the rattles being **ṭab** in Maya), just to describe it; but I think the Maya reader called the compound something else, a meaning I have not reached. The determination of the thunderbolt glyph I regard as unquestioned, yet I do not know what the priest writer used to call it; I think he probably said **Cauac,** as meaning the thunderbolt. He may have said, by metaphor and with the same understanding, **haṭ'-chac,** the bolt of the god; and in the glyph itself, the club and conventional flames (established by the burning firewood glyph) were then probably added as determinatives, to make clear that the **Cauac** was here the thunderbolt sign, and not the day-sign; with also an added artistic reason for the amplification. All such passages have been added to the text of this work more as calls to further study, than as assertions. Though many are I believe wholly sure.

There are many other parallelisms, left for later work-out, by myself or others. The work is issued for students.

A brief description of the three codices, the arrangement and continuity of their text as divided first into main subject chapters, then these into sections or t͡zolkins, and these then into clauses holding each usually four or six glyphs and a picture, will be found at the end of the volume. With this will then be given tables showing on what page and cross-division of the codex, any particular t͡zolkin or clause may be found. Freed from the meaningless previous references by page and line, the student following this resulting continuity of text, sections and glyphs, will soon find himself following the old Maya priest-astronomer as he developed his subject, using his glyphs in their combinations and relations, to do this.

In subsequent works on the science of the Maya, and also their daily culture as shown in the codices, I shall carry on this text analysis, checkable by the cross-indexes, and illustrated by reproductions of the single t͡zolkins, as seen at several places herein. But from the day that George Rigby sold me in Philadelphia my first Maya book, the copy of the Troano that had belonged to Dr. Lundy, on June 28, 1899 (and setting finis thereby to my collecting in Egyptology), down to the present, I have felt that the first great need and task was the "removal of impedimenta to research," the classification and ordering of the actual material itself, and (of course) the incidental lightening of the trash, as well as the road.

The work has made necessary my taking on myself also the development of sober Comparative Mayance Linguistics, and use thereto of the enormous amount of material that has survived (and is now in the room where I write this). For just as Proto-American history depends on a knowledge of the glyphs written and carved, so does that knowledge depend on the Linguistics of the Mayance family.

I cannot hope that in a work of such complexity, where the arrangements and references have had to be changed again and again as new clear association values developed, some few slips in the reference numbers may not have passed. The cross-indexing will make any such nearly self-correcting, and for any that may be, I ask the user's charity.

WILLIAM GATES.

The Johns Hopkins University,
July Third, Nineteen Thirty-one.

CONTENTS

DAY SIGNS

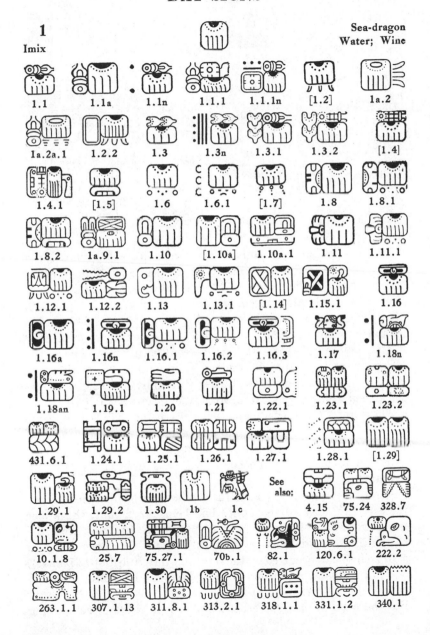

1
Imix

Sea-dragon
Water; Wine

1.1 1.1a 1.1n 1.1.1 1.1.1n [1.2] 1a.2

1a.2a.1 1.2.2 1.3 1.3n 1.3.1 1.3.2 [1.4]

1.4.1 [1.5] 1.6 1.6.1 [1.7] 1.8 1.8.1

1.8.2 1a.9.1 1.10 [1.10a] 1.10a.1 1.11 1.11.1

1.12.1 1.12.2 1.13 1.13.1 [1.14] 1.15.1 1.16

1.16a 1.16n 1.16.1 1.16.2 1.16.3 1.17 1.18n

1.18an 1.19.1 1.20 1.21 1.22.1 1.23.1 1.23.2

431.6.1 1.24.1 1.25.1 1.26.1 1.27.1 1.28.1 [1.29]

1.29.1 1.29.2 1.30 1b 1c See also: 4.15 75.24 328.7

10.1.8 25.7 75.27.1 70b.1 82.1 120.6.1 222.2

263.1.1 307.1.13 311.8.1 313.2.1 318.1.1 331.1.2 340.1

1	1.3	1.8	1.12.1	1.16.1	1.23.1
M.38.d.3	D.p31a.d.3	D.55.e.7	D.69.b.5	D.69.d.5	M.176.g.2
M.38.e.4	1.3n	D.71.c.9		D.69.j.6	1.23.2
1b	D.72.a.31	1.8.1	1.12.2	1.16.2	M.179.d.2
M.211.6	1.3.1	D.61.f.3	M.116.d.3	D.75.k.1	1.24.1
1c	D.72.a.24	D.74.g.3	1.13	1.16.3	M.116.f.4
P.4.d.5	1.3.2	D.74.1.3	D.55.a.3	D.75.o.2	1.25.1
1.1	D.p70.d.9	D.75.1.3	D.57.g.7	1.17	M.204.a.3
D.72.f.22	D.74.n.2	D.75.aa.2	1.13.1	D.71.37.1	1.26.1
1.1a	1.4.1	1.8.2	M.6.g.4	1.18n	M.204.b.3
P.16.a.3	M.162.g.3	D.70.e.4	1.15.1	D.p48.f.8	M.204.d.3
1.1n	1.6	1.9.1	D.70.i.2	1.18an	1.27.1
D.p52a.d.4	D.71.38.1	D.p50f.5	1.16	M.p35.c.6	M.p37.c.9
1.1.1	D.71.39.1	1.10	D.55.a.2	1.19.1	1.28.1
M.5.a.1	D.71.52.1	M.p37.b.3	D.72.a.34	D.59.a.11	D.75.p.1
1.1.1n	D.71.53.1	1.10a.1	1.16a	1.20	1.29.1
D.p51a.a.5	D.71.58.1	M.p34.b.3	D.67.a.2	M.194.a.4	M.p35.b.12
1.2a	D.71.60.1	M.p36.b.3	D.74.m.4	M.194.d.2	1.29.2
D.60.b.3	D.71.64.1	1.11	1.16n	1.21	M.38.c.1
1a.2a.1	D.72.e.1	P.18.f.4	D.55.b.4	M.194.f.2	1.30
D.61.a.3	1.6.1	1.11.1	D.55.d.5	1.22.1	D.66.b.4
1.2.2	M.6.f.2	D.62.c.3		M.p36.c.2	
D.66.c.3					

The above body of **Imix**-forms shows us the glyph under four phases or values, distinct from its use as a proper noun, the name of the first day of the calendar. In combination it appears with **akbal, kan, oc,** the cross, the sky; also glyphs **330, 336**; the compounds with **kan** and glyphs **313** and **340** should be particularly studied. With red and green it is used only in the Itzamná chapters of the Dresden; with white once in the Venus chapter; with **akbal** and ⊙⊙ in tzolkin 68; with black only in the Madrid. The **Imix**-glyph must be carefully distinguished from 🗊, **Mac,** and from glyph **336** 🗊.

The knot or tie ⊙)C appearing in form **1.1** is the same as seen in the red ties surrounding numbers like the 6–2.0 on Dr. p. 24; here the date 9.9.9–16.0 requires 6 tuns and 2 vinals to complete or tie up the count with the desired 9.9.16–0.0, **4 Ahau, 8 Cumhu.**

Across Dr. pp. 51–58 runs the well-known eclipse ephemeris, the zero-time day of the upper line being **12 Lamat,** the upper line covering 11,958 days and ending with **10 Cimi,** and the bottom line two days later, with **12 Lamat.** If a new moon and solar eclipse had occurred on the zero-time day (the first **12 Lamat**), one full eclipse cycle would have closed on **10 Cimi,** about $9\frac{1}{2}$ hours later in the day, or by the passage of 11,958.393 days. But the count would have been 1.497 days short of completing

405 lunations, 11,959.89 days. New moon would thus (by mean lunar time computation) fall on **12 Lamat,** about 2½ hours before the passage of an even 11,960 days (or 46 ȶolkins, in Maya numbers 1.13–4.0).

Just preceding the ephemeris, on page 52, the writer built up a calculation table to 3.4.15–12.0, which is 39 times the base term of 11,960 days, 466,440 days, or about 1280 years. Now this even number means nothing to us, in accurate computation such as is necessary in astronomical work; if 405 'moons' were exactly 11,960 days, it would be. The Maya however did not use fractions, but employed intercalations and 'tie-up' numbers at defined points, so as to arrive at the statement: So many cycles of this equal so many of that. This is also the Oriental method, and deals rather with conjunctions than fractional terms.

405 lunations are just 0.11 days less than 11,960; the eclipse cycle (of 34½ 'eclipse years') is 1.607 days less. At the end of the *accurately* calculated period for 405 lunations, the two are 1.497 days apart; multiply this difference by 39 and we get 58.383, or 0.67 more than two exact lunations. At the end of 39 eclipse cycles and at the same time of 15,793 moons, both terms end on the same day; and this is the first time in the 1280 years this evening up of the *exact* 1.497 days has taken place.

In this light the stopping of the calculation table at exactly this 39th multiple takes on meaning; it shows that the Maya astronomer knew the fractional errors connected with his period figures and corrected them by larger multiplications and intercalations.

Returning now to our glyph-forms **1.1n** etc. The ephemeris carries along accurate correlations of lunations and solar eclipses; at the end of the eclipse term, one of these ends on **10 Cimi,** the other on **12 Lamat,** shown by the upper and lower rows of day-signs. Above the thirteen red thirteens on page 51 we find our gl. **1.1n,** stating "2 days are needed to tie up," from **10 Cimi,** to the end of 46 ȶolkins, on **12 Lamat.** Immediately above this glyph is seen ⟨glyph⟩ another 'tie-up' form, our **50.5.1n,** which is to say ⟨glyph⟩ **hotun yetel hun vinal uȶolan chucpahal,** "5 tuns and one vinal to tie the count." The column at the left raises 1.13–4.0 to 3.4.15–12.0, but the number written is not 1.13–4.0, but 5–1.0 plus, or 1.18–5.0; the writer had some use we have not learned, for this higher number, set it down, and put the differential as the corrective.

At the top of the first column on page 51 we find **4 Ahau, 8 Cumhu, 12 Lamat,** followed by our above form **1.1.1n,** which in its turn tells us that 8 days are needed after **12 Lamat** to complete the ţolkin count to **4 Ahau.**

Glyph **1.1.1** begins the first ţolkin in the Madrid Codex; it might be read either as **uxocol** ţolkin, or **uxocol Imix,** the counting of the ţolkin, or of **Imix,** its determining day, as Sunday is of our week. We have not yet found a glyph for the ţolkin, though one must have existed, and we should expect **Imix** as its main element. This might possibly be the one; or another form, our **1.3, Imix** with the serpent's rattles ⟨⟨⟨⟩ prefixed. This latter however is chiefly found in the text to the high dragon dates, and the ţolkin, being essentially a divination ritual period, is less likely to be dealt with in larger chronological calculations.

Form **1.3** is however a most puzzling and important glyph. Its meaning would go far toward solving these high dates, based not on **4 Ahau, 8 Cumhu,** but on **9 Kan, 12 Kayab,** and clearly the most important part of the whole Codex. We see these rattles (in Maya ţab) prefixed with the tie to **Imix;** also **19 ţab-Imix;** and the ţab also prefixed to the kin, vinal, tun, katun and pictun.

Glyph **1.6** is chiefly found in the eclipse section.

Glyphs **1.8** and **1.16** are almost without exception used only in the Itzamná chapters; note the repetition of the 9.

The fact that form **1.18n,** with the number **7,** is used once each in the Madrid and Dresden, may lead to something.

The foregoing covers what is a quite certain use of the **Imix** by synecdoche, as being the initial and determining day, whether in vinal, ţolkin, or long count. We come next to another use, at present based wholly on its associations in the texts and pictures, yet immediately supported by the meaning of the day itself, in the various other calendars, its etymological meaning having disappeared in Maya.

Green color is used in the Dresden as a background in the pictures, in three ways: with red and yellow, solid, as in the ţolkins from pages 4–13, etc.; next in running drops denoting rain, most commonly below a 'constellation band,' or the ? 'eclipse glyphs' and finally as a light solid color, with darker wavy green lines, over which the deity rows a boat, etc. The third case obviously denotes the sea, or other

'waters.' At ʒolkin 60.b, page 36, a female figure, her head growing upwards into a bird's neck and head, the beak grasping a fish, is immersed in this sea. Above in the text is glyph 1a.2. At 60.a is what can be none other 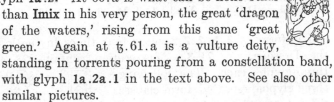 than **Imix** in his very person, the great 'dragon of the waters,' rising from this same 'great green.' Again at ʒ.61.a is a vulture deity, standing in torrents pouring from a constellation band, with glyph 1a.2a.1 in the text above. See also other similar pictures.

Finally, in ʒ. 55.f, page 36, we again find a full figure of the crested dragon, apparently not in the sea itself but in falling torrents, with a double-**imix** crest. The promise of a mythological content to these Itzamná chapters of the Dresden, in comparison with the clearly ceremonial and incantation archaic Maya text of the manuscript *Ritual of the Bacabs*, is amply attractive.

The whole complex of associations here seems unmistakably to imply the idea of 'the waters' as implicit both in the mythological being and in his glyph, except as used in its derived, technical calendric value. The remaining phase of the **Imix**-glyph, above referred to, follows along with this, but rests separately on its use as part of the common **kan-imix** compound; it will thus be better treated under **Kan**.

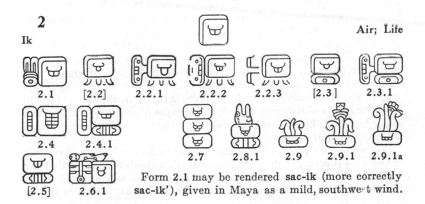

Form 2.1 may be rendered **sac-ik** (more correctly **sac-ik'**), given in Maya as a mild, southwest wind.

2.1	D.75.t.3	2.3.1	2.6.1	2.9	M.229.a.5
D.75.u.1	D.75.bb.3	D.66.c.4	P.10.b.13	M.195.a.5	M.229.e.5
	2.2.2	2.4	2.7	M.195.b.5	
2.2.1	D.75.r.3	M.43.b.2	M.p75–6.5	M.201.a.5	2.9.1a
D.72.g.4		2.4.1		M.201.c.5	M.195.d.5
D.74.o.5	2.2.3	M.43.c.2	2.8.1	2.9.1	M.202.a.5
D.75.f.3	D.75.q.2	M.43.d.2	M.p75–6.6	M.195.c.5	M.202.c.5

The forms 2.2.1, 2.2.2 occur four times in the long §75 in the Dresden, pp. 71–3. This section contains 28 clauses of three glyphs each. The following three glyphs, repeated, form clauses *d f n t*, except that in *d* the sky-glyph is turned level, and has as a superfix, and that the number Four only appears in clause *n*. Whatever be the mythological or other meaning of the head-glyph,* there must be some still unreached connection between it and the Ik-form 2.2.1; for we find this compound six times, in both the Dresden and the Paris, and each time associated with the same head-glyph.

Except for 2.3.1 in the last clause of the dragon section, the Dresden has no other case of Ik in composition.

* Förstemann thinks this is the glyph of the Four Bacabs, basing his conclusion on the following reasoning. He first assumes a 'vague' year of 364 days, divided into 28 thirteens, each of the 28 corresponding to one of these clauses. The cauac-sign, with different superfixes (one undetermined, but the others with the fixed meanings Green, White, Red) forms the glyphs for the four 'months' or vinals Ch'en, Yax, Sac, Ceh (the last being in Kekchí Chac, red); Landa places Ceh from Feb. 21 to Mar. 12. Förstemann now regards the Bacabs as ruling each one fourth of the year, so that their glyph should appear at equal 91-day intervals, 7 clauses apart, in this section. Maya writing is from left to right, but day interval series or tables are usually in columns, progressing and increasing from right to left. In the present section, the writer set out to raise the quarter-ʒolkin, 65, beginning with 4 Eb as zero-day, first to 5–1.0 (seven ʒolkins, where the day 4 Eb again applied); then to raise this 5–1.0 to 15.3–6.0 and a further (doubtful) 1.0.12–3.0. The numbers from 3.5 (65 days) up to 5–1.0 read consecutively, with their properly corresponding days, from right to left in the middle column, then from right to left in the lower. The glyph-triplet we are discussing therefore occurs actually in the 6th, 18th, 20th and 28th stages of the computation, at the lapse of not 91, 182, 273 and 364 days, but of 78, 234, 260 and 364 days; obviously *not* dividing the 'vague' 364-day year into four quarters.

To forward his 'proof' Förstemann next takes the hand-pointing superfix, which *always* points to the right, and occurs hundreds of times, with many different glyphs. In this section it occurs four times as a postfix pointing downwards as usual, and also ten times as a superfix. Since in the ten

In the Madrid, where the subject is almost wholly of plantings and growth, its use is both more common and more directly significant. In the form 2.7.1 it is held by the 'First Mother' on the double page 75–6; and tripled, 2.8.1 it is held by the 'First Father.' On page 32, following a section of planting clauses, the **Ik** is held in the hand of the large, grotesque female figure; then, strangely enough, it appears, double, on the shield of the black warrior, p. 33.

Tzolkins M. 41, 43, close a chapter wherein figures on the earth-sign as a base, plant, water or attack growing and budding **kan**-signs, while others hold forth either a **kan** or an **ik**. For the student's convenience the Madrid page 28 is here reproduced. Clause *a* of ₺. 41 is at the left, on page 27. In the text, glyphs *abc*.1 and *d*.2 show the **caban** or earth-sign with the **Cumhu**

instances it points (in its usual direction) toward the right, we are told that *here* this tells us we are to read the text *opposite* to the direction of the accompanying numbers and their days; in other words, that the glyphs (in this one instance) have nothing to do with the numbers beneath in their respective columns. This being thus settled, we are told that the writer *meant* to begin at the left in the upper column, with his text, in the sixth column of page 71; but he forgot, and started instead in the 7th column, went to the left to the 6th; then dropped to the 7th column in the bottom division, and again left to the 6th; then went up to the middle division, wrote along it from left to right, then again down to the lower division and across that; then again up the middle and again down to the lower—ending after this zig-zag at the lower right, in the middle of the numeral count. Re-arranging the text in this fashion, the four 'Bacab' signs occur 'where they *should*,' quarterly through the whole period of 5–1.0 x 28, or 1820 days; that is, at each successive 910 days, "clearly" showing the writer's real intention (91 being the quarter of 364).

Further to clinch the matter, we are referred to the appearance here at one place, of the quite common form, compounded of the **kin, cauac** and **tun** with the usual **tun**-subfix. Disregarding the other three month signs equally based on the **cauac**-sign, we are told that it here represents the month **Ceh**, beginning "about the Spring equinox," or on March 8th or 10th! This connects up the present section with the beginning of the "sacred tonalamatl," *at* the Spring equinox with the Mayas as with the Mexicans, and in the center of the 364-day year (52 days of which preceded and 52 followed the tonalamatl or ȼolkin), ruled in its 91-day quarters by the Four Bacabs, whose quarterly repetition (in the 1820-day period) we have thus verified, by discovering what the Maya writer "clearly" meant to set down. The foregoing, from his *Commentary on the Dresden Codex*, page 159, is an excellent illustration of the sort of glyph-interpretation we have had to put up with—and still do.

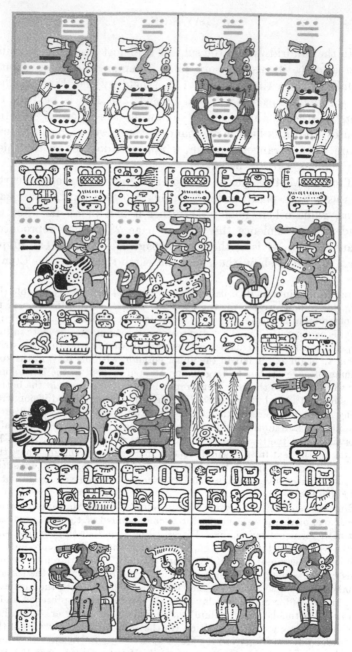

Madrid, page 28

(This illustration is reproduced in color on the inside back cover.)

superfix , replaced in the last clause *e* by **yax-caban.** In
the picture *a* the corn-god holds an **ik**; in *bcd* pests attack either
the corn-god or the growing shoots; in *e*, underneath the **yax-kan,**
the god holds the **kan,** the corn itself.

Below, in ʒ. 43, the usual glyph of Itzamná, with the tau-eye,
but *without* his specific determinative , is repeated as
initial in each clause. In the pictures, at *a* the corn-god holds a
kan; in *bcd* the black-banded god and the corn-god hold **ik,** the
ik-sign appearing above each, in *bcd*.2; note that the honorific
determinative (see under gl. **77, 120,** etc.) also is seen in position 2,
over the three figures of the corn-god, but not over the destroyer.
And then in positions *abc*.3 we see gl. **75**.7, to be replaced in
d.3 by **yax-kan,** pictorially shown. That is, in picture *d* the
corn-god, though holding the **ik,** has the **kan**-sign in his headdress
and also dots about the mouth. The glyph above reproduces
the face with these dots as its characteristic, with the **yax** as
prefix; thus giving us effectively the same meaning as in 41.*d*.1
above, when the life force has at last produced the new or green
maize. Note also the **kan-imix,** food and drink, in 41.*d*.4.

Note here in passing, that although the specific face-glyphs
75, 77, the common appellative glyphs of the god of the North
and of Itzamná, appear each four or five times, neither of these
gods has anything to do with the passage, which is altogether that
of the Corn-god surmounting the opposing forces; the glyphs in
question, being appellatives and not personal 'names,' are thus
transferrable to others.

The foregoing has been thus noted in detail, since it gives an
excellent idea of the manner in which the text glyphs successively
repeat, shift and correspond; as well as the way in which one
ʒolkin, text and pictures, leads over and works into the next, with
linked ideas and associations. The passages are also typical of
the Madrid, and its subject matters in general.

The Madrid chapter running from pages 89 to 102 is devoted to
various ceremonies, including the carving and aspersion of the
new *idolos* described by Landa as carried on in the month **Mol.**
In the midst of this image-carving we also find ʒ. 195, 201, 202,
showing the plant growing and then budding, out of an **ik**-sign
which is held forth by the seated figures. See under **Akbal.**

These persistent associations of growth, the **Kan** and the **Ik,**
not only bring these signs unmistakably into the Maize-cult

natural to the Middle Americans, but give good grounds for the
general interpretation of 'air' as also involving the meanings of
life or spirit.

Through an error in copying a partly erased instance of the
day-sign ⟨ ⟩ on Madrid p. 87, the sign ⟨ ⟩ has since been
called **Ik** by every writer, especially in the very common superfix
⟨ ⟩—erroneously named **'ben-ik,'** See later under gl. **341.**
The day-sign is never so found.

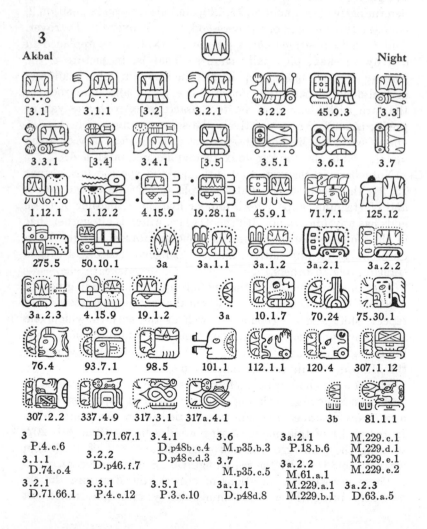

3
Akbal Night

[3.1] 3.1.1 [3.2] 3.2.1 3.2.2 45.9.3 [3.3]

3.3.1 [3.4] 3.4.1 [3.5] 3.5.1 3.6.1 3.7

1.12.1 1.12.2 4.15.9 19.28.1n 45.9.1 71.7.1 125.12

275.5 50.10.1 3a 3a.1.1 3a.1.2 3a.2.1 3a.2.2

3a.2.3 4.15.9 19.1.2 3a 10.1.7 70.24 75.30.1

76.4 93.7.1 98.5 101.1 112.1.1 120.4 307.1.12

307.2.2 337.4.9 317.3.1 317a.4.1 3b 81.1.1

3	D.71.67.1	3.4.1	3.6	3a.2.1	M.229.c.1
P.4.c.6	3.2.2	D.p48b.c.4	M.p35.b.3	P.18.b.6	M.229.d.1
3.1.1	D.p46.f.7	D.p48c.d.3	3.7	3a.2.2	M.229.e.1
D.74.o.4			M.p35.c.5	M.61.a.1	M.229.e.2
3.2.1	3.3.1	3.5.1	3a.1.1	M.229.a.1	3a.2.3
D.71.66.1	P.4.c.12	P.3.c.10	D.p48d.8	M.229.b.1	D.63.a.5

The word **akab** (correctly **ak'ab**) for Night, and in its definitive form **akbal**, darkness, is the common Mayance term, found with those meanings generally, in Maya, Quiché, Tzeltal, Ixil, Choltí, etc. There is no possible question as to the meaning of the word, whatever the original day-name was, or the value of the glyph as glyph. The scantiness of its use in glyph-composition is, however, remarkable. It is of much wider use when shown surrounded by dots, as main element or as prefix. In neither case do the associations and pictures permit as yet any positive readings, and it is only when we find it as infix that the meaning of 'night' or 'darkness' comes out clearly.

We may take this place to make clear one important point in our work. The student must keep before him constantly, literally constantly, the milieu and mental position of the Indian as he looks out upon the world. His is a world of things not only acted upon, but also moved as well by powers or forces innate; his is not a world of books. He cognizes his world not through them but directly by the senses. The words he uses he does not think of as made up, spelled out, by letters as seen on a page; his language is not a thing of spellings, but of words as wholes representing the meanings, and so pronounced and heard—as wholes, not letters.

His language, as it existed in the more advanced centers, is exalted, at times to magnificence, and great rhetorical power; its syntax is at times delightful; it carries delicate shades of thought and suggestion, and is at the same time extremely vivid because of its closely maintained link with the straight eye-vision of things and actions, which underlies the use and development of its words. Direct etymological meanings are always closer to the consciousness of the Indian as he speaks, than they are to us. This is an essential appanage of hieroglyphic and agglutinative tongues; ideas have not yet been lost in meaningless forms, of the dictionary or grammar. In the spoken languages certain terminations have come into being, of conjugational or declensional character, in each case markedly Indian, and as a part of what is said above.

In verbs the major line of distinction is not the personal one of active or passive, but the practical one of the transitive or intransitive; it is the doing something special, *resultful*, that makes the

line—a quality which also underlies the Indian's well-known
'taciturnity.' He is not therein just surly by nature; by mental
bent he uses the words, or parts of words, necessary; and then
stops.

The same in nouns: the thing possessed is not distinguished
from that not possessed, but the thing applied to use is dis-
tinguished. This fact is marked all through Mayance languages
by the most common of all word-terminations, the final -*l*, usually
preceded by the stem vowel. This denotes the concrete specializa-
tion, practicalization, of the thing- or idea-in-itself behind what is
seen or felt operating. **Akbal** is, in fact, a case in point; it is the
darkness *of* the night which we feel or see, and which presses on
our senses, affecting and changing our activities. It is not the
night, but its manifestation, its dark*ness*. The Indian is fully
believing, indeed ever-conscious of 'things within and behind';
but he also sees their effects, and the things without, directly
eye-to-thing, and carries that into his actions and speech. **Sac**
again, white in itself, is in just the same class as **ak'ab**; it is **saquil,**
the white*ness*, the specific manifestation, that is useful. **Vinak,**
man; **vinakil,** manhood, as an active force; then further, also,
'score,' his fingers and toes as a counting base.

It is directly connected with the foregoing that we find a second
factor of the highest importance directly in our glyph studies:
the ever-present recognition of the difference between character
and function, the permanent and the temporary: essence and
'accident' in the philosophic sense; the self and its cloaks. We
must here study all the costume or regalia changes in the characters
pictured in our texts; we will later see how Itzamná, the great
magician, the great god, not only has a head-picture as a glyph,
but an appellative glyph besides, the Tau-eye head—which may
at times be given to other deities. We must assume that this
second glyph means something like our 'the Lord Almighty,'
Odin the 'All-wise, the All-father.' See also glyphs **71** to **76.**

It is here that our glyph **Akbal** comes in for its third distinctive
use—as an infix. We have a number of head-infixes used with
various glyphs: the **kan** or maize, the sun, the **vinal** (**chuen**-sign),
the **tun** (either **cauac** or the normal **tun**-glyph, no. **50**), the death-
sign (our no. **21**), glyph **59**, the flint-knife (**eẗ'nab**), and **akbal.**

This latter we find in Soꜩ, the bat-glyph; with the human-face glyph **98**; in the predatory animal of some kind, used for the **Xul**-glyph and interchanging in its use with the **Oc**-glyph which does *not* take the infix. The dog, **Oc**, though a devouring animal has distinctive characteristics marked in the glyph, but never includes the 'darkness' infix, peculiar to the **Xul**.*

As stated above, our **Akbal** glyphs are few. In the 3.2 forms it takes the subfix special to the **caban**-sign, and is found only in the Venus and eclipse chapters. As 3.4.1 it takes the **'ben-ik'** superfix, and is one of the series of twenty signs across the Venus pages. And that is about all.

Surrounded by dots it is a prefix to a long list of face-signs, and with a specialized form is peculiar to the Aged God D, our gl. **81**. Apart from this extended use it is found as a main element in a passage that merits careful examination, and which among other points brings in the signs for wind, earth and darkness, all as composition word-elements. In Madrid ꜩ. 229 we have two standing figures holding what are apparently stalks, budding, with the **ik,** wind or life, enclosed below the bud; the first figure carries the **caban** bundled on his back, while the **caban**-form is repeated as second glyph, *abcd*.2; and the dotted **akbal**, our 3a.3.1 is the initial glyph throughout. Then in the next ꜩolkin two similar figures hold the bare stalk, without leaves or **ik**-sign, although both again carry the earth-bundle, with the same **caban**-glyph in each clause; while the **Tzec**-form, our 30.2, is here the repeated initial.

These cases of repeated, alternating and succeeding glyphs, ꜩolkin after ꜩolkin through our texts (both Dresden and Madrid) hold the most fruitful and direct promises for the student's investigations. In fact, it is to make this kind of work possible, that the present publication has been built up through the thirty years from the casting of its first type, and the basis of classification roughly established—to be changed and changed, as classifications (at first based on naked form) gradually yielded to others more defined by associations, and finally beginning, at least, to pass into those implying meanings.

* The student should here remember that Oc does not mean dog in Maya, as the day-name Tzi does elsewhere in Mayance; and that Xul means 'end' in Maya, and not any animal; so that we are here dealing with day-*names* and glyphs, but not with Yucatecan Maya words.

4

Kan **Corn**

[4.1] 4.1a 4.1n 4.1.1 4.1.2 4.1.3 4.1.4 [4.2]

4.2.1 4.2.2 4.3 4.3.1 4.3.2 4.3.2a 4.3.3

4.3.4 4.3.5 4.3.5a 4.3.6 4.3.7 [4.4] 4.5

4.6 [4.7] 4.7.1 [4.8] [4.9] 4.9.1 4.9.2 4.9.3

4.9.4 [4.10] 4.10.1 4.10.2 4.10.3 4.11 4.11a 4.11.1

4.11.2 [4.12] 4.12.1 4.12.2 4.12.3n 4.12.4 4.13 4.13a

Cumhu 4.15 4.15 4.15a 4.15a 4.15.1 4.15a.1 4.15.2

4.15.3 4.15.4 4.15.5 4.15.6 4.15.7 4.15.8 4.15.9

[4.16] 4.16a 4.16.1 4.17 4.18 4.19.1 4.20.1

4.21.1 4.22 4.23 4.23a 4.23b 4.23n 4.23.1

4.23.2 4.23.3 4.23.4 4.23.4n [4.24] 4.24.2 4.25

4.25.1 4.25.2 4.25.3 4.25.4 4.26 4.26.1 4.27.1 4.28.1

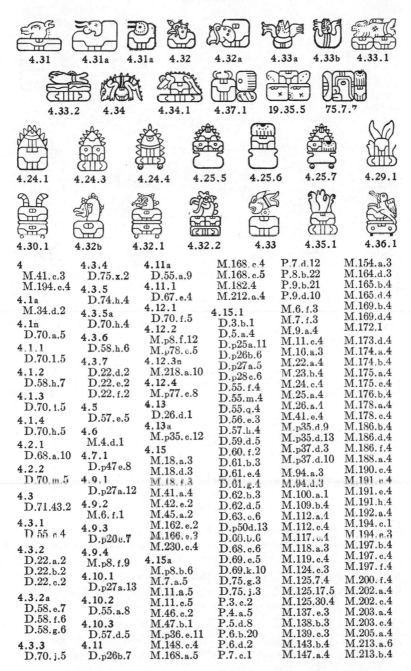

4.31 4.31a 4.31a 4.32 4.32a 4.33a 4.33b 4.33.1

4.33.2 4.34 4.34.1 4.37.1 19.35.5 75.7.⁷

4.24.1 4.24.3 4.24.4 4.25.5 4.25.6 4.25.7 4.29.1

4.30.1 4.32b 4.32.1 4.32.2 4.33 4.35.1 4.36.1

4	4.3.4	4.11a	M.168.c.4	P.7.d.12	M.154.a.3
M.41.c.3	D.75.x.2	D.55.a.9	M.168.c.5	P.8.b.22	M.164.d.3
M.194.c.4	4.3.5	4.11.1	M.182.4	P.9.b.21	M.165.b.4
4.1a	D.74.h.4	D.67.e.4	M.212.a.4	P.9.d.10	M.165.d.4
M.34.d.2	4.3.5a	4.12.1		M.6.f.3	M.169.b.4
4.1n	D.70.h.4	D.70.f.5	4.15.1	M.7.f.3	M.169.d.4
D.70.a.5	4.3.6	4.12.2	D.3.b.1	M.9.a.4	M.172.1
4.1.1	D.58.h.6	M.p8.f.12	D.5.a.4	M.11.c.4	M.173.d.4
D.70.1.5	4.3.7	M.p78.c.5	D.p25a.11	M.10.a.3	M.174.a.4
4.1.2	D.22.d.2	4.12.3n	D.p26b.6	M.22.a.4	M.174.b.4
D.58.h.7	D.22.e.2	M.218.a.10	D.p27a.5	M.23.b.4	M.175.a.4
4.1.3	D.22.f.2	4.12.4	D.p28c.6	M.24.c.4	M.175.c.4
D.70.1.5	4.5	M.p77.c.8	D.55.f.4	M.25.a.4	M.176.b.4
4.1.4	D.57.e.5	4.13	D.55.m.4	M.26.a.1	M.178.a.4
D.70.h.5	4.6	D.26.d.1	D.55.q.4	M.41.e.4	M.178.c.4
4.2.1	M.4.d.1	4.13a	D.56.e.3	M.p35.d.9	M.186.b.4
D.68.a.10	4.7.1	M.p35.c.12	D.57.h.4	M.p35.d.13	M.186.d.4
4.2.2	D.p47e.8	4.15	D.59.d.5	M.p37.d.3	M.186.f.4
D.70.m.5	4.9.1	M.18.a.3	D.60.f.2	M.p37.d.10	M.188.a.4
4.3	D.p27a.12	M.18.d.3	D.61.b.3	M.94.a.3	M.190.c.4
D.71.43.2	4.9.2	M.18.f.3	D.61.e.4	M.94.d.3	M.191.c.4
4.3.1	M.6.f.1	M.41.a.4	D.61.g.4	M.100.a.1	M.191.e.4
D.55.c.4	4.9.3	M.42.e.2	D.62.b.3	M.109.b.4	M.191.h.4
4.3.2	D.p20c.7	M.45.a.2	D.62.d.5	M.112.a.4	M.192.a.4
D.22.a.2	4.9.4	M.162.e.2	D.63.c.6	M.112.c.4	M.194.c.1
D.22.b.2	M.p8.f.9	M.166.c.3	D.p50d.13	M.117.c.4	M.194.e.3
D.22.c.2	4.10.1	M.230.c.4	D.66.b.6	M.118.a.3	M.197.b.4
4.3.2a	D.p27a.13	4.15a	D.68.c.6	M.119.c.4	M.197.c.4
D.58.e.7	4.10.2	M.p8.b.6	D.69.c.5	M.124.c.3	M.197.f.4
D.58.f.6	D.55.a.8	M.7.a.5	D.69.k.10	M.125.7.4	M.200.f.4
D.58.g.6	4.10.3	M.11.a.5	D.75.g.3	M.125.17.5	M.202.a.4
4.3.3	D.57.d.5	M.11.c.5	D.75.j.3	M.125.30.4	M.202.c.4
D.70.j.5	4.11	M.46.c.2	P.3.c.2	M.137.e.3	M.203.a.4
	D.p26b.7	M.47.b.1	P.4.a.5	M.138.b.3	M.203.c.4
		M.p36.e.11	P.5.d.8	M.139.c.3	M.205.a.4
		M.148.c.4	P.6.b.20	M.143.b.4	M.213.a.6
		M.168.a.5	P.6.d.2	M.147.a.4	M.213.b.4
			P.7.c.1		

M.213.c.2	M.81.a.4	4.16.1	4.23.4	4.25.5	M.218.k.4
M.213.d.2	M.146.c.3	M.6.e.3	M.219.e.3	M.211.5	M.219.c.3
M.214.a.2	M.170.d.4	4.17	4.23.4n	4.25.6	M.228.a.5
M.218.b.4	M.179.f.4	D.55.g.2	M.218.m.5	M.182	4.32b
M.219.g.2	M.199.b.4	4.18	4.24.1	4.25.7	D.p28c.8
M.222.b.3	M.210.a.4	M.33.a.2	M.87.a.5	M.91	4.32.1
M.223.c.4	M.218.b.4	4.19.1	M.184.1	4.26	M.218.e.4
M.224.d.3	M.222.a.4	D.69.f.5	4.24.2	M.187.6	4.33
M.234.a.4	M.226.c.4	4.20.1	D.67.c.4	4.26.1	D.58.a.5
4.15a.1	M.227.a.4	M.p35.c.16	M.218.b.7	M.228.c.5	D.64.c.5
D.7.b.3	M.228.c.4	4.21.1	4.24.3	4.27.1	4.33b
D.8.h.6	M.229.e.4	D.57.a.5	M.213.c.8	M.194.c.3	D.p27b.5
D.8.n.5	4.15.2	4.22	M.218.b.10	4.28.1	D.55.c.11
D.8.r.4	D.69.k.6	M.p77.e.8	4.24.4	M.p77.c.5	4.33.1
D.9.e.3	D.70.i.4	M.p78.b.5	M.p8.f.8	4.29.1	D.p27c.9
D.18.a.6	4.15.3	4.23	4.25	M.p77.g.8	4.33.2
D.20.c.3	M.28.a.2	M.179.a.5	D.55.c.9	4.30.1	M.p77.b.5
D.21.b.3	4.15.4	M.179.c.5	M.115.b.1	M.218.h.4	4.34
D.25.a.1	M.p37.c.8	M.179.e.5	M.125.24.7	4.31	D.58.c.5
D.25.b.1	4.15.5	M.218.e.6	M.125.25.8	M.p77.d.5	D.58.g.5
D.25.c.1	D.62.e.4	4.23a	M.218.d.9	M.p78.e.8	D.64.b.9
D.25.d.1	4.15.6	M.218.d.7	P.2.b	4.31a	D.68.b.9
D.26.b.4	M.180.c.1	4.23b	P.4.b	D.58.e.5	P.16.a.5
D.28.a.1	4.15.7	P.18.a.5	P.17.b.5	M.p77.a.8	M.p6a.4
D.28.b.1	P.17.e.3	4.23n	4.25.1	4.32	M.219.b.3
D.29.d.3	4.15.8	M.218.d.9	M.p77.b.8	D.58.d.5	M.227.a.5
D.31.d.6	M.30.c.2	4.23.1	M.p77.d.8	D.55.c.10	4.34.1
D.37.c.3	4.15.9	M.6.b.4	4.25.2	D.64.a.5	M.p77.f.5
D.46.f.2	M.5.b.1	M.6.i.3	D.57.a.7	D.67.d.4	M.p78.f.5
D.47.f.4	M.5.c.1	4.23.2	4.25.3	4.32a	M.p78.f.8
D.49.b.4	M.5.f.1	M.6.a.4	D.p28b.5	M.125.2.7	4.35.1
D.50.d.4	4.16a	4.23.3	4.25.4		M.p8.e.9
D.52.d.1	M.33.c.4	M.218.i.6	M.p12b.5		4.36.1
D.52.f.1					D.55.e.9
D.75.p.3					

The different local variations in the general calendar provide two possible meanings for the Fourth Day: Lizard and Maize. No trace of the former appears in the glyph-use and pictures, but innumerable cases of the second. The Corn-cult is everywhere, and all-important.

In spite of the long list of forms above, its glyph-development is comparatively simple. Down to, say, form **4.14** it may be regarded as a composition element; **4.14** is the month **Cumhu**; **4.15** sqq. the series of **kan-imix** forms, with nearly 200 occurrences in the texts; from about **4.23** on it merely shows the basic element of 'food, bread,' either alone or in combination with the other chief food-offerings, the turkey, deer, fish and iguana.

In the **4.1, 4.2, 4.3** forms we have what will later be seen as one of our most important qualifying or determinative 'minor

elements,' 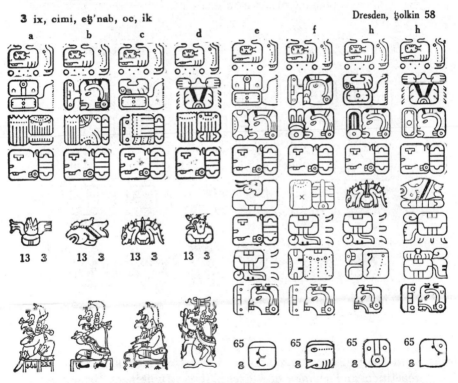. Its determinative function is especially marked in the formation of the month-signs, q.v. With the **kan** we find it chiefly used in the ceremonial Itzamná or sacrificial ʒolkins, 55, 58, 70, 74, 75. Its use in ʒ. 58, and in ʒ. 22 should be particularly noted. These Itzamná ʻceremonial ʒolkins' carry frequent serial use of the four cardinal points and their colors, and almost certainly represent an incantation ritual; their resemblance in this to the archaic chants in the Maya *Ritual of the Bacabs*, with their invocations of Itzamná and the four Pauahtuns, is very striking.

3 ix, cimi, eʒ'nab, oc, ik Dresden, ʒolkin 58

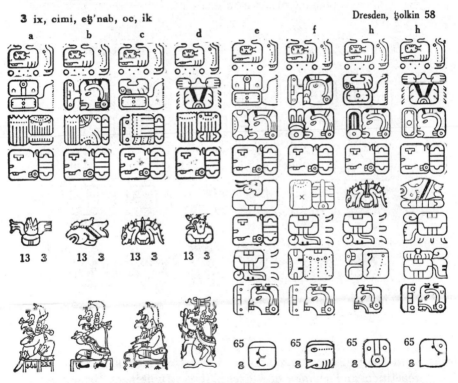

In ʒ. 58 we have eight clauses, each begun by glyph **92.2.1**, and with the east, north, west, south signs used and then repeated in the second place. The first four clauses have but four glyphs each, with food-offerings and then Itzamná below. The last four clauses have no pictures, but eight glyphs each, the last glyph being no. **74**, q.v. The glyphs in *abcd*.3, over the offerings, are

all compounds of gl. **340,** which there are various association reasons for our thinking to mean 'animal food,' as distinct from 'bread.' Bread, drink, meat, exhaust the major food distinctions, leaving other vegetable foods as minor sorts, or else brought generally, as plant products, under the word 'bread,' **vah.**

The fourth glyph in all eight clauses, *a-h.*4, is **77.1,** the special appellative of Itzamná (a shift is caused in clause *e* by the intrusion of another glyph). And then our **kan**-forms **4.1** etc. run across near the bottom of columns *e-h.* And again, as we saw above in the Madrid ꜩ. 41, 43, a **yax-kan** glyph, new or green maize, closes the ꜩolkin, replacing other combinations.

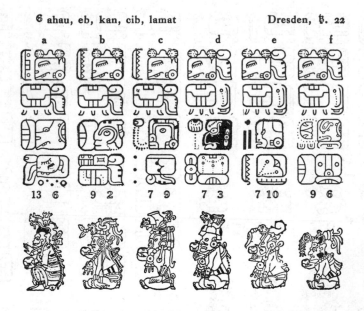

6 ahau, eb, kan, cib, lamat Dresden, ꜩ. 22

a b c d e f

13 6 9 2 7 9 7 3 7 10 9 6

In Dr. ꜩ. 22 we have another interesting case of this shifting repetition and change of affixes. It is a ꜩolkin of six clauses, where six deities hold forth a **kan**-sign. The initial in all six clauses, *a-f.*1, is our no. **23,** with the Landa **ma** or negative sign ⊛ꞁ⊛ as superfix. The prefix ▱ or ⟆⟆⟆⟆ in *abc.*1, yields to the postfix ⟅⟆ in *def.*1. Then in *a-f.*2 we have the **kan** repeated, with the triple-loop subfix, and the same postfix as above in *abc.*2, itself replaced in *def.*2 by ⟦ꞁ···⟧ which we shall

later discuss as a sign denoting the conclusion of different activities, when brought to their head. Tzolkin 23 then picks up the gl. 23 (with different affixes) and again a repeated glyph in *a-d*.2. Glyphs *abcd*.3 tell the gods. Then ʒ. 24 has another repeated pair of glyphs, also reflected in the pictures below. And a **kan-imix** repetition in ʒ. 25, with a sequence of others, following. The textual continuity and interlocking of all these is clear, and certainly a fruitful field for study and affix analysis.

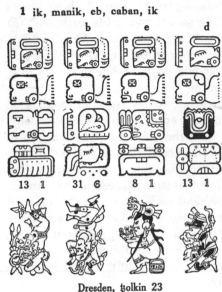

1 ik, manik, eb, caban, ik

Dresden, ʒolkin 23

The occurrence of **kan** with the calendric wing-affix, *[......* in form 4.9.1 is remarkable.

We next have compounds with the color signs for green and red, with the **kan** several times doubled, and also resting on the 'table of honor' subfix ⟨⟩ on which the offerings usually rest. In such a connection the green would be easily interpretable as new corn, the first-fruits offering; the use of red is more difficult, since the usual word to be expected here for *maduro*, ripe, would be yellow.

White ⟨⟩ as a prefix occurs just once, in Dr.70.f.5, in another long ceremonial Itzamná section, also with ⟨⟩ as sixth or final glyph in all thirteen clauses.

Kan-imix, or **imix-kan**, glyph 4.15 sqq. ⟨⟩. Here we reach the commonest glyph in all our texts. In the pictures the figures hold forth a **kan** 21 times in the Dresden, 10 in the Madrid; these instances are directly associated with planting or growing, and at various places we see the **kan** itself sprouting or budding. The figures also hold forth **kan-imix** or **imix-kan** once in the Dresden and six times in the Madrid. A specially important ʒolkin is Dr. 65; in this we see Itzamná seated once on the sky-band, with the

sky-sign as a glyph above; in the other eight clauses he sits upon a tree or plant (not maize-plants), one of these plants being a *maguey*, from which the seated god holds forth an **imix**. Again in Madrid ᵗᶻ. 211 god D holds forth an **imix**, with a curious hollow in the top, clearly drawn, before the descending spider, while in his right the god holds an aspersorium.

There are obviously paired ideas, to be expected in all such texts as these, as well as in human activities and uses generally. None is more to be expected than that of 'food and drink, bread and water, corn and wine.' In the face of these glyph and picture associations, and especially with the other **Imix** implications already noted, it is at least a fair tentative suggestion that **Imix** is paired with **Kan** in this sense, and carries the specific value of drink or wine, product of the maguey, as well as water generally. We shall also see it linked later with the sign ▦ —our gl. **340,** which may in its turn easily denote the other chief food, meat. See under **340.** The superfix to the **kan-imix** should be given especial attention, in our study.

Substantially all the remaining **kan**-forms are mere offerings, in which the glyph stands either for the maize itself, or as a determinative in general, 'food-offering, the deer,' etc. It also appears doubled and tripled; and rests either on the 'table of honor' ⬡ or a jar. The meaning of the points shown about the **4.24** etc. forms, is purely speculative. The present work, based on tabulation and comparison, rejects as a principle of procedure any guessing at what a glyph may or might mean, because of what it *seems* to look like. Every attempt on those lines so far has produced nothing lasting, and has only muddied the waters.

5

Chicchan

Serpent

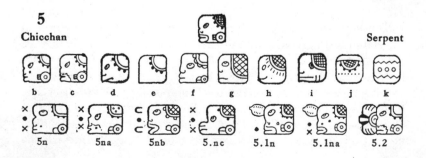

| b | c | d | e | f | g | h | i | j | k |

| 5n | 5na | 5nb | 5.nc | 5.1n | 5.1na | 5.2 |

| 5.2a | 5.2a | 5.2b | 5.2c | 5.2d | 121.5? | 5.2.1 |

| 5.2.1a | 5.3 | 5.4.1 | 5.4.2 | 5.5 | 5.6.1 | 5.7.1 |

| 5.8 | 5.9 | 5.10.1 |

		5.2	5.2c	5.3	5.7.1
5a	5nc	D.51.b.2	M.200.d.3	D.59.d.4	M.p34.c.14
P.8.d.4	M.164.b.4	5.2a		5.4.1	
5d	5nd	M.185.f.3	5.2d	P.23.a.12	5.8
M.140.a.4	M.56.e.4	M.218.f.3	P.24.a.8*	5.4.2	M.131.b.2
5g	5.1n	M.226.b.3		P.24.a.11	
M.18.d.2	D.p40b.d.1	5.2b	5.2.1	5.5	5.9
5na	D.p50c.a.3	D.16.d.3	D.72.a.17	M.24.b.3	M.204.c.4
D.3.a.3	5.1na	D.46.b.2		5.6.1	5.10.1
5nb	D.p24.b.7	D.p70.c.12	5.2.1a	M.p34.b.14	M.p37.b.11
D.7.e.2			D.72.f.17		

Chicchan must, upon all the evidence, be accepted as meaning Serpent, although some of the forms above are of doubtful inclusion under this head. The cross-hatched curve, surrounded by solid dots on the edge, is the typical form, deriving from the serpent's spots; inside spots or a blank may replace the hatching, and the dots be omitted. The loops in place of the dots are characteristic of glyph 123, associated generally with a priestess or goddess in the pictures; this gl. 123 also has the inside markings, and the prefix shown in form 123.1 ⊙⊕ as specific to that glyph, just as ⊘ yax, green, is to Chicchan.

It is to be doubted whether the cases with the number 1 denote a day-sign; they may denote a personage.

Form 5nc has been included despite the loops, as perhaps a case of the irregularity so common in the writer of the Madrid. This characteristic of that codex is one of our main troubles— when to ignore it as the work of a far inferior scribe, or when to give it note. In this matter the present work has gone much further in reproducing glyph variations than we believe will finally prove to have been required; the guide has consistently been: when any doubt exists, show the variation.

Form 5.1n holds yet stronger reasons for thinking it a 'name,' being one of the series of 20 across the Venus pages.

The outstanding **Chicchan** compound is that with **yax** 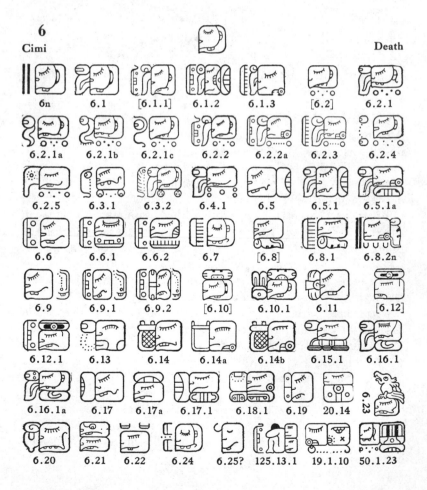 or green as prefix. Probably the most important passage in the whole Dresden is the paired long columns on pp. 61, 69. Here we find this 'green-serpent' at both 72.a.17 and 72.f.17, with the visible under jawbone, established in the inscriptions as meaning **lahun**, or 10. It is altogether likely that a reading of a few signs or affixes in these columns, would unlock all the cyclic astronomy in the Dresden.

The remaining forms, from the Madrid, are placed here only for form-reasons; they may not belong under **Chicchan** at all. Form **5.10.1**, with wing-affix, is noteworthy.

6

Cimi

Death

6n	6.1	[6.1.1]	6.1.2	6.1.3	[6.2]	6.2.1

6.2.1a	6.2.1b	6.2.1c	6.2.2	6.2.2a	6.2.3	6.2.4

6.2.5	6.3.1	6.3.2	6.4.1	6.5	6.5.1	6.5.1a

6.6	6.6.1	6.6.2	6.7	[6.8]	6.8.1	6.8.2n

6.9	6.9.1	6.9.2	[6.10]	6.10.1	6.11	[6.12]

6.12.1	6.13	6.14	6.14a	6.14b	6.15.1	6.16.1

6.16.1a	6.17	6.17a	6.17.1	6.18.1	6.19	20.14	6.23

6.20	6.21	6.22	6.24	6.25?	125.13.1	19.1.10	50.1.23

6	M.125.33.7	D.28.b.3	M.139.b.3	D.p60b.5	**6.9.1**
M.7.a.2	M.127.b.4	D.29.a.3	M.150.b.4	M.56.c.4	M.116.e.1
M.93.a.4	M.137.a.1	D.32.a.4	M.157.c.2	**6.2.1b**	**6.10.1**
M.99.a.2	M.137.c.1	D.38.b.4	M.164.a.1	D.71.i.2	D.49.a.1
M.116.d.1	M.138.a.1	D.39.b.4	M.164.b.1	**6.2.1c**	**6.11**
M.119.b.3	M.142.b.4	D.40.d.4	M.164.c.4	D.4.b.4	M.23.e.3
M.129.2	M.144.b.4	D.43.c.4	M.164.d.1	D.61.b.3	**6.12.1**
M.166.d.4	M.145.b.4	D.44.d.4	M.164.e.1	**6.2.2**	M.8.a.1
M.179.d.4	M.145.d.4	D.49.a.4	M.173.c.3	D.5.c.4	M.8.b.1
M.187.b.2	M.146.d.3	D.52.a.1	M.186.c.3	P.2.b.10	M.8.c.1
6n	M.147.b.3	D.52.b.1	M.186.e.1	P.2.c.2	**6.13**
M.177.d.3	M.148.b.4	D.52.c.2	M.186.e.4	M.125.3.1	M.165.a.3
6.1	M.148.d.3	D.52.e.1	M.191.b.2	**6.2.3**	**6.14**
D.14.h.2	M.153.a.3	D.59.c.6	M.191.d.4	M.125.5.5	M.179.b.1
D.46.d.3	M.154.b.4	D.63.b.5	M.191.f.2	M.125.8.3	**6.14a**
D.51.d.4	M.165.a.2	D.68.d.6	M.191.f.4	**6.2.4**	M.125.10.4
P.4.d.9	M.168.d.3	D.p47.f.2	M.192.c.3	D.48.a.4	**6.15.1**
P.6.d.9	M.169.a.3	D.71.1.2	M.195.e.3	**6.2.5**	M.87.c.3
M.10.b.3	M.169.c.2	D.71.3.1	M.197.e.3	M.7.g.2	**6.16.1**
M.10.d.3	M.170.a.3	D.71.a.9	M.197.g.1	**6.3.1**	M.58.b.4
M.10.d.4	M.171.a.2	D.71.14.1	M.197.g.4	M.61.b.3	**6.16.1a**
M.14.b.3	M.174.c.3	D.71.e.7	M.198.b.4	M.62.c.4	M.57.d.4
M 15.b.4	M.176.f.4	D.71.44.1	M.198.d.4	**6.3.2**	**6.17**
M.16.d.3	M.176.h.4	D.71.h.1	M.199.c.4	D.71.d.3	M.94.b.4
M.17.b.3	M.188.b.3	P.3.c.13	M.200.d.1	**6.4.1**	M.139.b.2
M 19.b.2	M.103.b.3	P.3.d.10	M.201.b.2	M.140.b.4	M.149.b.4
M.22.d.4	M.194.b.1	P.4.b.16	M.201.b.4	M.165.c.3	M.167.b.2
M.23.f.3	M.195.e.3	P.4.b.18	M.202.b.1	**6.5**	M.168.b.2
M.27.b.3	M.196.b.3	P.4.b.24	M.202.b.4	M.17.c.4	M.185.b.3
M.28.b.3	M.197.d.5	P.4.c.1	M.202.d.2	**6.5.1**	M.194.d.4
M.29.b.3	M.199.c.4	P.5.d.3	M.203.d.3	M.46.d.1	M.206.b.4
M.30.b.2	M.203.b.2	P.6.c.1	M.204.c.2	**6.5.1a**	M.231.b.3
M.31.a.4	M.205.b.4	P.6.d.10	M.209.a.4	M.124.b.3	**6.17.1**
M.31.c.3	M.213.b.6	P.6.d.13	M.210.c.3	M.125.27.4	M.43.a.2
M.41.d.3	M.218.c.4	P.6.d.15	M.212.b.4	**6.6**	**6.18.1**
M.42.c.3	M.222.b.4	P.7.b.23	M.216.b.4	M.116.b.1	M.p35.d.14
M.43.d.4	M.226.c.4	P.7.c.6	M.219.d.4	**6.6.2**	**6.19**
M.45.b.1	M.228.b.3	P.9.c.9	M.223.b.4	M.p34.c.8	M.100.b.1
M.45 c 2	M.229.b.1	P.9.c.10	M.224.c.3	M.p35.c.13	M.183.c.3*
?M.p36.c.10	**6.1.2**	P.10.c.1	M.226.d.4	M.98.a.3	**6.20**
M.p37.b.17	M.p36.d.14	P.10.c.2	M.227.b.3	M.167.b.4	M.19.a.2
M.61.f.3	**6.1.3**	P.11.c.1	M.228.b.3	**6.7**	**6.21**
M.104.b.4	M.125.21.4	P.11.c.2	M.232.b.4	M.93.a.1	M.179.b.5
M.112.b.1	**6.2.1**	P.11.c.5	M.235.b.4	**6.8.1**	M.170.f.5
M.112.b.4	D.3.a.4	P.11.c.9		M.191.a.1	**6.22**
M.112.d.3	D.3.c.4	M.7.b.2	**6.2.1a**	**6.8.2n**	M.p36.c.12
M.117.b.4	D.6.b.4	M.9.b.4	D.7.a.2	M.125.21.3	**6.23**
M.118.c.3	D.8.t.5	M.11.b.4	D.7.c.4	**6.9**	M.160.d.3
M.120.b.2	D.10.b.4	M.12.a.4	D.8.i.5	M.116.c.1	**6.24**
M.121.d.4	D.11.b.4	M.12.c.4	D.8.m.4		M.125.19.7
M.122.b.4	D.16.b.4	M.13.b.4	D.8.q.5		
M.124.d.2	D.21.c.3	M.61.g.1	D.24.d.4		
M.124.f.2	D.22.a.4	M.125.4.3	D.25.b.3		
M.125.28.5	D.23.b.4	M.125.31.5	D.50.c.4		

In this glyph we have agreement at every point: form, word, meaning and use. The form development is not very complex; except **6.2.5,** all forms down to **6.4** have probably only slight syntactic variations.

Forms **6.1, 6.2.1** provide the norm for the appellative glyph
of the Death God, 'A.' The **6.1** forms (without the subfix)
occur some 80 times, of which only two are in the Dresden and
none in the Paris. The **6.2** forms (with the subfix) occur 140
times: 58 in Dr., 25 in P., 56 in M. These cases, with many
other similar instances of affix use, have rather persistently
impressed the writer as involving a definite difference between
the use of prefix modifiers, and the subfixes. What is primarily
certain is, that upon these adjuncts rests the actual burden of
word development and meanings; sufficient specific cases are
clear enough for us to say that much, even now. And it is also
very probable that the prefix is the determining adjunct, which
provides the characteristic meaning of the united compound;
though this rests of course on the final verification of the values
and uses of all the adjuncts.

At the beginning of the present work, along back before 1905,
the writer thought not unlikely that some of these affixes might
in time prove out to be declensional elements, such as a plural,
etc., and then occupying the same prefixed or postfixed position
as the corresponding elements of spoken Mayance tongues. The
prefixed male and female heads to the **Oc**-glyphs at the bottom
of Dr. pp. 61, 62 seemed to support this. It seems now, however,
very doubtful indeed whether any such thing as a plural *form*
exists in the glyph-writing; there may easily be an agglutinative
sign or word of quantity, just as there are numerals; also sex-
denoting separable words like male, female, or he-, she-, but no
gender terminations such as *-er*, *-ess*. Still, without arriving at a
glyph expression of purely formal 'endings,' (such as plurals,
possessives—matters in fact usually left by the Indian unexpressed,
unless necessary), there is another stage of word-formation, lin-
guistically sound and general. It is this:

If we will regard our glyph main-elements (the simple forms to
which have been assigned each a single number, as **6** for **Cimi**)
as being equal to our stems like 'act,' our next stage of formation
will give us, action, active, actual, actualization, actuary, etc.
Such stem-modifications, usually postfixed in language generally,
may not unlikely have their Mayance and glyph equivalents in
subfixes like o∴o in our **6.2**. In other words, they would not
operate to change the meaning of the main element or stem; nor
bring in adjectives or new descriptive ideas. This latter would

be the function of the prefixes, just as we modify the simple idea
of acting, by saying reaction, inactive, double-acting, a good act,
etc. And many cases through the glyphs seem to work this out;
for one thing, the colors and numerals are always prefixed.

Taking our forms 6.1 and 6.2.1, they seem to be used in the
texts as practical equivalents. The subfix can be suppressed,
and still leave the glyph as the death-god's particular sign; but
drop the prefix, and it ceases to be such, and enters into various
other compounds, implying the presence or action of death in
general. Note, that 78 out of our 80 references to this form are
found in the Madrid, whose tendency to abbreviation and careless
writing is very evident. Affixes in the Madrid are constantly
written just once in a series of repeats, and omitted in the rest—to
be understood. This is rarely the case in the more careful Dresden
writing.

On this basis, it is the prefix here that carries the specific mean-
ing, as in many provable cases elsewhere. The sign 320 is shown
by its use to mean wood, or firewood; prefix the sign 314, and we
have, 'drawing fire from wood'; put 314 before the sign for flint,
and we have, 'drawing fire from flint,' Each of these cases is
verified by the pictures under the glyphs.

In short, this much is clear: these minor elements, the affixes,
contain the synthetic structure of the writing and glyph-composi-
tions; some of them are unmistakably specific in purpose, as will
be seen in later illustrations. It is not impossible, and only what
linguistically might be expected, that they may finally settle
down, when all worked out, as follows: First, Class or Functional
Determinatives such as the time-period wing affix; or the sub- or
postfix ◖◚◗ to be discussed under the vinal-signs for **Pop,
Kankin** and **Kayab**; with perhaps a certain number of elements
whose function is parallel to our word-endings -*ion*, etc. Subfixes
will probably constitute this class, at least in the main. Then,
Second, Qualifiers such as our adjectives, and the above prefix
illustrations; this class will, it is likely, be chiefly prefixes.

One special form must be noted, 6.2.5. This has the ◖
controversial ? elephant-trunk, ? macaw-beak prefix; see below,
401, where all glyphs taking this prefix are brought together. In
certain definite compounds, and only those, this prefix is asso-
ciated with sex-union pictures.

We thus get a definite and specific problem in glyph-determination: What has this prefix to do with, or to, the seven characters and ideas, **Imix, Cimi,** the tun, the cross, glyphs **74, 141, 331?** In attacking the problem we get three points d'appui: with **Imix** the form **1.13.1** shows the same pair of affixes as here with **Cimi;** why? The tun and no. **331** each have the **'ben-ik'** as companion to this prefix; what is there in common here, between the tun and **331?** Third, gl. **141** when used with this prefix, also takes either (⯊) or (⯊) as subfix; with the first, as **141.3.1,** it is the initial glyph in all thirteen clauses of Dr.ꜩ.**70;** but with the second as **141.4.1,** it only occurs in Dr.ꜩ.**66.a.1.**

Now note further that this glyph **141** (forms **141.1** and **141.2**) is initial in all clauses of Dr.ꜩ.**66** except the first, also in all clauses of ꜩ.**65** except ꜩ.**65.i.1** (where the subfix changes); is further the initial in ꜩolkins **56, 57, 67,** through pages 15–18 on the Paris and in Madrid ꜩ.**56.** Initial in all the above; in second place consecutively through Madrid ꜩ. **69, 148, 152;** third place in Madrid ꜩ. **68.**

Query then: What is the meaning of the **141** glyph, as shown connected with some common factor in all these ꜩolkins, why is the affix-order broken when it is broken and (specifically) what is the part played by the 'elephant-trunk' prefix that it should run all through ꜩ. **70** but only start ꜩ. **66?** And what possible similar use or effect can this prefix have with our present **Cimi** glyph **6.2.5,** and then the other six glyphs mentioned?

Whether the prefix be of elephant or macaw cannot now help a whit to read these glyphs. But a full study of these passages with their picture and glyph associations and changes, just as one would assail the solution of a cipher, might well do so. Remembering too, that these glyphs were not written and read by users of Indo-European tongues, with their equipment of present-day words, styles and thoughts; nor even, when the writing was in full bloom and use, by speakers of present-day Yucatecan Maya, but by the users of what (for a name) we may call proto-Mayance, just as Latin is common mother to all later Romance tongues.

For a consideration of form **6.5,** see under gl. **22.**

Most of the remaining **Cimi**-forms are of scattered use, all save one being in the Madrid, and largely with isolated affixes. The affixes to forms **6.12** to **6.16** may later throw light on their respective values.

Form **6.10.1,** however, calls for consideration. Death was just as great a factor among the Maya as with us, and everywhere; it came in many forms, by sword as by disease. As we speak of the Black Death, the White Plague, so surely must they have done. This may easily be the meaning of the form **6.10.1,** reading literally 'white-red-death,' to denote some special kind. Form **6.11** again, suggests the Quiché term **rax-camic,** sudden death, *muerte repentina.*

All ten pictures in Dr. ꜩ. 48 to 50 show a seated woman carrying some object in the pannier on her back. In nearly every case glyph 1 represents the object carried, while the second glyph is that for 'carrying,' (see **301.2.4**); the third and fourth glyphs denote the woman herself (the White Lady, *Ixchel,* consort of Itzamná and associated with him through the Bacab *Ritual*), with a glyph that further defines what she is carrying. In ꜩ.49. *a* she carries a skull (glyph **22**) in a bag or roped bundle; the text above shows our glyph, **6.10.1**; clause *b* brings in the god of the corn or of growth, with **? yax-kin,** and **kan-imix:** health and prosperity after times of death.

13 ahau, eb, kan, cib, lamat

a b

32 6 20 13

Dresden, ꜩolkin 49

7

Manik

Deer : Grasp

7.1 7.2.1 [7.3] 7.3.1 7.3.2 7.4 7.4a

7.4.1 7.4.2 [7.5] 7.5a 7.5b 7.5.1 7.6 7.6.1

7.6.2 7.6.3 [7.7] 7.7.1 7.7.2 [7.8] 7.8.1

7.8.2 7.8.3 [7.9] 7.9.1 7.10 7.10.1 7.10.2

7.10.3 7.10.4 7.10.5 70.14n 7.11.1 7.12.1 7.13

7.14.1 7.15 7.16 7.17 7.18 7.19.1 7.20.1

7.21 7.22 11.4.3n 19.29

7	M.11.a.1*?	M.62.c.2	**7.10.1**	D.8.k.2	**7.12.1**
M.150.b.1	M.11.b.1*?	M.62.d.4	D.15.a.2	D.8.1.2	M.160.d.2
M.162.e.3	M.11.c.1*?	M.62.e.2	D.16.a.2	D.8m.2	**7.13**
7.1	M.11.d.1*?	M.62.f.2	D.16.b.2	D.8.n.2	M.30.b.1
D.p25b.4	**7.4.2**	**7.6.2**	D.16.c.2	D.8.o.2	**7.14.1**
7.2.1	D.19.a.1	D.70.b.5	D.16.d.2	D.8.p.2	M.p35.c.7
D.p48d.13	D.19.b.1	**7.6.3**	D.24.a.2	D.8.q.2	**7.15**
7.3.1	D.59.a.6	M.61.e.2	D.24.b.2	D.8.r.2	M.21.a.3
M.56.a.4	D.59.b.6	M.61.g.2	D.24.c.2	D.8.s.2	**7.16**
7.3.2	D.59.c.6	**7.7.1**	D.24.d.2	D.8.t.2	M.21.b.3
M.175.a.2	D.59.d.6	M.207.a.1	**7.10.2**	D.20.c.4	**7.17**
M.175.b.3	**7.5a**	**7.7.2**	D.15.b.2	D.20.d.2	M.21.c.3
M.175.c.2	M.140.a.2	M.207.b.1	D.15.d.2	D.20.e.2	**7.18**
M.175.d.4	**7.5b**	**7.8.1**	**7.10.3**	**7.10.4**	M.21.d.3
7.4	M.140.b.2	D.3.a.2	D.8.a.2	D.9.a.1	**7.19.1**
M.22.a.1	**7.5.1**	**7.8.2**	D.8.b.2	D.9.b.1	D.75.n.3
M.22.c.1	D.65.i.3	D.3.b.2	D.8.c.2	D.9.c.1	**7.20.1**
M.22.d.1	**7.6**	D.3.d.2	D.8.d.2	D.9.d.1	M.113.c.3
M.22.e.2	P.7.d.14	**7.8.3**	D.8.e.2	**7.10.5**	**7.21**
7.4a	M.150.a.1	D.37.f.3	D.8.f.2	D.15.c.2	M.20.b.1
M.22.b.1	**7.6.1**	**7.9.1**	D.8.g.2	**70.14n**	**7.22**
7.4.1	M.61.c.2	M.208.a.1	D.8.h.2	M.66.b.4	M.61.b.2
D.66.h.3	M.62.b.4		D.8.i.2	**7.11.1**	
			D.8.j.2	P.2.b.18	

Exactly contrary to the preceding glyph, where we had complete agreement at all points—glyph, word, day-name, meanings, and use, here we have none save the extraneous one of the glyph-form and its use in the pictures and their attached texts. It is impossible to avoid the interpretation of this sign as being 'to grasp, or receive.' This does not rest merely on its pretty obvious likeness to a grasping or holding hand, with the common wrist ornament, but all through on the associations of the passages.

These are worth detailing at length, because if this holds, we have at least one positive case of a day-sign with a linguistic value, or common-word use, wholly distinct from its value as day-sign in the general calendar, which is everywhere the Day Deer (Maya **Ceh**).

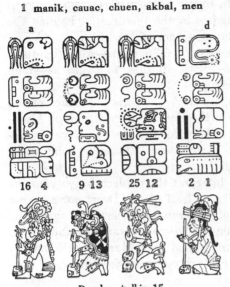

1 manik, cauac, chuen, akbal, men

a b c d

16 4 9 13 25 12 2 1

Dresden, ṭolkin 15

A full representation of Dresden ṭolkin 15 is here inserted. Four deities are clearly making fire by the drill; the position of the hands in the fourth is especially unmistakable. The glyphs of each occur in the 3rd line, with the appellative of D, the Aged God, below in the 4th place. As is so very common, the deities alternate in nature, beneficent and destructive or harmful; the second is Death, and the fourth the 'war-god,' of the banded face. The nature of the first is still uncertain, being by some confused with the 'war-god' by the curve about the eye, and the presence of the numeral Eleven, **buluc**. But the glyph seen at *a*.4 is not an attendant of harmful gods, as is *b*.4.

Glyphs *abcd*.1 all show the signs elsewhere associated with fire-making; in *abc* the prefix is attached to **Oc** and **Xul** (see hereafter, under **Oc**), and in *d* the compound form, which may indicate the completion of the act and appearance of the flames. In *abcd*.2 we have a double-**manik** sign, exactly as in the pictures below, where the **manik** *holds* or receives the drill; the prefixes again shift or alternate—of course with some reason or meaning, for us to learn.

In the following ṭ. 16, the scene shifts, but with the same double-**manik** in the same places. In ṭ. 17, 18, the prefix to the 'fire-drill' compound reappears, with a sign similar to that for black. In ṭ. 19 the **manik** reappears in a different compound, with the 'war-god' closing the story with a vase that holds the sprouting plant. After this we go on to ṭ. 20 and 21, with their repeated initial and more of the double-**manik**; and then on further to the presentation of the **Kan**, the Maize, by the gods in ṭ. 22. The division closes with ṭ. 24, where in *abcd*.1 we see as initial the identical figure held by the four deities, and with double-**manik** in *abcd*.2.

The **manik,** with the **ȼab,** or serpent's rattles as prefix, runs across Madrid ȼ. 22, the figures in the pictures all holding the rattle; it runs across the hunting scenes of Madrid ȼ. 61, 62, and finally appears in all four clauses of ȼ. 175, the so-called 'baptism' ȼolkin. It seems impossible, with all this, to avoid assigning the value of grasping or receiving.

But in final confirmation, we have the direct evidence of the signs for East and West. For the East we have the glyph **Ahau-Kin,** the Lord Sun, the Lord of Day; for the West we have **Manik-Kin,** exactly corresponding to the term **Chikin,** the biting or eating of the Sun, seizing it in the mouth.

Nor do we have to try to interpret the modern Maya name as representing **may-nik,** the cloven hoof of the Deer; nor as being **mani-ik,** the 'swift wind' of the running deer; nor again the Tzeltal **Moxic** as 'derived' from the Maya **ma-xan,** not slow. It is far more likely that the etymology of both **Manik** and **Moxic** go back to some lost word or archaic day-name. (See Brinton.)

8
Lamat Rabbit

b c d e f

11.19 14.13 244.5

With the exception of the prefix elements above shown, there are no traces whatever of a textual use of the **Lamat** sign; nor anything whereby to define etymologically this, or the Tzeltal form, **Lambat.**

The sign itself bears certain resemblances to the Venus-sign on the one hand, and to ⊟ on the other. Its persistent characteristic is the division into four quarters or corners, with a small circle in each corner. In a few cases, as on Dr. pages 47, 51, the lines are not extended, leaving only the center in the same form as the center of the Venus-sign, and the above right half of the wrongly named 'ben-ik' superfix, q.v. But the four small circles are never omitted in the day-sign, save once on D. page 49.

9

Muluc

Rain

9nn	9.1.1n	9.2 9.3.1

9.3.1a	341.2.1 427.2.1 434.4.1

9nn	D.20.b.1
M.p35.b.11	D.20.c.1
	D.20.d.1
9.1.1n	D.20.e.1
	D.21.a.1
9.2	D.21.b.2
P.23.a.33	D.21.c.1
9.4.1	P.2.b.8
D.20.a.1	P.8.b.12

This, in the general calendar, is the day Rain, but neither in the Maya **Muluc** nor the Tzeltal **Molo** or **Mulu** do we find any support for this meaning; nor do we get any evidence in the text associations to connect the sign with rain.

There are however, a very few forms at least containing this small circle, as above. From the position of the Dresden tzolkins 20, 21 among the Maize ritual passages, [o] may involve the meaning of the seed. A determination ⊂⊂⊃ of the value of the subfix would help; any further is mere speculation.

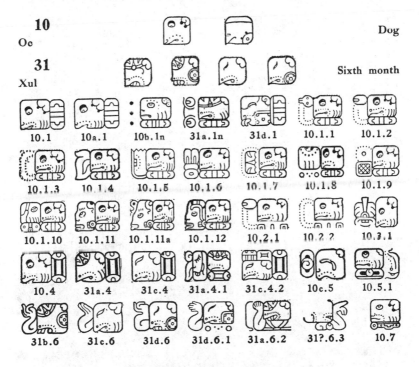

10

Oc

Dog

31

Xul

Sixth month

10.1	10a.1	10b.1n	31a.1n	31d.1	10.1.1	10.1.2
10.1.3	10.1.4	10.1.5	10.1.6	10.1.7	10.1.8	10.1.9
10.1.10	10.1.11	10.1.11a	10.1.12	10.2.1	10.2.2	10.3.1
10.4	31a.4	31c.4	31a.4.1	31c.4.2	10c.5	10.5.1
31b.6	31c.6	31d.6	31d.6.1	31a.6.2	31?.6.3	10.7

10.7n 10.7an 10.7.1n [blank] 31a.7.2 31a.7.2 31c.7.2

31a.7.2 31a.7.2a 31b.7.2a 31a.8 31b.8 10.9 31a.9

31a.10 31c.10 31a.10.1 31a.10.2 31a.10.3 31a.11.1 31a.12.1

31a.13 31a.13 31a.13 31c.13 31a.14 31a.14.1 31b.15.1

31g 31gn 31g.1 31e 31e.1 201.1

201.2 31k 31e.1 31f 31h

31	D.p45.a.3	D.71.28.2	D.55.g.3	**31a.8**	**31c.13**
M.176.a.1	D.p51a.b.2	D.71.41.2	**31c.6**	P.6.d.16	P.5.d.10
M.176.e.1	**10.1.4**	D.71.47.2	D.27.b.3	M.56.d.3	**31a.14**
31b	D.p24.b.2	**10.3.1**	**31d.6**	**10.9**	M.76.b.2
D.69.m.5*	D.p24.c.3	D.65.h.4	D.8.q.4	D.15.a.1	M.151.a.2
10.1	D.59.c.3	**10.4**	**31d.6.1**	**31a.9**	M.151.b.2
D.59.b.3	**10.1.5**	D.59.a.3	D.19.b.4	D.15.b.1	**31a.14.1**
D.p58.e.6	D.71.69.1	**31a.4**	D.20.b.4	D.15.c.1	D.58.b.3
31d.1	**10.1.6**	D.38.a.3	**31a.6.2**	**31a.10**	**31a.15.1**
D.71.i.5	D.69.a.5	D.38.b.3	D.52.c.3	D.45.a.2	D.p74.12
31a.1n	**10.1.7**	D.38.c.3	**31?.6.3**	D.45.c.2	**31g**
D.7.e.1	D.57.g.5	D.38.d.3	P.22.a.6*	**31c.10**	M.7.c.4
10b.1n	**10.1.8**	D.38.e.3	**10.7n**	D.45.b.2	**31gn**
M.125.23.3	D.69.c.3	D.p46.f.8	D.p60a.7	**31a.10.1**	M.9.d.3
10.1.1	**10.1.9**	M.p35.d.8	D.p60b.8	D.45.d.2	M.12.c.1
D.69.d.3	D.71.j.10	**31c.4**	**10.7an**	**31a.10.2**	M.116.c.3
D.72.f.35	**10.1.10**	D.43.b.2	P.7.d.5	D.p58.e.3	**31g.1**
D.73.a.4	D.69.e.3	D.43.c.2	P.8.b.4	D.p58.e.7	M.212.f.3
D.73.c.4	**10.1.11**	**31a.4.1**	**10.7.1n**	**31a.10.3**	M.221.b.3
D.73.d.4	D.72.b.14	P.10.c.8	D.69.1.3	D.61.d.1	**31e.1**
D.p70.b.2	D.72.c.13	**31c.4.2**	**31a.7.2**	**31a.11.1**	M.177.a.1
D.p70.c.4	D.72.e.14	D.43.a.4	D.p47f.3	M.69.a.3	M.177.b.1
D.p70.d.4	**10.1.11a**	**10c.5**	D.p49d.10	**31a.12.1**	M.177.c.1
10.1.2	D.72.c.14	P.17.a.6	**31a.7.2a**	P.6.c.5	M.177.d.1
D.72.e.13	D.72.d.13	**10.5.1**	D.p47d.14	**31a.13**	M.177.e.1
D.73.b.4	**10.1.12**	P.8.d.11	**31a.7.2b**	D.3.a.1	M.177.f.1
D.73.e.4	D.72.d.14	**31a.6**	P.3.b.4	P.2.d.1	M.177.g.1
10.1.3	**10.2.1**	M.164.a.3	P.4.b.10	P.8.d.1	**31f**
D.68.a.3	D.72.b.13	**31b.6**	**31b.7.2a**	P.11.d.1	M.24.c.2
D.68.b.2	**10.2.2**	D.7.a.6	D.8.s.6	M.123.j.1	M.24.d.2
D.68.c.3	D.71.11.2	D.8 m.5	**31c.7.2**	**31k**	**31h**
D.68.d.2			D.50.a.4	M.p36.b.14	M.26.d.2

No glyphs have given more trouble than these two in the arranging of their classification. The first is of the day **Oc,** the second the month **Xul.** The word for dog in Maya is **pek;** in Quiché, Choltí, Tzeltal, etc. **tzi;** the word **xul** in Maya means 'end.' The day-name in Quiché is **Tzi,** and in Tzeltal **Elab,** which latter means as little in this connection as the Maya word **Oc.**

We have two distinct glyphs, which actually fill each other's place in at least three cases, yet which have wholly different characteristics, as well as a definite line of distinction in their affix-taking. More important, the two seem to belong to two different classes of ideas and mythological relationships. The dog is a 'devouring' animal at times, certainly; yet its associations are not generally with the destructive and harmful passages. There are reasons for thinking it a specific character, of importance; also a celestial character in astronomy or mythology, which the **Xul** animal is not. The **Xul** animal is distinctly predatory and destructive, and takes as its affix-equipment and the flint-knife and another attacking instrument that probably represents a club. (See later.) The **Xul** also takes the **akbal** infix, making it a 'creature of the night.' None of these are shared by the **Oc**-glyph. Also the **Xul** form is alone attacked by the hatchet, as in forms **31.13**; and again alone takes the pointing arm and hand, as in the **31.6** forms. All these give another definite case of the importance of these affixes in classification, as leading to evaluation and interpretation.

Nevertheless, in forms **10.4** and **31.4** each takes on as postfix; in **10.9** and **31.9** each takes the 'fire-drill' prefix, and occur side by side in Dr. ꜩ.15, as seen above. Finally, the **Oc**-form actually replaces the **Xul**-form twice as month sign, in a defined month series. (See under **Xul,** in the months.)

There is just one definite form of the **Oc**-glyph—with the dark spot over the eye, and the two blobs on the ears. (These characteristic blobs are the defining element in the day-sign variant for **Oc,** see gl. **24.**) There are four **Xul**-forms: with the curving eye with or without the infix at the bottom right, and again with the **akbal** over the eye and with or without the lower infix. These four **Xul**-forms, as seen above, all take the same run of affixes; see, for instance, all four with the pointing hand, **31.6** sq.

The **Oc**-head does take the club subfix, as in **10.7** sq., but, noteworthily, only with the numeral **bolon, 9.**

One especial point remains to be noted, affecting the nature of the **Oc**-glyph: it takes as its particular affix the subfix ⟨▨⟩. This we have several times referred to as the 'table of honor.' Upon it rest the sacrificial offerings, as shown at the end of the **Kan** table of glyphs; it is the peculiar adjunct of Iȝamná and his consort Ixchel, the White Lady—as see glyphs [▨] [▨] [▨] nos. **77.1** and **120.1.** It is also the chief [▨] [▨] subfix for **Chuen**; outside of which five uses this important subfix has only scattering application.

That the subfix is used in such positions as the table of offerings, and as determinative with the two chief beneficent deities of the Yucatan pantheon (with their probable historical antecedents in the Old Empire), suggests some such value or implication as here assigned. In which case a like importance is to be inferred where the subfix is a major one with other, still not understood glyphs.

In glyph **24** we have a variant of the **Oc** day-sign, showing only the typical ears of the main sign. This variant is used as day-sign in numerous day-series. Outside of this the form [▨] is never used save with the subfix [▨], and is further almost never used except with the numeral Three, **ox,** as a qualifier (not as a day-number). It is used over ninety times in this way (see the list under gl. **24**), and uniformly in beneficent clauses or columns. Further, it is so often found in immediate glyph-juxtaposition with Iȝamná and Ixchel, and other good deities, as almost to suggest its rendering by the leading word of acclaim in the Bacab *Ritual:* **oxtescun,** thrice honored be thou!

We therefore have here a most remarkable mingling of the **Oc** and **Xul** animals, in the above occasional mutual replacement and affixes; and a clear problem in mythology. **Oc** might easily have been some deified personage, known by a dog as his attendant, placed in the sky and encountered by sun or moon in their passage along the celestial way; and also made one of the "twenty patrons of the day." Somewhat as we have our myths of Orion and Sirius.

A final confirmatory point to the above separation of **Oc** and **Xul** will be seen in the above reference lists to the passages: the no. **10** or **Oc**-forms run heavily in the Eclipse and Iȝamná sections,

the **Xul**-forms almost not at all, but in other parts of the manuscript, and frequently with the regular 'death or destruction' signs; as well as in the Madrid. Also note its connection with the thunderbolt; see below, page 51.

In short, we can do no less than feel that back of **Oc** in the calendar stands the beneficent quality of some celestial, mythological being, with astronomical or astrological significance; while in the **Xul** we must see a terrestrial marauder of some species.

Whether the **201** forms at the bottom of the glyph table belong in this connection, may be doubted; they have been included as also possessing the animal ears and teeth.

The **31g** forms have also been put in the present table for lack of a better. Also a few doubtful heads, as **10b.1n** and **10c.5**.

Attention, finally, should be called to glyph **98**. This also has the **akbal** infix, but somewhat differently placed, while the head is a human and not an animal one, and lacks the ears. It has not, therefore, been considered as **Xul**.

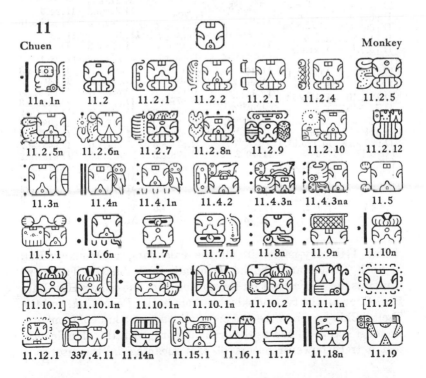

11

Chuen Monkey

11a.1n 11.2 11.2.1 11.2.2 11.2.1 11.2.4 11.2.5

11.2.5n 11.2.6n 11.2.7 11.2.8n 11.2.9 11.2.10 11.2.12

11.3n 11.4n 11.4.1n 11.4.2 11.4.3n 11.4.3na 11.5

11.5.1 11.6n 11.7 11.7.1 11.8n 11.9n 11.10n

[11.10.1] 11.10.1n 11.10.1n 11.10.1n 11.10.2 11.11.1n [11.12]

11.12.1 337.4.11 11.14n 11.15.1 11.16.1 11.17 11.18n 11.19

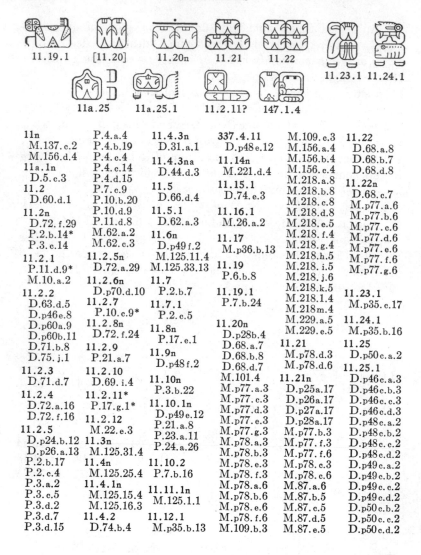

11.19.1 [11.20] 11.20n 11.21 11.22

11.23.1 11.24.1

11a.25 11a.25.1 11.2.11? 147.1.4

11n	P.4.a.4	11.4.3n	337.4.11	M.109.c.3	11.22
M.137.c.2	P.4.b.19	D.31.a.1	D.p48e.12	M.156.a.4	D.68.a.8
M.156.d.4	P.4.c.4	11.4.3na	11.14n	M.156.b.4	D.68.b.7
11a.1n	P.4.c.14	D.44.d.3	M.221.d.4	M.156.c.4	D.68.d.8
D.5.c.3	P.4.d.15	11.5	11.15.1	M.218.a.8	11.22n
11.2	P.7.c.9	D.66.d.4	D.74.e.3	M.218.b.8	D.68.c.7
D.60.d.1	P.10.b.20	11.5.1	11.16.1	M.218.c.8	M.p77.a.6
11.2n	P.10.d.9	D.62.a.3	M.26.a.2	M.218.d.8	M.p77.b.6
D.72.f.29	P.11.d.8	11.6n	11.17	M.218.e.5	M.p77.c.6
P.2.b.14*	M.62.a.2	D.p49f.2	M.p36.b.13	M.218.f.4	M.p77.d.6
P.3.c.14	M.62.c.3	M.125.11.4	11.19	M.218.g.4	M.p77.e.6
11.2.1	11.2.5n	M.125.33.13	P.6.b.8	M.218.h.5	M.p77.f.6
P.11.d.9*	D.72.a.29	11.7	11.19.1	M.218.i.5	M.p77.g.6
M.10.a.2	11.2.6n	P.2.b.7	P.7.b.24	M.218.j.6	
11.2.2	D.p70.d.10	11.7.1		M.218.k.5	11.23.1
D.63.d.5	11.2.7	P.2.c.5	11.20n	M.218.1.4	M.p35.c.17
D.p46e.8	P.10.c.9*	11.8n	D.p28b.4	M.218m.4	11.24.1
D.p60a.9	11.2.8n	P.17.e.1	D.68.a.7	M.229.a.5	M.p35.b.16
D.p60b.11	D.72.f.24	11.9n	D.68.b.8	M.229.e.5	11.25
D.71.b.8	11.2.9	D.p48f.2	D.68.d.7	11.21	D.p50c.a.2
D.75.j.1	P.21.a.7	11.10n	M.101.4	M.p78.d.3	11.25.1
11.2.3	11.2.10	P.3.b.22	M.p77.a.3	M.p78.d.6	D.p46c.a.3
D.71.d.7	D.69.i.4	11.10.1n	M.p77.c.3	11.21n	D.p46c.b.3
11.2.4	11.2.11*	D.p49e.12	M.p77.d.3	D.p25a.17	D.p46c.c.3
D.72.a.16	P.17.g.1*	P.21.a.8	M.p77.e.3	D.p26a.17	D.p46c.d.3
D.72.f.16	11.2.12	P.23.a.11	M.p77.g.3	D.p27a.17	D.p48c.a.2
11.2.5	M.22.e.3	P.24.a.26	M.p78.a.3	D.p28a.17	D.p48c.b.2
D.p24.b.12	11.3n	11.10.2	M.p78.b.3	M.p77.b.3	D.p48c.c.2
D.p26.a.13	M.125.31.4	P.7.b.16	M.p78.e.3	M.p77.f.3	D.p48c.d.2
P.2.b.17	11.4n		M.p78.f.3	M.p77.f.6	D.p49c.a.2
P.2.c.4	M.125.25.4	11.11.1n	M.p78.a.6	M.p78.c.3	D.p49c.b.2
P.3.a.2	11.4.1n	M.125.1.1	M.p78.b.6	M.p78.c.6	D.p49c.c.2
P.3.c.5	M.125.15.4		M.p78.e.6	M.87.a.6	D.p49c.d.2
P.3.d.2	M.125.16.3	11.12.1	M.p78.f.6	M.87.b.5	D.p50c.b.2
P.3.d.7	11.4.2	M.p35.b.13	M.109.b.3	M.87.c.5	D.p50c.c.2
P.3.d.15	D.74.b.4			M.87.d.5	D.p50c.d.2
				M.87.e.5	

The 11th day-name, in all the calendars, is Monkey: Baꜩ
in both Tzeltal and Quiché, Ozomatli in Nahuatl. The word
Chuen is not Maya; but on the authority of the names Hun-Baꜩ,
Hun-Chouen, the two monkey-brothers in the *Popol Vuh*, and the
Tzeltal Chiu (given in the Ara ms. dictionary as a kind of monkey),
we must accept Chuen as the original word, with this significance.
Not a trace however occurs of this meaning in the use as a

glyph. As seen above, the great bulk of the instances occur under the forms 11.2, 11.10, in the **chuen**-piles, 11.20 etc., and in the special form 11.25, found only with the wing- affix, and running across the Venus pages, 46–50c.

In 1897 Goodman identified the **chuen** glyph as representing the 20-day period, even calling these periods 'chuens,' instead of the now established term **vinal,** for which we have Landa's direct authority (Landa, 34). The use of this glyph as denoting the vinal on the monuments has become fully established. It can also hardly be doubted that with the subfix it has the technical meaning 'vinal' in the codices; in two cases the evidence here is quite direct: Dr.72.a.29, f.29. Here we have an unmistakable time-count of 15.9–1.3 and 15.9–4.4, with our glyph 11.2 in the vinal position.

Treating this subfix as the specific determinative in the sense discussed above under **Cimi,** it is urgently desirable that the modifying sense of the various prefixes 11.21.1 sqq. be determined, especially those occurring Dr. pages 61, 69.

The 11.4 forms with their numerals, usually Four, deserve study. So also the 11.10 forms, **yax-chuen,** or perhaps **yax-vinal,** and always with the numeral Six; except for once at Dr. p. 49e, this form is used only in the Paris codex.

The **chuen**-piles, scattered through both the Dresden and Madrid, with various prefixed numerals, constitute a very great puzzle. The temptation to treat them as multiples of the vinal period, and work them thus into an analysis of the sacrificial sections where they chiefly occur, is quite strong; but so far no combination of 20-multiples seems to yield results. See especially, Madrid, pp. 77–8.

The special form 11a.25, with swollen upper line and the wing affix, gives another problem for work. It occurs only on the Venus pages, where it runs across the whole section immediately under the middle row of month-signs. This series should be considered with the other series above, also found only on these pages, and stretching in the same manner across them just below the *upper* row of month-signs. here found, is exactly the same as the constant element in glyph C of the well-known Supplementary Series, where (with varying faces included)

prefixed by numerals up to 6, it has by Dr. Teeple's work been
established as recording the passage of lunations in the six-month
lunar period, directly connected with solar eclipse happenings.
Glyphs **91, 92,** with **chuen**-eyes and either closed or flaring top,
must be studied with this glyph **11.** The form seen
at Dr. 5.c.3, matching the **16 kins** at Dr. 5.b.4, can
hardly mean other than **6 vinals.**

12
Eb Broom

The day in Nahuatl and Zapotec is Broom, or the brush of
twisted twigs or stiff grass. **E** in Maya means a point, and in
Quiché a tooth; the plural in each is **eb.** The Tzeltal form **Euob**
is not however a correct plural in that language, where the plural
ending is **-ic** or **-etic,** so that we are not safe in using the Tzeltal
in interpretation. The glyph is completely sterile in word-forma-
tion, occurring only as the day-sign.

13
Ben Reed

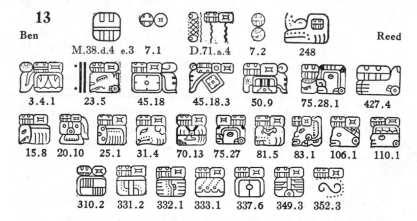

M.38.d.4 e.3 7.1 D.71.a.4 7.2 248

3.4.1 23.5 45.18 45.18.3 50.9 75.28.1 427.4

15.8 20.10 25.1 31.4 70.13 75.27 81.5 83.1 106.1 110.1

310.2 331.2 332.1 333.1 337.6 349.3 352.3

All the day-names except the Maya and Tzeltal mean Reed
or Cane; * the Quiché **ah,** *caña,* cane, is the same word as the

* In Brinton's **caghben,** Tzeltal for *caña de maiz seco,* it is the **agh** that is
significant and provides the meaning 'cane,' as noted above, and not the
word-ending **-ben,** which is a mere coincidence here, and has nothing to do
with the meaning Cane.

Tzeltal **agh,** cane; but the latter is not used as the day-name, which in Tzeltal is **Ben** or **Been.** Now **Been** is given by Núñez de la Vega as one of the chief four among the twenty 'heroes' who became patrons of the days; of **Been** we are also told that he erected the Pillars of Been "still to be found and worshipped in Soconusco."

The above Four Chiefs were Votan, Lambat, Been and Chinax, our days **Akbal, Lamat, Ben** and **Eƫ'nab;** these four days are the year-bearers in the Paris codex, also in Dresden, pages 25–28. As already noted, **Akbal** may have a relation to the *casa lobrega* of Votan; **Chinax,** the Quiché **Tihax,** and Nahuatl **Tecpatl** all mean flint-knife. Our day-glyph for **Eƫ'nab** is a flint-knife, and Núñez tells us that Chinax was a great warrior.

We thus again have both Maya and Tzeltal day-names, alike in both languages, but uninterpretable etymologically; certainly not corresponding to the given day-meaning, Cane. Also, just as we find the Quiché and Tzeltal both replacing the (lost) proper name **Chouen** or **Chuen,** by the common term in each for monkey, so here we have the common word for cane, **Ah,** in Quiché. But the Tzeltal, which took on **Baƫ,** retained the archaic **Been,** not going over to **Agh.**

Altogether it gives one more case of the retention by both Maya and Tzeltal of archaic and forgotten terms, replaced in both Quiché and Nahuatl by modern, ordinary words. This close cultural contact or agreement between Quiché and Nahuatl we find cropping up constantly, with a definite historical problem to be served. Also the preservation of the old sacred science of Copan, Nachan and Tula, often with forgotten words whose very meaning has been lost in the later spoken tongues, and yet with traces left in the glyphs or mythology.

Once again, as with **Lamat,** the **Ben** glyph has almost no use in the compounding of forms. It seems to occur as an eye-infix in one animal-head glyph, no. **248.** Apart from this, it is only found in the well-known **'ben-ik'** superfix. This will be treated at length elsewhere. We may only here say that the final element is not an **Ik** at all, the error having started from a misreading by De Rosny of a partly erased normal **ik-**sign; further, that the use of the superfix so far gives us no help whatever toward the interpretation of the day-sign form.

14

Ix Tiger : Magician

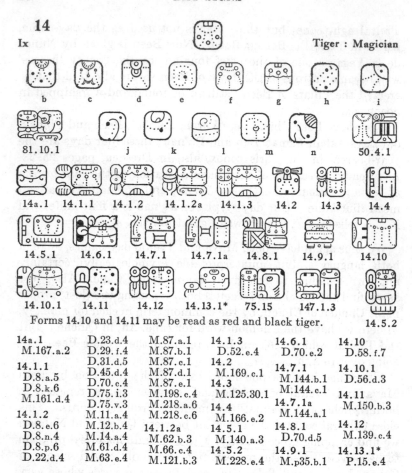

b c d e f g h i

81.10.1 j k l m n 50.4.1

14a.1 14.1.1 14.1.2 14.1.2a 14.1.3 14.2 14.3 14.4

14.5.1 14.6.1 14.7.1 14.7.1a 14.8.1 14.9.1 14.10

14.10.1 14.11 14.12 14.13.1* 75.15 147.1.3

Forms 14.10 and 14.11 may be read as red and black tiger. 14.5.2

14a.1	D.23.d.4	M.87.a.1	14.1.3	14.6.1	14.10
M.167.a.2	D.29.f.4	M.87.b.1	D.52.e.4	D.70.e.2	D.58.f.7
	D.31.d.5	M.87.c.1	14.2	14.7.1	
14.1.1	D.45.d.4	M.87.d.1	M.169.c.1	M.144.b.1	14.10.1
D.8.a.5	D.70.c.4	M.87.e.1	14.3	M.144.c.1	D.56.d.3
D.8.k.6	D.75.i.3	M.198.c.4	M.125.30.1		14.11
M.161.d.4	D.75.v.3	M.218.a.6	14.4	14.7.1a	M.150.b.3
	M.11.a.4	M.218.c.6	M.166.e.2	M.144.a.1	
14.1.2	M.12.b.4	14.1.2a	14.5.1	14.8.1	14.12
D.8.e.6	M.14.a.4	M.62.b.3	M.140.a.3	D.70.d.5	M.139.c.4
D.8.n.4	M.61.d.4	M.66.c.4	14.5.2	14.9.1	14.13.1*
D.8.p.6	M.63.e.4	M.121.b.3	M.228.e.4	M.p35.b.1	P.15.e.4
D.22.d.4					

The 14th day is that of the Jaguar, with an agreement among the
day-names: Quiché **Ix** or **Balam,** Tzeltal **Ix.** The word **Ix** in
Maya does not have the required meaning, the tiger and the diviner
or sorcerer being each called **Balam.** We have words i̱ʒ'at in
Maya, i̱ʒ' in Quiché, **ez** in Maya with meanings of wisdom and
witchcraft; but the *herida* ʒ' and the **x** are too distinct as letters
and sounds, and no cases of interchanging are found; while weight
must never rest on any such imperfect phonetic parallels, in the
absence of outside historical or confirmatory evidence. The
basic idea is also clearly the tiger, and the 'wearer of the tiger-skin,
the magician,' only the transferred meaning.

The glyph itself may be quite safely taken as representing the spots of the jaguar-skin, the usual distinctive mantle of the sooth-sayer, the Balam. Weight is added to this by the great variability of the drawn forms; since we regularly find pictographic forms so changing at each repetition, while non-pictorial ones have settled down into a quite definite conventional type.

There are only two cases of repeated use of **Ix** in a ţolkin, to provide us with starting points for interpretation. These are in Madrid ţ. 87, 144, where our forms **14.1.2** and **14.1.7** run as the initial glyphs in each case, with in both ţolkins as the second glyph in the clause.

15

Men

Bird, Eagle

Wise One

15.1 15.1.1 15.2 15.2a 15.2.1 15.2.2 15.2.3

15.2.4 15.2.5 15.2.6 15.3.1n 15.3.2 15.4.1 15.5

15.6 15.6a 15.6.1 15.6.2 15.6.2a [15.7] 15.7.1

15.7.2 15.7.3 15.8 15.1 15.8.2 15.8.3 17.26

15.9 15.10.1 15.10.2 15.10.3 15.11.1 15.12.1 15.13n

15.14.1

See also 17.26

15	15.2	M.61.g.4	15.2.4	15.3.2	D.8.k.4
P.8.b.21*	D.34.c.3*	D.66.n.3	D.66.n.5	M.38.c.3	D.8.o.5
	D.56.b.5	15.2.2	M.7.h.2	15.4.1	D.8.q.6
15.1	P.18.b.3	D.56.b.2	15.2.5	M.6.b.2	D.24.a.4
M.38.a.3	15.2a	D.70 m.2	M.61.e.4	15.5	D.25.d.3
M.200.b.4	P.18.e.1	D.70 m.7	15.2.6	P.23.a.6	D.26.d.4
	M.204.c.3	15.2.3	M.61.f.4	15.6	D.31.b.4
15.1.1	15.2.1	M.61.a.4	15.3.1n	D.7.a.4	D.39.d.4
D.12.a.2	M.61.c.4	M.61.b.4	M.p36.c.6	D.8.f.6	D.45.c.4
D.12.b.2					

D.46.d.4	P.23.a.18	15.6.2	15.8	15.8.1	15.10.3
D.52.c.4		D.14.h.3?	D.40.b.4	M.190.g.4	M.204.b.2
D.52.e.3	15.6a	D.75.a.3	M.30.a.2	M.200.g.4	M.204.d.2
P.7.a.2	D.15.d.4		M.94.c.4		
M.61.c.1	D.27.b.6	15.6.2a	M.94.d.4	15.8.3	15.11.1
M.62.a.4	D.37.a.5	D.70.f.4	M.94.e.3	D.65.i.4	D.60.g.3
M.62.e.1	D.38.d.4	15.7.1	M.179.c.4	15.9	15.12.1
M.157.d.3	D.42.a.4	M.204.a.4	M.190.a.4	D.60.b.1	M.p34.c.7
M.195.a.3	D.47.e.4	15.7.2	M.190.b.3	15.10.1	15.13n
M.224.a.4	M.p35.b.15	M.207.a.4	M.200.c.4	D.70.b.2	P.16.e.3
M.232.d.4	15.6.1	15.7.3	15.8.2	15.10.2	15.14.1
P.22.a.7	M.125.3.4	M.207.b.4	D.17.a.3	D.56.b.3	M.34.c.6

The day in Nahuatl is Eagle, in Quiché and Tzeltal **Tziquin,** the ordinary generic term for Bird. The Maya **Men,** or the **ah-men,** is the *Sabio,* the wise one.

In use the glyph is almost always found with one of the special superfixes, as in forms **15.2, 15.6, 15.7,** also the ⊕⊛ 'ben-ik' as in **15.8.** Note that the superfix in **15.6** is the common one 🔣 changing **tun** to **katun;** also that the 'ben-ik' lacks its customary postfix 🔣.

As to its placement, it has a rather general tendency to go to the end of a clause, and is almost never found as initial. Further it is usually found in the beneficent clauses; in other words, it does not denote evil or harm.

One question involved cannot be definitely settled until we have the meaning of the glyph fully established; this is that of the variant form we have numbered as a separate glyph **25.** The two forms have the same equipment of affixes, and are generally used in the same way—with the important exception that no. **25** is not found as the actual day-sign, which is always no. **15.**

Where two conventionalized forms, only slightly different, are persistently and often used, the variation must not be ignored until all is known of each. Where the variation is such as in the prefix 🔣 and 🔣 —one used regularly in the Dresden and the other as regularly in the Paris, it may be considered as matter of personal style in the scribe; the same with the comparative crudities in the Madrid. But in **15** and **25** we have a persistently regular difference, occurring in all three codices. The two may possibly be identical; they are quite surely closely allied; but it is out of attention to, and not the ignoring of, such 'irregularities' that discoveries come. For the present, the two forms should be kept separate, but studied jointly.

16

Cib Owl, Vulture

Except in the Maya and Tzeltal, the day-name in the calendar seems to be that of some bird of ill-omen, zopilote or owl. The Maya and Tzeltal show one word, different from all the rest; in each language it is the common word for Wax, with the correct normal change of **ch** in Tzeltal to **c** in Maya, **Chabin, Cib** (pronounced **Kib,** not **Sib**). Beyond this we cannot go with the glyph. To speculate now on the origin of these word differences would be as futile as to try to read meanings into the form of **Cib**; no one could possibly see a vulture, an owl, or a wax candle in the forms, unless he were trying to do so.

The glyph is again wholly sterile as an element. The student will once more note how often this is the case where we have Maya and Tzeltal words in agreement, and their meanings lost or else in complete disagreement with other regional terms—these latter in turn being usually translatable common words.

17

Caban Force : Earth

17.1	17.1n	17.1.1	17.1.1a	17.1.1	17.1.2n	17.1.3
17.1.4	17.1.5	17.1.6	17.1.7	17.1.8	17.1.9	17.1.10
17.1.10n	17.1.11	17.1.12	17.1.13	17.2	17.2a	17.2b
17.2.1	17.2.2	17.2.2a	17.2.2b	17.2.2c	17.2.3	17.2.4
17.2.5	17.2.6	17.2.7	17.2.8	17.2.9	17.2.10	17.2.11
17.2.12	17.2.13	17.2.14	17.2.15	17.2.16	17.2.17	[17.3]

17.3.1 17.3.2 17.4 17.4.1 17.4.1a 17.5 17.5n
17.6 17.7 17.7.1 17.7.2 17.8 17.8a 17.9
17.9.1 17.10 17.10.1 17.11 17.12 17.12.1 17.13.1
17.13.2 17.13.3n [17.13.4] 17.13.4n 17.13.4n 17.14.1 17.14.2
17.15 17.16 17.16.1 17.17 17.18.1 17.19 17.19.1
17.19.2 17.20.1 17.21n 17.22.1* 17.23 17.24 17.25.1
17.26 17.27.1 17.28.1 77.20 17.30 17.30.1 17.30.2 17.31
17.31a 17.31b 17.31c 17.31d 17.31e 17.31f 17.31.1 17.31.2
17.32 17.32n 17.33 19.30 45.7a 77.20.1 73.1

Form **17.8** denotes new, fresh earth. Form **17.9** is 'red earth.'

17	M.229.b.2	M.212.e.2	M.223.a.2	M.231.a.1	**17.1.2**
M.88.5	M.229.c.2	M.212.f.2	M.223.b.2	M.231.b.1	D.p49d.19
17.1	M.229.d.2	M.214.a.1	M.223.c.2	M.231.c.1	D.71.b.3*
D.p24.b.10	P.8.b.11	M.214.b.2	M.226.a.2	M·231.d.1	D.71.g.2
D.75.s.2	**17.1n**	M.218.f.2	M.226.b.2	M.232.a.2	D.74.f.4
M.213.b.2	M.139.c.1	M.218.h.2	M.226.c.2	M.232.b.2	
M.213.c.3	**17.1.1**	M.218.i.2	M.226.d.2	M.232.c.2	**17.1.2n**
M.213.d.3	M.p36.b.15	M.218.j.2	M.227.a.1	M.232.d.2	D.71.b.8
M.216.a.1*	M.201.c.4	M.218.k.2	M.227.b.2		
M.216.b.2	M.220.b.1	M.220.a.2	M.228.a.2	M.334.a.2	**17.1.3**
M.218.1.2	M.208.a.2	M.220.b.2	M.228.c.2	M.236.a.2	M.p36.b.17
M.220.b.3	M.212.a.2	M.220.d.2	M.228.d.3	M.236.b.2	M.112.a.1
M.220.c.3	M.212.b.2	M.222.a.2	M.228.e.3	M.236.c.2	M.112.c.2
M.220.e.3	M.212.c.2	M.222.b.1	M.230.a.3	**17.1.1a**	M.125.25.2
M.229.a.2	M.212.d.2		M.230.b.3	M.218.g.2	M.201.c.2

17.1.4
D.70.h.2
M.p35.b.10
17.1.5
D.p74.8
17.1.6
D.75.o.3
17.1.7
M.125.33.9
17.1.8
M.149.a.1
M.149.b.1
17.1.9
M.p78.d.2
M.152.a.1
M.152.b.1
M.177.f.3
17.1.10
M.125.31.1
17.1.10n
M.125.23.4
M.125.24.4
M.125.32.4
17.1.11
D.63.a.4
17.1.12
D.p48e.9
17.1.13
M.230.c.4
17.2
D.62.c.7
17.2a
D.61.c.5
17.2b
D.71.c.10
17.2c
M.p34.d.3
17.2.1
D.p60b.12



17.2.2
D.59.a.12
D.67.b.2
D.74.1.4
D.75.aa.3
P.4.a.1
P.7.a.1
P.7.b.25
P.23.a.26
17.2.2a
D.69.d.6
M.p77.e.2
M.p77.f.2
17.2.2b
P.3.b.14
17.2.3
D.71.d.8
D.74.a.4
17.2.4
P.24.a.23
17.2.5
P.23.a.23
17.2.6
D.p60a.5
17.2.7
P.5.c.4
M.161.e.1
17.2.8
D.60.a.1
D.61.b.4
D.61.c.2
17.2.9
D.61.e.1
17.2.10
M.p35.d.12
17.2.11
M.46.a.1
17.2.12
M.46.b.1



17.2.13
M.p34.d.12
17.2.14
P.8.c.3
17.2.15
D.59.c.12
D.59.d.12
17.2.16
D.p60.b.6
17.2.17
D.59.b.12
17.3.1
D.71.c.5
17.3.2
D.71.b.6
17.4.1
D.71.e.4
D.71.f.7
D.71.g.3
D.71.h.2
P.4.d.10
P.6.d.11
P.7.d.2
P.8.d.2
P.8.d.12
P.7.b.17
17.4.1a
P.24.a.9
17.5n
M.139.a.1
17.6
M.91.5
M.187.5
17.7
M.200.a.3
M.209.b.1*
M.209.b.2
M.209.c.2
17.7.1
M.233.a.3



17.7.2
M.233.b.3
17.8
M.33.b.2
M.123.f.3
17.8a
M.41.e.1
17.9
P.2.d.4
17.9.1
M.p36.d.11
17.10
M.123.g.3
17.10.1
D.70.a.2
17.11
M.218.m.2
17.12
D.71.68.2
17.12.1
D.71.25.1
D.74.o.3
D.75.n.1
17.13.1
M.p78.d.2
17.13.2
D.69.1.5
17.13.3n
M.218.i.4
17.13.4n
M.p78.d.5
17.13.4n
M.p77.f.8
17.14.1
M.224.c.1
M.224.d.1
M.224.e.1
M.234.b.1
17.14.2
M.234.a.1



17.15
P.15.f.4
P.16.e.1
M.171.a.1
M.171.b.1
17.16
M.218.d.2
17.16.1
M.218.b.2
M.218.c.2
M.225.a.2
M.225.b.2
17.17
D.58.g.7
17.18.1
D.71.h.4
17.19
D.67.b.5
17.19.1
M.123.f.4
17.19.2
M.p37.b.10
17.20.1
D.60.a.2
17.21n
D.55.d.8
17.22.1*
D.74.b.2
17.23
M.p36.b.17
17.24
M.p36.b.10
17 25 1
P.6.c.10
17.26
M.233.a.5
17.27.1
M.p34.c.13



17.28.1
D.60.e.4
17.30
D.55.a.10
M.10.e.5
M.233.b.5
17.30.1
D.55.j.3
17.30.2
M.213.c.7
17.31
M.41.a.1
M.41.c.1
17.31a
D.66.b.4
17.31b
M.39.d.4
17.31c
M.42.c.1
17.31d
M.42.d.1
M.42.c.1
17.31e
M.42.a.2
17.31f
M.41.d.2
17.31a.1
M.39.b.4
M.39.c.4
17.31a.2
D.61.b.1
M.41.b.1
M.41.c.2
17.32
P.6.c.2
P.6.c.7
17.32n
D.8.g.5

With **Caban** we again come, as with **Kan** and **Cimi**, upon solid verbal ground, at least in its use as a glyph. Among the various local day names and their meanings we have much confusion, which requires strained argumentation on forced etymological or phonetic grounds, to bring into apparent line.* The Nahuatl **Ollin** means Movement; the Quiché **Noh** means great or strong;

* The Tzeltal chic cannot be identified with Maya chich, hardness or force; Tzeltal ch would require hard c in Maya, just as we saw in **chabin**, cib. The ch of chic would correspond to the c of **caban**: but the -ic can not by any possibility be shunted with -ab, and an etymological parallel is further wholly lacking. There is no support in the dictionaries we have seen, for interpreting Chic as either Movement, Force or Earth.

the Zapotec **Xoo** is said to mean force or power; **Chic** in Tzeltal has two wholly inapplicable meanings—to burn or scorch, to sweat or ooze out.

The Maya word **cab** means earth, world, *tierra*, the place below, opposed to **caan**, the sky. The overwhelming evidence on the glyph and its associations in the pictures and texts is for this same meaning, Earth. A most interesting glyph in this connection is one found in Maudslay's Tikal, plate 74, glyph 13, our form **17.33.** The text of the stela shows that this glyph indicates the passage of one day, from **6 Eb, 0 Pop** to **7 Eb, 1 Pop**; the sun or **kin,** preceded by the numeral **1,** is seen entering between the **caban**-sign, and what we shall later come to identify as the sky-glyph. (Bowditch, page 137)

On page 74, Dresden, picturing the great cataclysm that is to mark the close of the astronomical cycles worked out through pages 24, 46–73, we find a most interesting pair of glyphs, the signs for sky and earth, each preceded by the sign for black: in other words, "darkness in the heavens, darkness on earth;" our form **17.1.5** above.

Several points in the above glyph table are to be noted: First that the subfix in forms **17.1, 17.2** sqq. is to be taken as the specific determinative for this glyph. Why, or how we should pronounce the two together, we have still to come at hereafter, as we reach back into Proto-Mayance.

The compound **17.2,** of **caban** joined with gl. **337** (which in its turn has the subfix ⟨ᴜᴜ⟩ as its specific), is worthy of the fullest and most detailed study. Pairs of glyphs or ideas are always of prime importance in matters of decipherment; they are almost our first apt point of attack. Here we have a very common glyph with many compounds and very many occurrences, in texts and also in the pictures, and which certainly stands for Earth. In form **17.8** we find it as 'fresh, new earth.' In **17.9** as 'red earth'. It forms compounds, a few each, with some half a dozen other common glyphs; and then it develops over twenty 'doublets' with this glyph **337.**

Except for forms **17.1.2, 17.1.4-6, 17.1.11-12,** found in the astronomical passages of the Dresden, the **caban**-sign with simple affixes is found almost wholly in the Madrid codex, the 'Book of Farm Rituals.' As **17.2,** compounded with gl. **337,** it occurs

almost solely in the astronomical passages of the Dresden, and in the Paris.

As **17.4** it is restricted to the Dragon section of the Dresden, and to the Paris. Compounded with gl. **311** (the five small circles), and with green or red, we find it practically restricted to the Madrid. In the forms **17.14, 17.15, 17.16** we find it as a repeat glyph in several Madrid ţolkins. Finally, in forms **17.31** sqq. we find it furnished with the identical superfix which causes **Cumhu** to grow out of **Kan**; and this superfix then further occurs with just three other glyphs: **302.18**—the cross; **321**—firewood; **333.**

We have here, in short, a wealth of comparative material, starting with such a common glyph and idea as 'earth,' developing about a hundred forms, with nearly 300 occurrences, and constant use in the accompanying pictures.

We must note, as one last point, the almost complete absence of numerals. One in **17.1n**, in **17.32n**, a possible one in **17.1.2n**; finally **17.13.4n**, with the numeral Nine.

18 Eţ'nab						Flint knife
18.1 D.46.b.3	18.1.1 D.p58.f.7	M.58.a.2 M.58.b.2	M.58.c.2 M.58.d.2	M.64.b.4 M.67.a.4	M.67.b.3 M.67.c.3	M.67.d.4 M.67.e.3

Here we have complete accord on all points, in the general calendar, names, meanings, and the glyph form and associations—save one, its etymology in Maya.*

The Quiché **Tihax**, Tzeltal **Chinax**, Nahuatl **Tecpatl**, all mean flint-knife. The glyph-form is obviously the same, and is constantly seen on the points or ends of spears. It is a common

* Eţ' in Maya does not mean to sharpen, but to lay or settle in place; the phrase in the Motul (quoted by Brinton): eţ'cab-te a tokyah, *punta la lanceta para sangrar*, is there given as one of several illustrations of putting a thing in its place or position, as an arrow in the bow, a lancet *on* the flesh; and eţ'ah is nowhere given as meaning 'to sharpen.' **Nab** also, means to anoint, varnish, etc; **nabzah ti kik** does mean, to cover (flow over) with blood, kik; but the **nabzah** itself does not. Such derived and merely incidental uses cannot be used to reach an etymological meaning. Two Maya words, meaning to put in position, and to anoint, cannot prove a specific meaning 'flint-knife,' especially when we already have tok as the common term therefor. The **nab** has no connection whatever with 'flint.'

affix with predatory or destructive creatures, as in the **Xul**-glyph. It must surely imply the action in question, of drawing blood or killing. Its use as an infix, as in glyphs **126, 127** (which have almost no characteristic save this infix and the hairy animal mouth), must be read in this sense.

The one independent glyph-form we show above, gives us the interesting superfix, 'exploding dots,' and brings us to a major problem in the glyphs, of the use and functions of added dots. A searcher for 'symbolic values,' could do about anything with a lot of dots. They could be drops of rain, or of blood, a mark of death, hair, feathers, and what not. None *impossible*, pictorially. But they were also certainly a convention for expressing one or more things; and speculation, without positive evidence of some kind, will not reach that far into past times and cultures. See later, where the surrounding dots about common glyphs are grouped together, no. **358.**

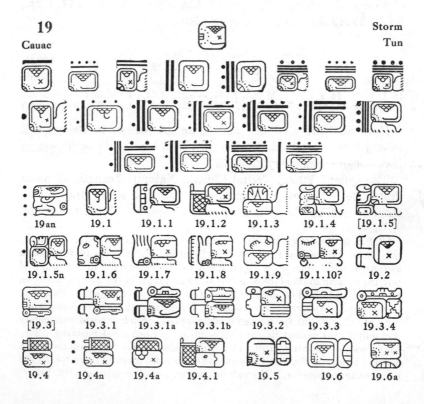

19
Cauac

Storm
Tun

19an 19.1 19.1.1 19.1.2 19.1.3 19.1.4 [19.1.5]

19.1.5n 19.1.6 19.1.7 19.1.8 19.1.9 19.1.10? 19.2

[19.3] 19.3.1 19.3.1a 19.3.1b 19.3.2 19.3.3 19.3.4

19.4 19.4n 19.4a 19.4.1 19.5 19.6 19.6a

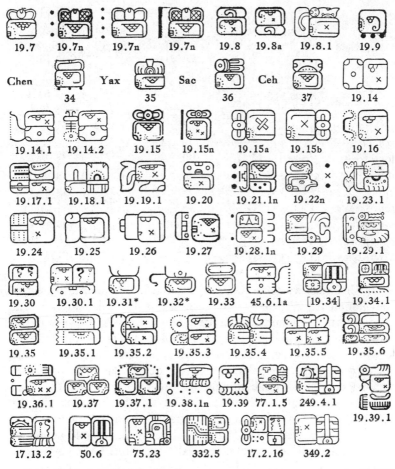

Form 19.1 is a variant for the tun.

19	P.8.b.24	P.9.b.22	M.186.e.2	19.1.7	M.146.b.3
M.10.f.1	P.9.b.24	P.9.c.8	M.191.e.2	M.125.4.1	M.224.a.3*
M.12.e.2	P.10.c.6	P.10.b.26	19.1.3	19.1.8	
M.100.c.1	P.11.c.8	P.11.b.16*	D.59.a.9	M.125,19,3	19.3.1a
				19.1.9	D.8.t.5
10an	19.1	19.1.1	19.1.4	D.p50d.5	D.55.g.4
D.71.h.5	P.15.b.6	M.p36.b.6	P.3.a.1*	19.1.10?	D.55.i.3
19n	P.15.f.1	19.1.2		M.125.21.1	D.55.o.4
P.2.c.8	M.122.b.2	D.59.b.9	19.1.5n		D.59.a.7
P.3.b.24	19.1n	D.59.d.9	P.4.b.15	19.2	D.63.d.6
P.3.c.7	P.2.b.24	P.8.c.5	P.4.c.9	M.166.c.2	M.228.d.4
P.5.b.24	P.6.c.8	M.185.a.2	19.1.6	19.3.1	M.234.b.4
P.5.c.11	P.7.b.30	M.185.b.2	D.72.g.6	D.20.b.3	M.236.b.4
P.6.b.24	P.7.c.7	M.185.e.2	D.p70.b.3	D.29.e.3	19.3.1b
P.7.b.20	P.8.c.10	M.185.f.2	D.p74.11	D.30.c.4	D.50.b.4

19.3.2	19.7n	M.26.b.3	19.21.1n	M.209.d.5	19.35.3
M.123.e.4	D.8.c.5	M.26.c.1*	P.9.d.6	M.216.a.5	M.p37.c.14
19.3.3	D.p24.b.5	M.26.d.4	19.22n	M.216.c.5	19.35.4
M.p37.b.6	D.p48c.a.3	M.26.e.4	P.24.a.28*	M.226.a.5	D.69.f.1
	D.14.e.2	19.15	19.23.1	M.231.a.5	19.35.5
19.3.4	D.30.b.3	P.8.d.8	D.9.e.1	19.30.1	M.p36.b.11
M.57.b.4	D.46.a.2	19.15a	19.24	M.125.14.2	19.35.6
19.4	D.51.a.2	D.26.c.3	M.7.h.3	19.31*	P.8.b.14
M.192.a.2	M.125.13.2	19.15b	19.25	P.6.c.13	19.36.1
19.4n	M.125.31.2	D.8.s.4	M.33.a.1	19.32*	M.125.27.3
M.125.26.5	19.8	19.15n	19.26	P.2.c.9	19.36.1a
19.4a	M.12.a.2	M.145.c.2	M.123.d.4	19.33*	M.125.30.3
M.132.5	19.8.1	19.16	19.27	P.6.c.12	19.37
19.4.1	D.75.y.1	M.26.c.4		19.34.1	P.23.a.16
D.59.c.9	19.8a.1	19.17.1	19.28.1n	P.11.c.14	M.68.e.1
	M.221.a.1	M.p36.c.9	M.p35.d.18	19.35	19.37.1
19.5	M.221.b.1	19.18.1	19.29	P.4.b.25	P.9.b.26
M.141.d.4	19.14	M.p34.c.16	D.66.a.4	19.35.1	P.11.b.24
19.6	M.26.c.3	19.19.1	19.29.1	D.71.41.1	19.38.1n
D.61.j.3	M.22.a.2	M.137.d.2	P.10.d.12	D.71.47.1	M.212.d.4
19.6a	19.14.2	19.20	19.30	19.35.2	19.39
M.124.f.1	M.26.a.3	M.p34.d.18	M.209.b.5	P.7.d.10	M.10.f

With **Cauac** we come to a glyph much like **Chuen** in its verbal development. Primarily, the 19th day in the calendar is Storm, Rain-storm. Nahuatl **Quiahuitl** means rain. Vico, xvi cent. ms. vocabulary of Cakchiquel, gives: **Caok**, *nombre de un día, sign. lluvia.* Ara, xvi cent. ms. vocabulary of Tzeltal, gives: **Chauc,** *relámpago, rayo.* So that we have quite the same calendric situation as with **Eȶ'nab,** and no Maya etymology at hand.

Until the solution (as noted below) of the meaning of form **19.3.1,** there was no case in the texts where the original meaning as above, appeared. The sign **cauac,** wherever it could be pinned down, appeared as a sort of general time-count base. Alone, or with the wing-affix, **19.1,** and with numerals, it is a fixed variant for the **Tun**-sign. This Morley was the first to verify. It is also the common element in the four vinal signs for **Ch'en, Yax, Sac, Ceh,** differentiated only by their superfixes. **Ch'en means** Well; **Yax** and **Sac** mean Green, White; and the superfixes are the characters fully established for those colors. The superfix to **Ceh** means Red, but the Maya and Quiché **Ceh, Quieh,** mean Deer. See further under the Vinal signs.

In **19.34,** and with the wing, **19.34.1,** we have a very common glyph combining the **kin,** the **cauac** and the normal **tun** form into what is probably a generalized term meaning something equivalent to Time.

And from this we go on to the higher time periods, into each of which one or the other **tun**-sign enters. The **cauac** forms the center of the superfix that makes **Katun** out of **Tun**. Doubled, and with special affixes, the **cauac** constitutes the glyphs for 400, 8000, 160,000 and 3,200,000 tuns. To form the **alau-tun** the normal **tun** form is used.*

In spite of the above remarkable development of the **Cauac** into a mere time symbol, of general and varied use, evidences should still be sought for of the persistence of the meaning Storm, in addition to the one given below. In the Madrid codex especially, the various personages are constantly seated on a **caban** or on a **cauac,** with distinct associations.

Form **19.3.1** does however preserve the original meaning, in an unmistakable connection, and in a manner throwing great light on the manner of Maya glyph formations. In Dr. 55.g, we see the **Xul**-animal, all his facial marks appearing, hanging by his tail from the sky-band. With tail and both paws he holds flaming torches. Above in the text we see our form **19.3.1;** the superfix is a club, constantly appearing as an instrument of attack; it is neither spear nor knife, and also shows the same marks as are seen on wooden posts, for the knots; the prefix we shall later see defined as the conventionalized flames of firewood, (See glyph **321.1.1,** and Dr. ꜩ.50.b.) These three elements united, the **cauac,** or Storm, *relámpago, rayo* or lightning bolt as rendered in the above cited vocabularies, with the club or stick as superfix, and the flames as prefix, give a complete compound for 'thunderbolt.' Modern Maya has lost the term **cauac** in this sense, but has two other fully expressive terms: **lemba,** lightning that shines; and **haꜩ'-chac,** which may be either the heavy bolt or blow, or the stroke of the Chac, Jupiter Tonans.

Another use of the **cauac** sign, still unsolved, is in combination with gl. **301,** which see. With a **cauac** as superfix, this means to carry something bound, as on the back; it appears in many places, among them in the above noted Dr.ꜩ.50.b, where the woman in the accompanying picture is thus carrying the (burning) firewood, whose glyph accompanies this carrying sign in the text.

* For the use of cauac in or for the higher time periods, **katun, baktun, pictun, calabtun, kinchiltun,** see glyphs 51 to 55.

20

Ahau Lord

20.1n 20.1n 20.1.1 20.1.2 20.1.3 20.1.4 20.1.5

20.1.6 20.1.7 20.2.1 20.3 Chikin West 20.3.1 20.3.2

20.4.1 20.5 20.5.1 20.5.2 20.5.3 20.5.4 20.6.1

20.7.1 20.8.1 20.9 20.9.1 20.9.2 [20.10] 20.10n

20.10.1n 20.10.2 20.11 20.12 20.13.1 20.14.1 20.14.1a

348.5.1 20.16.1 20.17.1 20.17.2 20.18 20.18.1 20.19.1

20.20.1 20.21.1a 20.22 20.23 4.21 45.4 93.9 427.5

20.1	D.22.f.4	M.6.f.4	M.144.a.4	M.191.d.3	P.6.d.14
M.17.e.1	D.24.b.4	M.6.i.1	M.145.a.4	M.194.a.3	P.23.a.9
M.26.a.1	D.25.a.3	M.13.a.4	M.145.c.4	M.197.e.4	
M.124.c.4	D.26.b.3	M.16.a.2	M.146.a.3	M.198.a.2	**20.1.2**
M.124.e.4	D.27.a.5	M.16.d.4	M.147.c.4	M.199.d.4	M.125.11.5
M.125.20.4	D.28.a.3	M.21.a.4	M.149.a.4	M.200.a.4	**20.1.3**
M.170.e.4	D.29.b.3	M.21.c.4	M.151.a.4	M.208.a.4	M.124.a.3
	D.30.a.4	M.21.d.4	M.152.a.3	M.209.b.4	**20.1.4**
20.1n	D.31.c.3	M.24.a.3	M.153.b.4	M.212.e.4	M.58.a.3
M.8.a.4	D.35.a.4	M.25.a.2	M.165.d.2	M.213.c.6	**20.1.5**
	D.39.c.4	M.25.b.3	M.166.b.3	M.214.a.4	M.29.a.2
20.1.1	D.40.e.4	M.26.d.1	M.167.a.4	M.217.2	M.121.c.3
D.8.j.6	D.42.b.4	M.26.e.1	M.169.a.1	M.218.a.4	**20.1.6**
D.8.1.5	D.43.b.4	M.27.a.2	M.169.b.2	M.219.b.2	D.43.a.2
D.8.p.4	D.45.d.5	M.p36.d.4	M.169.d.1	M.221.a.4	**20.1.7**
D.9.a.3	D.46.a.6	M.57.a.4	M.176.a.4	M.223.a.4	D.69.d.2
D.9.e.4	D.51.c.4	M.57.c.4	M.176.d.2	M.224.b.4	**20.2.1**
D.11.a.4	D.52.d.4	M.58.c.4	M.176.h.1	M.225.a.4	M.190.f.4
D.15.c.4	D.p27a.16	M.87.e.4	M.178.c.1	M.226.a.4	**20.3**
D.16.c.4	D.p27b.3	M.125.6.4	M.179.b.2	M.228.a.4	M.22.b.4
D.17.a.5	D.p48d.7	M.125.9.3	M.179.e.2	M.229.a.4	M.38.a.3
D.18.a.5	P.15.f.2	M.139.a.3	M.183.a.4	M.231.c.4	
D.21.b.4	P.18.a.4	M.143.a.4	M.185.a.4	M.235.a.4	

20.3.1 West M.35.c.2	20.5.1 P.5.c.7	20.8.1 D.56.d.2	20.10.2 M.p34.b.8	20.16.1 D.p47e.10	20.19.1 M.124.a.2
20.3.2 M.116.e.4	20.5.2 P.8.c.7	20.9 M.124.f.3	20.11 M.200.b.1	20.17.1 M.123.i.4	M.124.c.2 M.124.e.2
20.4.1 M.116.a.2	20.5.3 D.50.e.1	20.9.1 P.8.b.20	20.12 M.116.e.3	20.17.2 M.123.j.4	20.20.1 East M.21.a.1
M.116.b.2 M.116.c.2 M.116.d.2	20.5.4 M.p36.d.2	20.9.2 P.3.d.3	20.13.1 M.190.b.2	20.18 M.226.b.1	20.21.1 M.p36.d.16
M.116.e.2 M.116.f.1	20.6.1 M.p34.c.12	20.10n P.4.c.8	20.14.1 M.p35.d.5	20.18.1 M.226.c.1 M.226.d.1	20.22 P.5.b.20
20.5 D.71.48.1	20.7.1 D.p51a.d.2	20.10.1n D.p60b.1	20.14.1a M.190.e.3	20.18.1 M.226.a.1	20.23 M.96.a.2

Ahau means Lord, Ruler; the 20th day-name in Quiché is Hunahpu, a name also found in the *Popol Vuh*, and literally to be translated, 'the One Master of Magic Breath.' Yet, curiously, even here the Nahuatl contact reappears, for the various ms. Quiché dictionaries follow Vico, who gives: Hunahpu, *nombre de un día; sign. flor, o rosa.* This meaning, etymologically impossible, simply translates the Nahuatl day-name, Xochitl.

The origin of the word Ahau is of sufficient importance to be given here in detail. Up to date the word has been interpreted as ah-au, 'he of the collar,' implying the collar as the insignia royal. But this is faulty for several positive reasons; first, it lacks the historical grounds such as we have in the known term Ah-pop, He of the Council Mat, *i.e.* the throne or dais. This word pop, mat, came by this road to stand for the community itself, as in the term Popol Vuh. Further, a collar is u, and not au, giving an intrusive a which we have no right to ignore, especially in so prominent a word. The Maya did use all these words accurately; they did not say ah-au, when they meant ah-u; and we never find ah-u. Again, it is wholly improbable that a term so rooted in their culture, and the great day in their calendar system, would have come in by such a modern road; there were quite certainly ahaus before there were kings with royal collars.

But, fortunately, we are not dependent on arguments here. It is only another case of etymologizing ancient meanings by guesswork, with what is found in late Yucatecan vocabularies. The actual stem or root of ahau is very common in the southern Mayance branches, Quiché, Pokonchí, Kekchí, and Tzeltal. The stem is au or av, meaning a milpa-field, planted garden;

and as a verb, to sow. Kekchí and Pokonchí **abix,** cornfield; Cakchiquel **avan,** Quiché **avix,** milpa; also **avexan,** *tierra sembrada,* **ravexhab,** maize sown at the first rains. Tzeltal, **auil,** *sembrado,* **aualil,** *semilla,* **aual,** the act of sowing, and then with the aspirate prefixed (Maya **ah, 'h,** Tzeltal **gh**), **ghaual,** sembrador. The word is even found in an obscure place in the Maya, as **cauiil,** *i.e.* **c-auiil,** *sembrado segunda vez,* just as we find in Tzeltal, **auentay,** to re-sow what did not grow, *sembrar otra vez.*

So that in the **Ahau** we find that most important person, the land-owner, cultivator of the milpa, on whom the entire social order rested. The lord of the soil, planter, landed proprietor; a piece of cultural etymology such as we constantly meet, when we can reach to the early roots of words.

The glyph **ahau** takes several important affixes. The is one of the very few to be used in both positions at once. So used here it gives us the appellative of god D the Aged God; again we find it doubled on the face glyph of the Death God, see form **22.1.3**; again it serves as the main affix, the determinative, of the Tun. This affix has been constantly referred to as a sacrificial knife, a supposed pictograph, in spite of the known form for the knife, the flint-sign. Brinton, rejecting this, saw in the affix a symbol for the divination counters, or 'beans,' as he called them. Not because of its form, which might mean anything, but because of these and a number of other associations and uses, this is probably correct.

We shall discuss this affix in connection with the supporting hand, and glyph C of the Supplementary Series. But for the present we find it as the main affix to three of the most important 'Lords' of Maya mythology and science. With it as definer of counting and divination, the Aged God, the Ancient One, is seen as Lord of Fate, in beneficent aspects. Again doubled as affix to Death, he also is Lord of Fate, to be dreaded. And these two even meet in one very unusual form, their faces turned toward each other, see gl. **22.8**. Yet again, the personified Tun-deity is the keeper of Time, and its counting.

Form **20.1.1** occurs about 100 times, generally following the face-glyph of The Ancient, **81.1**, as his second glyph, or appellation. The forms with the base **20.5** sq. should be

noted. So also the repeat forms, **20.4.1, 20.18** and **20.19.1,**
found in Madrid ꜩ. 116, 124, 226. Also the **'ben-ik'** form, **20.10n,**
with the numeral **Buluc,** Eleven.

Attention should also be called to the fact that, both as day-
sign and in composition, the **ahau** is constantly found upside down.
There seems no regularity or system in this matter of position.

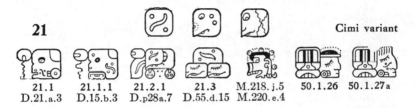

21 Cimi variant

21.1 21.1.1 21.2.1 21.3 M.218.j.5 50.1.26 50.1.27a
D.21.a.3 D.15.b.3 D.p28a.7 D.55.d.15 M.220.e.4

This and the four following glyphs are put here as actual day-
sign variants, connected in form or use.

Glyph **21** is used in a number of cases, in the usual day-columns,
as **Cimi.** It also appears as an element or infix in other glyphs.

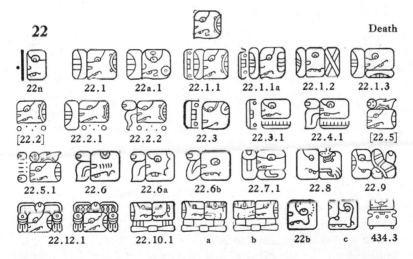

22 Death

22n 22.1 22a.1 22.1.1 22.1.1a 22.1.2 22.1.3

[22.2] 22.2.1 22.2.2 22.3 22.3.1 22.4.1 [22.5]

22.5.1 22.6 22.6a 22.6b 22.7.1 22.8 22.9

22.12.1 22.10.1 a b 22b c 434.3

Most or all of the gods in the codices, at least the chief ones,
have two glyphs; one we call their 'name,' as reproducing their
features, the other their appellation: Death the Destroyer.

22	D.p49c.c.3	M.144.b.3	M.197.d.2	22.1.1a	M.32.c.2
M.100.c.3	D.p27c.4	M.145.b.2	M.197.g.3	D.6.b.3	M.93.a.2
M.128.2	D.p28a.5	M.145.d.2	M.198.d.3	22.1.2	M.99.a.1
22b	M.8.b.4	M.146.d.2	M.199.c.3	M.28.b.2	M.123.e.1
M.33.d.4	M.9.b.3	M.147.b.2	M.200.e.3	22.1.3	M.164.a.2
22c	M.10.d.1	M.151.b.3	M.202.d.3	M.235.b.3	M.166.d.2
M.58.b.3	M.11.b.3	M.152.b.2	M.203.d.2		M.166.d.3
	M.12.a.1	M.154.b.3	M.205.b.3	22.2.1	M.167.b.3
22n	M.13.b.3	M.157.b.2	M.208.b.3	D.13.b.4	M.185.e.4
M.127.b.3	M.16.d.1	M.165.a.1	M.209.a.3	D.18.b.3	M.206.b.3
M.148.b.3	M.17.b.2	M.165.c.2	M.212.b.3	D.21.a.2	M.231.b.4
22.1	M.17.c.4	M.166.d.2	M.212.d.3	D.29.a.2	22.6b
D.4.b.3	M.18.c.2	M.168.d.2	M.213.b.3	D.41.b.4	M.27.b.3
D.8.t.3	M.19.b.4	M.169.a.2	M.216.b.3	D.43.c.3	M.53.2
D.9.d.2	M.20.b.4	M.169.c.3	M.218.c.3	M.201.b.1	M.93.a.2
D.11.b.2	M.26.e.2	M.170.a.2	M.219.d.3	22.2.2	22.7.1
D.14.h.1	M.29.b.2	M.170.c.1	M.221.d.3	D.9.d.3	M.152.b.3
D.16.b.3	M.29.d.4	M.170.d.3	M.222.b.2	22.3	22.8
D.17.b.3	M.31.a.3	M.171.a.3	M.223.c.3	M.94.b.1	P.6.b.7
D.21.c.2	M.31.c.2	M.173.c.2	M.224.c.2	M.99.a.1*	22.9
D.22.a.3	M.114.b.2	M.174.c.2	M.225.b.3	M.100.b.4	P.6.b.9
D.24.d.3	M.117.b.3	M.177.f.2	M.226.d.3	M.100.c.3	22.10.1
D.25.b.2	M.121.d.3	M.179.d.1	M.227.b.4	22.3.1	P.4.c.2
D.26.a.2	M.122.b.3	M.179.f.3	M.228.b.3	M.124.b.2	22.10.1a
D.28.b.2	M.125.33.11	M.180.b.2	M.229.b.3	22.4.1	P.3.b.2
D.32.a.3	M.131.b.2	M.188.b.2	M.231.b.3	M.168.b.3	22.10.1 b
D.39.b.1	M.137.c.3	M.190.d.3	M.232.b.3	22.5.1	P.3.d.12
D.40.d.1	M.138.a.2	M.191.f.1	M.233.a.4	D.75.d.2	P.3.d.16
D.46.d.2	M.139.b.1	M.192.c.2	22a.1	22.6	P.4.c.5
D.50.c.1	M.140.b.3	M.193.b.4	D.14.f.2	M.127.a.2	22.12.1
D.p46b.b.4	M.141.b.3	M.195.e.4	22.1.1	22.6a	D.72.a.9
D.p47c.a.2	M.142.b.3	M.196.b.2	D.48.a.1	M.30.b.3	D.72.f.9
D.p49b.b.4	M.143.c.3	M.197.a.2			

Just as the specific affixes of gl. 6 are seen in the form 6.2.1, for gl. 22 we have either 22.1 or 22.2.1. The association between the two is so close that the Madrid often transposes their affixes when thus paired. It is not uncommon to find this facility of placement, which is quite as characteristic of pure hieroglyphic writing as is the free position of Latin words in either metre or speech. Syntax indication may be either a matter of position or of form, either of which suffices when understood as such.

As to the function of the subfixes and prefixes in the above glyphs, see on page 24. The subfix is to be regarded as the specific determinative of class or function, the prefix as the modifier. In this light the bracketed form 22.2, not found by itself, should be regarded as Death's name, while the prefix tells about him, or his qualities; and then the short form 22.1 as merely an abbreviation. The subfix may be omitted, but the prefix not, as the essential defining element of quality, character or function.

23

| 23n | 23.1 | 23.1.1 | 23.1.2 | 23.1.3 | 23.1.4 | 23.2.1 |

| 23.2.2 | 23.3 | 23.3.1 | 23.3.2 | 23.3.3 | 23.4 | 23.5n |

| 23.6.1 | 23.7 | 23.8 | [23.9] | 23.9.1 | 23.9.1a | 23.9.2 | 23.9.3 |

| [23.9.4] | 23.9.5 | 23.10.1 | 23.11n | 23.12 |

23n	M.218.a.2	D.23.a.1	23.3.1	23.7	D.22.o.1
M.61.a.3	M.218.b.1	D.23.b.1	D.27.a.1	P.6.c.11	D.22.f.1
M.61.d.4	M.218.c.1	D.23.c.1		23.8	D.32.b.1
	M.218.d.1	D.23.d.1	23.3.2	D.30.a.1	
23.1	M.218.e.1		D.27.b.1	D.30.b.1	23.9.3a
M.189.a.1	M.218.f.1	23.1.3		D.30.c.1	D.32.a.1
M.205.a.1	M.218.g.1	M.205.b.1	23.3.3		
M.209.c.1	M.218.h.1		D.44.c.3	23.9.1	23.9.5
M.209.d.1	M.218.i.1	23.1.4		D.22.a.1	P.10.b.12
M.212.a.1	M.218.j.1	D.13.b.1	23.4	23.9.1a	
M.212.b.1	M.218.k.1		M.122.a.1	D.6.a.1	23.10.1n
M.212.c.1	M.218.l.1	23.2.1	M.122.b.1		D.69.i.3
M.212.d.1	M.218 m.1	P.6.b.13		23.9.2	
M.212.e.1		M.116.a.1	23.5n	D.22.b.1	23.11.1n
			M.63.e.3	D.22.c.1	M.158.a.2
23.1.1	23.1.2	23.2.2	23.6.1	23.9.3	23.12
M.218.a.1	D.13.a.1	D.6.b.2	M.63.a.3	D.22.d.1	P.18.b.5

This glyph has been generally treated as a **Cimi** variant; but
it is never used as a day-sign. It has three distinctive features
that are never ignored save in a few cases in the carelessly written
Madrid. These are the eye with double lines, and not with a
bent-up curve; the thumblike occiput; and the ear ornament.

Further, the equipment of affixes is quite different, and also the
associations. Glyph **23** does not enter into the 'evil' columns as
do **6, 22** and also **143.** Still more important, it is distinctly a
'repeat' glyph, serving mostly as initial in a series; its use thus in
D.ꜩ.22, 23, 30, and M. ꜩ. 209, 212, completely precludes its
serving as a death-sign; see both text and pictures.

Its main affixes are the hollow superfix seen in **23.1,** the color
red, and the two affixes used jointly in **23.9.3.**

24

Oc variant

| 24.1 | 24.1n | 24a.1n | 24.1.1n | 24.1.2 | 24.1.3 | 24.1.4 |

| 24.1.5 | 24.1.6 | 24.1.6n | 76.6.1 |

24.1	D.25.a.4	D.70m.4	M.66.e.4	M.180.a.4	24a.1n
M.5.b.2	D.26.d.3	D.75.d.3	M.87.a.4	M.183.b.3	M.p36.d.10
M.5.f.2	D.29.d.4	D.p26b.4	M.112.c.1	M.186.a.2	
M.137.b.4	D.31.c.6	D.p48d.6	M.118.a.4	M.186.f.2	24a.1.1n
	D.40.c.4	P.23.a.35	M.121.a.4	M.192.b.1	M.p37.d.5
24.1n	D.41.a.4	M.5.c.2	M.121.c.4	M.195.b.4	
D.7.d.4	D.44.c.4	M.5.e.1	M.124.e.3	M.195.d.2	24.1.2
D.8.b.6	D.45.b.4	M.7.a.4	M.125.1.4		D.75.v.1
D.8.e.4	D.47.b.4	M.7.g.3	M.125.6.5	M.199.a.4	
D.8.h.5	D.50.e.4	M.9.c.4	M.125.9.4	M.201.a.3	24.1.3
D.8.l.6	D.51.c.3	M.10.a.1	M.125.13.4	M.202.c.2	P.3.c.12
D.8.r.5	D.52.d.3	M.10.e.1	M.125.17.4	M.209.d.4	
D.9.c.4	D.52.f.3	M.10.e.8	M.139.a.4		24.1.4
D.10.a.4	D.55.n.4	M.10.f.5	M.145.a.2	M.210.b.4	M.177.f.4
D.16.a.4	D.55.p.3	M.11.d.3	M.146.a.4	M.218.a.5	
D.19.a.4	D.56.c.3	M.26.b.4	M.147.a.2	M.218.d.5	24.1.5
D.20.a.3	D.61.c.4	M.26.d.3	M.176.e.3	M.219.a.2	D.70.d.4
D.20.e.4	D.68.b.4	M.40.c.1	M.176.g.3	M.224.b.3*	24.1.6n
D.22.c.4	D.70.a.4	M.58.a.4	M.177.b.2	M.227.a.2	D.69m.6
				M.231.a.4	24.1.7
					D.69.b.6

This form, by itself, is an actual day-sign variant, in day-columns; it clearly reproduces what are generally taken as the lobbed dog's ears (see hereon, above, under gl. 10).

Its chief function, however, is to take the prominent and distinctive subfix shown (see under the month-signs and elsewhere), and then the numeral Three. In this combination it is used over 90 times, in connections 'of good omen.'

There is an archaic Maya word used constantly in the ms. *Ritual of the Bacabs*, on which the dictionaries give no light, and the writer never dared to give it its natural etymological definition, until he found it known and still used in the remote Bacalar district. The word is **oxtescun**; the **ox** means 3, the -**tescun** a good Maya factitive. It is used in salutation: **oxtescun ti tech, tat en,** I salute or thrice honor you, father; or, triple greeting to you, father, from me.' This fits the positional employment of the glyph so well, that one is greatly tempted to risk it as a meaning for the form **24.1n.**

25

Men variant ?

25.1 25.1.1 25.1.2 25.1.3 25.1.4 25.2 25.3.1

25.4 25.5 25.6 25.6.1 25.7.1 25.8 25.9 25.10

25.11 25.12 20.22

25	M.2.d.3	M.125.33.6	M.192.b.2	25.1.4	D.72.e.5
P.8.b.21	M.6.e.4	M.137.d.4	M.195.b.3	M.125.33.14	25.6.1
25.1	M.6.i.4	M.137.e.4	M.197.f.2	25.2	D.72.g.5
D.4.a.4	M.14.a.3	M.138.b.4	M.198.a.3	D.8.b.5	D.p70.a.3
D.8.j.5	M.16.c.3	M.146.c.4	M.198.c.3	D.8.n.6	25.7
D.11.a.8	M.17.c.3	M.147.e.3	M.202.c.1	25.3.1	M.26.c.6
D.23.a.4	M.18.c.3	M.164.f.4	M.218.b.6	M.218.d.6	25.7.1
D.25.c.3	M.25.a.1	M.166.a.2	M.219.e.2	25.4	M.178.d.2
D.27.a.3	M.33.b.1	M.167.a.1	M.236.a.4	M.137.a.4	25.8
D.37.d.3	M.33.c.1	M.168.a.4	25.1.1	M.146.b.4	M.172.3
D.39.a.4	M.43.a.4	M.168.c.2	M.229.c.4	M.147.d.3	25.9
D.40.a.4	M.45.a.3	M.169.d.2	25.1.2	M.171.a.4	P.10.b.22
D.45.a.4	M.p37.c.11	M.170.b.4	D.70.j.4	25.5	25.10
D.47.d.4	M.87.a.3	M.170.e.2	25.1.3	D.73.a.7	M.150.a.3
D.59.b.5	M.87.d.4	M.174.a.2	P.17.c.3	D.73.b.7	25.11
D.p48d.5	M.93.b.4	M.176.d.3	M.15.a.3	D.73.c.7	M.26.c.6
P.3.b.18*	M.93.d.4	M.178.d.6	M.18.b.3	D.73.d.7	25.12
P.9.b.20	M.98.b.4	M.179.a.4	M.28.c.2	25.6	M.20.a.1
P.10.b.17	M.112.a.2	M.180.c.4	M.41.a.3	D.69.g.4	
P.18.f.3	M.119.c.3	M.186.a.4	M.185.b.4		

As noted under form **15**, it is a very open question whether this is not a simple variant of **Men**. They match in use, and the equipment of affixes is closely alike. But the form with true eyes, nose and mouth is certainly the real **Men** form, whatever this may be.

MONTH SIGNS

With the study of the months and month-signs, we enter a wholly different task from that on the days. With the days we were dealing with single primary elements, which (in addition to and apart from their simple use as proper names for the days) served as stems or bases, often with wholly distinct meanings, for development of a long line of compound forms. The day-names and meanings gave us our start in a sort of root-vocabulary, while the resulting compounds and their associations offered us an induction into glyph syntax, and into linguistic structure and method.

In the month-signs however, we have to deal with a set of *manufactured* glyph-terms, simple and definite enough to reveal, on analysis, their own system. The study of the vinal-signs, in fact, almost reduces itself to a revelation of the use of three or four minor elements or affixes serving as determinatives to certain simple or compounded forms whose elements we already know, at least in large part.

Another most marked difference from the study of the day-glyphs lies in the fact that in these we had a set of appendant meanings substantially identical through all Middle America: in short, a common set of original day-names, that were rooted in the foundations of the calendar, and had spread and remained essentially the same through the centuries, and among the many nations. But whatever the archaic Vinal-series may have been, it gave place at nearly every point to new, local sets of names, with nothing in common save maintenance of the eighteen and a quarter vigesimals.

In Mexico the eighteen months were each known by the name of the festival celebrated on the last day. In the highlands of Chiapas and Guatemala (that is in both the non-Maya Chiapanec and the Quiché-Cakchiquel) the month calendars clearly took their names from natural seasonal events, connected with planting, rains, insect periods, etc. So that none of the above are of the least use to us in our present glyph studies.

Among the Tzeltal, on the lower levels in the *tierra caliente*, the case is a little different. We have two month-name sets for them, preserved by Ara in his ms. vocabulary of 1560, and by the two Pinedas in their works printed in 1845 and 1888; they vary

quite a little, but the second has no less than four names preserved which not only correspond to those we have in Maya and Kekchí, but also occupy the same place exactly in the year as given by Landa, and duplicated in the Kekchí list we shall later refer to. So that once again we find the Tzeltal standing with the Maya in preserving what can only be lost archaic terms.

In studying the vinal glyphs and names, therefore, we find ourselves entirely away from the systems in use in the later Highland kingdoms that began to arise both in the south and in Mexico, from the Eleventh century onwards. These latter kept or took over (it is true) the common inheritance of the vigesimal count, and with it the ritual tonalamatl or ţolkin of 20 days and 13 numbers; but their month calendars and observances they arranged and named anew, to suit themselves. The *tierras calientes*, on the other hand, kept the old system and its science alive, although with minor losses and changes. It lies doubtless somewhere in this story that "Pop was put in order," as the chronicles tell us.

The Maya maintained the calendar in Yucatan, with the glyphs; it stayed among the Itzás at Tayasal until their kingdom fell to Ursua in 1685. The Kekchí did not wholly lose the tradition. The Tzeltal, though reduced "to the woods, under the boughs," still retained recognizable fragments.

To make now a clear study of the coming nineteen vinal-signs, it will be necessary to treat them first as a whole, adding some few separate notations later. On account of the special nature and importance of the matter, it has been thought best to reproduce each glyph with all numerals as found, the more to aid the student.

26
Pop

26.1n
D.p70.d.7

26.1n
D.p48c.b.1

26.1n
D.p70.d.12

26.1n
D.73.b.9

27
Uo
Kekchi -
I-cat

27an
D.p48c.c.5

27an
D.p49b.c.1

27an
D.p49b.d.1

27an
D.p48c.d.5

27an
D.p47c.c.1

27a.1n
D.p24.c.19

27cn
D.73.e.2

27cn
D.72.e.12

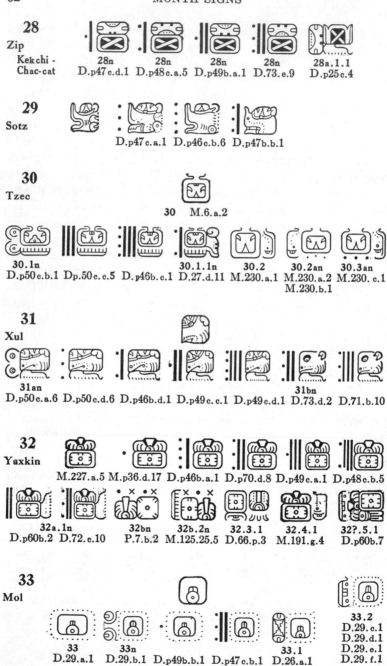

28
Zip
Kekchi -
Chac-cat

28n 28n 28n 28n 28a.1.1
D.p47c.d.1 D.p48c.a.5 D.p49b.a.1 D.73.e.9 D.p25c.4

29
Sotz

D.p47c.a.1 D.p46c.b.6 D.p47b.b.1

30
Tzec

30 M.6.a.2

30.1n 30.1.1n 30.2 30.2an 30.3an
D.p50c.b.1 Dp.50c.c.5 D.p46b.c.1 D.27.d.11 M.230.a.1 M.230.a.2 M.230.c.1
 M.230.b.1

31
Xul

31an 31bn
D.p50c.a.6 D.p50c.d.6 D.p46b.d.1 D.p49c.c.1 D.p49c.d.1 D.73.d.2 D.71.b.10

32
Yaxkin

M.227.a.5 M.p36.d.17 D.p46b.a.1 D.p70.d.8 D.p49c.a.1 D.p48c.b.5

32a.1n 32bn 32b.2n 32.3.1 32.4.1 32?.5.1
D.p60b.2 D.72.c.10 P.7.b.2 M.125.25.5 D.66.p.3 M.191.g.4 D.p60b.7

33
Mol

33.2
D.29.c.1
D.29.d.1
33 33n 33.1 D.29.e.1
D.29.a.1 D.29.b.1 D.p49b.b.1 D.p47c.b.1 D.26.a.1 D.29.f.1

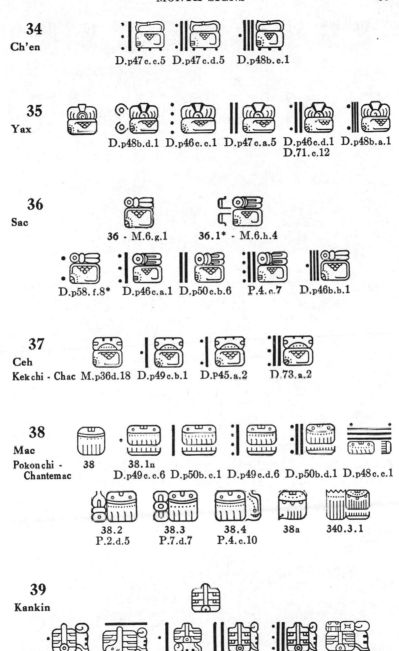

34
Ch'en

D.p47c.c.5 D.p47c.d.5 D.p48b.c.1

35
Yax

D.p48b.d.1 D.p46c.c.1 D.p47c.a.5 D.p46c.d.1 D.p48b.a.1
D.71.c.12

36
Sac

36 - M.6.g.1 36.1* - M.6.h.4

D.p58.f.8* D.p46c.a.1 D.p50c.b.6 P.4.c.7 D.p46b.b.1

37
Ceh
Kekchi - Chac M.p36d.18 D.p49c.b.1 D.P45.a.2 D.73.a.2

38
Mac
Pokonchi -
Chantemac 38 38.1n
D.p49c.c.6 D.p50b.c.1 D.p49c.d.6 D.p50b.d.1 D.p48c.c.1

38.2 38.3 38.4 38a 340.3.1
P.2.d.5 P.7.d.7 P.4.c.10

39
Kankin

D.72.e.13 D.p48c.b.1 D.p49c.a.6 D.p50b.a.1 D.73.c.9 See 349

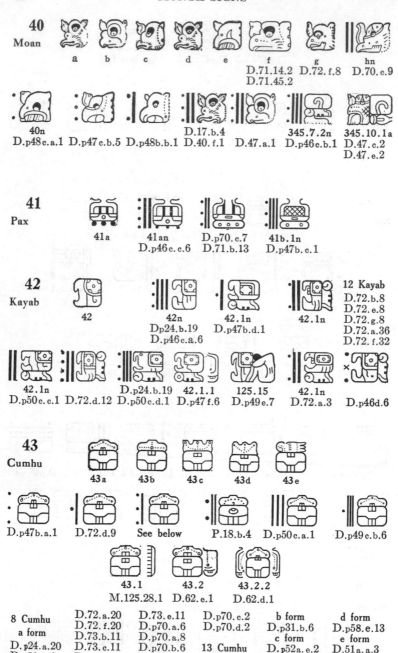

40
Moan

a b c d e f g hn

D.71.14.2 D.72.f.8 D.70.c.9
D.71.45.2

40n
D.p48c.a.1 D.p47c.b.5 D.p48b.b.1 D.17.b.4 345.7.2n 345.10.1a
D.40.f.1 D.47.a.1 D.p46c.b.1 D.47.c.2
D.47.e.2

41
Pax

41a 41an D.p70.c.7 41b.1n
D.p46c.c.6 D.71.b.13 D.p47b.c.1

42
Kayab

42 42n 42.1n 42.1n 12 Kayab
Dp24.b.19 D.p47b.d.1 D.72.b.8
D.p46c.a.6 D.72.e.8
D.72.g.8
D.72.a.36
D.72.f.32

42.1n D.p24.b.19 42.1.1 125.15 42.1n
D.p50c.c.1 D.72.d.12 D.p50c.d.1 D.p47f.6 D.p49e.7 D.72.a.3 D.p46d.6

43
Cumhu

43a 43b 43c 43d 43e

D.p47b.a.1 D.72.d.9 See below P.18.b.4 D.p50c.a.1 D.p49c.b.6

43.1 43.2 43.2.2
M.125.28.1 D.62.e.1 D.62.d.1

8 Cumhu	D.72.a.20	D.73.e.11	D.p70.c.2	b form	d form
a form	D.72.f.20	D.p70.a.6	D.p70.d.2	D.p31.b.6	D.p58.e.13
	D.73.b.11	D.p70.a.8		c form	e form
D.p24.a.20	D.73.c.11	D.p70.b.6	13 Cumhu	D.p52a.e.2	D.51a.a.3
D.p31.a.6	D.73.d.11	D.p70.b.8	M.125.33.5	D.p52a.f.2	D.73.a.11

44
Vayeb

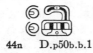

44n D.p50b.b.1

The following details are to be set forth in order:

Six glyphs at least are clearly pictographic in base: **Pop,** mat; **Soṭ,** bat; **Xul,** ?; **Kankin,** skeleton ribs; **Moan,** falcon; **Kayab,** turtle.

Two of these six contain the infix [○] —yellow.

Three of the same pictographic glyphs *require* the important affix, or determinative to fix them as vinal-signs. The mat, **pop,** is found elsewhere as a glyph element; it is only with the above infix and attached determinative that it becomes the vinal **Pop.** The **kankin** sign and the turtle head are found elsewhere, but without the determinative are not vinal signs.

Four of the above six are animal figures; two of them, the **Soṭ** and the **Moan,** are self-sufficient and require no affixes; incidentally, both of these show the usual free, variable drawing. The **Moan**-vinal, however, has a conventional variant, our **345.7.2n,** and to make a vinal-sign out of this glyph **345,** we must add the above determinative, as well as the regular time-period determinative, the .

Two signs, **Tzec** and **Pax,** require the flaring open top, to distinguish them respectively from the **chuen** and the **tun** normal sign, on which they are formed. We at once get here the query: What is the relation of **chuen** and **tun** to **Tzec** and **Pax,** underlying this use? The answer should be partly calendric, perhaps partly historical.

Two signs *require* the well-known 'comb' subfix, in order to serve as vinals, namely **Tzec** and **Mac.** The former *may* also take the vinal-determinative above noted with **Pop,** etc. but it is not essential, the comb sufficing.

One glyph, the pictographic **Xul**-sign, *must* take the wing-affix determinative. Certain others also *may* add it, namely **Zip** and **Yaxkin.** In Landa's set of month-signs, this wing-affix is given to **Xul, Yaxkin, Yax, Ceh.**

One sign is formed from **Kan** by adding a superfix which is also added to four other glyphs (see above, under **Caban**). What then is the relation of **Kan** to **Cumhu?**

One glyph, **Mol,** is distinguished by the necessary addition of a surrounding circle of dots.　These same surrounding dots are also found with certain other signs, such as **Kan,** etc.　See later, where these dotted signs are gathered together under the number **357.**

The **Vayeb** glyph is built on the **tun** as the **Cumhu** is on the **kan.** The five **Vayeb** days are the difference (numerically) between the 360 days of the **tun,** and the 365 of the ordinary year count, of the **haab.**

From the glyph forms, it also seems necessary for **Ch'en** and **Pax** to take the small black balls (or their equivalent, as in gl. **41a, 41b),** on which they rest.　Note, however, that the same supports also appear with **Pax** without the flaring top, where it probably represents merely the **tun;** so that the subfix-balls are not the vinal determinative, but only the flared top.

The remaining seven signs are straight compounds of known common signs, among them the color signs for black, red, white and green.

The 'omnium time-sign' **cauac** serves as main element to four of these.　The superfix to **Ch'en** we cannot yet value; **Yax,** green, and **Sac,** white, take the respective color signs as superfixes. The superfix for **Ceh,** Deer, is the sign for red ; but the month is not called Red, in Maya.

The sign for green is also placed over that for **kin,** day or sun, to form the compound **Yaxkin,** green or new sun or time.　This month is given by Landa as beginning Nov. 15th; but Pío Pérez translates **yaxkin** in his Dictionary as meaning *estío, que pasa en los meses de Febrero, Marzo y Abril.*　It is also rendered as *verano,* summer.　See further as to **Yaxkin,** below.

The last two of our vinal-signs are, for a special reason touching our glyph study, the most interesting of all.　They are **Uo** and **Zip,** each having a cross as main element, with the signs for black and red as superfixes.　**Uo** is usually translated, frog; and **Zip** connected with **Zuhuy Zip,** one of the goddesses of the chase (virgin like Diana), and celebrated in this month; neither of these explains the glyphs.

The writer has in his collection a native Kekchí *brujo* calendar, giving all the days of the year, marking those lucky or unlucky, and also adding the Vinal names at the side, only varying in

position two days from the dates in Landa. Two names are missing, for **Pop** and **Soꜩ**; but the **holob cutan, mahi yccaba,** five days without names, are given.

Eight of the 16 vinal words differ wholly from the Maya, but the other 8 preserve either the Maya words, *or the signs*, besides falling in the same places and order. Dec. 1 we find **Mol**; then beginning Jan. 10 we have the three **cauac**-made vinals, and **Mac,** represented by **Yax, Sac, Chac, Chantemat**; that is, Green, White, *Red*, (as to **Mac** see below). The Kekchí thus not only *translates* the first two color superfixes as does the Maya, but also the third.

Further down the list we reach our other two 'color'-vinals, **Uo** and **Zip**; and the superfixes to these also the Kekchí translates, giving us **Icat, Chaccat.** The **chac** we know is red; the **I-cat** is safely to be taken as a slightly corrupted **ekcat.** The evidence of the translated pair of superfixes affords the external support here, for these *are* the known color superfixes, only with their meanings lost in the Maya names. The Maya translates two color-names, the later Kekchí has even kept all five.

Further confirmation of the Lowlands preservation of the archaic terms or at least their traces, is shown by another unpublished list in the writer's possession, giving the Pokonchí terms, for both days and months. The days are merely the Maya. But the vinal terms repeat the Maya in only three cases, yet accord with the Kekchí in several others. Thus in place of **Yax, Sac, Ceh** we find **Yax, Sac, Tzi** (dog, instead of deer). In place of Maya **Moan** we find **Muhan** at April 20 in the Kekchí, and **Muguan** at April 27 in the Pokonchí. And then in place of **Mac,** we find in the Pokonchí **Chantemak,** which corrects the Kekchí final -t, and definitely connects up the **Mac.** The **Chante-** and the **cat** we have still to work out, as well as the other non-agreeing Kekchí terms. Such a workout must fall to comparative spoken language research, that most essential adjuvant to the whole glyph, and in fact, whole historical Maya problem.

As a final note here, it is possible that the superfix to **Ch'en** may in time be fixed as having that specific meaning. With four vinal signs differing only in their superfixes, and three now known to be named by those superfixes, this may quite likely be the same, and mean a Well.

CALENDRIC SIGNS

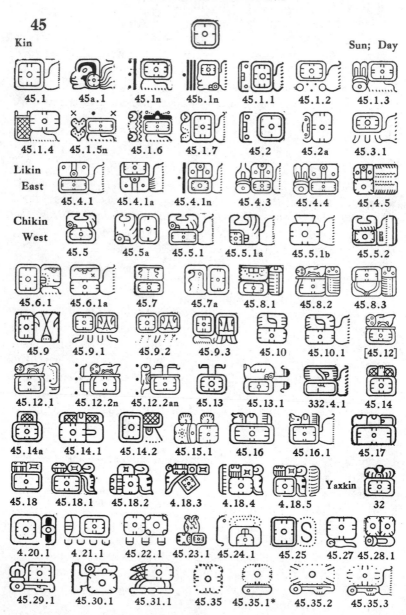

45

Kin

Sun; Day

45.1 45a.1 45.1n 45b.1n 45.1.1 45.1.2 45.1.3

45.1.4 45.1.5n 45.1.6 45.1.7 45.2 45.2a 45.3.1

Likin
East

45.4.1 45.4.1a 45.4.1n 45.4.3 45.4.4 45.4.5

Chikin
West

45.5 45.5a 45.5.1 45.5.1a 45.5.1b 45.5.2

45.6.1 45.6.1a 45.7 45.7a 45.8.1 45.8.2 45.8.3

45.9 45.9.1 45.9.2 45.9.3 45.10 45.10.1 [45.12]

45.12.1 45.12.2n 45.12.2an 45.13 45.13.1 332.4.1 45.14

45.14a 45.14.1 45.14.2 45.15.1 45.16 45.16.1 45.17

45.18 45.18.1 45.18.2 4.18.3 4.18.4 4.18.5 Yaxkin 32

4.20.1 4.21.1 45.22.1 45.23.1 45.24.1 45.25 45.27 45.28.1

45.29.1 45.30.1 45.31.1 45.35 45.35.1* 45.35.2 45.35.3

4.16.1 17.33 45.4.2 45.23.2 45.32.1 45.33.1 50.7 75.29.1

79.1 90.2.1 113.1 120.9.1

45
M.166.e.4
45.1
D.71.i.7
M.53.1
M.p37.c.16
M.197.e.2
45a.1
D.72.f.18
45.1n
D.p52a.d.2
D.72.a.30
D.72.f.30
45b.1n
D.5.b.4
45.1.1
M.p34.d.8
45.1.2
D.75.k.2
45.1.3
D.69.h.6
45.1.4
M.186.b.1
M.186.f.1
M.191.a.4
M.191.g.1
M.191.h.1
45.1.5n
D.72.f.25
45.1.6
D.72.a.18
45.1.7
M.125.11.1
45.2
M.166.c.3
45.2a
M.p37.b.7
M.173.b.4
45.3.1
D.75.c.1
45.4.1
East
D.45.a.1
D.p25c.3
D.p24.a.4
D.58.a.2

D.58.e.2
D.59.a.1
D.64.d.2
D.68.b.1
D.p46b.d.3
D.p46c.a.5
D.p46e.2
D.p47b.d.3
D.p47c.a.4
D.p47e.2
D.p48b.d.3
D.p48c.a.4
D.p48e.2
D.p48e.8
D.p48t.7
D.p49b.d.3
D.p49c.a.5
D.p49e.2
D.p50b.d.3
D.p50c.a.5
D.p50e.2
M.4.a.2
M.4.c.1
M.p9.3
M.7.a.1
M.7.e.2
M.22.e.4
M.39.c.1
M.50.1
M.55.2
M.p36.d.5
M.p36.d.15
M.56.a.2
M.66.b.1
M.67.a.1
M.68.a.1
M.69.a.1
M.76.d.1
M.88.1
M.80.1
M.90.1
M.91.1
M.p75-6.1
M.p77.a.2
M.p78.b.2
M.92.4
M.111.a.1
M.130.1
M.132.1

M.134.2
M.156.d.1
M.157.b.1
M.159.b.1
M.160.a.1
M.161.b.1
M.161.d.1
M.177.c.3
M.177.g.3
M.187.a.1
M.195.a.4
M.201.a.1
M.204.a.1
M.204.c.1
M.220.a.3
45.4.1a
M.35.a.1
M.36.a.2
M.175.a.1
M.211.1
M.113.a.1
M.220.n.2
M.231.b.2
M.231.d.3
45.4.1n
M.158.a.1
45.4.2
M.158.c.4
45.4.3
D.65.a.4
45.4.4
D.57.a.3
45.4.5
M.p34.d.10
45.5
M.50.4
M.p75-6.3
M.p77.c.2
M.134.1
45.5a
D.57.c.3*
P.16.a.6
45.5.1
West
D.12.c.1
D.45.c.1

D.p27c.3
D.58.c.2
D.59.c.1
D.65.c.4
D.68.d.1
D.p49c.c.5
D.p50c.c.5
P.4.b.14
M.p2c.d.1
M.p9.2
M.7.c.1
M.38.c.2
M.39.a.1
M.50.3
M.55.4
M.p34.c.2
M.56.c.3
M.66.e.1
M.67.c.1
M.68.c.1
M.69.c.1
M.76.b.1
M.88.3
M.89.3
M.90.3
M.91.3
M.92.2
M.111.c.1
M.113.c.1
M.p77.g.2
M.130.4
M.132.3
M.134.1
M.156.b.1
M.157.d.1
M.159.a.1
M.160.c.1
M.175.c.1
M.177.a.3
M.187.3
M.211.3
M.220.d.1
D.58.g.2
45.5.1b
M.21.c.2
45.5.1a
D.64.b.2
D.p46b.b.3

D.p46c.c.5
D.p47b.b.3
D.p47c.c.4
D.p48b.b.3
D.p48c.c.4
D.p49b.b.3
D.p50b.b.3
45.5.2
M.p34.d.15
45.6.1
D.75.w.3
45.6.1a
M.22.b.2
M.22.c.2
M.22.d.2
M.162.b.2
45.7
M.28.b.1
45.7a
M.41.d.1
45.8.1
D.71.56.1
45.8.2
D.75.d.1
45.8.3
D.71.34.1
45.9
M.38.a.4
45.9.1
D.55.a.7
D.55.d.7
D.55.k.3
D.55.p.4
D.60.a.4
D.60.c.3
D.61.d.1
D.61.k.4
D.62.d.3
D.63.a.3
D.66.j.4
D.66m.4
D.69.e.5
D.69.g.5
D.69.k.5
D.74.i.3

D.75.c.2
D.75.l.2
D.75.m.2
D.75.o.1
D.75.aa.1
45.9.2
D.60.e.3
45.9.3
D.70.l.4
332.4.1
P.7.b.8
45.10
M.145.b.1
M.145.a.5
M.145.c.5
45.10.1
M.145.a.1
M.145.c.1
M.145.d.1
45.12.1
D.74.g.4
D.75.l.1
45.12.2n
D.75.w.1
45.12.2an
D.75.e.1
45.13
M.120.d.3
45.13.1
P.24.a.21
45.14
M.p34.b.5
M.p36.b.5
M.p37.b.5
45.14a
M.203.b.3
45.14.1
M.p35.b.5
45.14.2
M.p35.b.17
45.15.1
M.p36.d.13

45.16	D.p48c.b.3	M.178.d.1	45.18.4	M.182.1	45.32.1
D.p50d.7	D.p49e.8	M.179.c.3	M.197.a.4	45.24.1	M.p34.b.6
45.16.1	D.p50d.6	M.195.e.1	M.201.a.4	D.74.a.3	45.33.1
D.p24.a.13	P.3.d.13	M.197.c.2	45.18.5	45.25	M.182.3
45.17	P.7.b.18	M.200.b.3	P.23.a.24	M.p35.d.2	45.35
M.p37.b.18	M.6.c.4	M.203.a.1			P.6.d.1
45.18	M.57.b.3	M.212.c.4	45.20	45.27	45.35.1*
M.177.a.2	M.113.a.3	M.218.1.3	M.197.f.1	M.181.b.1*	P.18.c.5
45.18.1	M.146.b.2	M.219.f.1	45.21.1	45.28.1	45.35.2
D.8.f.3	M.157.c.3	M.221.b.4	M.112.b.3	M.p34.a.1	D.30.a.2
D.20.b.2	M.164.c.3	M.228.d.2	45.22.1	45.29.1	D.30.b.2
D.24.a.3	M.169.b.1	M.234.b.3	M.6.c.3	M.200.f.1	D.30.c.2
D.29.e.2	M.173.c.1	M.236.b.3	45.23.1	45.30.1	M.125.9.7
D.30.c.3	M.173.d.2	45.18.2	D.p25c.7	M.141.d.3	45.35.3
D.45.c.3	M.174.c.1	M.145.c.3			D.32.a.2
D.p26b.2	M.175.b.2	45.18.3	45.23.2	45.31.1	D.32.b.2
D.p48b.a.4	M.178.b.4	M.40.a.1	M.p8.e.6	M.177.g.2	P.18.c.5*

The meaning of the sign for Sun or Day is of course so fully established that it is a matter mainly of seeking to find the effect of the various affixes. The wing-affix, $\llcorner \ldots \urcorner$ as in 45.1, frequent also with other signs, may be taken as a time-determinative, and not limited to the single day, its chief connection. It remains with the kin-sign even when that forms East and West.

The use of the prefix in 45.1.4, generally taken as a net bag or hamper, is interesting. 45.4.1 sq. are for the East; note the instance with the 'tying-up' prefix. The West is the seizing, the biting of the Sun.

45.7 shows the sun and earth together; 17.33 the sun entering between the sky and earth (see above, under Caban). 45.9 is the sun and night, day and night. The value of the affixes 11 to 14 is undetermined. At 45.16 the glyph becomes a time sign, taking the same superfix as changes tun to katun; no reason has appeared to give this a vigesimal numeral value here.

Form 45.18 adds the 'ben-ik' and the postfix we have specially noted in the month signs, and is the glyph usually associated with Kin-ich-ahau, or god G. His identification in the texts and figures is not clear, and he seems to have stood in the mythology chiefly as a manifestation of Itzamná. The latter himself declared the Sun to be his son.

What may be the value of the dotted kin-glyphs, with the club and wing, is involved in the reading of the series of various dotted initial glyphs in Dr.ꜩ.26 sq. But on the analogy of the cauac thunderbolt sign, 19.3.1, this form may well represent the sun's rays striking, u haꜩ'kin.

46

(glyph row labeled) α b c e e

46.1 46.1.1 46.1.2 46a.1.1 46a.1.2 46a.2 46b.1n

46c.1.2 46d.1.2 46e.3.1 46e.3.2 46a.1?

46.1	P.23.a.8	46.1.2	D.28.a.4	46b.1n?	46e.3.1
P.10.b.16	P.24.a.18	D.70.g.4	46a.1.2	M.87.b.4	D.71.a.10
M.152.a.4	M.198.c.2	D.70.k.4	D.8.r.6		46e.2.2
46.1.1	M.198.b.4	D.72.a.14	D.24.c.4	46c.1.2	D.71.g.8
P.6.b.18	M.218.b.5	D.72.f.14	D.25.c.4	M.125.18.5	M.p35.d.1
P.7.c.4	M.236.c.4	46a.1.1	46a.2	46d.1.2	46a.1*
P.8.b.18		D.27.a.6	P.6.d.6	M.125.1.5	M.145.d.3

There are among the glyphs several signs where a known element is placed across the top of a head or face without other features, such as the **kin, cauac, tun,** etc.; these may be taken as simple face forms, a style of personification more or less for artistic reasons, similar to the like method on the monuments.

Beyond this, however, we reach the distinctive American feature of incorporation or infixation, one easily understandable in mythological matters. An infixed element denotes either the character or the office of the personage or animal represented by the main element. Such is the night sign: a 'night-bird.' Again, the Sun-god; or the flint-knife infix used to denote predatory activity. These latter cases are distinguished from the former by the fact that the main element has independent existence in itself, and the infixes are only qualifiers.

Beyond this stage of infixation we would next come to where the qualifying element would be prefixed as an adjective, a looser union; and further still, linguistically and also mythologically, where the two would form compounds, both elements remaining main ones.

As in all like matters, the border line between these successive formations is at times hazy, however clear the distinctions and their patent instances may be. And in the present case, with the **kin**-sign, we find this so. Until the values of all the affixes are ironed out, it will not be possible to do more than put all these **kin**-infixations together, and next to the main **kin**-glyph.

With the wing-affix, there seems no present way but to read the form as meaning simply a day; in D.ʒ.5 we find it as 16 days, matched off with a corresponding 6 vinals in the next column. At D.72.a.14, f.14, we seem forced to render it as 'no days,' in a count of 1.18–16.0, and apparently involving a new symbol for naught.* All these forms show a definite black spot attached to the infix-border.

In forms 46d.1, 2 we find the same prefix and wing-affix, but attached to non-facial outlines.

In this connection we also come against the confusion of the normal **kin**-sign, with the equally definite sign for yellow; see later, under the color, gl. **68**.

In P.6.d.6 the glyph (though with the yellow infix instead of the **kin**) seems to be more than a mere equivalent for day; note the facial marks, and the 'club' prefix.

The plain **kin**-infix in a hollow border, forms 46e.2.1, 46e.2.2, occurs in two of the picture clauses of the eclipse ephemeris, furnished with the subfix.

* This prefix is also exactly the same as displayed on both sides of the flaring 'eclipse shields,' and also much resembles the characteristic **Cimi** prefix in gl. **6.1, 6.2.1**. So that some years ago the writer thought the 'eclipse' sign might be read as a naught or privative, "there is no sun," **minaan kin**; and also the **6.2.1** glyph be read 'deathless.' But the prefixes are only similar, and not identical; also the associations certainly prove **6.2.1** as not deathless, but death-bringing. So that the hope as to the present **kin**-prefix stalled, at least.

47 **Vinal**

48 or ? **Tzolkin**

49 ? **Haab**

The above, especially for the ⱱaab, are as yet only suggestions. See under **Chuen, Imix** and **331**.

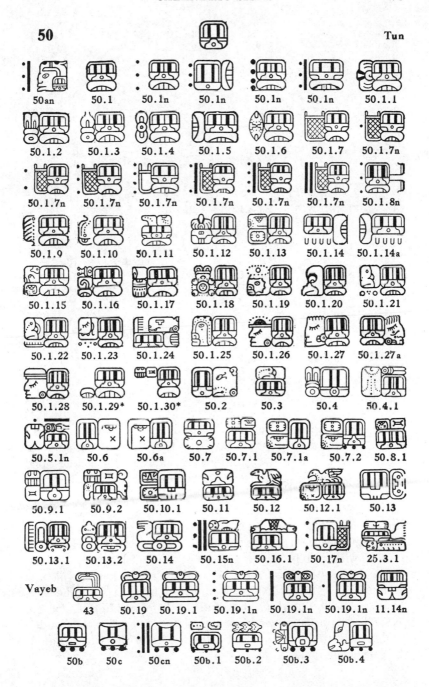

50

Tun

50an 50.1 50.1n 50.1n 50.1n 50.1n 50.1.1

50.1.2 50.1.3 50.1.4 50.1.5 50.1.6 50.1.7 50.1.7n

50.1.7n 50.1.7n 50.1.7n 50.1.7n 50.1.7n 50.1.7n 50.1.8n

50.1.9 50.1.10 50.1.11 50.1.12 50.1.13 50.1.14 50.1.14a

50.1.15 50.1.16 50.1.17 50.1.18 50.1.19 50.1.20 50.1.21

50.1.22 50.1.23 50.1.24 50.1.25 50.1.26 50.1.27 50.1.27a

50.1.28 50.1.29* 50.1.30* 50.2 50.3 50.4 50.4.1

50.5.1n 50.6 50.6a 50.7 50.7.1 50.7.1a 50.7.2 50.8.1

50.9.1 50.9.2 50.10.1 50.11 50.12 50.12.1 50.13

50.13.1 50.13.2 50.14 50.15n 50.16.1 50.17n 25.3.1

Vayeb

43 50.19 50.19.1 50.19.1n 50.19.1n 50.19.1n 11.14n

50b 50c 50cn 50b.1 50b.2 50b.3 50b.4

50	50.1.4	D.59.c.5	P.2.b.9*	50.6	50.15n
D.p48d.17	P.7.c.5	D.63.d.3	P.3.b.12*	M.36.a.1	M.125.3.3
M.p36.e.7	50.1.5	D.68.a.5	50.1.24	M.38.a.1	50.16.1
M.p36.e.12	P.2.c.3	D.68.d.5	P.3.c.9	50.7	P.3.c.11
50an	50.1.6	D.74.c.4	50.1.25	M.p34.b.13	50.17n
D.72.a.12	D.p26a.5	D.75.m.1	M.p34.d.9	50.7.1	M.125.2.3
50.1	50.1.7n	D.75.x.1	50.1.26	D.p25c.6	M.125.8.5
D.75.w.2	M.125.2.3	50.1.14	P.23.a.28	50.7.1a	M.125.13.5
D.75.z.3	M.125.4.5	D.p27a.7	P.24.a.4	D.61.h.4	M.125.30.5
P.3.b.28*	M.125.9.5	50.1.14a	50.1.27	50.7.2	50.19
P.6.d.3	M.125.10.5	D.p28a.8	P.5.c.3	D.p26a.7	M.164.d.2
P.4.b.11*	M.125.12.5	50.1.15	P.5.d.11	50.8.1	50.19n
P.4.b.30*	M.125.14.5	P.4.d.14	P.9.c.7	P.16.f.3	D.55.j.4
P.5.a.2*	M.125.23.5	50.1.16	P.23.a.30	50.9.1	D.p47b.d.4
M.10.f.4	M.125.24.5	P.6.d.17	P.24.a.24	D.66.1.4	P.4.b.9
M.p35.b.7	M.125.27.5	50.1.17	50.1.27a	50.9.2	M.124.c.1
M.p35.b.8	M.125.29.5	P.6.d.12	P.24.a.5	M.125.17.1	M.218.d.4
M.p37.c.13	M.125.30.5	50.1.18	50.1.28	50.10.1	M.219.a.1
50.1n	M.125.32.5	P.5.c.6	P.23.a.20	P.17.f.3	50.19.1n
M.125.1.3	50.1.8n	50.1.19	50.1.29*	50.12	P.3.b.6
M.125.7.3	M.125.1.3	P.23.a.29	P.4.b.11	P.3.c.8	50cn
M.125.19.5	50.1.9	50.1.20	50.1.30*	50.12.1	D.71.j.2
M.125.22.4	P.4.d.12	P.11.d.5	P.4.b.28	P.2.b.16	D.72.a.28
M.125.33.17	P.11.c.6	50.1.21	50.2	50.13	D.72.f.12
M.221.b.5	P.24.a.6	P.5.c.2	D.71.31.2	P.24.a.30	D.72.f.28
50.1.1	50.1.10	50.1.22	50.3	50.13.1	50b.1
D.p27c.5	P.4.d.8	D.75.u.3	P.5.c.1	M.197.a.1	D.75.z.1
D.p28c.4	50.1.11	50.1.23	50.4	50.13.2	50b.2
D.62.a.1	M.p37.c.17	D.74.d.3	D.65.b.3	M.p34d.13	D.p70.c.15
50.1.2	50.1.12	P.5.d.14	50.4.1	50.14	50b.3
P.4.b.12	D.p26c.4	P.9.c.6	D.p26a.6	M.176.f.8	D.75b.1
50.1.3	50.1.13	P.9.c.13	50.5.1n		50b.4
D.p50d.14	D.p27c.6	P.11.b.22*	D.p52a.d.3		D.74.k.3
D.75.a.2	D.55.i.4				
	D.59.a.5				

The **tun**-glyph is so completely fixed since Goodman in 1897 established the correct length of the **katun,** that its discussion is gratifyingly simple in itself, but with a multiplicity of questions to be solved on the meanings of the many prefixes, especially the facial ones.

Its specific affix or determinative is the ⬭, of which the three small supports seen in the **50a** forms may be an equivalent, a mere graphic variant, This subfix we have twice seen in a special position with glyphs **20** and **22,** in both of which cases we found reasons for treating it as a sign of counting, or the counters of time or divination. Such a value would also fit here with the **tun,** the great base of all Maya time and chronology. In this idea the personified form **50an** would be completely apt, with the banded head ornamentation added: the 'Great Lord of the Tun,' or of all the calendric system.

Only two colors are used with the **tun**; green or new, and white. The series of numeraled forms with the 'net' prefix, **50.1.7**, together with the whole Madrid ţolkin 125 in which they chiefly occur, should be a fruitful field for immediate study. Then next the combinations **50.5, 50.6** and **50.7**, with the other time periods; the triple combination of **kin-cauac-tun** is by no means solved, in all its occurrences, which note.

The presence of the **'ben-ik'** with its usual postfix ought to help greatly, since this combination correlates by its use a number of most important compounds. Why are **Pax** and **Vayeb** based on the **tun**-glyph? What is the connection between the different glyphs that take the superfix seen in form **50.19**?

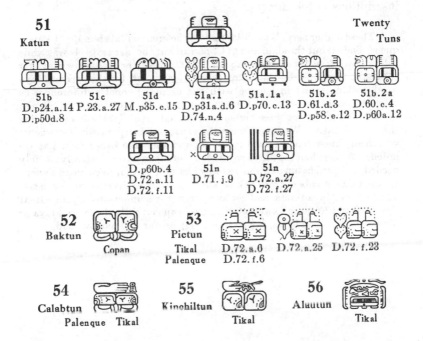

The above glyphs for the **baktun, calabtun, kinchiltun** and **alautun*** have been taken from the Tikal stela above referred to, and added here to round out our series of time-periods, and at the same time include what glyphs are actually deciphered on the

monuments. To have attempted to include the whole body of unread, unclassified inscription glyphs herein, would have delayed this work impossibly.

We have sought in it to classify, and cross-index for study every-thing so far actually known, and at the same time provide a system into which newly found or determined glyphs from the monuments might be added, by the work of students still to come. Outside of numerals and dates, and what we have learned of the existence of a Lunar Record, the inscriptions are still unread. We do not recall even the finding of the cardinal point signs among them.

The **pictun** glyphs above give us yet another difficult point in the Dresden Dragon pages. We should have thought to find **baktuns** in their place; but the evidence of the **pictun** forms in the inscriptions is too direct.

* These higher periods are all found on the great Tikal stela 10; at Palen-que we find all but the **alau,** and at Copan all but the last two. It was while riding away from Tikal with Morley in 1921, that the present writer first suggested that we drop the Nahuatl term **tonalamatl** for the correct Maya word **ʒolkin** (found in Quiché with the normal phonetic differences as **ch'olk'ih,** with the same meaning); and then also suggested the change in our terminology for these higher time-periods—the Tikal stela providing the needed basis. We found there the **cauac** as incorporated throughout; we already knew that it stood for a **tun,** and knew the other values above noted. We also had the Maya words **tun** and **katun** authoritatively; it only needed to regard **katun** as a shortening of **kaltun, 20-tun,** to go on and adopt all the other numbers from **bak** to **alau,** in order to give us, at the least, satisfactory Maya terms, and get away from the cumbersome Cycle, Great Cycle, Grand Era, etc. And anything we can correctly do to use Maya or Mayance terms and ideas, is that much help on our still narrow road.

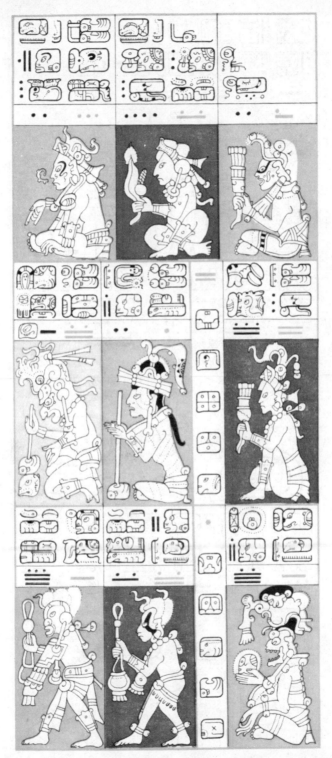

Dresden, page 6

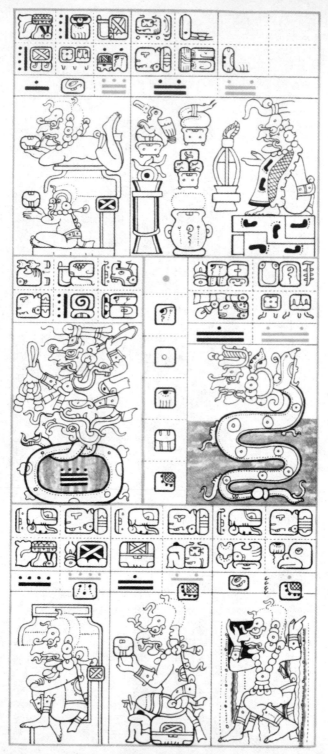

Dresden, page 35

THE CARDINAL POINTS

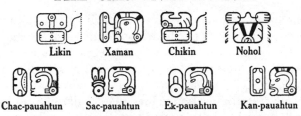

Likin Xaman Chikin Nohol

Chac-pauahtun Sac-pauahtun Ek-pauahtun Kan-pauahtun

At this point in our progress through the glyphs it will be well that we take account of what we actually know, and *how* we know and can rely upon it.

Our first knowledge of the day and month signs we have from the direct statements of Landa; they have been checked and verified by innumerable cases of day and date calculations in the codices and inscriptions.

Upon this fixed basis we have been able to find and authenticate a few day, month or other calendric sign variants, from their being found in places where by necessary calculations they could not be other. Such are the glyph-forms 21 for **Cimi**, and 345.7.2 for the month **Moan**.

The vigesimal time-count being known, we soon found that the numeral 20 never occurs where we should expect it as the last day of the vinal, the numbers ending with 19. We however found a symbol, our gl. 57, occurring between 19 and 1, in the place of the expected 20, but attached to the following vinal as its first or initial day; the figure 1 being then used with the next or second day. This is just as we speak of 1 o'clock after the first full hour has gone.

Much controversy then arose as to whether we should call this 'first day,' and this symbol, zero or 20. This has been settled as a matter of convenience by counting 19 **Pop**, zero **Uo**, 1 **Uo**, etc. But we do not know how the Maya expressed it; the term *zero*-**Pop** is ours, not theirs. We know and can use the numerical or calculation fact, but we have not *read* the glyph, Maya-wise; we do not know how it came to be so used, nor what it means, linguistically. Just as one might know that H_2O is a symbol used for water, without learning enough chemistry to know that it means two atoms of hydrogen to one of oxygen in the water mole-

cule. We are in exactly that situation with everything in Maya numerals and chronological signs, except their mere mathematical places and use.

The bar and dot numerals we have first-hand native information upon, through a Maya text found and published by Pío Pérez; and these were confirmed by innumerable cases of use. We next found that they were written, in accordance with Maya (and other hieroglyphic) writing custom, in columns downward. We found them here with position values, vigesimally, just as we write our *nine* digits horizontally, with decimal position values. Such a system requires a 'cipher' as position holding character; we found it in the Maya columns in the shell-like figure, somewhat variously drawn, and always in red, shown in our gl. 58. That verified.

In these figure columns we found the bar and dot numerals going up to 19, in every place but the second from the bottom, where they stopped with 17. Since these columns always end with verifying day and month signs at the bottom, by which we could check and carry on their count, it was clear that this second place represented here the vinals, of which there are only 18, and not 20. Much paper was also spent here, discussing whether the Maya 'broke' their vigesimal *mathematical* count in this way; quite needlessly, for it was no more so broken than we break our decimal count when we use numbers only to set down a date, as 1931, 3-13; or an amount in English money.

We have some uses of numerals that are not in dates or the usual day-name prefixes in the ʦolkin count; but we have so far not been given a single number series or table that is purely mathematical— that is, which is not a date or appendant day-count. As is to be expected in any date (or money) record, the count, vigesimal, or decimal, begins with the basic unit; with us the year (the dollar, pound), with the Maya the *Tun*. The Maya did not feel the need for a vigesimal point between the **tun** and its fractions. So that for a long time we wasted an immense amount of time and paper talking of 'five-place dates' instead of three; and in reducing all the Maya dates to days, so as to work with them in our own familiar decimals, only to have to recalculate the dates back, vigesimally, to other Maya terms. In so doing we blocked our own passage by ceasing to think in Maya terms, and trying to

carry in mind the dates as 1,411,560 days, instead of 3921 tuns, or in Maya form, **9.15.1-0.0,** a simple 3-piece number, with fractional points, the vinals and days.

It is in fact exceedingly easy to work with Maya numbers in their own fashion, and a Maya date can be verified and checked with another in a quarter the time, and with more safety. We should try to think and use Maya at every possible point.

The Maya did not, however, write all figures in columns; in certain cases they wrote them horizontally, and without vigesimal values fixed by position. This required a different system, and symbols: the Latin system as against the Arabic. Across the pages of the codices run ţolkin counts, requiring the setting down of interval numbers frequently of 20 or more; we have found no higher symbol as yet than 20. For this symbol see gl. **59,** below.

As an integral part of every day-name were the attached numbers 1 to 13; no particular day could be designated as **Ahau,** it must be **4 Ahau, Vuc-Ceh,** 7 Deer. Children took this as their birthday name; the ruler of Rabinal was **Hob-Toh,** 5 Toh.

After treating of the 18 months and the supplementary days with their ceremonies, Landa also tells of the chronological count, *de veinte en veinte años,* called by the name and sign **Ahau,** with the thirteen numbers running in order 13, 11, 9, 7, 5, 3, 1, 12, 10, 8, 6, 4, 2; that is, retroceding 2 at each successive "20 years." We have since learned that since the day-counts in the chronology all went back to a first day **1 Imix,** all the time-periods, vinal, tun, katun, etc, were called by their final day, **Ahau.** Now 20x365 is 7300, divided by 13 gives 7 over, so that the numbers do not retrocede by 2. If a katun is "veinte años," the numbers are wrong. But, if a katun were "24 years," 24x365, we would get the above retroceding series.

So here began an interminable controversy as to the true length of the katun, which lasted until Goodman published his great contribution to the study, in Maudslay's *Archaeologia,* in 1897, on which all the succeeding chronological studies have rested, and from which they have advanced.

Goodman showed that the tun was 360 days, and each successive higher period a vigesimal increase. This made the katun 7200 days, and at once the 13, 11, 9 series was seen to apply exactly. Also, all the dates in the codices and monuments at

once became workable, with the 18 vinals or 'months' in the
second place. Our basis of date calculation became solidly
fixed.

Next, working from this fact, Goodman found that while the
dot and bar numerals were used on the monuments, the Maya,
with their wonderful artistic sense, developed and used a series of
symbolic face-numerals, replacing the dots and bars at will. Since
in every culture of the kind the ritual, mythology, astronomy
and science are all interlinked, we must assume that these symbolic
numerals carried a mythological or esoteric purport; but what that
was we do not know. Speculation is worse than useless.

Goodman gave lists of these face-numerals, which have been
repeated by Bowditch and Morley in their books; and applied to the
study of the inscriptions, they *have worked*. That for the number 2
is still unsettled, for lack of instances; all the rest up to 19 are
safely fixed, and the effective elements are given below, only the
essential parts of the faces being reproduced, for clearness' sake.

Applying these two fundamental contributions by Goodman,
the inscription form of the cipher or naught came out; and then
the zero-time prefix, our gl. 57, was found to be replaced in the
inscriptions by a clasping outstretched hand, usually about the
lower jaw, but once about the forehead of a full front-face figure.

Following Sir Alfred Maudslay's magnificent work and contri-
butions, the discovery, photographing and recording of a con-
stantly mounting series of inscriptional dates, duly worked out and
checked, has in all honesty to be credited to Morley's energy and
enthusiasm. Incidentally, as stated above, we owe to him the
knowledge that the winged **cauac**-sign is used as a **tun**-variant.
Just as with the above noted **Cimi** and **Moan** variants, it is found
where, by calculation in a date series, it cannot be anything else.

But right here the student seeking to penetrate the problem of
the Maya glyphs and writing, must stop. Using Goodman's
contributions, made now thirty-three years ago, we have added
enormously to our available material; we can and have verified
and recorded for use numberless dates; we can read the dates and
numbers by what we got from Landa and Goodman, with the few
involved variant forms, and the symbols of the calculation. Can
read and calculate dates; we cannot *read* another thing—with the
few exceptions to be noted below. We have found that about

one-third of all the thousands of written or carved *characters* in codices and inscriptions, are either numerals or time-period signs for the day, vinal, tun and higher periods, made known to us by Landa in 1565, and by Goodman's discovery of the correct length of the tun, in 1897. This fact has led to various absurd statements in articles and lectures that we "can read one-third of the glyphs, and thus are that far advanced along the road toward the goal of decipherment."

We have however to record advance at a few points. For his doctorate thesis in 1920, Dr. Carl Guthe took the subject of the lunar data in the codices and inscriptions. He did not print the second part of his work, but through his codex work and the following study by Prof. R. W. Willson, the lunation and solar eclipse table in the Dresden codex was worked out—mathematically. Again we are stopped at the same point; the mathematical data show us what kind of astronomical periods are treated of, but we did not gain a single glyph meaning.

The lunar data on the monuments are found in what is known as the Supplementary Series—a number of glyphs accompanying various initial dates. The data on this having been printed by Morley, in the Holmes Anniversary Volume, the subject was laboriously taken up by Dr. John E. Teeple, so as to give us results of the highest value as to Maya treatment of lunar (and perhaps other) astronomical time-periods. The same treatment is seen at work as in the Dresden ephemeris, and important historical doors into the relations between the higher Maya centers or cities are at least indicated; if not actually opened, as the present writer believes has really been done.

But again, not a single actual glyph meaning as such has been the result—only the mathematical elements. We can and must accept that glyph C, with the outstretched hand and postfix (identical with our form 426.1.1 save that glyph C has a variable face or other element in place of the ⟨⟩), and preceded by a numeral 2–6, means a lunation. It must be that the variable element defines the particular lunation, or tells *something;* but we only know it for what it is because of the appropriate numerals attached. Any other character or hieroglyph, with the same numerals attached, would tell us just as much.

Another most interesting point has been lately verified by Dr. Eric Thompson, out of this same Supplementary Series. He discovered (again by calculation and association) that the hitherto useless Glyph G had a 9-day variation. There seem to have been nine different glyphs, repeating in sequence as do the Nahuatl Lords of the Night. Most of the forms are either too uncertain or of too rare occurrence, to rest upon ; but the head with a **kin** as upper part (our form **46a**) is found both frequently and clearly definable, and *only* on the last day of a tun, or at 9-day intervals within the 360 days. And there is as yet no assurance that the Maya **Bolon ti Ku,** "the Nine Gods," were the same as the Nahuatl Lords.

The student will at once see that steps like these, fixing the lunation sign with its variable element, and a possible succession of Lords of the Night, are not only valuable for astronomy and chronology, but are leading toward the mythological identifications the material for which stares at us on every page of the codices (at least), but on which we are most distressingly ignorant For with all that Landa told us of gods and ceremonies, the most we can do so far is to recognize that the New Year pages in the three codices—are such; plus some such slight identification as that of Ekchuah, the black one, god of the merchants.

A few other contributions to our knowledge have also come, in every single case by calculation of dates, or by glyph associations. Dr. Förstemann long ago made extended studies in the codices, especially the Dresden. He is to be credited with determining the day **4 Ahau, 8 Cumhu** as the starting point, the zero-date of the calculations. Also with assigning our form **326** as the glyph of the planet Venus, because of its repetition across the pages that are beyond question a solar-Venus correlation, shown by the repetition of the numbers 236, 90, 250, 8 (equals 584, the Venus term) and the verifying vinal dates attached.

Landa gave us quite full information as to the ceremonies beginning the successive four years, and their involvement of the cardinal points, and assigned colors, which he gave: red, white, black, yellow—starting with the East. On pages 75–6 of the Madrid we have a table closely matching one in the Mexican Codex Fejervary-Mayer, of all the days in succession, and in four quarters, with a glyph to each quarter. In two of these there was little difficulty in recognizing the East and West: the **kin** with an

ahau, lord, for the East, and with a grasping hand, for the West. Some controversy arose as to the placement of the other two, but the first credit is, we believe, to be given to De Rosny, who in 1879 gave them, with self-expressed hesitation, but as since fully accepted. The settlement here was final, on the basis of the assigned colors, and is confirmed by the association evidence in Dresden ʒolkin 64, and elsewhere, beyond possible question.

With this has also come, partly by the evidence of the Landa month-signs and such confirmations at that of the Kekchí calendar above cited, the definite settlement of the glyphs for the five colors.

On the pure evidence of association with pictures, as the Venus-sign was with calculations, a number of glyphs were assigned as the Name-glyphs of various deities or personages, by Schellhas, in 1897. Dr. Schellhas very wisely limited himself to designating the personages by letters, leaving the mythological and other problems to the future. Some qualifications in his name-glyph assignments are noted in the present work; but in the main they stand, being based simply on the facts of frequency of repetition and association.

NUMERALS

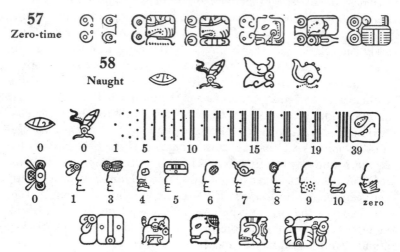

57 Zero-time

58 Naught

| 0 | 0 | 1 | 5 | 10 | 15 | 19 | 39 |

| 0 | 1 | 3 | 4 | 5 | 6 | 7 | 8 | 9 | 10 | zero |

We have in the foregoing review of the progress of decipherment to date, covered the general facts as to the numerals, leaving only certain specific details.

In one line above are shown the codex forms for naught* and the bar and dot numbers up to 19. Instances of the symbol for 20 with bar and dot numerals attached, are also given. There is still uncertainty as to the reading of these compound numerals, and what license was allowed the scribe as to placing the bar and dot portion before or above the **kal** sign. Prima facie, a pre-position should indicate multiplication. But in Dr. ꝫ. 17 the black number 26 is needed twice, once in a horizontal line, then in a column; in the first instance the 6 follows the **kal,** in the second it is put above, with the same meaning, unquestionably.

In Dr. ꝫ. 18 the numbers **33** and **32** are given: 33 in the line, with the 13 part at the side, as shown above; the **32** in the column also has the **12** part at the *right* side, *after* the **kal** sign, turned upright with the dots away from the **kal;** see above. The writer clearly had liberties, at least where the meaning was not in question. See also the **33** and **32** at the bottom of Dr. p. 18. Also the **29, 23, 28** in the middle of Dr. p. 19, where the **8** is again above the **kal.** Also on p. 45, where the dot making **21,** precedes the **kal.**

It is to be noted that when dot and bar numerals are attached as part of the day-signs, as in **12 Lamat,** etc., the dots are at the left of the bars, away from the following character; when a **12** follows a **kal,** as above, to make **32,** the dots are at the right, again away from the character.

Note next that, as on Dr. pp. 61, 69, we have the dots and bars placed either above or at the left, as multipliers to **katun, tun,** etc. Other numerals with glyphs are probably part appellative, part multipliers of objects indicated.

But in ţolkin 67 we are in trouble. Below the figures we see six numbers, apparently **26, 20, 39, 26, 39, 26.** The total is 176, which is not a ţolkin count. Four of the numbers have the **6** or **19** part preceding the **kal,** although the space would easily allow them to follow. Once the **19** is immediately next to the **kal,** under the house-roof; the other time it is entirely separate, outside the pedestal, with the **kal** inside. While the problem is added to by the presence of the three **19's** within the coils of the great dragons in ţolkin 59.

On the whole it seems probable that dots and bars used with a **kal** sign are meant to be read as added to it, and may be placed anywhere. But we are certainly left with the mythological solution of the above passages.

On another line above the student will find the face-numeral elements for **1, 3-10,** as well as the signs for naught and zero-time, as found on the monuments. No number **2** is given, as it is too uncertain (see Morley's *Introduction*). It is understood that **11-19** are produced by combination of the signs given.

Beneath these numerals we have also placed a number of glyphs from the codices, showing what appear to be the same. We curiously find an **ahau** with the frontal **1** very clearly drawn. The fangs of god B, our gl. **78,** are clearly seen in the numeral **4,** while the loop around the eye in the numeral **7** too much resembles the 'divine eye' and the loop also seen in gl. **78,** to be ignored.

The cross or 'hatchet' eye that constitutes **6,** is clear in our gl. **79,** which probably also has the jaw for **10,** giving us a reading of **16** at Dr. 72.a.13 and f.13; i.e. **1.8–16.0.** The jaw for **10** seems to be further shown in the same passages, on the face of the Corn-god, 72.a.7, f.7; also on the **Moan** at 72.f.8; on the **yax-chicchan** at 72.a.17, f.17; on the bird with **akbal** infix at 72.a.23.

Still another numeral factor is to be found in these columns, at
72.a.14, f.14, our gl. 46.1.2. By all rights we should read these
four glyphs as 1.8-16.0, just as below we read 15.9–1?.3 and
15.9-4.4; also as being interval numbers. But the readings as
yet lead nowhere in the exasperating complexities of these columns.
Any other value than naught to the prefix seems untenable.

This seems to exhaust the question of glyph-numerals, as such,
until we can retrieve *signs* for **40**, etc., **400**, and so on, usable as
symbols like the **kal**, in the Roman method.

A most important matter of numbers remains to be studied in
connection with individual glyphs, namely their appellative value
as in the **3 Oc, 13 Moan, 13** Heavens, the **9,** the **11,** accompanying
glyphs **95, 126,** etc. This is clearly the province of mythology,
and doubtless ritual, and ahead of our present task.

Again, we must assume that many cases of numerals denote a
simple quantity count; and that others again (especially in the
eclipse and later sections of the Dresden, and also perhaps in
Madrid ꜩ. 125) have to do with celestial conjunctions and cyclic
periods.

* The matter of our nomenclature here was a question. We use the three
words zero, naught and cipher interchangeably, save that 'cipher' rather
denotes the symbol itself, for zero or naught. The Maya using both the
Arabic and the Roman systems, and further complicating the matter by the
'zero' or initial day of a time-period, a definite choice of terms became
necessary. We solved the point by adopting the term 'zero-time' for the
period-initial signs, which leaves untouched the current convenient term
'zero-**Yaxkin**,' etc.

The shell signs and their inscription correspondent are strictly the Maya
ciphers, meaning naught; a proper term is then, the sign for naught.

59 Twenty

59.1	59.1.1	59.2	59.3*	59.4	59.4.1	59.4.2	59.4.3

59.4.4	59.5.1	59a.5.1	59b.5.1	59.5.2	59.5.3	59.6

59.7.1	59.8n	59.8n	59.8n	59.9.1n	59.9.1n	59.9.1n

59.10.1	59.11	59.12.1	59.13.1	59.13.2	17.19

17.19	19.17	263.1	265.1	352.3

59	M.194.c.2	D.p48f.3	M.190.e.1	59.9n	59.13.1
D.p70.c.10	M.194.f.1	D.p48f.6	M.190.f.1	D.p26a.16	M.162.a.1
59.1	59.4.1	D.p49e.9	M.190.g.1	59.9.1n	M.162.b.1
D.74m.3	M.194.d.1	D.p49f.5		D.p25a.14	M.162.c.1
59.1.1	59.4.2	D.p25b.3	59.5.3	D.p27a.15	M.162.d.1
D.72.a.21	M.p37.b.10	59a.5.1	M.29.b.4	D.p28a.16	M.162.e.1
59.2	59.4.3	D.p58.f.3	59.6		M.162.f.1
D.71.f.2	P.3.d.1	59b.5.1	D.p46e.7	59.10.1	M.162.g.1
59.3	59.4.4	D.p46f.2	59.7.1	M.165.b.1	59.13.2
P.3.b.20*	P.8.d.7	59.5.2	D.p49d.9	59.11	D.69.i.1
59.4	59.5.1	M.190.a.1	59.8n	M.200.d.1	M.163.a.1
M.194.a.1	D.p24.a.11	M.190.b.1	D.p26c.6		M.163.b.1
M.194.a.2	D.p24.a.12	M.190.c.1	D.p27c.7	59.12	M.163.c.1
		M.190.d.1	D.p28c.7	M.p34.b.11	M.163.d.1

A full discussion of this glyph would require many pages and reach to a treatise in itself, which the writer must deter now. The following must here suffice:

The glyph is unquestionably the simple numeral **20,** as much a symbol as is the Roman **XX.** It has been persistently called also a symbol for the Moon, by nearly every writer, on reasons which in every single case fall short (to the present student) of sufficient ground as proof. The writer has not found a single case

where the symbol *must* mean Moon. Nor yet a single bit of satisfactory evidence connecting the number 20 with the moon and her course.

Vinal, as correctly noted by Seler, is not and cannot be derived from the Maya **U,** moon, by any known derivative word method, either in Maya or any other Mayance tongue. Further, **vinak, vinic,** is the universal Mayance word for man; from it comes **vinikal, viniquil,** in the different languages, meaning 'manhood,' and then also 'score. It is the common word in Quiché for score. The count is vigesimal, the 20 hand and foot digits of the man, represented by the dots, bars and **kal,** just as by the Roman I, V, X. To accept a shortening in Maya to the term **vinal** does violence to no principle, and **vinal** is the calendric 'score of days.'*

Landa in telling us that, besides the 20-day time count, they had another month, called **U,** moon, does no more than recognize the natural phenomenon, as done by every non-city dweller, whatever the keepers of books may work with. We are told that the word **vinal** was "derived" from **U,** because the moon is notable or "alive for twenty days of her term," something that is first not true, and wherein the necessity for such an explanation defeats its aim.

We have not a trace anywhere of the *calendric* use of a 30-day, or moon-month, at any time. And further, the numeral 20 is too deeply rooted in all Maya mathematics and time-counting, to have come up in any such way. To assert, in a supposedly sober treatise (as Spinden in his *Reduction of Maya Dates*) that prior to 600 B.C. the Maya *of that time* used a 30-day month called **U;** that then they held a great astronomical Congress, whose gathering they have displayed carved on the Copan altar, at which they suddenly changed to the whole elaborate 20-day system we know, and gave the name of the moon to the new term as a memorial; and then to use the fact that the first letter of the term **vinal** is the same as the Maya word for moon, as 'proof' of the thesis, quite transcends the methods we should have a right to expect.

To say nothing of the overlooked fact that the different Mayance languages have three distinct root-words for moon. In Yucatan she is called **U;** in Kekchí **Po;** in Quiché **Ik'.** Who is to tell, in in the present non-state of Mayance comparative linguistics, what was the name among the archaic people, ancestors of all the later branches?

We are again told that because Glyph A of the Supplementary Series is made up of the sign for 20 plus either 9 or 10, to give the 29½ day average lunation time, the sign for 20 must itself mean Moon, by virtue of this association. What about all the other places it occurs? We are even further told that the affix (⸙···⸊ is a "form of the moon sign," and thereby reveals the lunar element in compounds where it occurs.

This affix is used with **Imix, Kan, Manik, Caban, Ahau, Xul, Kayab, Cumhu, Kin,** also the glyphs for Sky, Houseroof, Firewood, and at least a dozen others. In the glyph **426.1.1,** it exactly parallels the critical Glyph C of the Supplementary Series; but its use is across the Venus pages, where no question of a constant lunation glyph can conceivably enter. See the affix, as an affix, at our glyph-form **602-a.** This does not contravene the lunation value of Glyph C; that is fixed by the numerals, and probably also defined by the still unread variable element.

The fact that the oval-enclosed dots are also seen over the eye of god D, leads Schellhas, and all others after him, to call that deity a moon-god. In the utter paucity of our mythological knowledge as yet, as confessed by Schellhas, and especially of traces of moon worship, this has to stand as a mere assumption. Of course, *if* the **kal** sign is also a moon-glyph, then the interesting deduction holds; but we have rested too much, from astronomical congresses to gods, on the assumption that a symbol which we know is a simple numeral, is also something very else.

In just one place does the evidence look attractive: in the 'eclipse' shields, where the **kin** sign occurs, and also the **kal** sign. But that too falls short of proof, for two definite reasons: first that a number of other characters are also there found—including the sign for Night. How can one eclipse night? Also, the **kin** and **kal** 'eclipse' glyphs usually occur in pairs; and we cannot have an eclipse of both sun and moon at the same date. The presence of the eclipse glyphs just as they do in the provable solar eclipse ephemeris is an undeniable fact; they may be eclipse signs, for which they are graphically perfect; or they may not.

The present writer does not withal wish to be taken as denying that the **kal** sign may be a moon sign; only that he has so far not seen the proof. He only wants to see Maya research methods come down out of the 'moon' to earth. And if the number 20 can

shed any full lunar radiance on our difficult problems, it will be almost as welcome as the sun's.

The above glyph-forms made on the kal-sign have a great many attractive questions for study. Among them is the use of the three subfixes, two already somewhat discussed, seen in forms 59.1, 59.4, 59.5. The last two have repeat uses in two Madrid ṭolkins that should give aid, and the 59.5.1 is prominent on the Venus pages—incidentally with the exact prefix which Landa gives for his alphabetic letter u ⬬ — which according to the 'phonetic' school of assonance should be an additional indication that the kal is really u, in conjunction with Venus.

The use of the kal with the 'net-hampers' and numbers in forms 59.8, 59.9, especially as occurring on the New Year pages of the Dresden, would probably be an easily open door if Landa had told us a little more.

Glyph 59.12, where the sign seems to be tied around with a knotted cord, is exceedingly interesting; note that it also takes on the above postfix.

* The evidence on the identity between the words for 'man' and the 'score of days' is too strong to be ignored. Flores, *Cakchiquel Arte*, 1753, says: *Para contar Xiquipiles de cacao de veinte en veinte:* hu-k'ala, ca-k'ala, etc. *Para contar meses al modo de los Indios, que es de veinte en veinte:* hu-vinak, ca-vinak, etc. *Para contar años de veinte en veinte:* hu-may, ca-may, etc. In his Pokoman grammar, ms. 1720, Moran tells us definitely that k'al is used for score, 20, ad omnia, *para todo*, except in the single case of four-score, 80, for which cah-vinak is used. But to count days in Pokoman one always uses vinak, just as the Quiché-Cakchiquel above. (Pokoman also uses the above Quiché term May for the Maya Katun; and, incidentally, Quiché and Pokonchí give us k'al, ok'ob, chuy, calab for the numerals from 20 to 160,000; the terms for the two higher periods have been lost.) The southern branches thus use the word vinak, man, in exactly the sense and place of the Yucatecan vinal.

COLORS

The positive evidence supplied by their association with the Cardinal Points, together with that of their presence and actual translation in six of the Vinal signs, has placed the five color signs beyond question. In the various glyph sections these as prefixes have been, so far as possible, all put together, in the order: red, white, black, yellow, green. Their special values with special glyphs are considered at their places.

With the exception of the prefixed, adjectival use, none of the five has much to show, except the green, and in less degree the yellow. A very difficult and unsolved question is given by their use with attached numerals, especially in M.ƫ.66 sq., at the end of the hunting chapter.

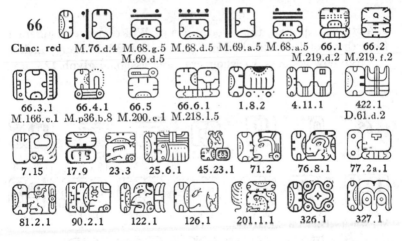

66

Chac: red M.76.d.4 M.68.g.5 M.68.d.5 M.69.a.5 M.68.a.5 66.1 66.2
 M.69.d.5 M.219.d.2 M.219.f.2

66.3.1 66.4.1 66.5 66.6.1 1.8.2 4.11.1 422.1
M.166.c.1 M.p36.b.8 M.200.e.1 M.218.1.5 D.61.d.2

7.15 17.9 23.3 25.6.1 45.23.1 71.2 76.8.1 77.2a.1

81.2.1 90.2.1 122.1 126.1 201.1.1 326.1 327.1

As a note to the color red, we should remember that this word (or homonym) has two uses in several Mayance languages, and yet a third in the Maya of Yucatan. **Chac** means red, and is also an intensive, 'very.' **Chaccat** in Kekchí translates the **Zip** glyph as 'red-?' **Chacavil** is fever, and **Chacekel** tiger, in Maya; also intensive, **chacetcun,** to aggravate, increase. And similar forms in Quiché, Tzeltal, etc. And finally in Yucatan it is the common, still-known name of the Four Chacs, or Bacabs, rulers of the Quarters. **Hatƫ'-chac** may equally be read as fire-

stick, heavy stroke, or 'bolt of the Chac' (Jupiter Tonans), any one of which helps to describe the thunderbolt, and its actual glyph, as above.

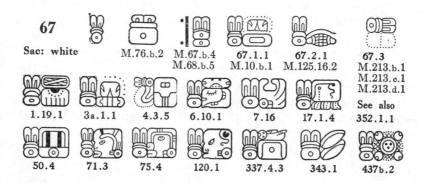

67

Sac: white

M.76.b.2 M.67.b.4 67.1.1 67.2.1 67.3
 M.68.b.5 M.10.b.1 M.125.16.2 M.213.b.1
 M.213.c.1
 M.213.d.1

1.19.1 3a.1.1 4.3.5 6.10.1 7.16 17.1.4 See also
 352.1.1

50.4 71.3 75.4 120.1 337.4.3 343.1 437b.2

As to be expected, the associations of White are very different from those of Red; its chief use is with the White Lady, **Ixchel**, the Rainbow goddess, to whom we have assigned glyph **123**, q.v.

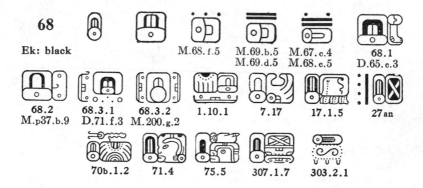

68

Ek: black

M.68.f.5 M.69.b.5 M.67.c.4 68.1
 M.69.d.5 M.68.c.5 D.65.c.3

68.2 68.3.1 68.3.2 1.10.1 7.17 17.1.5 27an
M.p37.b.9 D.71.f.3 M.200.g.2

70b.1.2 71.4 75.5 307.1.7 303.2.1

Difficulty is encountered with this glyph, on account of its similarity of form with the month **Mol**, minus the surrounding dots. Its use as a main element is therefore unclear. As a color prefix it is simple, either as sign of the West, or in other connections, discussed as reached.

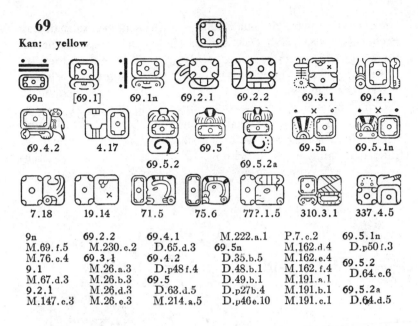

69

Kan: yellow

| 69n | [69.1] | 69.1n | 69.2.1 | 69.2.2 | 69.3.1 | 69.4.1 |

| 69.4.2 | 4.17 | | 69.5 | | 69.5n | 69.5.1n |
| | | 69.5.2 | | 69.5.2a | | |

| 7.18 | 19.14 | 71.5 | 75.6 | 77?.1.5 | 310.3.1 | 337.4.5 |

9n	69.2.2	69.4.1	M.222.a.1	P.7.c.2	69.5.1n
M.69.f.5	M.230.c.2	D.65.d.3	69.5n	M.162.d.4	D.p50f.3
M.76.c.4	69.3.1	69.4.2	D.35.b.5	M.162.e.4	69.5.2
9.1	M.26.a.3	D.p48f.4	D.48.b.1	M.162.f.4	D.64.c.6
M.67.d.3	M.26.b.3	69.5	D.49.b.1	M.191.a.1	
9.2.1	M.26.d.3	D.63.d.5	D.p27b.4	M.191.b.1	69.5.2a
M.147.c.3	M.26.e.3	M.214.a.5	D.p46e.10	M.191.c.1	D.64.d.5

This sign must first be definitely separated from ⬭ the glyph with five small circles within, distinct from the corner positions shown here. In this present form it is proven to equal yellow, by its use in series.

But we also get it in more than one place where it can hardly be separated from being a mere **kin** variant. Notwithstanding the numerals, the apparent **Yaxkins** here shown are by no means proved as vinal signs; Seler vehemently disputed this.

Again, however, we find the technical **kin** face-sign noted above, **46b.1.1** with the infix clearly in the 'yellow' form. On the other hand, we never find the **kin**-form replacing the 'yellow' as the distinctive infix to **Pop** and **Kayab**. Before we settle these vinal signs, we must include an answer to the question, Why should these signs take either a **kin** or 'yellow' infix, and which? Neither part of the question can be answered deductively.

The best we can see at present is this: Brightness and the color yellow are closely allied, in natural facts; the sun is both golden and bright. By a wholly normal linguistic development, the sign for yellow might have come to be applied to and define a Season, just as we associate yellow and purple with Spring and Easter.

The above forms **69.7** might denote New Season, naturally one of brightness. The association of ideas would be close enough to the **kin** sign, and its compounds, to result in parallels. Note that we never find the **kin** sign where we expect yellow, only the reverse.

That the confusion in the glyph forms exists, cannot be denied; also that it cannot be solved by merely calling the sign **69** a variant of **45,** for **69** is settled as yellow. The above reasoning, while *only* reasoning, and hence not suggested as *proof,* is the only thing one can see which acknowledges both the facts and the confusion, yet denies neither.

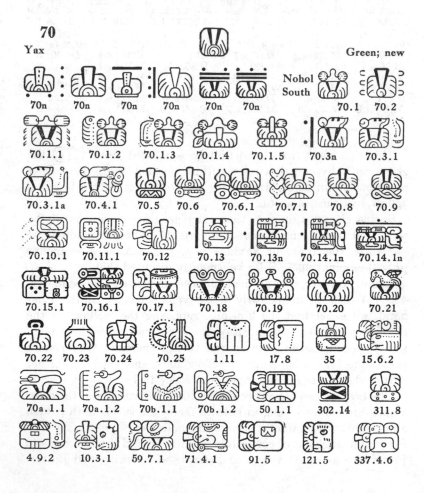

70

Yax

Green; new

70
M.35.d.2
M.143.a.5
M.143.b.5
M.166.b.1
70n
M.p34.d.19
M.p35.d.17
M.p35.e.2
M.p36.e.9
M.68.e.5
M.69.e.5
M.166.b.2
M.200.c.3
70.1
South
M.7.d.1
M.21.d.1
M.38.d.3
M.39.b.1
M.50.4
M.p35.d.11
M.p35.d.15
M.p35.d.16
M.67.d.1
M.68.d.1
M.69.d.1
M.76.c.1
M.88.4
M.89.4
M.90.4
M.91.4
M.92.3
M.111.d.1
M.113.d.1*
M.p75–6.4

M.p77.b.2
M.p78.a.2
M.p78.f.2
M.132.4
M.134.4
M.137.e.1
M.156.a.1
M.160.d.1
M.161.a.1
M.176.c.1
M.187.a.4
M.195.d.4
M.211.4
M.220.d.5
M.231.c.2
70.1.1
D.12.a.1
D.45.d.1
D.p26c.3
D.57.d.3
D.58.d.2
D.58.h.2
D.59.d.1
D.64.c.2
D.65.d.4
D.68.a.1
D.p46b.c.3
D.p46c.d.5
D.p47b.c.3
D.p47c.d.4
D.p48b.c.3
D.p48c.d.4
D.p49b.c.3
D.p49c.d.5
D.p50b.c.3
D.p50c.d.5

M.3.d.4
M.55.1
M.56.d.2
M.66.c.1
M.130.4
M.132.6
M.158.c.1
M.175.d.1
M.177.b.3
M.180.b.3
M.204.d.1
70.1.2
D.71.d.5
70.1.3
M.137.b.2
70.1.4
M.123.h.4
70.1.5
M.p35.c.2
70.2
M.116.a.4*
70.2a
M.100.p.3
70.3n
M.125.6.3
M.125.19.1
M.125.22.2
70.3.1 –1a
M.125.1.6
M.125.2.6
M.125.3.6
M.125.4.6
M.125.5.6
M.125.6.6

M.125.7.6
M.125.8.6
M.125.9.6
M.125.10.6
M.125.11.6
M.125.12.6
M.125.13.6
M.125.14.6
M.125.15.6
M.125.16.6
M.125.17.6
M.125.18.6
M.125.19.6
M.125.20.6
M.125.21.6
M.125.22.6
M.125.23.6
M.125.24.6
M.125.25.6
M.125.26.6
M.125.27.6
M.125.28.6
M.125.29.6
M.125.30.6
M.125.31.6
M.125.32.6
70.4.1
D.p60b.3
70.5
M.123.a.3
M.123.b.3
M.123.d.3
70.6
P.18.a.3
M.200.a.1

70.6.1
D.70.g.2
P.16.b.3
70.7.1
M.153.a.1
M.153.b.1
70.8
D.71.c.4
70.9
D.71.62.2
70.10.1
D.71.61.1
70.11.1
D.66.p.3
70.12
M.125.18.3
70.13n
D.p48b.b.4
70.14n
D.66.b.2
D.p48c.c.3
P.10.b.6
70.14.1n
P.4.d.4
P.9.b.2
P.11.c.7
70.15.1
P.11.c.7
70.16.1
P.8.d.3
70.17.1
P.9.d.7
70.18
P.6.b.19

70.19
P.5.b.18
P.7.c.3
70.20
P.8.c.1
70.21
P.8.c.6
P.8.c.9
P.9.d.1
70.22
M.p34.d.7
70.23
M.179.e.4
70.24
M.6.a.1
70.25
M.125.26.4
M.125.29.4
70.26.1
D.70.g.2
70a.1.1
D.72.a.22
70a.1.2
D.p31a.d.5
70b.1.1
M.13.a.1
M.13.b.1
M.14.a.1
M.14.b.1
M.15.a.1
M.15.b.1
70b.1.2
D.p70.c.11
D.74.n.3

In Green we have a positive glyph and settled value. In the different languages the word (in Maya, Choltí, Chortí, Tzeltal, **yax**; in Quiché, Kekchí, Pokonchí, **rax**; in Mam, Ixil, etc. **chax**) has the several meanings of green (including blue), new, fresh, and sudden. Note the Quiché **raxcamic,** sudden death, *muerte repentina,* see glyph 6.11. We may expect any of these meanings, according to the context, and whether we are dealing with plant growth, change of seasons, astronomical or zodiacal passages, or other subjects.

About half of the places where **yax** is used will be seen as **70.1.1,** for the South. With the superfix ⊙ᴼ⊙ , Landa's **ma,** the negative, a supposed translation of the glyph would be "not green." But there is no supporting evidence, and it does not fit anything we have. Incidentally, Landa's negative here has not helped our glyph solutions anywhere.

East and West are fairly general values, Sunrise and Sunset; North and South, curiously enough, are not even given in many Mayance ms. vocabularies. Only by direct catching them in use in the mouth of a Quiché did the writer get the latter terms there: **u cax cah, u cax uleu,** the place or land of the sky, the place of the earth. In Maya the terms **Xaman, Nohol,** remain mere proper names, uninterpreted. **Noh** in Maya means great, but that hardly interprets the South, which was not the region of honor; and still less the glyph.

The forms **70.2** with superfix and numerals, again running through the important Madrid ƫolkin 125, should be carefully studied in detail. So should the **70.14,** with the **'ben-ik'** and 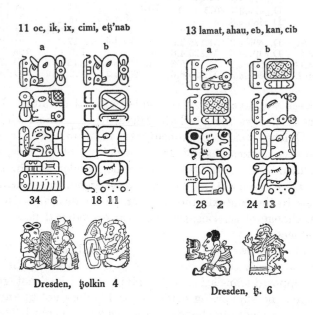 postfix, and with numerals.

The forms **70a, 70b,** raise interesting questions. They look like broken open **yaxes;** all have the same element issuing above. But in M.ƫ.13, 14 we see, under these glyphs, different gods coming forth from, or seated in, open dragon jaws, of which the form **70b** is a clear glyph, and suggests not **yax** but **Imix.**

11 oc, ik, ix, cimi, eƫ'nab **13 lamat, ahau, eb, kan, cib**

a b a b

34 6 18 11 28 2 24 13

Dresden, ƫolkin 4

Dresden, ƫ. 6

FACE SIGNS

71

Xaman
North

| 71.1 | 71.1a | 71.2 | 71.3 | 71.4 | 71.5 |

| 71.6 | 71.6.1 | 71.7.1 | 71.8.1 | 71.9.1 | M.34.b.1 |

71.1	D.p50c.b.5	D.p47c.b.4	D.58.e.3	D.69.h.3	71.6.1
North	M.p5a.1	D.p48b.a.3	D.64.d.3	M.34.d.1	D.73.e.5
D.45.b.1	71.1a	D.p48c.b.4	71.3	71.5	71.7.1
D.p28c.3	D.12.b.1	D.p49b.a.3	D.57.b.3	D.58.h.3	D.60.b.2
D.57.b.4	D.65.b.4	D.p49c.b.5	D.58.f.3	D.64.c.3	71.8.1
D.58.b.2	D.68.c.2	D.p50b.a.3	D.64.a.3		D.p58.f.2
D.58.f.2	D.p46b.a.3	71.2	71.4	71.6	71.9.1
D.59.b.1	D.p46c.b.5	D.55.a.4	D.58.g.3	D.73.a.5	D.70.j.2
D.04.a.1	D.p47b.a.3	D.55.1.4	D.64.b.3	D.73.c.5	

Glyphs **71** to **76** must first be considered together. It is certain that we have to do with at least two separate deities, and our first step must be to separate the different elements in the glyph heads.

No. **76** may be definitely passed as the god of the Maize. **Yum Kaax,** as suggested by Brinton, Lord of the Sown Fields, will do for his name until we find a better.

No. **75** has been set aside as god of the North Star; that must be studied, since it takes various mythological points for granted, on which we have little or no information.

All six heads have the banded headdress; since **75** and **76** are clearly different, it cannot be the specific of either.*

The face and head covering are the same in both **71** and **75,** except for the nose and mouth. No. 71 occurs 39 times in the Dresden, 4 in Madrid; no. 75 occurs nearly 500 times, of which 22 are in the Paris, 21 in the Dresden, the rest in the Madrid. That would at first imply merely scribal variation in the three codices, were it not for other factors, to be considered below.

* We cannot call it a "pottery decoration," on a clay tortilla griddle, in Maya **xamach,** and then say that these rim marks were added to the head of the god ruling **Xaman,** the North, as a rebus or 'ikonomatic' punning reminder of his name; and then on those grounds establish the Polar Star as a special god with this glyph. (*Brinton, Primer.*)

72

D.27.b.2 72.1 72.2
 D.27.a.2 M.124.b.1

In no. **72** we have the head used three times, both with and without the special nose and mouth, and with the closed **Cimi** eye; that can only mean that Death has come to whatever personage it may be.

73

73.1 73.2 73.4 19.22
D.71.i.8 M.218.j.3 D.66.n.4

In **73** the lower jaw is taken away, to show devouring teeth, or to receive the thumb of a spread hand in the mouth. This must denote action, devouring. And in **74** we have the same teeth, but with the top of the head flared, as we have seen elsewhere, on the signs for **chuen, tun,** to change them to **Tzec, Pax,** etc. This **74** is used exclusively as a final through several long ţolkins in both codices, also the Paris.

74

74.1 74.2

74	D.46.c.4	D.57.e.6	D.59.c.10	D.70.d.6	74.2
D.58.g.8	D.46.e.4	D.57.f.6	D.59.d.10	D.70.e.6	D.70.i.6
P.6.a.1*	D.46.f.3	D.57.g.6	D.62.b.4	D.70.f.6	D.70.j.6
P.15.a.6	D.p25a.8	D.58.e.8	D.62.c.4	D.70.g.6	M.219.a.4
P.18.a.6	D.57.a.6	D.58.f.8	D.62.e.6	D.70.h.6	M.219.b.4
	D.57.b.6	D.58.h.8	D.70.a.6	D.70.k.6	M.219.c.2
74.1	D.57.c.6	D.59.a.10	D.70.b.6	D.70.l.6	M.219.e.4
D.46.a.4	D.57.d.6	D.59.b.10	D.70.c.6	D.70m.6	M.219.g.4
D.46.b.4				P.17.b.6	

In the above elements we clearly have to do with personality (shown by the nose and mouth, and the clear reproductions of the maize-deity headdress); with character or function, shown by the head-covering; with actions (shown by the closed eye and the devouring teeth).

75

God of
the North

| 75n | 75n | Xaman North | 75.1 | 75.1a | 75.1b | 75.1.2* |

| 75.2 | [75.3] | 75.4 | 75.4.1 | 75.4.2 | 75.5 | 75.5a |

| 75.5.1 | 75.6 | 75.6.1 | 75.7 | 75.7.1 | 75.7.2 | 75.7.3 |

| 75.7.4 | 75.7.5 | 75.7.5a | 75.7.6 | 75.7.7 | 75.7.8 | 75.8 |

| 75.8.1 | 75.8.2 | 75.9 | 75.9.1 | 75 9.2 | 75.10 | 75.11 |

| 75.11.1 | 75.11.2 | 75.12.1 | 75.12.2 | 75.12.3 | 75.13 | 75.14 |

| 75.15 | 75.16.1 | 75.17 | 75.18 | 75.19 | 75.20 | 75.21 |

| 75.22.1 | 75.23 | 75.24 | 75 24.1 | 75.25 | 75.26 | 75.27 | 75.27.1 |

| 75.28.1 | 75.29.1 | 75.29.2 | 75.30.1 | 75.30.2 | 75.3.11 | 75.32.1 |

| 75.33.1 | 75.33.1a | 75.33.1b | 75.33 1c | 120.7.1 | 75.34 | 75.35 |

| 11.21.10 | 50.1.19 | 17.28.1 | 427.6.1 |

75
P.4.b.13*
M.2.b.2
M.2.d.2
M.7.d.3
M.29.c.1
M.33.d.3
M.34.a.2
M.34.c.2
M.p34.e.3
M.p35.e.3
M.p37.e.3
M.118.a.1
M.118.a.5
M.119.a.5
M.125.18.7
M.130.2
M.166.e.1
M.170.d.2
M.172.5
M.176.c.4
M.190.a.5
M.190.b.5
M.191.a.5
M.191.c.5
M.191.e.5
M.191.g.5
M.191.h.5
M.192.a.5
M.192.b.5
M.194.a.5
M.194.c.5
M.194.e.4
M.196.a.5
M.204.b.5
M.204.d.5
M.205.a.3
M.205.b.2?
M.206.c.2
M.235.a.2
M.235.b.2
75n
M.18.f.2
M.137.d.1
M.198.c.1
75.1
North
P.6.d.8
M.p4a.3
M.4.a.1
M.4.c.2
M.p9.1
M.21.b.1
M.28.a.1
M.31.d.2
M.38.b.3
M.39.d.1
M.50.2
M.55.3

M.56.b.2
M.66.a.1
M.67.b.1
M.68.b.1
M.69.b.1
M.76.a.1
M.88.2
M.89.2
M.90.2
M.91.2
M.92.1
M.111.b.1
M.113.b.1
M.120.c.2
M.121.2.1
M.126.e.1
M.p75–6.2
M.p77.d.2
M.p78.c.2
M.134.2
M.159.c.1
M.160.b.1
M.187.a.2
M.211.2.
M.220.a.5
M.228.c.3
75.1.2*
M.206.c.1
75.2
M.13.a.2
M.13.b.2
M.p37.c.1
M.176.e.4
M.180.d.4
M.203.c.3
75.4
M.6.a.3
M.7.b.1
M.42.c.4
M.44.2
M.p36.d.8
M.120.c.1
M.125.15.3
M.125.28.3
M.164.e.4
M.176.g.4
M.216.a.4
75.4.1
M.94.c.1
M.96.a.1
75.4.2
M.178.b.2
75.5
M.p34.c.1?
M.94.d.2
M.176.d.4
M.180.d.4

75.5a
M.42.b.3
75.5.1
M.42.b.1
75.6
M.42.a.3
M.p36.b.9
M.p36.c.1
75.6.1
M.42.a.1
75.7
M.11.c.3
M.18.a.2
M.22.a.3
M.23.b.3
M.35.b.1
M.36.b.2
M.40.a.2
M.40.b.1
M.40.c.2
M.41.a.2
M.42.d.4
M.42.e.4
M.43.a.3
M.43.b.3
M.43.c.3
M.45.a.1
M.45.b.3
M.45.c.1
M.p36.c.14
M.p36.d.12
M.p37.b.8
M.46.c.1
M.101.2
M.112.a.3
M.112.c.3
M.118.a.2
M.119.c.2
M.123.h.1
M.125.7.2
M.125.18.2
M.125.26.3
M.126.b.1
M.126.c.1
M.126.d.1
M.132.2
M.141.c.3
M.153.b.3
M.155.a.4
M.164.d.4
M.165.b.2
M.168.c.3
M.170.b.2
M.178.a.3
M.179.c.4
M.185.a.3
M.185.b.3
M.185.d.3
M.185.f.4

M.186.a.3
M.186.b.3
M.186.f.3
M.189.b.4
M.191.a.3
M.191.c.3
M.191.e.3
M.191.f.3
M.191.g.3
M.191.h.3
M.192.a.3
M.196.a.3
M.197.b.3
M.197.c.3
M.197.f.3
M.202.c.3
M.203.a.3
M.204.b.1
M.220.a.5
M.224.d.2
75.7.1
M.33.a.3
75.7.2
M.40.d.2
M.201.c.3
75.7.3
M.30.c.1
75.7.4
M.32.b.4
75.7.5
M.p37.d.6
75.7.5a
M.p37.d.11
75.7.6
M.126.a.1
75.7.7
M.46.3
75.7.8
M.p36.c.7
75.8
M.16.c.1
M.23.d.3
M.25.a.3
M.41.b.2
M.125.11.2
75.8.1
M.119.b.1
75.8.2
M.p37.d.1
75.9
M.118.b.1
M.118.c.1
M.119.a.1
M.119.a.2
M.119.c.1
75.10
D.8.e.3

D.60.d.4
D.65.e.4
D.65.f.4
D.72.a.4
D.72.f.4
P.4.b.2
P.4.c.3
P.7.a.3
P.9.c.11
P.10.c.3
P.15.a.2
P.15.b.2
P.15.c.2
P.16.a.2
P.16.b.2
P.16.c.2
P.17.a.2
P.17.b.2
P.17.c.2
P.18.a.2
P.18.b.2
P.18.c.2
P.21.a.6
M.8.a.3
M.68.a.4
M.68.g.4
M.68.h.4
M.69.a.4
M.69.b.4
M.69.d.4
M.69.e.4
M.69.f.4
M.69.g.4
M.141.a.3
M.141.b.4
M.141.c.4
M.143.b.2
M.143.c.2
M.144.a.2
M.144.b.2
M.144.c.2
75.11
D.14.a.2
D.14.c.2
D.22.c.3
D.25.c.2
D.38.c.2
D.38.e.4
D.65.g.4
D.p47e.9
D.p50e.8
M.7.a.3
M.7.b.3
M.7.c.3
M.7.d.3
M.7.e.4
M.7.f.1
M.7.f.4

M.7.g.4
M.7.h.4
M.7.i.2
M.8.b.3
M.8.c.3
M.9.c.3
M.10.a.6
M.11.a.2
M.11.b.2
M.11.c.2
M.11.d.2
M.12.d.1
M.16.a.4
M.20.b.3
M.27.b.2
M.27.c.2
M.28.c.1
M.63.b.4
M.63.c.4
M.63.f.3
M.63.g.4
M.68.b.4
M.68.c.4
M.68.d.4
M.68.e.4
M.68.f.4
M.68.a.4
M.69.c.4
M.87.a.2
M.87.b.2
M.87.c.2
M.87.d.2
M.87.e.2
M.114.a.2
M.117.a.3
M.120.a.2
M.121.a.2
M.121.b.2
M.121.c.2
M.121.d.2
M.123.a.2
M.123.b.2
M.123.c.2
M.123.d.2
M.123.e.2
M.123.f.2
M.123.g.2
M.123.h.2
M.123.i.2
M.123.j.2
M.123.k.2
M.123.1.2
M.123.m.1
M.125.4.4
M.126.b.2
M.126.c.2
M.126.e.2
M.p77.a.7
M.p77.b.7

M.p77.c.7	M.173.d.3	75.12.1	M.206.a.1	75.25	75.30.2
M.p77.d.7	M.176.h.3	M.102.1	75.18	M.146.a.1	M.p37.d.5
M.p77.e.7	M.198.b.2	75.12.2	M.126.d.2	M.146.b.1	75.31.1
M.p77.f.7	M.198.d.2	D.63.b.3	75.19	M.146.c.1	M.p36.d.7
M.p77.g.7	M.207.a.3		M.161.c.1	M.146.d.1	75.32.1
M.p78.a.7	M.207.b.3	75.12.3	75.20	75.26	M.p36.b.14
M.p78.b.7	M.210.a.2	M.148.a.3	M.143.a.2	M.20.a.4	75.33.1
M.p78.c.7	M.210.b.2	75.13	75.21	75.27	M.p34.b.1
M.p78.d.7	M.218.g.3	P.22.a.9	M.p34.d.5	P.23.a.42	75.33.1a
M.p78.e.7	M.218m.3	75.14	75.22.1	75.27.1	M.36.b.4
M.p78.f.7	M.221.a.2	D.61.i.3	M.125.12.3	P.16.e.2	75.33.1b
M.147.e.4	M.221.b.2	D.74.d.4	75.23	75.28.1	M.p37.b.4
M.150.a.2	M.221.d.2	75.15	M.10.c.2	P.17.f.4	75.33.1c
M.150.b.2	M.231.a.2	D.13.a.4	75.24	75.29.1	M.p35.b.4
M.153.a.2	M.232.a.4	75.16.1	M.206.a.2	M.p36.d.1	75.34.1
M.153.b.2	75.11.1	D.60.g.4	M.34.a.1?	75.29.2	P.7.b.26
M.154.a.2	M.126.a.2	75.17	75.24.1	M.p35.c.1	75.35
M.154.b.2	75.11.2	M.193.a.3	M.p37.c.12	75.30.1	D.72.e.3
M.155.a.2	M.p34.c.15			M.p37.d.7	
M.155.b.2					

Regarding the personality of **71, 75**, we find that Dresden uses the two forms, 60 times. Of the 21 times where **75** is the form, in three cases the deity is figured below with the nose and mouth very clearly drawn, and bearded: Dr.8.e.3, 22.c.3, 25.c.2. That shows us that such a figure was an actual one in the mythology. But: with the prefix shown in **71.1** and **75.1**, a banded headdress is clearly shown as the symbol for the North. The Dresden has the glyph for the North 19 times, not once with the 'monkey' face, in spite of the scribe's meticulous care generally in his work. In other words, there was a Lord of the North, and marked by the banded headdress; but he was not necessarily 'monkey-faced,' in spite of the regular use of that form in the Madrid. The Dresden writer knew of the existence of a bearded 'monkey-faced' deity or personage; he knew of the banded headdress as applying to the Lord of the North; he never showed the two together.*

* The 'monkey' character of this glyph, and consequently of the Polar Star ruler, has become so fixed in the literature of the glyphs, that the student should know how it started. In 1807 Dr. Förstemann published an article in *Globus*, stating as follows: That in looking at the long ƫolkin of 20 clauses, Dr. 8, he had just noticed that the 14th and 15th clauses showed the jaguar and vulture, with two days noted as passing; that he at once recalled that the jaguar and vulture were separated in the Mexican day list by just two days; from this as a start, he went back to the 5th clause (Dr. 8, e—with the special bearded figure above referred to) and there "found god C." Then counting back the interval noted by the black ƫolkin figures, 23 days back from the jaguar, he reached the day *Ozomatli*,

Dr. Schellhas refers constantly in his monograph to the way in which the deities in the codices interchange regalia, glyphs and functions, and also the difficulty of identifying the chief ones with any of the data left us, through Landa or otherwise. God C he calls one of the most remarkable and difficult figures we have, "obviously one of the most important, yet it can be identified with none we have had handed down."

Dr. uses the plain face 19 times with ⌒⌒ for the North; M. uses the plain face twice, and 'monkey face' 24 times for the North. Next in frequency we find 75.10, 75.11 (never the 71 form), about 160 times, in all three codices, at or near the end of the clauses. The god, when shown in the pictures in the Madrid, is regularly given the nose, mouth and beard. He is therefore a definite personality in the Madrid, and wears the banded headdress. The above prefix, in its two forms, ☺ ◎ is most likely to denote action of some kind, and touch- 〽 〽 ing the mouth; the action most likely would be speech.

Next in frequency we find the glyph preceded by the four colors, in series, and corresponding to the four points, of which the white alone belongs to the North. In these cases the deity is god B, Itzamná, in the Dresden. In the Madrid the color red is not found, but the other three are, the color changing according to the action, or the deity. With black as prefix it is common in the chapter of **Ekchuah,** the Black God, of the merchants.

Monkey, **Chuen.** Seeing at once that this deity in clause e had a "monkey nose and mouth," he at once saw further that the Polar Star constellation must be that of a monkey, swinging by his long tail.

Dr. Förstemann omitted, however, to note that just 3 days back of the jaguar, on the way to clause 8 with its assumed monkey, he had passed the figure of **Cimi,** Death, with his glyph above in the text; but while **Chuen** does lie 23 days back of **Ix,** the jaguar, **Cimi** does not lie 3 days earlier, but 8 days. Also, 12 days after the vulture and 14 days after the jaguar, is another **Cimi,** in the last clause; and 14 days after **Ix,** the jaguar, would bring us not to **Cimi** but to **Lamat.**

Further, the entire ṭolkin begins with **10 Imix,** and advances 15 days to clause e, where it reaches **12 Cib,** and not **Chuen.** Dr. Förstemann accounts for this difficulty by correcting the entire ṭolkin to make it fit his discovery, saying that the scribe had *intended* to start the ṭolkin with **10 Cib, Lamat, Ahau, Eb, Kan,** but started five days out and so set down the **10 Imix** series in the initial column; but nevertheless proceeded to work out the ṭolkin *correctly* from **10 Cib.** Which brought **Chuen** in clause e with the 'monkey-god,' but did not save the two **Cimis** at the end.

Since this publication by Dr. Förstemann, everybody has called the North Star god the "monkey-faced one."

In the ms. *Ritual of the Bacabs*, the **cantul kuob, cantul bacabob,** the four gods, the four bacabs, occur constantly in the incantations, with the four colors, four directions, and their various names and offices. Also, natural objects are repeated four times, once for each of the directional colors. The parallel with the text of Dr. ҍ. 64, herewith shown, is very striking. The following from one of the chants will also show their rhythm and content.

3 ix, cauac, kan, muluc Dresden, ҍ. 64
a b c d

16 6 16 9 16 12 16

Red flint-stone is its stone, and red the buried earth; red **Imix** the ceiba-tree; its arch stands to the East; red the sticks of the trees, and red the beans within; red are the entrails of the fowls, and red the crackled corn.

Oh ye Nine Gods, to the North comes prayer, and in the North the softening. Four days shrinks the red whipped water, four days shrinks the white whipped water, the black whipped water, the yellow whipped water. Four days shrinks the red hand, white hand, black hand, yellow hand. Four days will shrink the face of the White Ixchel, four days the White Itzamná. Four days will shrink the face of the Nine Hills, four days the face of the Eight Thousand Gods. They shall come to the entrance of the stone house, with those of Canchakan, those of Canҍucché. . . . To the South the prayer, . . . the Yellow Ixchel, the Yellow Itzamná, as they come to the Nine Peaks. And there will come the red nagual, the white nagual, black nagual, yellow nagual; they shall arrive with the Red Ixchel, the White Ixchel, the Black Ixchel, the Yellow Ixchel.

Yellow art thou, yellow the Moan-bird; yellow are the greedy ones, yellow the lands of the arch, when comes the time of birth. Away ye thrust them, behind the sky to the East, to the doors of the house of the Chac-Pauahtun, the red blossom, the white blossom in the doors of the house of the Chac-Pauahtun, . . . as came the words of the Thirteen Gods, thrice honored the wine of knowledge, as came the command, as came the response.

Four Ahau alone, ever Four Ahau; Four Ahau creation comes, with Four Ahau alone comes night; fourfold the doors of the arch.

In the above ṭolkin 64 we see Itzamná engaged in four occupations, with the four sacred offerings of turkey, iguana, fish and deer. Glyph 4 is his appellative glyph, no. 2 the cardinal points, and no. 1 is our **141** (with one subfix change in the last clause). Glyph 3 is now our **71,** with the four colors in their order; and below the West, ruled by the black, Itzamná's body is painted black.

There being four activities in the pictures, glyph 1 can not differentiate these; it must apply to some idea common to the whole section. It is very common as a repeated initial in ritual ṭolkins, where some such meaning as "Do honor, Worship," would at least apply. With the parallel of the chants before us, one may at least suggest a translation—uncertain indeed only as to the initial glyph:

Do honor and sacrifice (a turkey) in the North, to the White Lord, Wise Itzamná, (at his task);
Do honor and sacrifice (an iguana) in the West, to the Black Lord, Wise Itzamná, (at his task);
Do honor and sacrifice (a fish) in the South, to the Yellow Lord, Wise Itzamná, (at his task);
Do honor and sacrifice (a deer) in the East, to the Red Lord, Wise Itzamná, (at his task).

76

Yum Kaax
Corn God

76.1 76a.1 76.1.1 76.7.2 76.2 76.3 76.4

76.5 76.6.1 76.7.1 76.8 76.9

76					76.3
M.32.d.2	D.33.b.4	D.69.i.6	P.11.c.4	M.230.c.3	D.68.d.4
76.1	D.35.b.4	D.69.k.3	P.23.a.13	M.232.c.3	
D.3.b.4	D.45.d.3	D.75.y.3	M.8.c.4	**76a.1**	**76.4**
D.5.a.3	D.46.e.2	P.4.b.17*	M.9.a.3	D.72.a.7	D.p26b.3
D.7.b.2	D.49.b.3	P.5.d.4	M.24.c.3	D.72.f.7	**76.5**
D.8.r.3	D.50.d.1	P.5.d.13	M.137.b.1	**76.1.1**	D.p46d.5
D.9.e.2	D.59.b.7	P.6.d.4	M.146.c.2	D.63.b.6	**76.6.1**
D.10.a.3	D.61.g.3	P.7.d.13	M.147.a.3	**76.1.2**	D.69.j.5
D.12.a.4	D.62.d.4	P.8.b.23*	M.171.b.2	D.60.c.1	
D.16.a.3	D.68.a.4	P.8.c.8	M.210.a.3		**76.7.1**
D.18.a.3	D.68.c.5	P.9.c.2	M.218.i.3	**76.2**	D.p26c.5
D.20.c.2	D.p48e.5	P.9.c.5	M.219.g.1	D.p24.c.10	
D.22.b.3	D.p50e.12	P.9.d.2	M.223.c.3	D.p25c.5	**76.8**
D.29.d.2	D.p50b.a.4	P.9.d.3	M.226.c.3	D.p46e.11	M.p35.d.5
D.30.b.4	D.p50c.b.3	P.9.d.5	M.227.a.3	D.69.f.6	**76.9**
	D.69.a.6	P.9.d.9	M.229.e.3	D.75.k.3	M.139.c.2

Glyphs **71, 75** have many other compound forms, of which the most striking (in our present state of progress) is the alternation with the typical woman's head, as a prefix to the **Oc**-glyph, at the foot of Dres. pages 61, 62. Such an alteration can hardly mean other than male and female. (As to the independent importance of the **Oc** personage, see above, under the day-sign.)

There is only one solution that will satisfy the above uses of glyphs **71** to **76.** The banded headdress in itself must be a sign of Lordship, as in **Yum Kaax,** Lord of the Cornfields, With the prefix ⊂⊐ it denotes the Lord of the North, whether the same deity as shown in Dr. 8.e or not. And then to whatever other deity it applies, it would also give the title, White Lord, Black Lord, Lord of —, etc. Note particularly M.ƫ.42, where it applies to three deities, Itzamná, the Corn-god, and Death; also M.ƫ.125.15 where as White Lord (instead of the usual White Lady) it appears in the text above the "old woman" holding out the budding maize plant.

The above interpretation of the headdress by itself does not therefore deprive us either of gods C or E, or of a North Star god, though it leaves us just where we were as to the mythology of both "C" and the North.

As said above, almost if not quite the most important deities in the Maya ritual were the Four Chacs, the **Pauah-tun,** ruling the four quarters and colors. It is their cult that goes through the chants from first to last, with the colors and offerings, and with Itzamná and his consort Ixchel as the great superior, beneficent deities. Both the Chacs and Itzamná ruled the Quarters, He through them; He was the God, they the Guardians, and either could be called Red Lord, White Lord, etc. In most mythologies the East and the North are the sacred quarters; in one of the chants Itzamná is called **U yum kin chac ahau Itzamna,** "Father of the Sun, Great Lord Itzamná," repeating one of the traditions which represents **Kin-ich-ahau** as the son of Itzamná. So that we not only have "the Lord Sun, the East," on the authority both of the glyphs and the texts, but also (on the strength of our glyph **71**.1 or **75**.1) "The Lord" among the Chacs, for the North—and of course its Star.

77 Itzamna

77.1 77.1a 77.1n 77.1.1 77.1.2 77.1.3 77.1.4

77.1.5 77.2 77.2a.1 77.3 77.4 77.4.1 77.5

77.5.1 77.6 77.6.1 77.6.2 77.7 77.7an 77.7.1

77.8.1 77.9 77.9.1 77.10.1 77.10.2 77.11 77.12

77.13 77.14 77.15 77.16 77.17 77.18 77.19

77.20.1 77.21.1n 77.22 77.23 4.25.4 50.1.24

77	D.55.i.2	D.61.j.2	D.66.j.2	D.69.i.4	P.3.d.6
M.23.a.3	D.55m.2	D.61.k.2	D.66.k.2	D.69.j.4	P.15.b.5
M.35.b.2	D.55.n.3	D.62.b.2	D.66.1.2	D.69.k.4	P.15.f.3
M.35.d.1	D.55.o.3	D.62.c.2	D.66.n.2	D.69.1.4	P.16.f.4
M.39.a.2	D.55.p.2	D.62.d.2	D.66.n.2	D.69 m.4	P.17.e.4
M.41.d.2	D.55.q.2	D.62.e.2	D.66.o.2	D.70.a.3	P.17.f.2
M.120.a.1	D.56.a.4	D.64.a.4	D.66.p.2	D.70.b.3	P.18.d.2
M.165.d.1	D.56.b.4	D.64.b.4	D.66.q.2	D.70.c.3	M.p4a.2
M.178.b.2	D.56.c.4	D.64.c.4	D.66.t.2	D.70.d.3	M.p5a.3
	D.56.d.4	D.64.d.4	D.67.a.3	D.70.e.3	M.p6a.2
77.1	D.56.e.4	D.65.a.2	D.67.b.3	D.70.f.3	M.6.b.3
D.8.b.4	D.56.f.3	D.65.b.2	D.67.c.3	D.70.g.3	M.6.c.2
D.14.g.2	D.58.a.4	D.65.c.2	D.67.d.3	D.70.h.3	M.6.d.3
D.19.a.3	D.58.b.4	D.65.d.2	D.67.e.3	D.70.i.3	M.6.e.2
D.23.a.3	D.58.c.4	D.65.f.2	D.67.f.3	D.70.j.3	M.6.h.3
D.29.f.2	D.58.d.4	D.65.h.2	D.68.a.2	D.70.k.3	M.10.d.5
D.38.e.2	D.58.e.6	D.66.a.3	D.68.b.3	D.70.1.3	M.10.e.6
D.39.a.1	D.58.f.4	D.66.b.3	D.68.c.4	D.70 m.3	M.10.f.3
D.45.a.3	D.58.g.4	D.66.c.2	D.68.d.3		M.22.e.1
D.53.a.4	D.58.h.4	D.66.d.2	D.69.a.4	D.73.a.6	M.27.c.1
D.53.b.4	D.59.a.4	D.66.e.2	D.69.b.4	D.73.b.6	M.35.a.2
D.53.c.4	D.59.a.8	D.66.f.2	D.69.c.4	D.73.c.6	M.36.e.1
D.53.d.4	D.59.b.8	D.66.g.2	D.69.d.4	D.73.d.6	M.56.d.4
D.53.e.4	D.59.c.8	D.66.h.2	D.68.e.4	D.73.e.6	M.95.4?
D.55.a.5	D.59.d.8	D.66.i.2	D.69.f.4	D.75.g.2	M.117.a.4
D.55.e.3	D.61.g.2		D.69.h.4	D.p74.13	M.141.e.3
D.55.h.3				P.3.d.4	

M.144.c.3	**77.1.3**	**77.4**	**77.7**	**77.9.1**	**77.16**
M.154.b.1	D.65.i.2	P.18.e.4	M.25.b.4	M.6.g.3	M.179.e.1
M.209.d.3	**77.1.4**	M.39.d.3	M.45.a.4	**77.10.1**	**77.17**
M.216.c.3	D.p60a.6	**77.4.1**	M.45.b.2	M.151.b.1	M.154.a.1
M.236.a.3		D.57.c.4	M.112.b.2	**77.10.2**	
77.1a	**77.1.5**	D.59.c.4	M.168.b.1	M.191.c.1	**77.18**
D.62.a.2	M.p37.b.12	D.p70.d.5	M.179.b.4	**77.11**	M.161.a.3
M.p34.b.2		**77.5**	**77.7n**	M.43.a.1	M.161.b.3
M.p35.b.2	**77.2**	D.59.d.3	M.125.32.3	M.43.c.1	**77.19**
M.p36.b.2	D.57.a.4	D.61.c.3	**77.7a**	M.43.d.1	M.39.a.4
M.p37.b.2	D.61.e.2	**77.5.1**	M.33.c.3	**77.12**	**77.20.1**
M.218.b.3	P.4.d.13	D.57.b.4	**77.7.1**	M.16.c.4	M.p8.b.5
77.1n	P.10.b.4	M.39.b.3	M.188.b.1	M.20.c.3	**77.21.1n**
M.125.24.3	**77.2a.1**	**77.6**		**77.13**	M.61.e.1
77.1.1	M.39.c.3	D.57.h.3	**77.8.1**	M.43.b.1	**77.22**
P.11.d.6	**77.3**	**77.6.1**	M.188.a.1	**77.14**	M.161.a.4
M.13.a.3	D.59.b.4	D.55.c.8	**77.9**	M.43.a.1	**77.23.1**
77.1.2	D.61.b.2	D.72.e.2	M.114.b.1	**77.15**	M.189.b.1
P.16.b.6	M.34.c.1	P.18.f.2	M.127.b.2	M.19.b.3	

At least with the major gods, the use of two glyphs is common, one reproducing his features (i.e. himself) and the other a characteristic appellative. Such as glyphs 6 and 22 for **Cimi**, Death. With glyphs **77, 78** we come to another like pair. Schellhas makes two gods of these, B and G, but with remarks as to the surprising infrequency of so important a god as G, the sun-god; he gives to G as his separate glyph our form 45.18.1 Fewkes is inclined to make one deity of B and G, in which we think he is surely right.

Form **77.1** is so very common with 'god B' that it has come to be taken as his special glyph, which it is in a sense; but it is also used with various other deities. Taking god B as Itzamná, as we do for many reasons, we see him with the dragon features—fangs, dragon eye, long or ornamented nose. The forms below of glyph **78** repeat these features, sometimes omitting the nose ornament, which is not an 'elaborate nose-plug,' but a definite 'dragon' feature.

The head of this dragon deity is presented on each of pages 2–11 in the Paris codex, with the glyph itself at P.11.b.4. As noted above, the 'nose-curl' with the curve about the eye, closely resembles the face-numeral element for 7. Glyph **78** is used only six times in the Dresden; in tzolkin 60 Itzamná appears in four of the six clauses, each time with this exact face reproduction as his glyph above, instead of his appellative, the Tau-eye sign, **77.1**. Tzolkin 65 shows Itzamná nine times, with the same repetition of

cardinal points and colors as we have just illustrated above; **77**.1 occupies position 2 eight times as this glyph, and is replaced by **78** in the remaining clause, the glyph being an exact reproduction of the face below.

As a further confirmatory point: we have already noted the use of the subfix as the 'base of honor' on which the offerings commonly rest; also the fact that it is restricted as a post- or subfix to the two great deities of the Maya pantheon, **77** and **120,** (beyond question, as we think, Itzamná and Ixchel, the White Lady), and the **Oc,** discussed above. This subfix also accompanies glyph **78,** and no others.

Where a deity has, (as nearly all have, in whatever mythology) a pair of names, one personal and the other appellative, nothing is more common than to refer to the god by his 'appellation' rather than his Name. In fact, it is almost universal to find the latter 'unpronounceable,' and the requirement to speak of the deity, especially the highest deity, by his appellation. The Tau-eye is certainly not a pictograph of 'god B.' Its presence, here as well as as an architectural element, takes us straight into the field of world-mythology. We cannot pretend to define or explain it in Maya 'terms, still less to bring in now outside cultures in efforts at Maya interpretations. But as *the* glyph of the great god of the Dresden and Paris codices, so clearly as we think, the Itzamná of the Ritual, the great magician (for such the root **itz** means) of the Itzás, the god of Iȝamal ('the place of the Iȝá), and Chichen Iȝá, it must be some symbol of greatness and wisdom. Unable to know how it was uttered when the texts were read, we cannot be very far wrong if we render it as we have done in the translation of ȝolkin 64 above, 'The Wise,' for the 'All-knowing, All-powerful One.'

The student will note that in the Dresden and Paris, where **77** is *the* great god, the glyph is never used without either the specific subfix or the colors, the latter usually in series. In the Madrid, dealing with more terrestrial matters, where Death and the Corn-god are at constant war, and the Four Chacs or Bacabs are the direct rulers and Guardians, there are numerous lesser forms, and without the . Also that glyph **77** is almost never compounded with other 'main elements.'

78

P.11.b.4 M.147.a.2

78.1	78a.1	D.60.e.1	78.1.1	78.2	78.2.1	78.3
D.60.c.2	D.7.e.3	D.60.f.1	D.65.g.2	D.p49b.a.4	D.p49c.b.3	P.10.d.5
		D.60.g.2				

79

79.1 D.71.42.2

This face of a solar deity occurs only in the eclipse ephemeris. It should however be considered with the other **kin**-infix glyphs gathered under no. **46.** It may be the same as the **tun**-ending Glyph G, above referred to.

80

D.72.a.13 D.72.f.13

This cross or 'hatchet-eye' face, with the lower jaw for the number 10, making 16, is one of the double set of twenty glyphs across the Venus pages.

81

81.1 81.1.1a b c d e f

g h i j k l 81.2

81.2.1 81.2.2 81.3 81.4.1 81.5.1 81.5.2 81.6

81.6a b c 81.7 81.8 81.9 81.10.1

81.11 81.12 81.12a 81.13

81	D.25.a.1	M.145.a.3	M.223.a.3	M.169.b.3	81.5
D.70.e.7	D.26.b.2	M.146.a.2	M.230.a.4	M.175.c.3	P.6.c.3
M.17.b.2	D.28.a.2	M.147.c.2	M.231.c.3	M.176.e.3	M.153.a.3
M.29.a.1	D.29.b.2	M.148.a.4	M.232.b.3	M.183.a.3	81.6
M.29.e.1	D.39.c.1	M.148.c.3	M.234.a.3	M.191.g.2	D.8.1.4
M.109 m.2	D.40.e.1	M.149.a.3	M.235.a.3	M.195.c.3	D.43.a.3
M.147.a.2	D.43.b.3	M.161.c.3	81.1.1c	81.1.1 k	P.10.b.14
M.169.b.2	D.48.b.3	M.170.e.3	D.71.2.2	M.125.22.1	M.125.18.4
M.182	D.p27b.2	M.188.a.3	D.22.f.3	M.200.a.3	M.125.20.2
M.187.e.1	D.p28c.5	M.190.f.3	D.27.a.4	81.1.1 l	81.7
M.202.d.2	P.6.b.12	M.198.a.1	D.31.c.4	M.120.a.2	M.p36.c.4
81.1	P.11.b.2	M.199.d.3	D.32.b.3	81a.2	
M.27.a.1	P.23.a.15	M.201.a.2	81.1.1 i	D.55.m.3	81.8
M.117.c.2	P.24.a.10	M.202.a.2	D.16.c.3	D.62.e.3	M.151.a.3
M.119.a.3	M.11.a.3	M.208.a.3	81.1.1 j	D.p70.c.5	81.9
M.212.e.3	M.12.b.1	M.209.a.3	M.19.a.3	D.p74.14	M.45.c.3
M.233.b.4	M.31.b.2	M.212.a.3	M.20.a.3	P.2.d.8	81.10.1
81.1.1	M.114.a.1	M.218.a.2	M.24.a.4	81.2.2	M.222.a.3
D.5.b.3	M.122.a.3	M.219.b.1	M.42.e.3	D.p25c.4	81.11
D.13.a.3	M.124.a.1	M.225.a.3	M.57.a.3	81.3	M.p35.d.3
D.14.b.2	M.139.a.2	M.226.a.3	M.57.c.3	M.100.a.4	81.11 a
D.15.c.3	M.141.a.4	M.228.a.3	M.58.c.3	81.4.1	M.19.a.4
D.17.a.4	M.142.a.3	M.213.c.4	M.123.f.1	D.p26c.2	M.179.e.3
D.18.a.4	M.143.a.3	M.214.a.3	M.152.a.2	D.p27c.2	81.13
D.24.b.3	M.144.a.3	M.221.a.3	M.167.a.3	D.p28c.2	M.22.b.3

This deity (Schellhas' god D) shows the sunken mouth and single tooth of age; he has the divine eye, above which is either a single small circle, or the oval of dots characteristic of the numeral **kal,** 20. In his specific face-glyph the prefix is a dotted **akbal,** properly with its own extra subfix as shown in **81.1, 81.1.1.** As a prefix the head also takes the colors red and green, and perhaps black— **81.5.** The face at times loses the human character, and the specific one-toothed mouth, to take on the more typical animal form, as seen in **81b.1.** The **'ben-ik'** superfix is also found.

A number of the forms shown above are doubtful, as belonging to this deity, but are grouped here on the strength of the special ornamented eye. This eye, a typical 'dragon-eye', is restricted to the gods to whom belong glyphs **78** to **81.** Until reaching this glyph we have clearly been dealing with solar deities. That god D, **81,** is also a major deity, must be taken as clear.

Complete confusion and difference have reigned among students as to gods B and D, as also to Itzamná and Kukulcan or Quetzal-coatl, and which is which. We see and hear a very great deal of Itzamná, and the sun, in the Dresden and Madrid codices; also in the *Ritual,* and in Yucatan mythology. We have great trouble in identifying Kukulcan, and of a moon-ritual there is almost, or

quite, nothing. Until the oval with dots is *proved* to denote the moon, or the questions otherwise met, there is no safe way of placing this 'Old God.'

One very interesting glyph in this connection is the above **81.13.1.** Here we see the eye with the oval above; then the identical nose and mouth of C, the 'god of the north,' from which runs up a curving line which (*if* it were pictographic) might equally well represent clouds, or waves. And the whole is surrounded by rays. Seen thus, this should by all ways be a stellar deity; but how reconcile the clear union of the elements we have been told mean, one the moon, the other the 'monkey-god' of the North Star?

89

M.104.a.2 M.104.b.2 M.104.c.2
M.117.a.2 M.117.b.2

82

82 82a 82c 82e 82e.1
D.44.a.3 D.p50b.b.4 D.p50c.c.3 P.5.c.13 P.5.b.6

82.1 82d.1 82a.1 82a.2 82b.2 82b.3 82 on
D.22.d.3 D.31.d.4 D.p24.c.4 D.20.e.3 D.40.b.1 P.11.b.6 P.8.d.5
 D.p16e.3 P.9.b.4

These forms are gathered under one number, but it is rather probable that blackness is an incidental addition to a deity-glyph, just as we see Itzamná's body made black in D.ħ.64, 65, in connection with the West. The first five heads shown above are clearly the head of **81,** above. The heads taken from the Paris codex are probably of some other.

83

83n 83.1 83a.1
D.71.g.4 D.p48b.d.4 D.p49c.c.3

This occurs in picture section *g* of the eclipse ephemeris; the prefix is the zero-time sign. The flaring crown of the head will be discussed elsewhere.

87

87.1a | 87a.1 | 87.2 | 87a.2 | 87.3 | 87.4
D.71.40.2 | D.71.30.2 | D.71.3.2 | D.71.63.2 | D.71.52.2 | D.71.49.1
D.71.44.2

87.1
D.71.15.2
D.71.17.2
D.71.23.2
D.71.24.2
D.71.29.2

This occurs only in the Dresden eclipse ephemeris.

88

88.1 | 88.2 | 88.3 | 88.4 | 88.5.1
D.p58.f.6 | D.p24.c.12 | D.p50e.5 | D.p58.e.9 | P.5.a.6

This again stands alone, and without helps to its value.

90

90.1 | 90.2 | 90.2a | 90.2.1 | 90.3 | 90.4
D.8.g.4 | D.52.b.2 | D.52.a.4 | D.p49e.3 | P.5.a.5 | P.4.d.2

This the same. These two glyphs are definitely involved in the Venus-Lunar calculations; after appearing on the pages of the former, they reappear in the introductory and final columns of the latter.

91

P.9.c.3 M.98.a.4

91.1
D.13.a.3
D.13.b.3
D.23.a.2
D.23.b.2
D.23.c.2
D.23.d.2
M.180.a.2
M.189.a.4
M.189.b.3

91.1 | 91b.2 | 91.2 | 91b.3 | 91.4 | 91.5
 | D.p.49f.3 | D.75.h.1 | D.71.32.1 | M.125.10.3 | M.179.a.1
 | | D.75.s.2 | D.71.33.1 | |
91.1.1 | 91.1n | D.75.x.1 | D.71.55.1 | also |
M.125.21.5 | D.5.c.3 | | | 17.25.1 |
 | | | | | P.7.b.28

How far this **chuen**-eye face is connected with the **vinal** is a matter for careful search. The tails at the side of the eye are the same as appear in the head with **et͡z'nab** infix, no. **126.** See also next glyph.

92

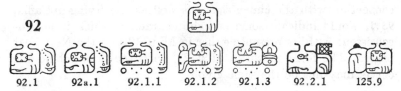

92.1 92a.1 92.1.1 92.1.2 92.1.3 92.2.1 125.9

It is doubtful whether form **92.2.1** belongs here; it lacks the **chuen** in the eye, but having all the rest is placed here, for lack of a better.

92	92a.1	D.58.c.1	D.59.d.2	D.71.16.1	P.5.d.9
M.10.e.4	P.4.d.6	D.58.d.1	D.61.c.1	D.72.b.5	92.1.2
M.17.e.2	92.1.1	D.58.e.1	D.66.1.3	D.72.f.34	D.55.a.1
92.1	D.55.b.1	D.58.f.1	D.66.o.4	D.73.a.3	92.1.3
D.68.c.1	D.55.c.1	D.58.g.1	D.66.q.4	D.73.b.3	D.66.e.4
D.p70.c.3	D.55.d.1	D.58.h.1	D.66.s.4	D.73.c.3	92.2.1
D.p70.d.3	D.55.e.1	D.59.a.2	D.p45.b.2	D.73.d.3	M.123.1.1
P.6.d.5	D.58.a.1	D.59.b.2	D.p51a.c.2	D.73.e.3	125.11
P.7.b.28*	D.58.b.1	D.59.c.2	D.p58.e.2	D.p70.a.2	D.66.g.4

This glyph has almost wholly a repeat use, in the form **92.1.1**. It carries the tails to the eye, and differs only from gl. **91** in having the flaring top. The student should note the repetition of this flare in a number of periodic glyphs. It is essential to change **chuen** and **tun** to ţec and **pax**; in **83** its glyph receives the zero-time sign; and the only other that takes it as a modification is gl. **74**, which in its turn is a persistent repeat final.

93

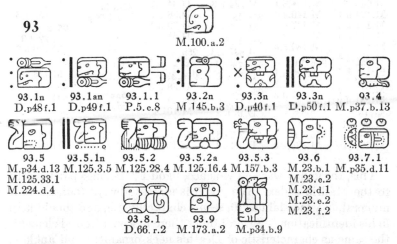

M.100.a.2

93.1n 93.1an 93.1.1 93.2n 93.3n 93.3n 93.4
D.p48f.1 D.p49f.1 P.5.c.8 M 145.b.3 D.p40f.1 D.p50f.1 M.p37.b.13

93.5 93.5.1n 93.5.2 93.5.2a 93.5.3 93.6 93.7.1
M.p34.d.13 M.125.3.5 M.125.28.4 M.125.16.4 M.157.b.3 M.23.b.1 M.p35.d.11
M.125.33.1 M.23.c.2
M.224.d.4 M.23.d.1
 M.23.e.2
 93.8.1 93.9 M.23.f.2
 D.66.r.2 M.173.a.2 M.p34.b.9

Except for its appearance once in P.5.c.8, and four times as the initial glyph in the final section *f* of the Venus pages, this figure belongs entirely to the Madrid. Its assortment of numerals, and

connection with the **chuen**-signs, as well as the 'tying-up' affix, **93.1,** would indicate some periodic character, which is not inconsistent with its presence either in M.ゕ.125, or the New Year pages. The form shown in M.ゕ.23, with the dots behind the curve, may not be the same glyph.

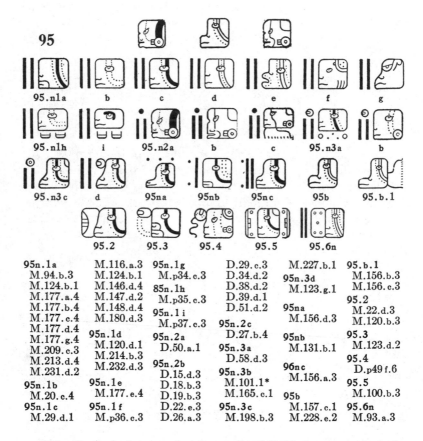

95.n1a	b	c	d	e	f	g
95.n1h	i	95.n2a	b	c	95.n3a	b
95.n3c	d	95na	95nb	95nc	95b	95.b.1
95.2	95.3	95.4	95.5	95.6n		

95n.1a	M.116.a.3	95n.1g	D.29.c.3	M.227.b.1	95.b.1
M.94.b.3	M.124.b.1	M.p34.c.3	D.34.d.2	95n.3d	M.156.b.3
M.124.b.1	M.146.d.4	85n.1h	D.38.d.2	M.123.g.1	M.156.c.3
M.177.a.4	M.147.d.2	M.p35.c.3	D.39.d.1		95.2
M.177.b.4	M.148.d.4	95n.1i	D.51.d.2	95na	M.22.d.3
M.177.c.4	M.180.d.3	M.p37.c.3		M.156.d.3	M.120.b.3
M.177.d.4		95n.2a	D.27.b.4	95nb	95.3
M.177.g.4	95n.1d	D.50.a.1	95n.2c	M.131.b.1	M.123.d.2
M.209.c.3	M.120.d.1	95n.2b	95n.3a		95.4
M.213.d.4	M.214.b.3	D.15.d.3	D.58.d.3	96nc	D.p49 f.6
M.231.d.2	M.232.d.3	D.18.b.3	95n.3b	M.156.a.3	95.5
95n.1b	95n.1e	D.19.b.3	M.101.1*		M.100.b.3
M.20.c.4	M.177.e.4	D.22.e.3	M.165.c.1	95b	95.6n
95n.1c	95n.1f	D.26.a.3	95n.3c	M.157.c.1	M.93.a.3
M.29.d.1	M.p36.c.3		M.198.b.3	M.228.e.2	

This, the god of war and violence, "god F," belongs particularly to the Madrid codex. His glyph is almost always found with a numeral, of which **lahun,** 10, seems characteristic, and should help in his identification. Several times there is seen a frontal element, the same as characteristic of Death's neck-ornament and anklets; and this is also transferred to *above* the numeral 10; whether this changes the 10 to 11 is very doubtful. All the forms in the

Dresden except one have, however, this as a black dot over the 10, apparently making 11.

The resemblance of the god's figure to that of the Mexican Xipe, is distinct, and accords with his destructive functions in both codices. Also, in accordance with the usual custom in pictographic representations, the distinctive stripes are almost never drawn twice alike.

96

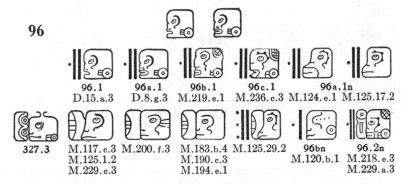

96.1 96a.1 96b.1 96c.1 96a.1n
D.15.a.3 D.8.g.3 M.219.e.1 M.236.c.3 M.124.e.1 M.125.17.2

327.3 M.117.c.3 M.200.f.3 M.183.b.4 M.125.29.2 96bn 96.2n
 M.125.1.2 M.190.c.3 M.120.b.1 M.218.e.3
 M.229.c.3 M.194.e.1 M.229.a.3

This glyph is placed by Schellhas among the variants of god F, above, and so described by him. It is however an entirely different deity. In every case where it occurs in either Dresden or Madrid, the deity figure is beneficent, lacks the distinctive stripes of the preceding, and at times closely resembles the Corngod. In Dr.ꜩ.15, which we have reproduced above, both deities are shown, making fire upon the holding **manik**-sign. The distinction is here clearly shown. If the curve behind the eye is to be taken as a variation of the typical line dividing the Corngod's face, we will have here at least a manifestation of that deity; otherwise we have here another personage active in beneficent deeds, and also important enough to be one of the twenty in the long Dresden ꜩolkin 8.

98

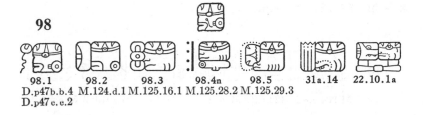

98.1 98.2 98.3 98.4n 98.5 31a.14 22.10.1a
D.p47b.b.4 M.124.d.1 M.125.16.1 M.125.28.2 M.125.29.3
D.p47c.c.2

This glyph is a quite special one, distinct from the **akbal**-bearing
Xul. The face is human, not animal, and carries the **akbal** across
the whole top. As **98 .1** it is one of the doubled twenty on the
Venus pages; otherwise it occurs only in Madrid ꜩ. 124 and 125.

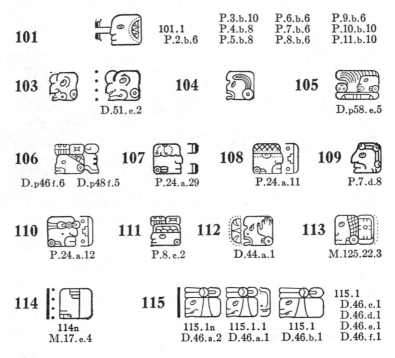

101 101.1 P.3.b.10 P.6.b.6 P.9.b.6
 P.2.b.6 P.4.b.8 P.7.b.6 P.10.b.10
 P.5.b.8 P.8.b.6 P.11.b.10

103 104 105
D.51.c.2 D.p58.e.5

106 107 108 109
D.p46f.6 D.p48f.5 P.24.a.29 P.24.a.11 P.7.d.8

110 111 112 113
P.24.a.12 P.8.c.2 D.44.a.1 M.125.22.3

114 115 115.1
114n D.46.c.1
M.17.e.4 115.1n 115.1.1 115.1 D.46.d.1
 D.46.a.2 D.46.a.1 D.46.b.1 D.46.e.1
 D.46.f.1

In the above section we have gathered a number of heads of
isolated character and occurrence, and on which almost no com-
ments can be made. **106** is another of the doubled series of twenty
on the Venus pages, and again shows the characteristic combina-
tion of the **'ben-ik'** and the postfix. **115** is an interesting glyph
showing a plain head tied with a knotted cord, just as we saw the
kal-sign, **59 .12 ;** it is found only in Dr.46.

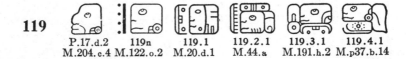

119 P.17.d.2 119n 119.1 119.2.1 119.3.1 119.4.1
 M.204.c.4 M.122.o.2 M.20.d.1 M.44.a M.191.h.2 M.p37.b.14

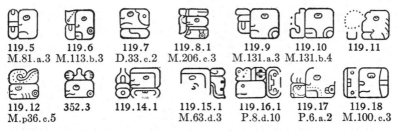

119.5	119.6	119.7	119.8.1	119.9	119.10	119.11
M.81.a.3	M.113.b.3	D.33.c.2	M.206.c.3	M.131.a.3	M.131.b.4	

119.12	352.3	119.14.1	119.15.1	119.16.1	119.17	119.18
M.p36.c.5			M.63.d.3	P.8.d.10	P.6.a.2	M.100.c.3

Under the above number we have grouped faces with no distinguishing characteristics, and nearly all in the Madrid.

120

Ixchel
Lady Woman

120a	120.1	120b.1	120.1a	120.1.1	120.2	120.2?

120c.3	120.4	120.5	120.6.1	120.7.1	120.8*	120.9.1

120.9.2	19.1.6	75.34	10.1.11

120	D.51.d.3	D.47.a.3	120.2	M.164.b.2	120.4
M.180.a.3	D.52.a.2	D.47.b.3	D.3.c.2	M.164.f.1	D.44.a.1
	D.52.f.4	D.47.d.2	D.3.d.4	M.176.a.3	D.44.b.1
120a	D.73.b.5*	D.47.e.3	D.31.d.1	M.181.b.2	D.44.d.1
D.6.a.3		D.47.f.3	D.35.b.3	M.199.a.3	
D.33.a.3		D.48.a.3	D.36.b.4	M.199.b.3	120.5
D.33.b.3	120.1	D.48.b.4	D.40.e.3	M.219.c.1	D.44.c.1
D.34.c.4	D.37.a.2	D.48.c.4	D.41.a.3	M.231.a.3	
D.35.a.3	D.37.c.2	D.73.d.5	D.41.b.3		120.6.1
D.35.c.3	D.39.a.3		D.45.b.3	120.2?*	D.72.e.4
D.35.e.4	D.39.b.3	120b.1	D.47.c.3	D.36.b.4	
D.36.a.1*	D.39.c.3	M.95.5	D.50.a.3		120.7.1
D.36.a.2*	D.39.d.3		D.50.b.3	120c.3	D.65.g.3
D.40.f.3	D.40.a.3	120.1.1	D.50.c.3	M.113.b.4	
D.41.a.2	D.40.b.3	D.37.b.2	D.50.d.3	M.113.c.4	120.8*
D.42.b.2	D.40.c.3	D.37.d.2	D.50.e.3	M.125.23.2	M.164.f.3
D.49.a.3	D.41.b.2	D.37.e.2	D.52.b.4	M.125.24.2	M.170.a.4
D.51.a.3	D.42.a.2	D.37.f.2	M.164.a.4	M.125.31.3	120.9.1
D.51.b.3	D.46.a.5	D.40.d.3		M.125.32.2	P.7.d.6
					120.9.2
					P.7.b.2

To this personage, called by Schellhas the water-goddess, we have given the term Lady, or Woman. The glyph is clearly the woman's head, with one or two locks of hair, and by no means restricted to the Old Woman, with tiger feet, etc. shown on Dr. page 74 and elsewhere.

As glyphed in **120 .2 .1** she is clearly the White Lady, or Ixchel, of whom we have spoken above; in this form the glyph carries both the special postfix and the prefix for white, either of which may at times be omitted, as can be done with Itzamná himself, especially when accompanied by the color prefix. The prefix in **120c .3** is poorly defined, but being from the Madrid, is probably white also; black is never the color of *La Diosa*.

The association of **120** and **75** in the form **120 .7** is interesting, as also the forms **120 .9**, with **kin** prefixed.

121

| 121a | 121b | 121.1 | 121.2 | 121.3 |
| M.p36.c.18 | M.94.a.1 | M.99.b.2 | M.164.f.1 |

122

D.4.a.3 See M.5.d.2 M.43.d.3 M.45.b.4

It is probable that the marks on the face denote the wrinkles of old age, and also that a distinction was thus made between different female characters. Certainly some were definitely old women, or old goddesses. It was not found practicable to separate all the faces on this line, however, so that some with these marks are included under **120**; although no. **121** has been set apart as a special number for an "old woman," and also **122** for the particular one with the sunken mouth, found in Dr.4.a.3. Several of the forms have also been included as the 'woman-glyph' on the strength of these wrinkles, and of the prefixes and associations.

123 Priestess

| 123n | 123.1 | 123.1a | 123.1b | 123.1c | 123.1d | 123.1e |

| 123.1.1 | 123.2 | 123.2n | 123.3n | 123.3a | 123f.4 | 123.5 |

123e.6 123h.6 123h.7 123.7

123n	D.21.b.2	123.1.1	D.66.d.3	123.6	M.174.a.3
D.9.c.2	D.24.c.3	D.60.a.3	123.4	M.143.b.3	M.174.b.3
	D.26.d.2	123.2	P.3.c.3	M.147.e.2	M.175.a.3
123.1	D.30.a.3	D.8.a.3	123.5	M.200.g.3	M.175.b.4
D.4.a.2	D.32.b.4	D.71.e.2	D.23.c.3	M.218.k.3	M.175.d.3
D.8.a.4	D.38.c.4	123.2n	D.42.b.3	123.7	M.179.a.3
D.8.h.3	M.118.b.2	D.8.h.4	M.180.a.1	M.125.6.2	M.179.b.3
D.12.b.4	M.127.a.4	123.3a 3n	M.186.a.1	M.125.14.4	M.197.a.3
D.14.d.2	M.180.a.3	M.192.b.4	M.210.b.3	M.169.d.3	M.202.a.3

This glyph has been distinguished from **Chicchan,** and discussed under the latter head. Schellhas makes a god H, out of this **123** and **Chicchan** combined; he shows both forms of infixes, the specific prefix of this, our 'Priestess' glyph, together with [glyphs] prefixes for **yax** and **sac,** green and white, and also [glyphs] He then adds: "there are thus four different forms of the prefix. It is to be assumed that all these hieroglyphs have the same meaning, notwithstanding their variations."!

Seler, on the contrary (as criticised by Schellhas) made the same distinction as we have here shown between the two specific forms for glyphs **5** and **123,** making of **123** "another face ornament, which cannot be satisfactorily proved, and must be regarded as an arbitrary assumption," says Schellhas. We feel that Seler is wholly right here, as shown by the associations. Also, one cannot possibly say that the prefixes for green and white are one. Schellhas then devotes a full page to controverting Seler's view that we have here to do with "a young god," calling this idea an invention of Brinton's, and not to be accepted as against his (Schellhas') "purely inductive" and descriptive study of the manuscripts.

To the writer this interlocking, or rather touching, of these two glyphs (one clearly **Chicchan,** and a serpent sign, the other definitely associated with the Chapter of the Women, or Priestesses) may point to the latter as a Serpent Priestess. The very definite markings in the head-ornament can very well be the notation of a specific headdress. And the differentiation of the prefixes, with the special assignment of the form in **123.1,** and White, to the priestess, and Green, with the distinctive crosshatched circle to the Serpent, are, we think decisive.

The student should make a careful study of all the citations; to facilitate the work, we have reproduced in the type forms even very minor variations.

125

125c 125b 125dn 125an 125.1 125.2 125.3

125.4 125.5 125e.6 125a.6.1 125b.6.1 125b.7.1 125b.8.1

125.9 125.10 125.11 125.12 125.13.1 125.14 125.15

125	125c	125.4	D.71.31.1	125.10	M.147.e.1
P.5.b.14*	D.p58.f.4	D.66.q.3	125b.6.1	D.71.i.1	125.13.1
P.22.a.4*	125.1	125.5	D.69.j.3	D.71.j.1	M.p36d.9
M.10.f.2	D.p24.c.11	D.70.f.2	125.7	125.11	125.14
M.160.a.4	D.p47e.12	125.6	D.69.b.3	D.66.g.4	D.52.c.1
125n	125.2	D.66.g.5	125.8	125.12	D.69.j.1
D.p49f.4	D.75.h.2		D.71.30.1	M.147.a.1	M.123.c.1
P.11.b.8	125.3	125.6.1	125.9	M.147.b.1?	125.15
125b	D.43.b.1	D.71.10.1	P.4.b.22	M.147.c.1	D.p49.e.7
P.9.b.10	D.43.c.1	D.71.20.1		M.147.d.1	

Speculation on this glyph could run wild. It occurs with numerals, only one or two prefixes, back to back with itself, and then almost wholly with month or celestial signs. Three times it is drawn upside down. That it connotes an astronomical event of some sort seems evident—but what?

126

126 126.1 126.1.1 126.2.1 126.2.2 126.2n

M.93.b.3 D.p46b.c.4 P.11.d.10 D.66.t.4 P.2.c.6 D.57.h.5

 D.p46c.d.4 D.67.b.4

 P.3.b.8

126.3 126.2.1 126.3 126.4 P.7.b.4

D.72.a.10 D.72.f.10 P.8.b.9 P.11.b.12 P.6.d.18 P.7.d.4

The separation of glyphs **126** and **127** has been made almost wholly on the features of the eye. But it will be noted that in **126** the face is more usually human in type, while in **127** it has the typical animal mouth. The markings at the eye also occur, as we have just seen, on glyphs **90, 91** and **92**—the **chuen** eyes. The

eye typical of **127** is however a definite animal eye, seen especially on the figures of deer. That a predatory or destructive character is implied in each glyph is indicated by the **eȼ'nab** infix.

127

| 127n | 127.1n | 127.3 | 127.2 | 127.4.1 | 127a.4.1 |

127n	127.1n	127.4.1	D.8.g.1	D.8.n.1	127.4.1a
D.66.f.2	M.162.b.4	D.8.a.1	D.8.h.1	D.8.o.1	D.14.a.1
		D.8.b.1	D.8.i.1	D.8.p.1	D.14.b.1
127.3	127.2	D.8.c.1	D.8.j.1	D.8.q.1	D.14.c.1
D.12.a.3	D.12.c.3	D.8.d.1	D.8.k.1	D.8.r.1	D.14.d.1
D.12.b.3		D.8.e.1	D.8.l.1	D.8.s.1	D.14.e.1
D.12.d.4?		D.8.f.1	D.8m.1	D.8.t.1	D.14.f.1
					D.14.g.1

Glyph **127** is distinguished by being mainly a repeat glyph in the Dresden, first as a final in ȼ.12, then as initial all through the 20-clause ȼolkin 8, and also ȼ.14. Whether anything is implied by the presence of the eye-marks all through ȼ.8 and their omission in ȼ.14 is questionable, but it is hardly likely that the animal character of the glyph (hence its base) is cancelled by the omission.

1 ahau, eb, kan, cib, lamat Dresden, ȼ. 67

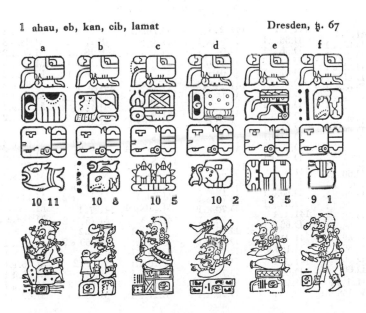

a b c d e f

10 11 10 8 10 5 10 2 3 5 9 1

QUASI-FACIAL FORMS

141

141.1.1 141.1.2 141.1.3 141.1.4 141.1b.5 [141.2] 141.2.1

141.2.2 141.2.3 141.2a.4 141.2.5 141.2.6 [141.3] 141.3.1

141.3.2 141.4.1 141.4.2 141.4.3 141.5 141.5.1 141.5.2

141.5.3 141.5.4 141.6 141.7.1 141.7.2 141.8

141.9 141.9.1 141.9.2

141.1.1	**141.1.2**	**141.2.3**	D.70m.1	P.17.b.1	M.68.d.3
D.65.a.1	D.56.c.1	D.62.a.4	**141.3.2**	P.17.c.1	M.68.e.3
D.65.c.1	D.56.e.1	D.64.a.1	D.57.b.1	P.18.a.1	M.68.f.3
D.65.e.1	D.57.a.2	D.64.b.1	**141.4.1**	P.18.b.1	M.68.g.3
D.65.f.1	D.57.b.1	D.64.c.1	D.65.i.1	P.18.c.1	M.69.b.2
D.65.h.1	D.57.c.1*		**141.4.2**	**141.5.4**	M.69.c.2
D.66.b.1	D.57.d.1*	**141.2a.4**	D.66.a.1	M.155.a.3	M.69.d.2
D.66.c.1	D.67.a.1	M.159.b.2	**141.4.3**	M.155.b.3	M.69.e.2
D.66.d.1	D.67.b.1	**141.2.5**	D.p46f.5	**141.6**	M.69.f.2
D.66.e.1	D.67.c.1	M.63.b.3	**141.5**	M.7.c.2	
D.66.f.1	D.67.d.1	**141.2.6**	M.188.b.4	M.7.d.2	**141.9.1**
D.66.g.1	D.67.e.1	M.157.d.2	**141.5.1**	M.7.e.1	M.68.a.3
D.66.h.1	D.67.f.1		M.188.a.2	M.7.g.1	M.68.h.3
D.66.i.1		**141.3.1**	**141.5.2**	M.156.a.2	M.69.a.2
D.66.j.1	**141.1.3**	D.70.a.1	M.7.h.1	M.156.b.2	M.69.g.2
D.66.k.1	D.64.d.1	D.70.b.1	M.116.b.4	M.156.c.2	M.148.a.2
D.66.l.1	D.65.d.1	D.70.c.1	**141.5.3**	**141.7.1**	M.148.b.2
D.66.n.1	D.65.g.1	D.70.d.1	P.15.a.1	M.159.a.2	M.148.c.2
D.66.o.1	**141.1.4**	D.70.e.1	P.15.b.1	**141.7.2**	M.148.d.2
D.66.p.1	D.66.q.1	D.70.f.1	P.15.c.1	M.159.c.2	
D.66.r.1	**141.1b.5**	D.70.g.1	P.16.a.1	**141.8**	**141.9.2**
D.66.s.1	M.158.b.1	D.70.h.1	P.16.b.1	M.7.i.2	M.56.a.1
D.66.t.1		D.70.i.1	P.16.c.1	**141.9**	M.56.b.1
141.1.1a	**141.2.1**	D.70.j.1	P.17.a.1	M.68.b.3	M.56.c.1
M.158.b.1	D.66m.1	D.70.k.1		M.68.c.3	M.56.d.1
	141.2.2	D.70.l.1			M.56.e.1
	D.65.b.1				M.62.f.1

From **141** to **148** is a short series of quasi-facial glyphs, in a sort of mid-territory between the face-glyphs of personages, and the conventional forms we shall come to at glyph **301**. Our insight into the meaning or use of most of these present few is quite fair—in one case even complete.

No. **141** is a glyph of very great importance, as indicated by the repeat use shown by the index, but which has, we believe, been hitherto wholly ignored. The use, repetition and alternation of the few affixes is extremely interesting, and too clear not to show definite purpose and method. Owing to the dominance of the special prefix, we have arranged the sub-numbering according to the four subfixes.

The entire glyph should be considered as a unit, controlled by the main and other prefixes, and with a position-definition supplied by the play of the subfixes. We should here recall that the Dresden is to be read as a connected whole from page 1–24, 46–74, the page of the final cataclysm; all the astronomical and other matters beginning with the Venus pages (and certainly prepared for at the start of the codex) lead up to and climax at page 74, in the middle of the reverse side. This done, and with 24 blank pages backing pp. 1–24, the writer filled them first with the wholly unrelated New Year pages, and then set out on a sort of extension or amplification of the Itzamná mythology or ritual, set forth somewhat in secs. 69, 70.

It is noteworthy that in spite of the close parallel between secs. 59, 70, glyph **141** does not appear in sec. 69, but begins its repeat office with 70. Then it continues in the same use straight through ʦ. 64, 65, 66, and 67; also serving in ʦ. 56, 57. Outside of this it only occurs twice in the entire Dresden—once in ʦ. 62 as a final, once on page 46f.

We then see it again as a repeat initial through P. 15–18, and nowhere else. Next through seven or eight Madrid ʦolkins, as repeat glyph. Not half a dozen times in all does it appear isolated. In Dresden 64 sq. it is certainly rhythmic in character; and everywhere it must connote some idea common to the series of clauses or pictures with which it is successively found.

We have above shown the full text of Dr. 64, with a translation which is complete, subject only to just what specific value this glyph has in the whole. Through ʦ.65 Itzamná is seated on trees,

or the sky, in action; in ꜩ.66 in another series of actions, largely ruling the waters. In ꜩ.67 engaged in other less strenuous acts, controlling or guided by the numbers below; through ꜩ.64, 65, 67 run the cardinal points (always ceremonial and rhythmic) and the four sacred offerings. In ꜩ.56, 57 are other like series of his activities, in ꜩ.57 again with the Four Directions.

On the Paris pages 15–18 god C, our **75,** is engaged in a quite parallel series of activities to those above noted. In Madrid ꜩ.7, the same god, **75,** dominant in that codex as Iꜩamná himself is in the Dresden, is carried through another similar series, again with the Four Directions.

At Madrid ꜩ.56 begins the hunting (something never to be begun without worship and ceremonies), and with ꜩ.68, 69 the hunting section ends, again with the Four Directions appearing, and the curious complexities of the counted colors. In ꜩ.148, 149, 188 we have special magical ceremonies to protect the fields, and in ꜩ. 159 again the Four Directions.

Through all the above runs our glyph **141,** slightly varying in its affixes, as must have been the chants and rhythms of the accompanying ceremonies. Its meaning may not have been, "Do honor, reverence and sacrifice," but it can hardly have been enough different in essence to count. And that it was rhythmic chanting, and varied as are the alternating affixes, is hardly to be doubted.

142

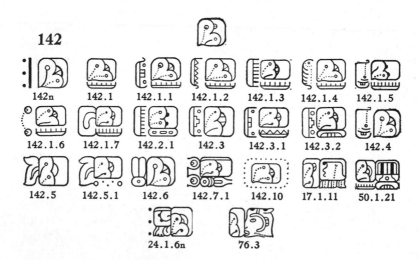

142n 142.1 142.1.1 142.1.2 142.1.3 142.1.4 142.1.5

142.1.6 142.1.7 142.2.1 142.3 142.3.1 142.3.2 142.4

142.5 142.5.1 142.6 142.7.1 142.10 17.1.11 50.1.21

24.1.6n 76.3

142	D.14.h.4	D.p48e.11	M.87.c.4	M.155.b.4	**142.3.2**
M.94.e.1	D.15.b.4	D.p49d.7	M.94.b.2	M.161.e.4	P.22.a.3
M.98.a.2	D.16.d.4	D.p49e.7	M.139.b.4	**142.1.5**	P.24.a.20
M.156.d.4	D.20.d.4	D.p49f.7	M.151.b.4	M.124.d.3	P.24.a.27
M.157.c.4	D.21.a.4	D.p50d.7	M.165.c.4	**142.1.6**	**142.4**
M.166.d.1	D.23.b.3	D.p50e.9	M.212.f.4	D.9.d.4	M.159.b.4
142n	D.25.b.4	D.p50f.2	M.218.c.5	**142.1.7**	**142.5**
M.159.a.4	D.25.d.4	D.p50f.6	**142.1.2**	D.74.k.3	D.71.g.6
142.1	D.26.a.4	D.p50d.15	D.22.e.4	D.75.f.3	**142.5a**
M.9.d.4	D.20.c.4	D.p50e.7	D.34.d.3	D.75.h.3	M.99.c.2
M.41.b.4	D.27.b.5	D.p58.e.8	D.37.e.3	D.75.y.2	M.138.a.4
M.97.a.4	D.28.b.4	D.75.e.3	D.44.b.4	**142.2.1**	**142.5.1**
142.1.1	D.29.c.3	D.75.x.3	D.47.a.4	M.125.10.1	D.70.b.4
D.7.a.5	D.29.e.4	P.4.a.3	D.48.c.3	**142.3**	**142.6**
D.7.e.3	D.33.a.4	P.6.b.10	**142.1.3**	P.3.d.8	M.100.b.2
D.8.a.6	D.40.f.4	P.23.a.19	M.p36.c.11	M.42.b.4	**142.7.1**
D.8.d.6	D.47.b.2	P.24.a.17	M.194.f.3	M.124.b.4	D.47.d.3
D.8.k.5	D.47.c.4	M.17.b.4	M.224.c.4	M.165.a.4	**142.8**
D.8m.6	D.52.a.3	M.27.b.4	**142.1.4**	M.166.c.4	D.26.c.1
D.8.s.5	D.52.b.3	M.42.d.3	D.p47f.7	**142.3.1**	**142.10**
D.8.t.6	D.p47d.7	M.p36.c.13	M.124.d.4	D.21.c.4	D.26.c.1
D.9.b.4	D.p47e.7	M.p37.c.16	M.137.c.4	D.31.a.4	
	D.p47f.5	M.63.e.1			

Glyph 142 is wholly different in its use from the preceding. It has no repeat use whatever, but has a constant appearance in the death or destruction clauses of the ʒolkins, where it is a regular companion of the Death and War gods, and glyphs 6 and 22. Its presence in a clause either with or without a picture below, may be taken as a determinative of the 'evil' force active.

It takes chiefly the very common affixes, which by their very frequency of use in all kinds of positions and so many glyphs, cannot yet be pinned down. Thus only two of the above forms call for special attention: 142.7.1 where the 'tying-up' affix ⊙Ⅽ is used, and the zero-time prefix; also 142.9.1, the only case where 142 compounds with another main element, and where it is united to the beneficent 3 Oc form, on Madrid page 36.

143

143.1n 143a.1n
D.p47b.c.4 D.p47c.d,2

This shows glyph 142 amplified in the same way as the Tun, sky and other glyphs, with the hand superfix, and number 13.

144

144.1 144.1 144.1.1 144.1.2 144.1.3
D.71.57.2 D.71.20.2 D.71.10.2 D.71.f.3 D.71.35.2
 D.71.36.2

This appears only in the eclipse ephemeris of the Dresden, and only with the 'tying-up' sign. For this reason we have separated it from **145**, which it partly resembles in form.

145

145							
145.1	145.2	145.3	145.3.1	145.4.1	145.5	145.5a	
145.6	145.7	a	b	c	145.7.1	145.7.2	
[145a]	145a.1.1	145a.1.2	145a.1.3	145a.1.4			

145	M.141.d.1	145.4.1	145.6	M.176.b.3	D.4.b.1
M.141.a.1	M.141.e.1	M.228.a.1	M.p35.c.11		D.5.a.1
M.198.d.1		M.228.b.1	145.7.1		
	145.3	M.228.c.1	145.7	M.16.b.1	145a.1.2
145.1	M.199.b.2	M.228.d.1	M.24.b.1		D.5.c.1
M.198.b.1	M.199.d.2	M.228.e.1	M.24.c.1	145.7.2	
145.2		145.5	M.24.d.1	M.19.b.1	145a.1.3
M.141.a.1	145.3.1	M.20.b.2	127.7 a b c	M.24.b.1	D.5.b.1
M.141.b.1	M.199.a.2	145.5a	M.173.a.1	145a.1.1	145a.1.4
M.141.c.1	M.199.c.2	M.20.c.2	M.173.b.2	D.4.a.1	D.7.d.1

The two forms are those of the Madrid and Dresden codices, the difference being the projecting element, which we shall come to consider again with glyph **301**. The actions shown in the ʒolkins, both Madrid and Dresden, are nearly all connected in some way with weaving frames, or woven objects. In Madrid 141 the gods are holding frames ornamented with **cauacs**; in ʒ. 198 they worship similar frames, with **cauacs,** bound with an interlaced cord, and (most curiously) with added **ik** signs. In ʒ. 199 the women are at a loom. In Dresden ʒ. 4, 5 the figures are working, whether weaving or adorning, similar frames, using needles and thread. In Dr. ʒ. 6 two figures hold up mantles, while above is seen glyph **433.4.1,** show-ing the completed woven piece, obviously just produced in the ʒolkins above. And finally in Madrid ʒ. 7 the figures hold up similar woven articles. It would seem that gl. **145** must be a weaving glyph in some way. We shall later see gl. **301** as having two definite values, one the (interwoven)

house-roof, the other where objects are carried off. The same projection as seen in the Dresden forms above, is there repeated as attached to **301**.

A most interesting question is raised by the presence of the **cauacs** in the frames in Madrid ҕ. 141, 198, the addition of the **ik**-signs on the frames in 198, and also the use of the time-element wing affix, **145.2** at ҕ. 141.

Form **145.4.1**, as repeated initial in Madrid ҕ. 228, in the Bee Chapter, does not seem connected with the above at all. Forms **145.7** are doubtful.

147

				147.1.1
				D.31.a.2
				D.31.b.2
147.1.1	147.1.2	147.1.3	147.1.4	D.31.d.2
	D.9.c.3	D.31.c.1		D.51.d.1

This remarkable glyph has only one subfix, with four very distinct qualifying affixes. It is found only in Dr. ҕ. 9, 31. It partly resembles the banded headdress, has the peculiar mouth and nose of **75**, and also the looped line we saw in gl. **81.13.1** above, which see. God C, our **75**, does not appear in any of the pictures, and the use of these elements in the glyph, which by position seems to denote activity rather than a person, plus its varying affixes, makes it a definite problem. In spite of the pictures, is probably not a sex-glyph. That we shall see definitely, later.

148

Ekchuah	a	b	c	d	e	f	g	h
D.23.d.3	M.93.c.4	M.98.b.3	M.101.5	M.161.d.3	M.197.b.1			
M.10.c.3	M.93.d.3	M.99.b.1	M.137.d.3	M.162.c.3	M.212.c.3			
M.93.b.1	M.94.d.1	M.100.a.3	M.138.b.1	M.190.g.3	M.218.d.3			

This, the glyph for the Black Merchant, with his corded hamper and head-bands, is definite and clear. The writer has no opinion as to what it represents, as a form; as a glyph, it stands for **Ekchuah**, by common agreement.

ANIMAL FIGURES

No attempt has been made to define these characters. Their study lies in natural zoology and mythology, not in linguistics. The presence of the very few defining or qualifying affixes, as in **201.1,** red tiger, **chac-balam,** or **chakekel;** such cases as the 'tie' affix specific to the vulture, **222;** the 'comb' affix in **222b.2,** the **imix** with dropping dots in **222.3** should be helpful in defining those affixes, and mythologically. Such questions are less those of syntax than of possible activities or characteristics of the animals (or perhaps naguals) involved. Why, for instance, do **213, 217,** take the well-known time-affix, the \angle? These animal glyphs are, in short, primarily pictographs, proper names, of living creatures, in their natural or mythological status.

201 201 201a 201b 201.1 201a.1 201c 201d

202 202 202a 202.1.1 201b.2 **203**

204 **205** **206**

207 **208** **209** **210**

211 **212** **213**

214 **215** **216** **217**

201	201bn	202.1.1	205	210.1	214.1
P.2.c.1	M.63.a.2	D.p24.c.9	M.33.d.2	P.10.b.8	M.115.a.4
201a	M.63.c.2	D.p26.b.5	206		
M.2.c.1	201.1	201b.2	M.2.a.1	212.1	215.1
M.41.d.4	D.8.n.3	M.p34.d.4	207.1	D.66.s.3	M.196.b.4
	D.p47e.5	M.p35.d.7	M.35.c.1		
201c	P.7.c.8	203	208.1	213.1	216.1a
M.178.b.3	M.61.f.2	M.81.1	M.80.2	M.160.a.2	M.63.b.1
201d	201.1a	204.1	209.1.1	213.1a	217.1.1
M.178.d.5	M.10.b.3	P.24.a.14	M.191.b.4	M.160.c.2	M.125.21.2

221
221 221.1

222
222.1 a.1 b.1 e.1 f.1 g.1

h h.1 i j 222b.2 222.3

223
70.21 1c 225 225.1n 225a.1n

226 227 228
226.1 345.10.1 40hn

230 231 231a 231.1* 232
230.1 231 232.1

221	P.3.c.6	222g.1	222b.2	40hn	230.1
D.65.r.3	P.8.b.2	D.8.o.3	M.229.d.4	D.47.c.2	D.75.n.1
	M.24.a.2		222.1n	D.47.e.2	
221.1	M.27.c.3	222h i j	D.71.h.6	345.10.1	231
D.66.s.2	M.57.d.3	M.26.c.2	P.11.d.4	D.72.a.23	D.66.m.3
	M.99.c.1	M.32.a.2		D.p70.c.5	P.10.d.8
222.1	M.125.5.1	M.40.b.2	222.3		
D.20.d.3	M.230.b.4	M.99.h.1	D.66.h.4	225.1n	231.1?
D.36.a.4		M.100.c.2		D.61.h.3	D.71.67.2
D.47.c.1	222e f.1		223	P.6.b.4	
D.60.d.2	M.137.a.3	222h.1	D.46.c.3		232.1.1
D.61.a.4	D.46.f.4	M.99.c.1	M.5.a.2	226.1	D.40.a.1
P.2.b.4			M 41.b.3	P.8.d.6	D.47.d.1

241
a b c d e f g h i j

241a.1 — etc.

241.1.1 241.2

241.2 241.2a 241.3.1 241.4 241.5a 241.5b 241.5c

241.5.1 241.6.1 241.7.1 242.1 242b.1 427.10.1 76.6.1

241.1	D.69.c.2	M.20.d.3	M.p78.c.4	M.87.c.3	241.5
D.8.1.3	D.69.h.2	M.p35.c.4	M.p78.d.4	M.179.d.3	M.10.f.7
D.20.a.2	D.69.i.2	M.113.d.3	M.p78.e.4	M.137.b.3	M.p34.c.4
D.10.a.5	P.2.c.12	M.p77.a.4	M.p78.f.4	M.137.e.2	M.p35.c.4
D.46.c.2	P.4.b.4	M.p77.b.4	M.170.b.3	M.138.b.2	M.p36.c.4
D.p25a.6	P.5.b.4	M.p77.c.4	M.218.h.3	M.178.d.3	M.p37.c.4
D.p25b.2	P.8.c.11	M.p77.d.4	241.1.1	241.3	241.6.1
D.p46b.e.5	P.9.c.12	M.p77.e.4	D.p24.c.8	M.5.d.1	M.125.14.1
D.p49b.c.4	P.10.d.3	M.p77.f.4	241.2	241.4	241.7.1
D.p49c.d.3	P.18.e.3	M.p77.g.4	M.56.a.3	M.123.k.1	M.131.a.2
D.p49e.10	P.24.a.16	M.p78.a.4	M.56.c.3	241.5.1	242.1
D.71.69.2	M.11.d.4	M.p78.b.4	M.56.e.3	M.159.c.2	M.125.26.2

243 243.1 243a.1 243b.1 243.2 243.2.1 243.3

244 244.1 244a.1 244.1.1 244a.1.2 244a.1.3 244a.2

245 245a 245b 245c 245d 245.1a 245.1b 245.1c

246 **247** **248** **249**

250 250 125.4 **251** 251.1

243.1	243.2.1	D.71.50.2	244a.2	246	249.1
D.71.22.2	D.p47c.b.2	D.71.52.2	P.5.b.5	M.118.c.2	P.17.c.5
D.71.46.2		D.71.58.2		246n	250
D.71.55.2	243.3	D.72.b.4	245	M.119.b.4	P.23a.31
D.71.60.2	D.p47b.a.4	M.15.b.3	D.71.19.2	M.162.c.4	251
D.75.i.2			D.71.33.2		D.63.a.2
D.75.w.2	243.2.1	244a.1.1	D.71.55.2	246.1	D.63.b.2
D.75.y.2	D.71.21.1	D.72.g.3	245.1	M.173.a.1	D.63.b.2
			D.71.c.6		D.63.d.2
243a.1	244.1	244a.1.2	D.p60a.12	247	D.69.k.2
D.71.39.2	D.71.13.2	D.71.g.5	M.137.b.3	D.p70.c.14	
	D.71.18.2		M.161.e.3		250.1
243.1n	D.71.26.2	244a.1.3	P.2.b.2		D.74.a.2
D.74.h.2	D.71.38.2	D.71.e.5	P.6.b.15	248.1	D.74.a.2
D.75.o.2	D.71.45.2	M.125.3.2		P.4.d.7	

261 261a 261.1 261.2 261.3 261.4

262 262.1 ?262.2 263 263.1 264 264

265 265.1 266 266 266.1 266.2

267 267.1 268 268.1 269 269.1 270 270.1n

271 271 271.1 271a.2 271b.3 271c*

275 275.1 275a.1 275b.1 275c.1.1 275d.1.2 275.2.1 275.3

261	262.2	266.2	271	271b.3	M.125.25.1
M.10.b.2	D.p46c.a.2	D.71.i.4	M.6.h.2	M.17.a.1	M.125.25.3
261.1	263.1	267.1		271c*	275c.1.1
D.p50b.b.4	D.75.p.2	D.72.a.33	271.1	P.5.a.7	M.p35.b.6
261.2	264.1	268.1	M.6.g.2		275d.1.2
D.71.21.2	M.125.29.2	M.17.e.2		275.1	M.p35.d.10
261.4	265.1	269.1	271a.2	M.63.g.1	275.2.1
D.60.g.1	D.p52a.b.2	M.p34.b.12	M.12.a.3	M.160.a.2	M.41.c.4
262.1	266.1	270.1n	M.12.b.3	275ab.1	275.3
D.p24.b.7	M.158.b.2	P.8.c.4	M.12.c.3	M.62.a.1	M.p8.c.2
			M.12.d.3	M.125.13.2	

276	279.1	M.219.a.3	292	D.58.b.5	293.2.1
D.62.e.5	P.8.d.9		M.220.b.4	D.67.a.4	M.125.5.3
		291.1	292a		293.4.1n
276.1	280a	M.213.a.5	M.220.d.4	293.1	D.p26b.8
D.71.8.2	M.3.d.1		292.1	P.5.d.1	D.p27c.8
		291.2	M.p8.f.6	P.7.d.11	
277	291	M.218.h.6		P.9.d.11	293.4.2
M.6.c.1	D.46.e.3		293		M.218.a.7
	D.53	291.3	D.46.a.3	293.1.1	M.218.a.9
279	D.55.e.6	D.p28.c.9	D.57.g.4	D.69.c.1	293.5
D.66.i.3	M.4c.4	M.p8.c.5			D.58.h.5

301

301.1n | 301.1.1 | 301.1.1n | 301.2 | 301.2.1 | 301.2.2 | 301.2.3

301.2.4 | 301.2.5 | 301.2.6 | 301.2.7 | 301.3 | 301.4 | 301.4.1

301.4.1a | 301.5.· | 301.5.2 | 301.5.3 | 301.5.4 | 301.5.5 | 301.5.6

30·.5.7 | 301.5.8 | 301.5.8?

301.1n	M.123.a.1	D.48.c.2	301.2.7	M.223.c.1	301.5.2
P.5.c.10		D.50.a.2	D.50.b.3	M.231.b.2	D.66.p.4
301.1.1	301.2.2	D.p26a.8	301.3	P.15.a.4	301.5.3
D.55.i.1	D.17.a.1	D.p27a.6	M.174.b.2	P.15.b.3	D.66.k.4
M.62.f.3	D.17.b.1	D.p28a.6	301.4	301.5.1	301.5.4
M.62.g.3	301.2.3	301.2.5	M.116.f.2	M.125.19.2	M.225.a.1
301.1.1n	D.18.a.1	D.39.d.2	301.4.1	M.178.a.2	M.225.b.1
P.9.c.4	D.18.b.1	D.49.a.2	D.p28b.3	M.178.c.2	301.5.5
301.2	301.2.4	D.49.b.2	D.55.d.2	M.178.d.2	M.180.c.2
M.101.3	D.33.a.2	D.p25a.6	D.66.f.3	M.179.a.1	301.5.6
301.2.1	D.34.d.1	301.2.6	D.67.e.2	M.179.e.1	M.206.b.1
M.61.d.1	D.39.a.2	D.33.b.2	301.4.1a	M.179.f.1	301.5.7
M.62.a.3	D.39.b.2	D.48.b.2	M.7.d.4	M.183.a.2	M.154.a.2
M.62.b.1	D.39.c.2	D.50.c.2	M.7.e.3	M.183.b.2	301.5.8?
M.62.d.3	D.39.d.2	D.50.d.2	M.223.a.1	M.220.c.3	P.10.d.11
M.63.f.1	D.48.a.2	D.50.e.2	M.223.b.1	M.206.b.2	

This glyph appears with three chief superfixes: the **cauac,** the roof (as defined by the many pictures of a house shelter), and the mat. Alone, with the element shown in **301.2** it accompanies the striking, binding, or carrying off a captive. The attached element corresponds to the ⊂══▱ frequently seen as beating or striking something; it also suggests the tree-knots shown on the pillars in Dr. pp. 26 sq., on houseposts, and on the upright posts to which the looms are fastened on Madrid, page 79, etc.

With the **cauac** superfix, as in **301.2.4** sq., it always is above some person carrying something tied up on his back. Below **301.3** the god holds some braided object.

With the braided mat as superfix, figures are seated on a mat, in Madrid ꜩ. 178, etc. In ꜩ. 179 they carry objects in a woven hamper on the back.

With the roof superfix (a woven or interlaced thatch, above pillars or supports, as clearly seen in house figures) the pictures constantly show these house shelters. In the Dresden we always see here this full form; in the Madrid it may be abbreviated to the simple woven 'mat' form.

With the 'comb' affix as in **301 .1n, 301 .5 .5,** its use is uncertain. Also in the form **301 .2 .2,** where we have the double oval prefix, and in the pictures two persons seated in conversation.

But wherever it has attached either the **cauac** or the mat or roof element, it is associated either with the act of binding, or carrying away bound, or with the product of that action, of binding. In this the above noted adornment of the woven frames by **cauac** signs is not only interesting, but adds one more function apparently discharged by that widely spread sign.

In Dr. 48 sq., **301 .2 .4** is regularly glyph 2, glyph 3 is **120** designating the woman seated below, while glyph 1 as regularly shows the object she is carrying in the pannier on her back.

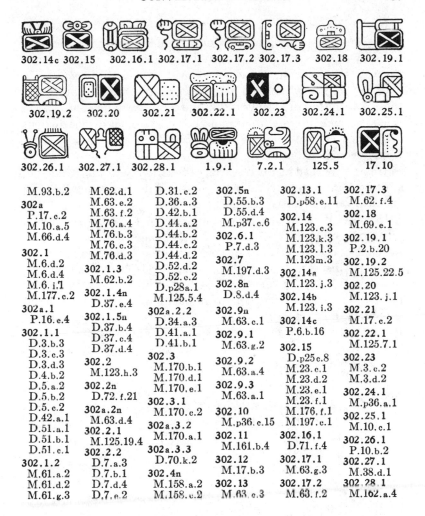

M.93.b.2	M.62.d.1	D.31.c.2	302.5n	302.13.1	302.17.3
302a	M.63.e.2	D.36.a.3	D.55.b.3	D.p58.e.11	M.62.f.4
P.17.c.2	M.63.f.2	D.42.b.1	D.55.d.4	302.14	302.18
M.10.a.5	M.76.a.4	D.44.a.2	M.p37.c.6	M.123.c.3	M.69.e.1
M.66.d.4	M.76.b.3	D.44.b.2	302.6.1	M.123.k.3	302.19.1
302.1	M.76.c.3	D.44.c.2	P.7.d.3	M.123.1.3	P.2.b.20
M.6.d.2	M.76.d.3	D.44.d.2	302.7	M.123m.3	302.19.2
M.6.d.4	302.1.3	D.52.d.2	M.197.d.3	302.14a	M.125.22.5
M.6.i.1	M.62.b.2	D.52.c.2	302.8n	M.123.j.3	302.20
M.177.c.2	302.1.4n	D.p28a.1	D.8.d.4	M.123.j.1	M.123.j.1
302a.1	D.37.e.4	M.125.5.4	302.9n	M.123.i.3	302.21
P.16.e.4	302.1.5n	302a.2.2	M.63.c.1	302.14c	M.17.c.2
302.1.1	D.37.b.4	D.34.a.3	302.9.1	P.6.b.16	302.22.1
D.3.b.3	D.37.c.4	D.41.a.1	M.63.g.2	302.15	M.125.7.1
D.3.c.3	D.37.d.4	D.41.b.1	302.9.2	D.p25c.8	302.23
D.3.d.3	302.2	302.3	M.63.a.4	M.23.c.1	M.3.c.2
D.4.b.2	M.123.h.3	M.170.b.1	302.9.3	M.23.d.2	M.3.d.2
D.5.a.2	302.2n	M.170.d.1	M.63.a.1	M.23.e.1	302.24.1
D.5.b.2	D.72.f.21	M.170.e.1		M.23.f.1	M.p36.a.1
D.5.c.2	302a.2n	302.3.1	302.10	M.176.f.1	302.25.1
D.42.a.1	M.63.d.4	M.170.c.2	M.p36.c.15	M.197.c.1	M.10.c.1
D.51.a.1	302.2.1	302a.3.2	302.11	302.16.1	302.26.1
D.51.b.1	M.125.19.4	M.170.a.1	M.161.b.4	D.71.f.4	P.10.b.2
D.51.c.1	302.2.2	302a.3.3	302.12	302.17.1	302.27.1
302.1.2	D.7.a.3	D.70.k.2	M.17.b.3	M.63.g.3	M.38.d.1
M.61.a.2	D.7.b.1	302.4n	302.13	302.17.2	302.28.1
M.61.d.2	D.7.d.4	M.158.a.2	M.63.c.3	M.63.f.2	M.162.a.4
M.61.g.3	D.7.e.2	M.158.c.2			

This glyph, a cross, occurs in several very different classes of text, in both the Dresden and Madrid. In the constellation band (see later, gl. 480 sq.) and in astronomical passages, it very probably means conjunctions. In planting and other like passages in the Madrid, it may well denote seasonal changes (note particularly with the **yax** prefix running through M. ȶ. 123), although this conclusion as well as that of celestial conjunctions, must be very carefully worked out and checked, before drawing any specific deductions.

In the forms **302.1.1** and **302.2.2** it gives us an excellent example of the dangers of drawing conclusions without verifying not only *every* passage and occurrence, but also of running down every possible counter value, or even instance which *may* be in line, but also *may not*. In a number of the pictures attending these two forms, sex converse is quite clearly indicated; but in others no such interpretation could be given except by one anxious to prove a cut-out theory, or 'discovery,' Such a method is far from uncommon, but it is equally unwise. There is only one way to treat a new lead in any research problem: try to kill it oneself, and check every countervailing datum. But these forms **301.1.1, 302.2.2** will well repay extended effort.

In spite of the prima facie simplicity of the cross-glyph as a 'meeting' glyph, there is only one form among those shown above, which does check out with a distinct and clear association meaning in every instance. With the so-called 'elephant-head' prefix, in forms **303** sq., sex-converse is shown every time in the picture below. (In view of the full ritual character of both codices, it should be taken as a viewpoint, that all such passages connote the union of *forces*, symbolized as this or that god or being, and not as referring to human marriage. Nothing in the codices supports this latter interpretation.)

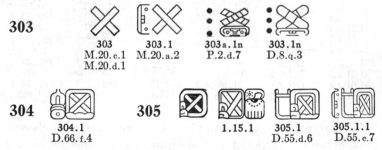

303

303
M.20.c.1
M.20.d.1

303.1
M.20.a.2

303a.1n
P.2.d.7

303.1n
D.8.q.3

304

304.1
D.66.f.4

305

1.15.1

305.1
D.55.d.6

305.1.1
D.55.c.7

These two glyphs show a remarkable instance of the incorporation method of glyph-formation. **304.1,** with the tying up prefix, is above a picture where Itzamná sits within a house, whose pillar is bound by the crossed bands; within the glyph above we see a 'wave-line.' Dr. ꜩ. 66, page 35c.

On page 34, a is a full-width picture with the head of

the corn-god, resting on an earth-sign, on top of a pyramid.

Four figures are engaged in musical and other magical acts to bring about the growth; the growing plants are seen, fire burns on a altar, and offerings of fish and turkey are shown.

Above this picture is the same cross-glyph with wave-bottom, but also with the mouth and nose we had to examine so detailedly in the matter of glyph **75,** the North; as a prefix is the 'hamper.'

Just to the right, on page 35, we see Itzamná lying at length on top of the same house as he below was sitting in, with the cross on the house-post, and himself holding forth the **Kan**-sign of the sought-for Maize. Within the house beneath him, sits god C, with fully shown mouth, nose and beard, also holding forth the **Kan.** Then above we get the same glyph as just described, but with the mouth and nose *added*, and the 'hamper' also as prefix. The cross of the house-post, the face of god C, the wave-base, are all joined in one complex, incorporated symbol. See color plate, page 78.

Incidentally, where does the Polar Star come in, in all this? This makes the third case where we have found the specific nose and mouth, with the wave-line worked into other main glyphs.

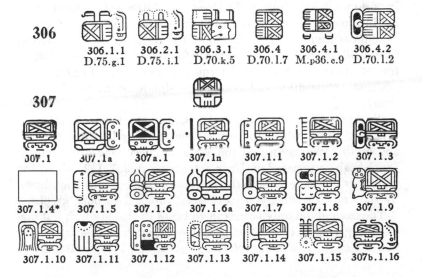

307.1.17 307.2.1 307.2.2 307.3 307.3.1 307.4n 307.5

307.6 307.7.1 307.8.1 307.9n 307.9an 307.10n 307.11.1

427.7.2 17.33 125.5 349.2 17.21n

307	307.1a	307.1.5	307.1.9	307b.1.16	307.5
D.61.a.5	P.18.f.1	D.61.j.4	P.8.b.16	D.69.k.1	P.18.e.2
D.61.f.5	307a.1	307.1.6	307.1.10	307.1.17	307.6
D.61.g.5	D.55.o.2	D.55.j.5	D.69.f.3	D.55.p.1	D.72.a.8
D.66.b.5	307.1n	D.55.h.2	307.1.11	307.2.1	307.7.1
D.66.g.3	D.71.c.7	D.60.d.3	D.71.45.1	P.23.a.10	D.69.e.6
D.66.r.5	307.1.1	D.61.h.2	307.1.12	307.2.2	307.8.1
P.5.b.10	D.71.c.3	D.65.f.3	D.71.e.8	P.11.d.7	D.69.h.5
		M.56.c.2	307.1.13	307.3	307.9n
307.1	307.1.2	M.63.b.2	D.71.24.1	D.75.f.1	D.p24.c.6
D.71.12.2	M.125.16.5		D.71.35.1	D.75.n.1	307.9an
D.71.37.2		307.1.6a	D.71.57.1	D.75.bb.1	D.p47.e.3
D.71.48.2	307.1.3	D.67.c.2	307.1.14	307.3.1	307.10n
D.71.54.2	D.61.g.1		D.71.29.1	D.p74.6	D.26.c.2
D.71.56.2	P.9.d.4	307.1.7	D.71.e.3	D.75.r.1	307.11.1
D.71.61.2	P.9.d.8	D.p74.7	307.4n	M.123.1.4	
D.71.62.1	307.1.4*	307.1.8	307.1.15	D.8.s.3	307.12.1n
P.24.a.15	D.69.a.2	D.69.i.5	D.70.d.2	D.10.b.3	M.125.5.4

This glyph, to be rendered **caan**, sky or heavens, is of first importance in any study of the Dresden. Fifteen of its occurrences are in the eclipse ephemeris, and most of the rest in ꜩ. 55 or the Iꜩamná sections. The solution of the meaning of the different forms will follow detailedly on the definition of the affixes. Only a few of these can now be determined, but every form and its position, composition and associations should be given exhaustive study.

We have referred above, under **Caban,** to form **17.33,** from the Tikal lintel, where the sun is seen entering between the sky and earth. We again find the earth and sky (**cab** and **caan,** in Quiché **cah**) associated on Dr. p. 74, above gl. **307.1.7,** where the reading is, "darkness on earth, darkness in the heavens," as shown by the known color glyph for 'black,' prefixed to both glyphs.

The **caan** glyph only occurs three times in the Madrid, but one of these giving an interesting probable value: ꜩ.56, the first of the hunting chapter (already referred to under gl. **141**), contains five

clauses, *abcd*. 2 showing the four cardinal points. The fifth clause, at *e*.2, changes to our form **307.1.6**, with the 'tying-up' prefix. A fair and probable rendering would be, "the four quarters of the earth, and all the heavens," *todo el cielo*. The same form occurs in six other places, q.v. At ҕ.55.h.2 it comes next after the 'thunderbolt' clause and glyph (see above, under **Cauac**).

The glyph occurs constantly where we also find the sky- or constellation-band; the instance at sec. 71.c.7, with a number 6, should be studied. **307.9**, with an unusual prefix, and occurring on pp. 24, 47, should help to throw light on the numeral **10** and ?**11**, with the same dot above the **10** as we noted in connection with the War-god glyph no. **95**.

Forms **307.4**, **307.10** give us the Thirteen Heavens, a known mythological reference, **oxlahun ti caan.**

The subfix (⬭) appears as the specific determinative throughout; in fact, no other subfix or postfix appears at all except in **307.2** (both Paris codex forms), and **307.6**; query **307.9** as a particular variant of the same subfix.

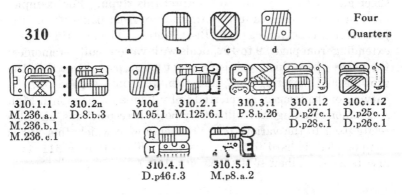

This probably denotes the Four Quarters, especially as used initially in division *c* of each Dresden New Year page. In the incomplete M.ҕ.236, at the end of what we have, it occurs three times as initial, followed each time by the earth-sign.

311

					311.4	311.4.1
311.1	311.2.1	311.3.1	311.3.2	311.4	M.191.b.3	D.67.d.2
M.192.b.1	M.210.a.1	D.58.e.4	D.67a		M.192.b.3	D.70.c.2
	M.210.b.1				M.195.c.1	M.7.f.2
					M.197.g.2	M.230b2

311.4.1 311.4.2 311.4.3 311.4.4 311.5
 M.204.a.2 M.102.a.1 M.186.e.2

M.202.b.3 311.4.4
M.203.a.2 M.161.a.2
M.203.b.4 M.161.b.2
M.203.c.1 M.161.d.2
M.203.d.1 M.161.e.2

311.6.1 311.7.1 311.7.2 311.8 311.8.1 311.8.2 311.8.3
M.27.b.1 M.201.b.3 M.201.c.2 P.16.b.4 P.16.b.5 P.17.a.4 P.15.c.5

17.7 31b.15.1 76.5 95b.5n 90.2a 4.2.2 307.1.11

Although of quite frequent and even repeat occurrence, it were sheer guessing to try now to interpret this glyph. For example, most of its occurrences in the Madrid are from pages 97 to 101, just before the beginning of the Bee chapter. The Madrid chapter extending from page 89 to 102, deals with various cult ceremonies; the pages where this glyph is frequent are in part devoted to the growing and flowering corn, and then pass into sections on the carving of the images, as referred to by Landa in the month **Mol**. A common meaning that will satisfy both these positions, and also relate itself to the various other elements with which this **311** is compounded, is hard to find. Its chief affix is that in **311.4**; it also takes the **caban** subfix, see form **311.7**.

312

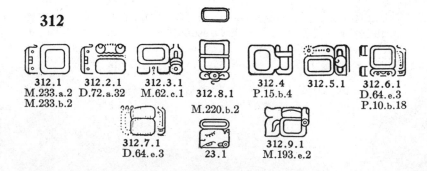

312.1	312.2.1	312.3.1		312.4	312.5.1	312.6.1
M.233.a.2	D.72.a.32	M.62.c.1	312.8.1	P.15.b.4		D.64.e.3
M.233.b.2						P.10.b.18
			M.220.b.2			

312.7.1 23.1 312.9.1
D.64.e.3 M.193.e.2

A glyph that is a mere hollow outline quite challenges one's imagination; but the forms shown are not cases of partly erased glyphs, but are clearly left with unfilled centers. Only knowledge of their affixes can aid us.

313

a b
P.16.a.4

313.1
D.57.c.2

313.2.1
D.66.t.3

This glyph has been assigned the meaning of Water on the basis of its appearance in the various pictures. It is always being walked through, and nearly always carries the coloring green.

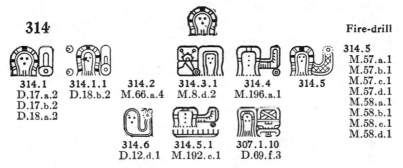

314

Fire-drill

314.1
D.17.a.2
D.17.b.2
D.18.a.2

314.1.1
D.18.b.2

314.2
M.66.a.4

314.3.1
M.8.d.2

314.4
M.196.a.1

314.5

314.5
M.57.a.1
M.57.b.1
M.57.c.1
M.57.d.1
M.58.a.1
M.58.b.1
M.58.c.1
M.58.d.1

314.6
D.12.d.1

314.5.1
M.192.c.1

307.1.10
D.69.f.3

The present writer is wholly opposed to all 'pictographic' interpretations of glyphs, based on what the individual interpreter *thinks* the glyph looks like or represents, except where the representation is so obvious as to require general recognition, or where a positive association gives the necessary weight to the evaluation. Also, in this latter case only where the interpretation fits every known case to which it can apply, and (still more strongly) is not contradicted by any other position or factor.

In all research, interpretation of phenomena, forms, or code reading, a preliminary and tentative 'guess' or hypothesis is a necessary step; but it must be followed by a rigid try-out, and an effort by its author not to be too charitable to his own mental offspring, and too quick to proclaim something, but to disprove it himself first, if he can; instead of leaving the disproof to come from outside—as it certainly will, if deserved.

In so difficult a problem as the present, and after all the futile, imaginative efforts to read the Maya glyphs, the writer has tried to be rigid in the above principles, to rely himself first and last on 'association' methods just as he would in any effort to read a cipher; and rather to make the present work an aid to study, for himself and others, by its gathering of the glyph-forms, and full classification and cross-indexing.

The 'firewood' glyph was first suggested by its appearance burning, on the back of the woman in Dr.50.b, and its recurrence above, as a glyph, with the flares. Those flares reappeared with the **cauac** thunderbolt, or 'fire-stick' over the torch-bearing, descending **Xul**-animal. And the fire-wood glyph again appeared in association with this **314.4**, with the fire-drill in operation in every case in the picture. In M. t͡s.57 the red sparks come from the wood, in the pictures; in t͡s.58 the base changes to a flint, and the et͡s'nab or flint sign replaces the flared wood sign in t͡s.57, with what we can therewith feel safe in calling the rising sparks. In M.t͡s.192 and 196, we again get the same glyph (forms **314.5**), and the fire-drill in operation below.

Finally, in Dr.t͡s.6 we have the form **314.4a.1**, with a fire-drill. Dots, and small curves can of course mean anything, according to circumstances; but the glyph-writer certainly intended them, here as in all other parts of his writing. And quite as certainly, the Maya glyphs are ideographic, with ancient pictographs behind them just as also lie not only behind the Chinese, but the Egyptian and Cuneiform hieroglyphs, and even our own letters. We shall in the future doubtless come to see many original pictographs behind the Maya (as we still can, upon *historical* study, in the otherwise blind Chinese characters); only so that we do not anticipate the 'proof' but rely on our only present available evidence—the association grounds. This is, in fact, the only way that a single Maya glyph has ever been fixed, outside of the direct tradition through Landa, and in the bit of Kekchí month-meaning evidence above cited.

For the meaning of the main element, or as in form **314.2,** the writer has no suggestions to offer. In each of the two Dresden t͡solkins, we see two seated figures in conversation. We can only hope that some other student will see a definable link, showing why this element, part of the fire-making sign, should be used here.

317

a b

See 70.9

317.1.1 317.2 317.3.1 317.3.2
D.71.f.6 M.42.a.4 M.p35.c.9 D.75.i.2

318

318.1.1 318.1.2 318.1.3 318.1.4 318.2.1 318.3.1 318.4.1n
D.66.r.4 D.69.c.6 D.60.b.4 D.69.g.6 D.60.f.4 M.p35.c.8 M.125.9.2
 D.69.1.6

319

a b c

319.1 319.1.1 319.1.2 319.2.1 319.3.1 319.4.1 319.5.1

319.1 319.1.1 319.1.2 319.2.1 319.4.1
M.39.a.2 M.39.b.2 M.117.c.1 M.127.a.1 P.9.b.8
M.117.a.1 M.39.c.2 M.127.a.3
M.117.b.1 M.39.d.2 319.3.1 M.127.a.5 319.5.1
M.117.c.1 M.176.b.1 M.178.a.1

The drawing renders uncertain the inclusion of the above forms
under one head. All occur in the Madrid, and at first try would be
taken to indicate the woven mat, or bag, *costal*. Note the clear
difference in the superfixes; in M.ꜩ.127 the whole glyph looks like
a tied-up bag, and below four "gods draw from their stores," as
described by Brinton. In ꜩ.178 a mat is shown in the pictures,
but that **319.5.1** refers to it is more than doubtful. Finally, in
ꜩ.39, 117, form **319.1**, the figures are all engaged in planting. In
ꜩ.39 we have a typical four-clause ꜩolkin: the initial glyphs the
cardinal points, no. 3 gl. **77** with the four colors just as shown in
Dr. ꜩ.64, page 105 above, gl. 4 the earth-sign with a superfix
that can hardly be other than the sprouting seeds the figures are
planting, gl. 2 the above **319.1**.

320 Firewood

320.1 311.6

320.1.1 320.1.2 330.2.1 320.3 320.4.1 320.5.1n 76.7.2

320.1	M.10.c.4	M.10.a.3	M.57.d.2	320.3	320.4.1
D.50.b.1	M.10.d.2	M.57.a.2	P.2.c.7	M.65.h.3	M.125.14.3
D.p58.e.4	320.1.1	M.57.b.2	320.1.2	320.2.1	320.5.1n
M.6.h.1	D.61.h.1	M.57.c.2	M.56.b.3	M.60.f.3	M.125.15.1

On purely association grounds this glyph develops the clear
meaning of wood or firewood, as reference to the pictures in
the above references will show. In Dr. ꜩ. 50. b a woman
bears the sign, with flames, on her back; above is the
glyph **320.1**. We have just seen its association with the
fire-drill, and the fire-kindling flint. In Dr. page 58 (no
picture) the text includes this same flint-form, and also
the **Xul** or torch-bearing animal we have noted in connec-
tion with the **cauac** thunderbolt. M. ꜩ. 6, 10 show flames; D. ꜩ. 61
a macaw with torches; in D. ꜩ. 65. h the god sits within a tree
(or possibly imprisoned); D. ꜩ. 60. f, the god holds a bundle of
sticks (note the loop subfix to form **320.3**).

Only in M. ꜩ. 56 is there no correspondence in the pictures to
this glyph, in b.3. But the pictures here do not correspond to
any of the text above. It is the introductory ꜩolkin to the
hunting chapter, discussed above as a ritual or incantation
section; none of the gods whose glyphs appear are seen below, but
instead only five hunters setting out, and capturing. The text is
obviously not a translation of the pictures, as it often is.

The only remaining use of this glyph is in a position which seems
to call for a notation. In the long Madrid ꜩolkin 125, clauses
14, 15, we first find in the text the above form **320.5.1,** showing a
superfix allied to the **katun** superfix (a period sign), and prefixed
by a normal zero-time sign. In clause 15 we find again the wood
sign, surmounted by the superfix which changes **Kan,** the maize, to
the month **Cumhu** (query, the corn fruition or harvest), and with
the postfix ꜩ). We have referred to this postfix in discussing
glyph **59,** and shall go more into detail in our last section, upon the
Affixes. But, this affix, used with at least 25 different main

elements, can without straining be read as denoting the conclusion of what has been gone through, taken, or counted. This value will fit perfectly its position after the Supplementary Series Glyph C and its preceding signs, taken all together as a total, reached or passed. This leaves the variable element in Glyph C to its quite certain proper place, as the lunation definer. This postfix now is added to the wood-sign, as in form 320.4.1.

The combination of all these elements, most of them already definitely settled in values, brings up a query whether we cannot consider these two forms as denoting the beginning (zero-time) of the wood-burning time, and its finish; after which the growth of the maize comes on, as seen in the picture under the second form.

Glyphs 321 to 325 are all very common affixes, three of them among the most common in the whole list. The affixes or minor

elements, as determinatives or syntactic elements of the glyph forms, will be gathered into one final section. These five are here placed, however, since each has itself become a 'main element,' and in its turn defined or qualified by affixes. These combinations are striking enough in themselves. What can one say of the 'comb' doubled, with the important subfix, and a *numeral*? Of the development of the very common gl. **324**? The student should also note the full parallel between the flint, under the fire-drill, and form **321.1**.

323

323.1n	323.2	323.3	323.5	323.6n	323.7	1.26.1
M.131.a.4	M.p78.e.5	M.p77.e.5	M.157.a.3	M.131.a.1	M.204.b.4	M.204.b.3
			M.159.a.3		M.204.d.4	M.204.d.3
			M.159.b.3			
			M.159.c.3			

324

a b c

324.1 324.1a 324.1b 324.2.1 324.3 324.4 324.4.1 324.5.1

324.6 323.6.1 324.6.1a

324.1	324.1a	324.1b	324.3	324.5.1	M.168.b.1
D.17.a.6	M.24.b.4	P.3.b.16	D.71.65.1	M.168.a.2	M.168.c.1
D.23.c.4	M.87.c.3	P.10.b.19	324.4	324.6	324.6.1a
D.p27a.8	M.123.b.1		M.166.a.1	M.118.b.3	M.173.a.1
D.61.e.3	M.125.2.5	324.2.1	324.4.1	324.6.1	M.173.b.1
		D.74.c.3	M.94.a.4	M.168.a.1	M.173.d.1

325

325.1	325.3	325.2.1	325.3.1	325.6
M.140.b.1	M.76.b.1	D.p27a.4	M.140.a.1	M.162.g.2
		D.p28a.4		

11.5.1 14.1.1 23.9.1 70.1 302.1.2

326
Venus

326	326.1	326.1	326.2	125.9

326	D.p24.c.5	D.p47b.c.5	D.p48b.b.5	D.p49c.a.4	D.p50b.d.5
D.71.4.2	D.p46c.a.4	D.p47b.a.3	D.p48b.c.5	D.p49c.b.4	D.p50c.a.4
D.71.j.16	D.p46c.b.4	D.p47c.b.3	D.p48b.d.5	D.p49c.c.4	D.p50c.b.4
326.1	D.p46c.c.4	D.p47c.c.3	D.p48e.4	D.p49c.d.4	D.p50c.c.4
D.p24.a.5	D.p46c.d.4	D.p47c.d.3	D.p49b.a.5	D.p49e.4	D.p50c.d.4
D.p24.a.7	D.p46d.4	D.p46c.4	D.p49b.b.5	D.p50b.a.5	D.p50d.4
D.p24.a.9	D.p46e.4	D.p48b.d.5	D.p49b.c.5	D.p50b.b.5	326.2
D.p24.b.3	D.p47b.a.5	D.p48b.a.5	D.p49b.d.5	D.p50b.c.5	M.123.c.4

That this is the glyph for the planet Venus is generally accepted, on the strength of its repetition on the corresponding Dresden pages. It occurs just once in the Madrid, and a few times, we believe in the inscriptions. It is found twice in the eclipse ephemeris, all the other times on pages 24, 46–50. Everywhere in the latter it carries the prefix red.

327

327.1	327.2	327.3	125.10	17.22.1	70.18

	327.1	D.p24.c.7	P.p46b.c.5	D.p50e.4	
327	D.p24.a.6	D.p46b.a.5	D.p47b.d.5	327.2	327.3
D.p47b.d.5	D.p24.a.8	D.p46b.b.5	D.p47e.4	P.5.d.6	P.7.d.1

This glyph, no. **327,** has been generally taken as an equivalent of **326,** because of its resemblance to a 'half' of **326,** and occurrence only on these pages, also with the prefix red. This identification with the planet may be provisionally accepted, subject to later and better definition.

328

328.1n	328.2	328.2.1	328.3	328.4	328.4.1	328.4.1?*
D.31.a.3	M.176.f.1	P.5.c.9	P.10.c.10	P.6.c.9	P.9.c.1	P.11.d.3

328.5	328.6	328.7.1	328.8	328.9.1
P.10.c.10	M.p35.c.14	P.17.b.4	M.p35.b.14	M.p35.d.10

7.3.2 23.3.3 77.1.3 81.8 144.1.2

The form on Madrid page 35, may be a different glyph.

329

| 329.1 | 329.1 | 329.1.1 | 125b.7.1 | 329.2.1 | 329.3.1 | 329.4 |
| D.71.65.2 | D.72.b.3 | D.71.g.1 | D.69.b.3 | D.71.f.8 | D.71.68.1 | D.71.b.5 |

This and the next occur only in the eclipse chapter.

330

330.1.1	330.1.2	330.1	330.2.1n	125b.8.1	427.7
D.71.b.4	D.71.46.1	D.71.34.2	D.71.b.10	D.71.30.1	
		D.71.a.3			
		D.71.9.2			

331

331.1n 331.2 331.2.1 331.2.2 331.2.3 331.2.4 331.2.5

331.2.6 331.2.7 331.2.8 331.2.9 331.2.10 331.2.11 331.4n

331.5 331.6.1 331.7.1 331.8.1

The chief thing to note about this glyph is that its dominant, almost its only, affixes are the 'ben-ik' with the specific vinal affix seen in **Pop,** etc.; next its taking of the wing-affix, and. numerals in two places.

331.1n	D.71.d.6	P.6.b.5	P.11.b.7	331.2.4	331.2.9
M.125.17.3	D.71.i.3	P.6.b.21	P.11.c.3	M.41.e.3	M.125.12.1
331.2	P.2.b.1	P.7.b.12	P.11.c.11	M.125.15.5	331.2.10
D.20.a.4	P.2.b.3	P.8.b.1	M.121.a.3	331.2.5	M.125.7.5
D.p28b.1	P.2.b.5	P.8.b.3	M.121.b.4	M.125.20.1	331.2.11
M.p37.c.7	P.3.b.5	P.8.b.5	M.122.a.4	M.125.27.1	M.125.20.5
M.202.b.1	P.3.b.7	P.9.b.1	M.124.a.4	M.125.29.1	M.125.2.4
331.2n	P.4.b.1	P.9.b.3	M.141.e.4		331.3
M.125.33.12	P.4.b.3	P.9.b.5	M.142.a.4	331.2.6	M.30.d.1
331.2.1	P.4.b.5	P.10.b.1	M.144.c.4	D.p25b.1	331.4n
D.8.e.5	P.4.b.6	P.10.b.3	M.154.a.4	D.p27b.1	M.56.b.4
D.8.g.6	P.5.b.1	P.10.b.5	M.154.a.4	M.125.23.1	331.5
D.15.a.4	P.5.b.3	P.10.b.7	M.165.d.3	M.125.24.1	M.30.d.1
D.22.b.4	P.5.b.5	P.10.b.9	331.2.2	M.125.32.1	331.6.1
D.29.b.4	P.5.b.7	P.10.c.4	D.7.b.4	331.2.7	M.p37.c.10
D.p26b.1	P.5.d.2	P.11.b.1	331.2.3	P.24.a.22	331.7.1
D.p49d.8	P.6.b.1	P.11.b.3	M.12.d.4	331.2.8	M.p34.b.7
D.p50e.10	P.6.b.3	P.11.b.5	M.173.a.3	D.71.h.9	331.8.1
					M.p35.b.9

It is only at present a bare suggestion; but we have not yet
verified a glyph that must surely exist in what texts we have,
namely for the **haab**, or solar year. The peculiar position and
repetition of this **331.2.1** on the first side of the Paris codex, in
Madrid 125, and in the Dresden, have suggested this as a
candidate for that meaning. It occurs besides on the New Year
pages, both Madrid and Dresden, where such a glyph should by all
means be expected.

332

332.1.1	332.1.1a	332.1.2	332.2	332.3.1	332.4.1*	332.5
D.p49 f.8	P.21.a.9	D.p60b.9	D.71.66.2	D.75.e.2	P.7.b.8	D.55.e.4
D.p60b.10						D.57.c.4
						D.70.c.5

This glyph again takes the same pair of affixes, and occurs almost
wholly in astronomical passages in the Dresden.

333

333.1	333.1.1	333.1.2	333.2	333.2.1	333.3.1
D.51.a.4	D.71.j.4	D.29.f.3	M.p37.b.1	M.p34.b.1	M.158.c.3
		D.44.a.4		M.p35.b.1	
				M.p36.b.1	

This again takes the same pair; and is also found in the same position on all four Madrid New Year pages, with the **Cumhu** superfix. Form **333.3.1** may not belong here.

334

334nn
D.8.t.4

334.1
D.71.a.4

344.1a

334.1a
D.71.16.2
D.71.27.2
D.71.32.2
D.71.64.2

334 at least is certainly an astronomical sign.

335

D.8.m 3

338

P.23.a.14

336

336.1.1 336.1.2 336.1.3 336.2.1 336.3.1 336.4.1 11.5.1

336.5 336.6 336.7 336.7.1 336.7.2 336.8.1 336.9 340.9

336.9.1 336.10n 336.11.1 336.12.1 17.16.1 307.8.1 344.8

319.5.1 77.1.4

336.1.1	336.2.1	M.66.c.2	M.69.d.3	336.7.1	336.9
D.11.b.3	D.9.e.1	M.66.d.2	M.69.e.3	M.66.a.1	M.142.a.1
D.29.c.4	336.3.1	M.67.e.2	M.69.f.3	M.66.b.2	M.142.b.2
D.34.d.4	D.26.a.4	M.68.b.2	M.111.a.2	M.66.e.2	336.9.1
	336.4.1	M.68.c.2	M.111.b.2	M.68.a.2	M.142.b.1
336.1.2	D.57.b.5	M.68.d.2	M.111.c.2	M.68.h.2	336.10.n
D.29.a.4		M.68.e.2	M.111.d.2	M.69.g.3	M.218.g.4
D.51.b.4	336.5	M.68.f.2		336.7.2	336.11.1
	D.62.a.5	M.68.g.2	336.6	D.58.d.3	M.164.c.2
336.1.3	336.7	M.69.b.3	D.74.b.3	336.8.1	336.12.1
D.37.f.4	M.66.a.2	M.69.c.3	D.74.e.4	M.61.c.3	D.72.b.6

This glyph must be carefully distinguished from **Imix, Mac** and **Ix,** each of which it resembles in part. The indications as to its meaning are not sufficient for anything definite as yet. As seen by its compounds and the associated pictures, it is much connected

with hands and with acts of taking; note the knife and club affixes to form **336.8.1,** where a captive is seized by the hair.

A noteworthy combination is with gl. **340,** which for several reasons the writer has tentatively considered as meaning flesh, meat. **336** and **340** are combined and repeated fifteen times in M. ꜩ.66–69, and again four times in ꜩ.111; in all it is a repeat glyph, in the second or third position. In ꜩ. 111 it is repeated below the Four Directions, and immediately above four altars.

In form **336.9** it accompanies D and A drawing a cord through the member; the prefix shows the cord itself, as seen also in gl. **340.9**; also see the cords of the pack on the shoulders of Ekchuah, and the cords about his head.

337

337.1 337.1.1 337.1.2 337.1.3 337.2 337.3 337.3.1

337.4 337.4.1 337.4.3 337.4.4 337.4.5 337.4.6 337.4.7

337.4.8 337.4.9 337.4.10 337.4.11 337.4.12 337.4.13 337.4.14

337.5.1 337.6.1 337.6.1a 337.7* 337.8.1* 337.9.1 337.10.1

337.11.1* 337.12 See 17.2 etc. 1.23.1 431.6.1 9.3.1 434.4

337.1	337.3.2	337.4.6	D.61.i.4	337.4.12	M.125.26.1
D.75.s.3	P.5.c.5	M.42.e.1	D.63.d.4	P.11.c.12	337.7*
337.1.1	337.4		D.p40a.0	337.4.13	M.191.e.1
D.p24.b.11	P.5.a.3	337.4.7	D.75.b.2	M.p34.d.8	
337.1.2	337.4.1	D.59.d.7	D.75 u.2		337.8.1*
D.p48e.10	D.p25b.5	D.74.j.4		337.4.14	M.43.c.4
		D.75.m.3	337.4.9	M.p36.b.12	
337.1.3	337.4.3	D.75.c.3	D.63.c.5		337.9.1
D.71.b.9	M.42.c 2	D.p74.15*	D.68.b.5	337.5.1	M.p36.b.7
337.2	337.4.4	P.23.a.22	337.4.10	P.22.a.8	337.10.1
P.23.a.21	M.42.b.2	M.5.e.2	D.63.a.6	337.6.1	D.71.j.3
337.3	337.4.5	337.4.8	337.4.11	M.125.8.4	337.11.1*
M.2.c.2	M.42.d.2	D.61.f.4	D.p48e.12	M.125.13.1	P.21.a.10

Glyph **337** occurs heavily in planetary or constellation divisions of the Dresden, as well as M.ꜩ.125 (which is to be rated in the same general class, and distinct from the usual Madrid farm and hunting, etc. sections); also at the end of the Paris ms.

It takes prefixed all the colors, except red; and (what is most important) it forms a persistent 'pair' with **caban,** as we have above seen. The student's very first question in this connection must be: What can be the special meaning of this character which causes it to pair with the *known* earth-sign? That is the one road upon which success all through this task must follow. That question, adapted to the different contexts, and then followed by full and complete cross-checking and tabulation.

Forms **337.4.13, 337.4.14** and **337.10.1** *may* not belong here, but the presence of the hand-superfix would indicate its rightness here. Also note that the down-line is at times a jagged one.

339

| [339.1] | 339.1.1
P.3.c.4 | 339.2
D.61.f.2 | 339.3.1
M.157.a.1 | 339.4.1
M.175.d.2 | 339.5.1
P.17.b.3 | 125.3 |

One glyph, with four different prefixes, in four wholly distinct contexts, in three codices. ??

339a 339a.6
D.71.54.1 D.71.26.1

This shows similarity in form with gl. **339,** but standing alone in the eclipse ephemeris, is to be taken as distinct.

340 Flesh?

| 340.1 | 340.2.1 | 336.7.2 | 348.2 | 31a.14.1 | 340.3.1 | 77.21.1n |

| 340.4.1 | 340.5 | 340.6 | 340.7 | 340.8 | 340.9 | 340.10 |

340.1	340.2.1	340.4.1	340.5	340.7	340.9
M.76.a.3	D.58.c.3	M.8.a.2	D.71.f.1	M.16.b.2	M.142.b.2
M.76.c.2	340.3.1	M.8.b.2	340.6	340.8	340.10
M.76.d.2	D.58.a.3	M.8.c.2	M.61.b.1	M.21.a.2	M.p8.c.3

In form **340.5** this glyph is above a vulture feeding on a slain deer; the superfix is again used as a prefix at M.ꜩ.62.a.2, below which a rattlesnake is biting the hunter's foot. In forms **340.5** and **340.6** it is glyph *ab*.2 in M.ꜩ.142, above two pictures where D and A draw cords through their flesh, or member.

We have above reproduced Dr.ꜩ.58 in full; the reader should note the repetition of gl. **340** in varying compounds at positions *abcd*.3, above the four meat-offerings of fish, iguana and turkey. In M.ꜩ.76 we find the Four Directions, **340** three times with an **Imix**, form **340.1**, and once with the **Xul**-head (the devourer); with at least three of the Direction colors, correctly placed and with numerals; finally with a cross-glyph, with a coarsely drawn prefix resembling either **yax** or **ma**, but more probably the latter.

As noted before, the above collocations suggest that **340** may mean 'meat, flesh.' The two kinds of food, meat and bread in general, are sharply distinguished throughout Indian usage and language.

Some instances do not show the saw-edge; this may change the glyph.

341

341	341.1	341.2.1	341.3	341.4n	341.4.1	341.4.1n	341.5
M.76.a.6	'ben-ik'	M.123.k.4	P.23.a.17	D.p26a.15	D.p25a.13	M.181.a.3	M.40.d
				D.p27a.14			
				D.p28a.15			

356.1	356.1.1	14.6.1	1.25.1	310.4.1	331.5

This sign has up to now been erroneously called an **ik**, an error that we are fortunately able to trace to its direct origin. In the day-column to ꜩ.137, Madrid p. 87, is an **ik**-sign which examination (especially with photographs, which the writer has), shows to

be partly erased, but which is certainly only of the normal form. In his *Essai sur Déchiffrement*, printed in 1876, De Rosny read and copied this as ⊞ giving the citation of the passage. No other case of this form is anywhere listed, or appears.

The **ben-ik** superfix is however a very common and important suffix, and since it holds this element (otherwise unnamed or deciphered) it received that name, which has persisted in all writings from then to now. The form is not the day-sign, or wind-sign **ik**.

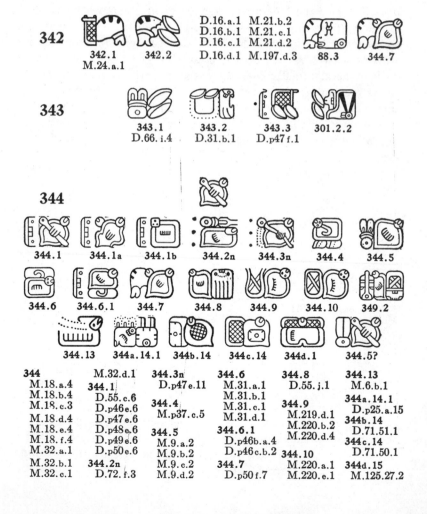

342		D.16.a.1	M.21.b.2		
		D.16.b.1	M.21.c.1		
		D.16.c.1	M.21.d.2		
342.1	342.2	D.16.d.1	M.197.d.3	88.3	344.7
M.24.a.1					

343				
	343.1	343.2	343.3	301.2.2
	D.66.i.4	D.31.b.1	D.p47 f.1	

344

344.1	344.1a	344.1b	344.2n	344.3n	344.4	344.5

344.6	344.6.1	344.7	344.8	344.9	344.10	349.2

344.13	344a.14.1	344b.14	344c.14	344d.1	344.5?

344	M.32.d.1	344.3n	344.6	344.8	344.13
M.18.a.4	344.1	D.p47e.11	M.31.a.1	D.55.j.1	M.6.b.1
M.18.b.4	D.55.c.6		M.31.b.1		344a.14.1
M.18.c.3	D.p46e.6	344.4	M.31.c.1	344.9	D.p25.a.15
M.18.d.4	D.p47e.6	M.p37.c.5	M.31.d.1	M.219.d.1	344b.14
M.18.e.4	D.p48e.6			M.220.b.2	D.71.51.1
M.18.f.4	D.p49e.6	344.5	344.6.1	M.220.d.4	344c.14
M.32.a.1	D.p50e.6	M.9.a.2	D.p46b.a.4		D.71.50.1
M.32.b.1	344.2n	M.9.b.2	D.p46c.b.2	344.10	344d.15
M.32.c.1	D.72.f.3	M.9.c.2	344.7	M.220.a.1	M.125.27.2
		M.9.d.2	D.p50f.7	M.220.e.1	

Brinton calls this a conch shell, but one cannot possibly read 'conch shell' into all the passages where this glyph occurs. In forms **344.1, 344.3** the center can be easily imagined as a conventionalized hand, holding some sort of a cross-rod, or a bone. As a whole, the glyph could be a conventionalized residuum of a picture of almost anything one might think of. All writing, whether phonetic letters or ideographic symbols, goes back to an ultimate base in a pictograph; tracing it down is wholly a historical question, and a matter of direct evidence, which amounts in short to proof. When we at last know the primitive, we can see the chain; although even that does not tell us how to use the final result today. To know that our letter A came down from the picture of a bull, and G from that of a camel, is historically comfortable, but of no use in correct spelling.

So with glyphs. Knowing from real evidence that the **kin**-sign does mean sun, gl. **320** a firewood sign, one can see in each an excellent graphic representation, somewhat conventionalized, of what they stand for. But any other shape, starting from other originals, once established in use, would have served the same linguistic ends. And once the conventionalization has passed to where it can mean different things to different people, pictographic speculation ceases to be a help, and becomes an actual hindrance.

That **344** is an important glyph is shown by its numerous forms, and many and varied associations; it comes in growing plant sections, the eclipse ephemeris, the Venus pages. In form **344.12.1** it is combined with the (?dog's) backbone and the sky-sign. What we can really only say is that something is being done to something; yet that does not mean that the student by careful and checked study of the passages (either direct or parallel) might not hit on some common linking factor of meaning.

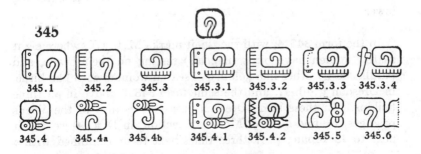

345

345.1 345.2 345.3 345.3.1 345.3.2 345.3.3 345.3.4

345.4 345.4a 345.4b 345.4.1 345.4.2 345.5 345.6

345.7.1 Moan 345.7.2n 345.10.1 345.8.1 345.9.1 93.8.1

345.12.1 345.13.1 345.14.1 345.15.1 19.35.4 427.9

345.1	M.58.d.4	M.179.c.2	M.209.c.4	345.4.1	345.8.1
D.p48d.15	M.61.e.3	M.179.f.2	M.213.d.5	D.40.a.2	D.24.a.1
M.147.b.4	M.147.d.4	M.180.b.5	M.225.b.4	D.40.b.2	D.24.b.1
M.229.d.3	M.152.b.4	M.186.c.4	M.228.d.5	D.40.c.2	D.24.c.1
345.2	M.214.b.4	M.191.b.1		D.40.d.2	D.24.d.1
M.12.e.4	M.228.b.4	M.191.d.2	345.3.3	D.40.e.2	345.9.1
	M.231.b.5	M.191.f.3	M.143.c.4	D.40.f.2	P.10.d.6
345.3	M.231.d.4	M.192.c.4	345.3.4		345.10.1
M.26.e.3		M.195.a.2	M.125.33.8	345.4.2	D.47.e.2
		M.195.b.2		D.47.a.2	D.48.c.2
345.3.1	345.3.2	M.195.c.2	345.4	345.5	93.8.1
D.p24.a.10	M.164.b.3	M.195.e.2	M.12.a.2	D.48.c.1	D.66.r.2
D.p46e.9	M.164.e.3	M.197.e.5	M.12.b.2		345.12.1
D.p46f.4	M.169.a.4	M.196.b.1	M.12.c.2	345.6	D.75.n.2
D.p48e.7	M.169.c.4	M.196.b.4	M.12.d.2	M.122.a.2	345.13.1
D.p49e.11	M.170.c.4	M.197.e.1	M.176.a.2		M.p8.b.3
D.p50d.11	M.173.c.4	M.199.d.2	M.176.b.2	345.7.1	345.14.1
D.p50e.11	M.176.c.3	M.202.b.2	M.176.c.2	D.47.f.2	M.p8.b.5
D.p50f.4	M.176.g.1	M.202.d.1	M.176.e.2	345.7.2n	
M.18.c.4	M.178.b.1		M.176.h.2	D.p46c.b.1	

In this we have another exceedingly important and common glyph, only a little less hard to pin down than the preceding. It form it resembles the shoots that appear growing and then showing buds, especially in Madrid pages 89–102. Death preys, the hatchet and birds attack, yet the corn grows and finally comes to bearing, by the aid of the magic ritual and ceremonies, done in those days as we pray today for rain and crops. The 'comb' affix is a constant one, and is besides doubled in the above form 345.3.2, an unusual thing. The closely similar form 345.3.1 is not only common in the Madrid, but specifically marks sec. *e* of the Venus pages, where the middle figure attacks the lower.

In the form 345.4, with the tie, it marks M.ƫ.176, where eight seated women have birds (naguals) resting on their heads, and parallelled by other like ƫolkins, of seated women, with like birds, in Dresden ƫ.40, 47, and the same form 345.5 above in all three ƫolkins. In these same Dresden passages, as also in the Venus passages, we find a direct Moan connection; in D.ƫ.40 we find it next to 13 Moan; ƫ.47 three times next to or combined with a

Moan; in ƫ.47.f.2 it needs only the wing subfix to make it identical with the proved **Moan** month-variant, as seen on page 46c.b.1.

In constant repetition in these passages we also see the destruction-sign **143;** in 47.d.3 we even see this sign with the same tie subfix, and a zero-time prefix; but these cases of **143** work out as in alternating death and life clauses, and seemingly as *affecting* gl. **345,** or what it stands for.

Finally, in the form **345.8.1** it is the initial glyph in Dr.ƫ.24.-*abcd*, pages 4, 5, with holding or containing signs (**manik** and ▱); while below all four figures hold the glyph in their hands. If it were not for its relation or even, possibly, identification, with **Moan,** and the uncertainty of the Venus passages, we could unhesitantly pronounce it something beneficial, of worth, to be defended. But the **Moan**-connection must be worked out before that.

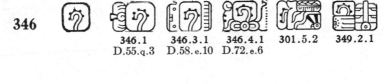

346.1 346.3.1 346.4.1 301.5.2 349.2.1
D.55.q.3 D.58.e.10 D.72.e.6

347.1 347.1.1 347.1.2 347.2 347a.2 347b.2 347c.2 347d.2 347e.2

347.2.1 347.2.2 347.2.3 347.2.4 347.3* 347.4.1 347.5.1

347.1	M.199.c.1	M.100.b.4	347.2.1	M.207.b.2	347.3*
M.199.d.1	347.2	M.190.c.2	M.66.e.3		M.190.a.2
347.1.1	P.11.c.10	M.190.d.2	347.2.2	347.2.3	347.4.1
M.199.b.1	M 66 b.3	M 100.o.2	M.193.a.2	D.04.a.3	M.66.a.3
347.1.2	M.66.c.3	M.190.f.2	M.193.b.2	347.2.4	347.5.1
M.199.a.1	M.66.d.3	M.190.g.2	M.207.a.2	P.3.d.5	M.162.d.2

The meaning of this glyph is clearly controlled by its affixes. Form **347.1** accompanies a loom and weaving. Almost the only other affix is the 'club'—associated in ƫ.190 with the carving of

the new images, in ꜩ.66 with deer in spring-traps, on M. p.102 again with looms. Form 347.2.3 is the first of a four-color series, with Iꜩamná sitting on trees.

348						
	348nn	348.1	348.2	348.3.1	348.4.1	348.5.1
	D.69.b.2	M.38.b.2	M.142.a.2	D.66.a.2	D.p46b.b.4	D.p47f.8
					D.p46c.c.2	D.p50e.3

Whether this is the same as the preceding is more than doubtful; the forms of the marks at times approach each other, but the associations are different; and this form lacks the distinctive ☞ 'club' affix. 348.4.1 is one of the repeated twenty on the Venus pages.

349

349.1	349.2	349.2.1	349.3.1	349.3.2	349.3.3	349.4.1
D.8.k.3	D.61.i.2	D.70.e.5	D.47.f.1	D.p47f.4	M.p34.d.16	D.p24.a.16
D.31.b.3			D.58.f.5		M.p37.d.12	D.71.a.4
D.40.c.1			D.68.c.8			D.71.j.8
D.44.b.3			M.162.d.3			P.6.b.23
M.176.d.1		See Kankin; also 2.6.1				P.6.d.7

Although used as glyph for the month **Kankin,** this is also clearly shown in the pictures as an animal backbone and ribs. Why we should not have 'yellow-sun' parallelling **Yaxkin;** and why the glyph should form the compounds, and take the affixes it does, would tell much.

351				
	351.1.1	351.1.2	351.1.3	351.1.
	D.p26a.3	D.p27a.3	D.p28a.3	D.p25a.3

352						
	45.25	352.1.1	352.2.1	352.3.2	352.3.1	352.4.1

353			354			
	353.1n	434.2		354	354an	4.25.3

355

M.19.b.1

355.1	1a	1.1	2.1	2.2
M.235.a.1	M.235.b.1	M.19.a.1	M.174.a.1	M.174.b.1

355.2.3a	b	c	d	e
M.143.a.1	M.143.b.1	M.143.c.1	M.193.a.1	M.193.b.1

356

356.1	356.2	356.3.1	356.4	356.4.1	Mol - 33.1

356.5.1	356.6.1

352	352.2.2	D.59.d.11	M.222.b.5	M.195.b.1	356.4.1
M.6.e.1	D.55.n.1	M.163.b.2	M.227.b.5	M.195.d.1	M.200.a.2
M.p34.d.2	352.3.1	M.181.b.3	354n	M.197.d.1	M.200.b.2
M.p36.d.2	D.69.j.2	M.181.d.3	M.218.c.7	M.201.c.1	M.200.c.2
M.p37.b.18	352.4.1				M.200.f.2
	D.71.e.1	354	356.1	356.3.1	
352.1.1		M.210.c.5	M.190.a.1	D.71.f.3	356.5.1
M.p37.d.2	353.1n	M.218.c.9	M.190.b.1	356.4	D.66.j.3
352.2.1	D.59.b.11	M.218.j.4	356.2	M.200.d.2	356.6.1
D.62.a.6	D.59.c.11	M.219.d.5	M.195.a.1	M.200.e.2	D.66.o.3

This glyph is most puzzling. Surrounded by dots it becomes
the month **Mol,** that word meaning 'heap.' In the pictures in the
Madrid the form at times seems to represent the sprouting plant.
Again the form is at times almost indistinguishable from glyph
68, for black; note **356.3.1.** Very careful analysis is called for.

357

357.1	357.2	35c.2a	357.2b	357.2c	357.2n	357.2dn

357.2.1	357.3	357.3.1	357.3.2	357.4	357.5	357.6	357.6.1

358

4.13	45.35	142.10	322.3.1	341.4	33.1	345	358.1

359

359.1	359.1.1	359.2	359.3	359.4	359.5.1	359.6.1

M.213.b.1	M.125.12.2	357.2.1	M.9.c.1	359	359.2
M.213.c.1	M.163.c.2	D.63.b.4	M.9.d.1	P.2.b.22	M.189.b.2
M.213.d.1	M.170.c 3	357.3	357.5	P.10.d.1	359.3
357.1	M.194.b.3	M.150.a.4	M.18.a.1	M.141.a.2	M.125.12.4
M.232.a.1		357.3.1	M.18.b.1	M.141.b.2	
M.232.b.1	357.2n	M.232.a.3	M.18.c.1	M.141.c.2	359.4
M.232.c.1	D.42.a.3	357.3.2	M.18.d.1	M.141.d.2	M.232.c.4
M.232.d.1	D.p50b.c.4	D.47.c.1	M.18.e.1	M.141.e.2	359.5.1
M.232.a.3	D.p50c.d.3	357.4	M.18.f.1	M.189.a.2	P.4.d.1
357.2	M.62.d.2	M.9.a.1	357.6.1	359.1	359.6.1
M.119.b.1	M.162.b.3	M.9.b.1	D.71.h.7	P.2.b.22	M.p36.d.6

The various dotted forms are here gathered together for comparative study. In the lower division of Dresden, page 6, there begins with ꜩ. 26 a series of ꜩolkins displaying, mostly in the initial position, different known glyphs each here surrounded by dots. At times the figures below hold these same dotted forms in their hands. It is obvious that the dotting has a definite meaning, a definite modification of the main elements enclosed.

Dots elsewhere must have their specific influence on the full meanings of the glyphs they are with, a value that can hardly be the same in the several instances. Dots about a shield, or flint; falling from the sky-glyph, especially when the latter is turned sideways; about the **ak'bal** prefix; a common factor modifying these various forms in D.ꜩ.26 sq. What of the double curve, dotted, and used with a **kin,** white, black, numeral 20, etc.? What of the erroneously called **'ik'** (our glyph **341**), with its numerals, repeated on the Dresden New Year pages? Apart from the flint and shield, etc. such dots most probably have a definite, general, modifying value on the meaning.

361	**362**	**363**	**364**
M.159.f.2	D.61.j.1	D.71.43.1	D.p48e.3

365 M.19.b.4

366 P.6.b.14

367 D.72.f.33

368 D.43.a.1

369 P.4.b.7

370 P.5.a.4

371 P.5.b.2

372 M.p12.a.1

373 D.55.d.3

374 D.71.59.2

375 P.5.c.14

376 M.184.c.4

377 M.125.16.2

378 M.94.a.2

379 M.108.d.4

380 M.179.b.4

381 M.217.b.4

382 M.157.a.3

383 M.100.c.4

384 M.p37.c.18

385

386

387 M.p8.d.5

388 M.193.e.3

389 M.p37.b.15

390 P.10.b.24

391 M.160.b.2

392 D.71.25.2

393 P.0.d.5

394 M.p36.b.17

395 M.p36.c.16

396

397 M.152.a.1 M.152.b.1

398 M.182

399 D.64

400 M.218.f.5

401 D.70.g.6

402 P.8.b.13

403 D.65.k.3

404 D.61.f.1

405 M.125.33.16

406 M.181.c.3

407 D.75.q.1

408 P.6.b.17
 P.7.b.14

409 D.71.63.1

410 M.33.d.1

411 M.167.b.1 324.4

412 M.p36.c.16

421 1.13 6.2.5 73.2 77.1.2 434.4

302.3 434.5 324.2.1

The 'elephant-trunk' affix, with its associations.

422 66.7 25.6.1 15.7.2 15.7.3

PICTOGRAPHIC OBJECTS

426
Hands

426.1 426.1.1 426.1.2 426a 426b.1 426c.1

427

427.1.1 427.2.1 427.3.1n 427.4 427.5.1 427.5.2 427.6.1

427.7 427.7.1 427.7.2 427.7.3 427.8 427.9 427.9.1

427.9.2 427.9.3 427.10.1 24.1.5 73.4

426a
M.233.a.1
M.233.b.1

426.1
D.p46b.a.2
D.p46b.b.2
D.p46b.c.2
D.p46b.d.2

426.1.1
D.p24.b.4
D.p46e.1
D.p47e.1
D.p48e.1

D.p49e.1
D.p50e.1
D.p47b.a.2
D.p47b.b.2
D.p47b.c.2
D.p47b.d.2
D.p48b.a.2
D.p48b.b.2
D.p48b.c.2
D.p48b.d.2
D.p49b.a.2
D.p39b.b.2
D.p49b.c.2
D.p49b.d.2

D.p50b.a.2
D.p50b.b.2
D.p50b.c.2
D.p50b.d.2

426.2.2
M.125.5.2

427.1.1
M.125.18.1

427.2.1
M.p37.c.19

427.3.1n
M.125.1.1

427.4
D.52.f.2

427.5.1
P.5.c.12

427.5.2
M.p37.d.8

427.6.1
M.175.b.1

427.7
P.7.b.22

427.7.1
P.5.b.22

P.6.b.22

427.7.2
D.p24.a.15
D.71.a.7
D.71.h.3
D.71.j.7

427.7.3
D.71.g.7

427.8
M.148.a.1
M.148.b.1
M.148.c.1
M.148.d.1

427.9
M.219.c.4
P.18.c.3

427.9.1
D.31.c.5

427.9.2
D.6.a.4
M.193.a.4

427.9.3
D.69.h.1

427.10.1
D.69.b.1

428 P.9.c.14

429 M.p37.c.15

430
Club P.11.d.11 P.11.d.2 318.2.1

431
Web

431.1 431.2 431.3.1 431.4.1 307.3.1 17.12.1 337.10.1

1.28.1 70.10.1 433.3.1 301.5.1 301.4.1 431.6.1

432 432.1.1 432.2 432.3 433 433.1.1

434
Jar 434.1 434.2 434.3 434.4.1 434.5 4.26 1.30

436 437 438

D.64

435
Hatchet

| 435.1 | 435.2 | 435.3 | 31a.13 | 59.5.2 | 322.4.1 |

437
Shield

| 437a.1 | 437b | 437b.1 | 437b.2 | 437c.2 | 437d.3 |

431.1	431.4.1	D.72.a.26	433.1.1	435·	437b
M.7.d.4	D.71.15.1	D.72.f.5	D.55.o.5	P.11.d.11	P.2.d.11
M.7.e.3	D.71.36.1	D.72.f.15		435.1	M.10.d.6
M.121.a.1	D.71.40.1	D.72.f.26	434.1	M.200.g.1	M.10.e.2
M.121.b.1	307.3	431.6.1	M.3.a.2	435.2	437a.1
M.121.c.1	D.71.68.1	M.179.a.2	M.4.a.2	M.183.a.1	D.p60a.11
M.121.d.1	17.12.1	432.1.1	434.2	435.3	437b.1
M.125.8.1	D.71.68.2	D.6.a.2	M.158.b.3	M.183.b.1	P.6.b.6
431.2	337.10	D.6.b.1	434.3	436	437b.2
	D.71.j.3	432.2	M.158.a.3	M.220.a.3	P.3.c.1
431.2.1	431.5.1	D.61.k.1	434.4.1	M.220.a.6	437c.2
P.9.b.8	D.71.e.6	D.p60.a.4	D.71.c.10	M.220.d.3	P.4.d.11
431.3.1	D.72.a.5	432.3	434.5	M.220.d.6	437d.3
M.38.b.1	D.72.a.15	P.6.b.2	M.68.h.1		M.p34.d.4

There is little that can now be said about the characters in the next section, that of the Eclipse and Constellation Band, beyond what is shown by the glyphs and their positions, in the texts, as given in the index below. The 'wings' make a very speaking glyph for an eclipse, but what of the centers? And why an **Akbal**? Why a continual pairing of the **kin** and **kal** at specific points, positions, in the eclipse ephemeris?

That the 'constellation band' is really such, or a Maya zodiacal figure, can hardly been doubted, from its appearances. Note the frequency of the cross-sign, probably for a conjunction. Note the presence of the sky itself, also the sun, night, the banded head-dress figure, the **kal** (which really *ought* to be the moon here), and the noteworthy figures **485–497**. Astronomers and chronologers as we know the Maya were, these latter figures must certainly represent stellar movements or positions in some way. If we could only date the Venus and eclipse dates (**1 Ahau** and **12 Lamat**), these ought to open up something really worth while.

451 451a 451b 451c 451d 452

453 454 455 446 458

451				453	
D.61.a.1	D.71.b.1	P.23.b	P.5.d.7	D.71.d.11	D.71.j.15
D.63.c.3	D.71.c.1	P.23.b	P.10.c.5		D.p74.21
D.66.r.5	D.71.d.1	P.23.b	M.p12.b.1	454	
D.66m.7	D.71.d.13	P.24.b	M.p12.b.2		454a
D.66.r.7	D.71.e.11	P.24.b	M.10.a.7		P.4.b.21
D.69.e.1	D.71.g.12	P.24.b	M.10.e.9	D.66.r.5	P.5.b.25
D.69.e.7	D.71.h.12	P.24.b	M.52.5	D.69.e.2	P.10.c.7
D.69.e.10	D.71.i.11	P.24.b	M.52.6	D.60.e.11	M.54.5
D.69.'l.7	D.71.j.5	P.24.b	M.54.5	D.69.1.11	455
D.69.1.10	D.71.j.14		M.125.13.10	D.71.a.6	D.63.c.4
D.71.42.1	D.p74.20	451a	M.125.13.11	D.71.b.2	456
D.71.49.2	P.22.b	D.61.k.3		D.71.c.2	P.5.d.12
D.71.a.5	P.22.b	M.10.e.9	451d	D.71.d.2	457
	P.23.b	451b	M.125.20.3	D.71.j.6	D.p52a.c.2
	P.23.b	P.4.b.20	M.125.22.10		

466 467 468 469 470 471

472 473 474 475 476 477

478 479 480 481 482 483

484 485 486 487 488 489

490 491 492 493 494 495

496 497

466
D.61.h.6
D.p46d.14
M.6.d.5
M.6.d.8
M.7.c.5
M.7.h.6

467
D.55.j.6
D.61.h.5
D.66m.6
D.66.r.6
D.69.j.12
D.71.b.12
D.71.c.11
D.p74.18
M.76.c.6

468
M p2bb2

469
M.p35.e.1
M.p35.e.4
M.p37.e.5

470
M.p34.e.4

471
M.p37.d.14
M.p36.e.4

472
D.71.e.10

473
D.71.h.9

474
P.22.b

475
P.21.3

476
M.p95

477
D.55.g.5
D.65.f.6
D.66.1.7
D.69.j.11
D 71.j.12
D.p46d.16
D.p46d.18
D.p46f.10
M.6.d.7
M.6.d.11
M.7.c.6
M.10.c.6
M.54.3
M.125.13.7
M.125.13.9
M.125.22.8

478
D.61.a.6
D.61.g.6
D.71.d.9
D.71.f.9

479
D.55.g.6
D.61.f.6
D.66.1.5
D.66.m.5
D.67.c.5
D.69.g.7
D.70.d.8
D.71.g.11
D.71.i.10
D.71.j.13
D.p47d.17
D.p74.19
M.52.2
M.52.3

480
D.65.f.5
D.66.1.8
D.69.e.8
D.69.g.8
D.69.j.13
D.69.l.9
D.70.d.7

D.p49d.22
D.p74.17

481
D.p50d.17

482
D.61.i.5
D.71.c.13
D.p49d.23
D.p74.16

483
M.p34.e.3
M.p35.e.3
M.p37.e.3

484
D.61.i.6
D.71.h.10
M.6.d.10
M.52.4
M.76.c.7
M.125.13.8

485
D.71.e.9

486
D.55.g.7
D.66.1.6
D.67.c.8
D.69.j.9

D.p47d.18
D.p46f.9
D.p46d.19
D.p46d.15
D.71.j.11
D.69.1.8
M.6.d.6
M.7.c.7
M.7.h.5
M.7.h.7
M.10.c.7
M.10.e.10
M.10.e.11
M.52.1
M.p34.e.1
M.p35.e.4
M.p36.e.1
M.63.b.7
M.125.22.7
M.125.22.9

487
D.70.d.9

488
D.69.k.8

489
D.71.c.12
D.71.d.10

D.71.f.10
D.71.g.10
D.71.b.11
D.71.i.9

490
D.69.k.9

491
P.23.b

492
D.p46d.17

493
P.22.b

494
D.p50d.18
M.10.c.5
M.p36.e.5
M.63.b.5
M.76.c.5

495
M.p35.e.2

496
D.71.g.9

497
M.54.1

It was the writer's first intention to take up a number of these Minor Elements, shown on the next page, for discussion here, in their various relations. But the chief among them have already been gone into at various places in the preceding text, in connection with specific main elements to which they were attached. Their position in the system has thus been shown, and lines of study marked out. The coordination of the material, to lighten and make possible the labor, was our main object. And detail after detail is left for future work.

MINOR ELEMENTS

600 321 323 324 b c d 322 601 602 a 603 a

604 605 606 607 b c d e f g h 608 609 b

610 611 612 b 613 614 615 616 617 b c 618 619

620 631 632 633 634 635 636 637 638 b 639 640 b

641 642 643 644 645 646 647 648 649 b c d 650

661 662 663 664 665 666 667 668 669 b c d 670

671 3a 672 673 674 657 57 676 677 678 679 680 681

682 b c d e 683 684 685 686 687 688 689 690

701 325 430 704 705 706 707 708 700 710

711 712 b c d 713 714 715 716 717

718 719 720 721 723 724 725 726 727 728

7.1 741 742 743 744 745 746 747

748 749 750 751 a 752 753 754 756 757

REFERENCE KEY TABLE

When the Maya writer set out to produce a manuscript, he had before him a long strip of prepared paper—in the case of the Dresden 12¼ ft. He first measured off the desired width of the folds or pages, and made the actual folds, that the pages on the reverse might register. Next he outlined each separate page with red.

He then determined on the number of pages necessary for the first main subject division, or chapter, of what he purposed to write. Then settled on whether to write in two, three or four horizontal bands, and drew the red lines to mark these, adjusting the widths to what he was planning. He then wrote straight across these horizontal divisions, disregarding the folds, or pages as we term them; at times even a glyph or figure is half on one page, half on the next. In writing he did not think in terms of 'pages,' but of a continuous strip, to the end of the section or chapter, and then back to the next lower band. The ruling, breaking of text, consecutive march of the pictures and the glyph successions as gone into above on pages 18 sq. all show this; and also enable us to reconstruct the text as a consecutive whole.

By far the greater part of the chapters are arranged in a succession of tzolkins, as used to carry the story. A tzolkin, in Mexican **tonalamatl**, in Quiché **ch'olk'ih**, is the count of 260 days, used as a Ritual Divinatory Book of Days, and also interwoven into the structure of the annual calendar and the long chronological count of tuns. To each of the 20 day names or signs is attached a number, 1–13, always in red; the numerals being repeated 20 times and the names 13 times, and no combination repeating until the 261st day, and a new tzolkin. For text purposes these 260 days were divided into four, five or ten equal parts, of 65, 52, 26 days; the 52-day division being commonest.

At the beginning, e.g. of a 52-day division, the writer set down in a column at the left the initial red numeral of the zero-day from which the count was to start, together with five signs. Counting through 52 days (4 x 13) we come again to the initial red numeral, having used the 20 days twice, and 12 more; the same red numeral then applies to the 12th day; the 104th day of the tzolkin is then the 4th day of the series, the 156th is the 16th, the 208th is the 8th, and the 260th again the previous 'zero-day.' These five day-signs appear under the initial red numeral, but whether the ensuing text and pictures are to be understood as applying and re-applying five times in succession, we can by no means even guess. Why the writer built his story on subdivided tzolkin counts, we know nothing of.

Each of the tzolkin divisions, of 52 etc. days, was then again irregularly subdivided into minor clauses, as we shall term them. Each was headed by a black and a red numeral, the black being the counter of the passing days, the red the numeral of the day reached. In a few cases the day-signs are added to the numerals. In any 52-day division, the total of the black numerals must be 52, and the final red number the same as the

initial. In our texts shown in the preceding pages, outline figures denote the red.

Over these black and red figures the text is written, usually four or six glyphs; if a picture accompanies, the glyphs are in double column; if no picture, in single.

Having thus gotten away from the meaningless 'page-numbers,' and into a consecutive textual arrangement, it is necessary for reference purposes to number all these sections or ṭolkins as they come, as above described. Some few sections have the same glyph arrangements, but without being technical ṭolkins; these have been numbered in. In a few cases, as in the Venus chapter, those of the annual ceremonies, etc, it has been necessary to retain page reference numbers, with special sections.

In the editions of the Dresden and Madrid soon to be issued, we will mark the ṭolkin numbers in; but since the user will have to work with the codices as already paged, the following correlation of the two systems will be needed. Its use will be quickly picked up. Taking, for example, Dresden ṭolkin 22, reproduced on page 18: this has six clauses, numbered *a-f;* the zero-day is **6 Ahau**, the numeral **6** being again reached each time we arrive at the last clause, and **6 Ahau** being finally the 260th day. There are four glyphs in each clause, numbered 1–4. The reference in our concordance under glyph-form **76.1**, D.22.b.3, therefore denotes the third glyph in clause or column *b*, being the normal glyph of the Corn-god. The present table shows that ṭ. 22 occupies the middle division *b* across pages 13–14, clause *b* being the middle clause on page 13. The old style of reference to this would have been: Dres. page 13, division b, column 4, line 2. The ṭolkin arrangement and numbering here used, at once shows us that glyphs *def* 1 are the same; that *abc* 2 are the same, and with the same postfix as seen in *def* 1; that *def* 2 are again the same, and also have the same main element and subfix as have *abc* 2, but with different postfix. It is therefore, in short, this rearrangement in type of the ṭolkins in parallel single columns, *plus* the foregoing concordance, with its cross-indexing, that has started the key to turning in the lock of interpretation and decipherment—of course with the accompanying pictures to help.

In the tables below, the first column gives the section or ṭolkin number, 75 sections in the Dresden, 236 in the Madrid; the third column gives the page and lateral division of the codex, and the middle column tells which clauses of the ṭolkin are on that page. Dres. ṭ. 8 crosses thus seven pages, top division. The clauses are always noted by letters, except for the eclipse ephemeris, numbers 1–69, across pages D.51–58; and also M.ṭ.125, numbers 1–33, across pages 65–73.

Special cases are: the five Venus pages had to be referred to as being in sub-sections *a-f; abc* are on the left of each page, in single columns; the *a* section containing only day-signs; *def* are the right-hand sections, to be read in double columns.

Dresden pages 25–28 are divided into *a, b, c,* each with its glyphs. The Dragon-number section is numbered 72, *abc* on page 61, *de* on

page 62, *fg* on page 69; the glyphs read down, in double columns. Section 73 intervenes, and then sections 74, 75 follow, to be closed by page 74.

In the eclipse ephemeris the 'pictures' are lettered, a-j.

Where the references are to pages, as pages, the columns are lettered, left to right, and the glyphs numbered down.

The Madrid references call for no further explanation, except to the Year pages, 34–37. Here the left columns are numbered single-column down. Owing to the uncertainty caused by there being 16 glyphs in sec. *c*, on the right top of pages 34–36, and only 12 glyphs (three columns), on page 37 these sec. *c* glyphs are numbered 1–16, and 1–12, horizontally across. The placement seemed to favor this order, instead of downwards; but not settled.

In the Paris Codex there are no ꜩolkins. Following the arrangements of the printed parallel text pages accompanying the present writer's edition of the Paris, published in 1909, one side is numbered as pages 2–11; sec. *a* is at the top, almost all erased; *b* the columns at the left, *c* the text over the central picture, *d* that below; *b* read in double columns, *c* and *d* in single, for lack of any definite guide to their order.

Turning over: pages 15–18 are in one style: an upper division nearly erased, a middle with three sections to the page, *a-c*, 6 glyphs each, double column; below, fragmentary sections, *d-g*, 4 glyphs each, double column.

The references to the few glyphs left on the upper parts of pages 21–22 are horizontal, 1–10 in the two lines. This is undoubtedly not the original reading order, but too little is left to do otherwise.

Careful measurement of pages 23–24 showed that there had been 42 glyphs in seven columns on 23, 36 in six columns on 24; these have been numbered in single columns downward, beginning at the left. The seven columns on page 23 made doubtful the usual double-column order, so no attempt was made to determine the point. Also, a reading from left to right on pages 21 to 24 is unquestionably wrong. All the glyphs face to the right, and also take their normal prefixes or numerals at the right side. The reference numbers must therefore be taken here as mere place-finding, and in no way intended as suggesting the textual order, which stands uncertain. In the type-forms in the body of this work, most of these forms have been reversed to the normal method.

Thus the arrangement of the pages and text in the Paris do not aid us to study the glyphs as we can in the Dresden and Madrid, with their combination of ꜩolkin order, pictures, glyph repetitions, shifts and changes.

Dresden Sections and Tzolkins.

♮	cl.	p.
1	abc	1b
2	ab	1c
3	a–d	2a
4	ab	2b
5	abc	2c
6	ab	2d
7	a–e	3a
8	abc	4a
	def	5a
	ghi	6a
	jkl	7a
	mno	8a
	pqr	9a
	st	10a
9	a	10a
	bcd	11a
	e	12a
10	ab	12a
11	ab	13a
12	abc	14a
	d	15a
13	ab	15a
14	abc	4b
	d	5b
	e	4b
15	ab	5b
	cd	6b
16	a	6b
	bcd	7b
17	ab	8b
18	ab	9b
19	ab	10b
20	a	10b
	b–e	11b
21	abc	12b
22	abc	13b
	def	14b
23	abc	15b
	d	16b

♮	cl.	p.
24	abc	4c
	d	5c
25	ab	5c
	cd	6c
26	a	6c
	bcd	7c
27	ab	8c
28	ab	9c
29	abc	10c
	def	11c
30	abc	12c
31	ab	13c
	cd	14c
32	ab	15c
33	ab	16a
34	a	16a
	bcd	17a
35	abc	18a
	de	19a
36	a	19a
	bcd	20a
	e	21a
37	ab	21a
	c–f	22a
38	—	22a
	a–e	23a
39	ab	16b
	cd	17b
40	abc	17b
	def	18b
41	ab	19b
42	a	19b
	b	20b
43	abc	20b
44	a–d	21b
45	a–d	22b
46	a–f	23b
47	abc	16c
	def	17c

♮	cl.	p.
48	a	17c
	bc	18c
49	a	18c
	b	19c
50	ab	19c
	cde	20c
51	abc	21c
	d	22c
52	abc	22c
	def	23c
53	abc	29a
	de	30a
54	—	30a
	—	31a
55	a	32–3a
	b	33a
	c	34a
	d	34–5a
	e	35a
	fgh	36a
	ijk	37a
	lmn	38a
	o–r	39a
56	abc	40a
	def	41a
57	ab	42a
	cde	43a
	fgh	44a
58	abc	29b
	def	30b
	g	31b
59	a	31–2b
	b	32–3b
	c	33–4b
	d	34–5b
60	a	35b
	bcd	36b
	efg	37b
61	abc	38b

♮	cl.	p.
61	def	39b
	ghi	40b
	jk	41b
62	a	41b
	bcd	42b
	e	43b
63	a	44b
	bcd	45b
64	abc	29c
	d	30c
65	a	30c
	bcd	31c
	efg	32c
	hi	33c
66	a	33c
	b–e	34c
	fgh	35c
	ijk	36c
	lmn	37c
	opq	38c
	rst	39c
67	abc	40c
	def	41c
68	a	42c
	b	43c
	c	44c
	d	45c
69	abc	65a
	def	66a
	ghi	67a
	jkl	68a
	m	69a
70	abc	65b
	def	66b
	ghi	67b
	jkl	68b
	m	69b

♮	cl.	p.
71	1–6	53a
	a	53a
	7–13	54a
	b	55a
	14–18	55a
	c	56a
	19–22	56a
	23–26	57a
	d	57a
	27–30	58a
	31–36	51b
	e	52b
	37–40	52b
	41–45	53b
	f	53b
	46–50	54b
	g	54b
	51–58	55b
	h	56b
	59–62	56b
	63–67	57b
	i	57b
	68–69	58b
	j	58b
72	abc	61
	de	62
	fg	69
73	ab	62
	cde	63
74	ab	71a
	c–i	72a
	j–o	73a
75	nm	71b
	l–f	72b
	e–a	73b
	bb–aa	71c
	z–t	72c
	s–o	73c

References by pages and columns

25–a, b, c	46b, a–d	47b, a–d	48b, a–d	49b, a–d	50b, a–d	60b,
26–a, b, c	c, a–d	c, a–d	c, a–d	c, a–d	c, a–d	63, a–c
27–a, b, c	d,	d,	d,	d,	d,	64, a–g
28–a, b, c	e,	e,	e,	e,	e,	70, a–f
31a, a–e	f,	f,	f,	f,	f,	71, a–e
32a, a–g	24, a–g	45a, a–f	51a, a–e	52a, a–f	60a,	74

Madrid Sections and Tzolkins

♮	cl.	p.	♮	cl.	p.	♮	cl.	p.	♮	cl.	p.	♮	cl.	p.
1	a–h	2a	3	d	3b	5	fgh	12a	9	a–d	15a	11	a–d	16a
2	a	3a	4	a	4b		ij	13a	10	a	13b	12	a–e	17a
	b	4a		b	5b	6	a–d	10b		b	14b	13	ab	18a
	c	5a		c	6b		e–i	11b		c	15b	14	ab	19a
	d	6a		d	7b	7	a–d	10c		d	16b	15	ab	20a
	e	7a	5	ab	10a		e–i	11c		e	17b	16	a–d	21a
3	c	2b		cde	11a	8	abc	14a		f	18b		e	22a

#			#			#			#			#		
16	e	22a	61	abc	40a	112	a–d	62a	147	a	86b	191	e–h	100b
17	a–e	19b		d–g	41a	113	a–d	63a		b–e	87b	192	abc	101b
18	abc	20b	62	abc	40b	114	ab	64a	148	a	87b	193	ab	102b
	def	21b		d–g	41b	115	ab	57b		bcd	88b	194	a–f	96c
19	ab	20c	63	abc	40c	116	abc	58b	149	ab	88b	195	abc	97c
20	a–d	21c		d–g	41c		def	59b	150	ab	79c		de	98c
21	abc	20d	64	a–d	42a	117	abc	60b	151	ab	80c	196	a	98c
	d	21d	65	—	42b	118	abc	61b	152	ab	81c		b	99c
22	ab	21d	66	a–e	42c	119	abc	61b	153	ab	81c	197	ab	99c
	cde	22d	67	a–e	43a	120	a–d	62b	154	ab	82c		c–g	100c
23	ab	22a	68	a–h	43b	121	a–d	63b	155	ab	83c	198	a–d	101c
	c–g	23a	69	a–h	43c	122	ab	64b	156	a–d	84c	199	a–d	102c
24	abc	22b	70	—	44a	123	a	58c	157	a–d	85c	200	abc	95d
	d	23b	71	—	44b		bcd	59c	158	abc	86c		d–g	96d
25	ab	23b	72	—	44c		efg	60c	159	abc	87c	201	abc	97d
26	a–e	22c	73	—	45a		hij	61c	160	a–d	88c	202	a–d	98d
27	abc	23c	74	—	45b		klm	62c	161	abc	89a	203	a–d	99d
28	a	22d	75	—	45c	124	abc	63c		de	90a	204	a–d	100d
	bc	23d	76	ab	46a		def	64c	162	a	90a	205	ab	101d
29	a–e	24a		cd	47a	125	1–2	65a		b–e	91a	206	abc	101d
30	a–e	25a	77	—	46b		3–4	66a		fg	92a	207	ab	102d
31	a–d	24b	78	—	46c		5–6	67a	163	ab	92a	208	ab	103a
32	a–d	25b	79	—	47b		7–8	68a		cd	93a	209	a–d	104a
33	ab	24c	80	—	47c		9–10	69a	164	ab	93a	210	abc	105a
	cd	25c	81	—	48a		11–2	70a		c–f	94a	211	—	106a
34	a–d	24d	82	—	48b		13–4	71a	165	a–d	89b	212	a–g	107a
35	a–d	25d	83	—	48c		15–6	72a	166	a–e	90b	213	a–d	108a
36	abc	26a	84	—	49a		17–8	65b	167	ab	91b	214	a–d	109a
	de	27a	85	—	49b		19–20	66b	168	a–d	92b	215	a–d	110a
37	a	27a	86	—	49c		21–2	67b	169	a–d	93b	216	a–d	111a
	bcd	28a	87	a	49c		23–4	68b	170	a–e	94b	217	—	112a
38	abc	26b		b–e	50c		25–6	69b	171	ab	89c	218	abc	103b
	de	27b	88	ab	50a		27–8	70b	172	a–d	90c		d–g	104b
39	a	27b	89	ab	51a		29–30	71b	173	a–d	91c		h–k	105b
	bcd	28b	90	—	50b		31–2	72b	174	abc	92c		lm	106b
40	abc	26c	91	—	51b		33	73b	175	a–d	93c	219	a	106b
	d	27c	92	—	51c	126	ab	73a	176	a–d	94c		b–e	107b
41	a	27c	93	ab	52a		cde	74a		e–h	95c		fg	108b
	b–e	28c		cd	53a	127	ab	74b	177	a–d	89d	220	abc	108b
42	ab	26d	94	ab	52b	128	—	79a		efg	90d		de	109b
	cde	27d		c–e	53b	129	—	80a	178	ab	91d	221	ab	109b
43	a–d	28d	95	—	52c	130	—	81a		cde	92d		cd	110b
44	—	29a	96	ab	53c	131	ab	82a	179	a–d	93d	222	ab	110b
45	abc	29b	97	ab	54a	132	82–83a			ef	94d	223	abc	111b
46	a–d	29c	98	ab	55a	133	—	83a	180	abc	94d	224	a	111b
47	—	29d	99	abc	55b	134	—	84a		d	95d		b–e	112b
48	—	30a	100	abc	55b	135	—	85a	181	abc	95a	225	ab	103c
49	—	30b	101	—	54c	136	—	86a	182	—	96a	226	a–d	104c
50	—	31a	102	—	55c	137	abc	87a	183	abc	97a	227	ab	105c
51	—	31b	103	abc	56c		de	88a	184	ab	98a	228	a–e	106c
52	—	32a	104	abc	56b	138	ab	88a	185	abc	99a	229	a–e	107c
53	—	32b	105	abc	56c	139	abc	79b		def	100a	230	a	107c
54	—	33a	106	cd	57a	140	ab	80b	186	abc	101a		bc	108c
55	—	33b	107	cd	57b	141	a	80b		def	102a	231	ab	108c
56	ab	38a	108	—	57c		b–e	81b	187	—	95a		cd	109c
	cde	39a	109	a	57a	142	ab	82b	188	ab	96a	232	abc	110c
57	a–d	38b		b–e	58a	143	abc	83b	189	ab	96a	233	ab	110c
58	a–d	38c		fgh	59a	144	abc	84b	190	abc	97b	234	ab	111c
59	—	39b	110	a–d	60a	145	a–d	85b		d–g	98b	235	ab	111c
60	—	39c	111	a–d	61a	146	a–d	86b	191	a–d	99b	236	abc	112c

THE MAYA SOCIETY QUARTERLY

| Volume I | SEPTEMBER, 1932 | Number 4 |

GLYPH STUDIES
by William Gates

The purpose for which the QUARTERLY was started was to bring into print as many pieces as possible of the manuscript or otherwise inaccessible literature, too short for separate books or pamphlets; also to stimulate study in the cultural, mythological, historical and linguistic phases of the Maya problem, with a continuation of documented and verified glyph solutions. Among the other immediate and gratifying responses to the appearance of the QUARTERLY, and the coming together of a new body of students as associate members of the Society, were various suggestions

for something like a " Question and Answer " department in the magazine, devoted to the glyphs. Our first number had already stated that something in the way of glyph studies was intended to appear in each issue.

Valuable suggestions, drawn from direct observations in the field, began to come in—such as those from Dieseldorff on the dog as the thunder-storm animal, and from Thompson on the surviving connections in modern folklore with ancient mythology and also glyph passages. The above were printed.

Another member, also suggesting the advantages of a " glyph forum," contributed a possible pictographic origin of the **Imix** glyph, in connection with the Ceiba tree, interesting since there are quite definite traces of a mythological connection. It was my desire to see a section of the magazine devoted to a free controversial discussion of glyphs and glyph-elements, which might at the same time avoid both dogmatism and wild speculative interpretations void of all support save the free imagination of the speculator. The difficulties in opening the limited space of the QUARTERLY to such discussions have been definite, and only recently has a satisfactory method been reached, and the way to develop such a soundly controversial, and stimulating, section of our pages begun to take shape.

Max Müller once said, in somewhat similar circumstances, that " it should be remembered that words have histories." Comparative linguistic research a generation and more ago became a historical science, and since Müller's time has established itself thoroughly not only in the Indo-European, but in substantially all the languages of what we call the Old World. But so far, Americanist studies have been so absorbed in the phase and display of physical museum objects, and in the removal of the débris which has covered the innumerable ruined cities, that comparative linguistic science there has not yet even begun; the study has not gotten beyond the stage of mere collecting forms, and the modern ones at that. Outside the great ancient culture centers of Middle America, our Indian languages are a collecting problem, and not a literary one; while at the same time the immense literary remains of native Middle Indian languages have been (so far as thorough and established methods are concerned) just ignored. It means immense drudgery, and is not nearly so fascinating as the romance of exploration. Also what is really its chief handicap, there are still not enough workers in it to make a genuine forum, and the real rewards are still hidden.

I am quite willing to be criticised for saying that at least nine-tenths of what with us today are called linguistic studies not only in American tongues, but even in most Indo-European ones, are deadly dull futilities, dealing only with morphological minutiae, such minutiae being regarded

as the sufficient objective of the time spent upon them, and a proof of scholarly learning, the frequent production of articles being a necessary part of a university professor's duty to his institution, as football tactics are in building the public fame of a college. One looks in vain today for the study of syntax and structure, which are however the heart of the problem.

We get too, from Bogotá to Boston and other spots, from California to Hungary, newspaper reports that some one has found the secret of the glyphs and so solved the Maya problem. In every effort that reaches beyond the horizons of work and history we get constant learned symbolic interpretations of esoteric meanings (usually with an attempt to link them up by phonetic similarities), and an ignoring of innumerable instances where the propounded interpretations cannot possibly fit. All this passing for "learning" (and even posted as reached by the stock claim "induction"), and only possible because there are no readers informed enough to criticise.

We have been having these things for seventy-five years, cropping up and dying out, just as Hor-Apollo's old explanations of the Egyptian hieroglyphs preceded the time when Young and Champollion, by a study of associations, broke open the door to facts.

The original obscure origin of a glyph form is of little moment to our present work, any more than the fact that our letter G goes back through many changes to an abbreviated picture of a camel, in Phoenician Gimel. The only thing that is of any real use to us is the *meaning* of the character when used in the texts we seek to translate. To this its form-origin and its abstract phonetic value are wholly secondary. What does count now, therefore, is that the glyphs shall be studied, their instances checked and submitted to sound, honest controversial treatment. And on these lines I think it will be possible to undertake the called-for "question and answer" section of the QUARTERLY. We might treat the glyphs as visitors arriving at the jousting-ground of a tourney; in this the right to appear and couch a lance can safely be given to interpretations which come supported by observed data, either in the texts or through other associations encountered by students in the Maya region itself.

A special stimulus toward this section, and a help to the provision of matter for discussion, came a month or two ago from a man whom I have long known, to many of whose interpretations of certain glyphs I have persistently objected as not sufficiently taking account of all elements of the problem, and as relying too exclusively upon a matching-up of Yucatecan Maya words. But recently, in his explanation of one particular compounded form, I saw for the first time the introduction of

a principle which (as I immediately wrote him) I had been been rubbing
up against for thirty years without giving to it its place in the study.
As a principle this fact is beyond all question sound; it goes to the
word-combination of glyphs and characters, as well as of spoken terms,
in all languages and writings—Chinese, Egyptian, Sanskrit, English, Maya.

Both communications and records everywhere certainly began with
pictures, on rocks, skins or fibers. These pictures became abbreviated,
formalized, losing their original character; and in time developed into
mere symbols. In short, they first became pictographs and then ideo-
graphs. Then, as a result first of the necessity for indicating the names,
as pronounced, of foreign persons or objects, abbreviated phonetic sym-
bols were developed. This is quite marked in Egyptian, where the ideo-
graphic and phonetic are found side by side. We also find it in the
Japanese *katakana* syllabary, shortened for phonetic purposes from the
original Chinese characters, and used today in Japanese newspapers to
give the pronunciation of an unfamiliar Chinese ideograph. Later in
time, phonetic writing and declensional word-forms entirely superseded
the older ideographic systems.

There are many kinds of symbols; roughly they may be classed as
ideographic, phonetic, and esoteric—or the result of an agreed con-
vention. Our letters are phonetic symbols, for the vocal elements of
speech; Chinese, Egyptian and Maya ideographs are symbols of ideas.
So also are the long line of our modern scientific symbols, known to
and used by the initiates of science just as were religious symbols in
older days to the Initiates of religion or the Mysteries; both are esoteric.
A symbol can only be explained by one who has a direct knowledge of
its rationale, whatever its class. From the standpoint of world history
I must believe the Maya to be older than the Egyptian because of the
entire lack in the Maya of a developed phonetic element; although that
conclusion must of course submit itself to the result of future research,
when we have learned a great deal more of the Maya and their history
than we know now. Neither do I believe in the least in the assumed
migration of ancient American man and his culture via Behring Strait;
(Esquimo infiltration, of course yes). That theory ignores too much,
takes too many unknown things for granted, and tries to explain too much
with too little.

An ideographic symbol can, then, be followed back to its original
pictograph, and the underlying course of its development traced through,
provided we can find the connecting data. But that is absolutely a
historical problem; it is not a case for guessing. Candidates must come
to the jousting-place with supporting facts as vouchers. If we may be

allowed the illustration, they may present themselves for a "Testing of the Princes," to see whether they can bring their knowledge for the solving of the riddles and the proving of their places in the true line of ancient Maya descent. **Suyva t'an.**

Thus now the current value of a phonetic symbol must be communicated mouth to mouth and person to person; its historical course down from the ideographic stage, as with our letters descended through the Phoenician, may be traced, when we have the material; but the phonetic value can pass only from teacher to pupil. While what we have called the third class, the esoteric symbols, in whatever science, religious or physical, being based on a convention, can also not be interpreted except by direct transmission from one instructed in their use. That transmission may be face to face, or it may also be through preserved records that give the key; but one of these two must be present.

Above all, the fact that we in our day and environment and mental habits *might* use a symbol or an idiom in a certain way, *can* not and *must* not be taken as any real evidence whatever that the older or other people used it that way. Note the well-known pitfalls of a translator from one language into another; as a simple illustration here, take the Spanish word *formal*. In Spanish *formal* means well-bred, and *informal*, impolite, ill-bred; the same words have quite different values in English; and knowing the past tradition of Spanish culture and our own we can see the cause for this: In the Latin races it is the form and formalities that have counted, and 'formality' is politeness; we on the other hand praise informality, which to us is a sign of the 'natural.' (Neither point of view should be criticised; each has its reason in time.)

In a similar way he who would enter into the syntax of Maya and Mayance languages must understand those languages as they were known and used at the time of the Conquest, bringing us a direct contact with the cultured people of the race at the time—a culture since submerged, although not beyond re-visualization. And one who would build up Maya glyph-combinations must also be sure of his Maya ground, by which I mean the ground of old Maya thought, or the evidence of comparative Mayance.

I have above referred to a particular principle to be applied in efforts at interpretation. I can call it, "pictographic incorporation," as a method or principle in the formation of Maya Glyph compounds. Soberly used, and with restraint, it should help much in our study. I have been at the glyphs for a good many years, but all my time has been put to the making of a font of type, and working out a practical dictionary system of

classification, with the cross-indexed concordances. I have intentionally refused to try to 'interpret' or read until this facilitating groundwork was done; just as one postpones desired chemical studies until he has the needed sets of tables of atomic weights, defining the broad differences of class, and the possibilities of combination, or not—their sympathies and antipathies. Others have at the same time been trying to put the glyphs together in accordance with what they regard as natural Maya methods, and also tryings-out of the Landa alphabet.

Symbolic incorporation is a method used in every language for its word-formations, spoken or written, ideographic or phonetic. We take the root-word 'see', add the present active ending -ing to express the present activity, and then further add the negative idea by prefixing un-: 'unseeing.' The worn-down but still largely recognizable Egyptian pictographs were in the same way built into their compounds. Ideas are compounded and modified in the Chinese, the main element and the adjuncts being in every case symbols of the desired ideas. In this sense -ing and un- are also symbols to us, one of present action, the other of negation. That this principle is therefore both universal and sound is beyond question; in fact, we cannot conceive of word-compounds as being built any other way.

But in its application there will come difficulties: we must be first sure of the value of the element to be incorporated, and then further that it is correctly representative of the habits of thought of the Indian, the Maya mind; and then sufficient evidence that they did so use it—not merely that they might have done so. Next, to get anywhere with the problem, it must be found to work toward the actual translation of text passages. And finally, and of the greatest importance of all, the assigned meaning must work everywhere the character is found, or an explanation be found for the contrary fact. The meanings must be tested out by their associations.

A study of this kind can lead us far, and promises much. See, for instance, the use of the characteristic part of the day-sign Cib, as having the Yucatecan Maya meaning of 'wax, ? honey,' and marked on a jar as we have our containers marked as for 'flour, sugar,' etc. So far it is simple; but how account for the change in meaning of the 16th day from Owl, or Vulture, to Honey, Wax? When the old Maya used the day-name Cib, did he think of Honey, or was its meaning as blind to him as the origin of our Tuesday, from the Norse war-god Tiw? And did he in fact mean a honey-pot when he marked the characteristic curl on his jar?

Or again take the sign of dots dropping from small circles, to in-
dicate falling water or rain. ᨆᨆᨆ. In many places in the codices it is
almost obvious; take the repeated sky-sign in Dres. sec. 75, where we even
see the sky-sign tilted, with this attached. Then we must next take all
the other places were rain is actually pictured as dropping, and look for
the presence, or absence, of the dots in the text-glyphs. Then further,
we must check and seek to account for the presence of the prefix in *every*
other compound where it occurs; see below.

As a final result of this, we are in due course certain to turn up
mythological or other associations of great value, for every time any
element is placed 'at home' with another, a new lead will be suggested.
If an affix is found regularly attached to calendric signs, it gives a prob-
ability that other unknown signs to which it is added are also calendric;
and much could follow from that. Where a certain affix occurs chiefly
or only with known destructive or ill-omen signs, or again with certain
deities only, any meanings assigned either to the main or affix element,
must take those associations into account. Step by step only must we
pass from the known or proven, to the still uncertain. Also, of the first
importance, we cannot have any character or element mean one thing
in one connection, and something else in another—at least without
positive proof. If, for instance, Landa's sign for ma, the regular
superfix also for the glyph for South, *is* the negative sign, we must inter-
pret it as such in *all* compounds, or determine why not. And the very
fact that this rule of study must be rigid, is our most potent key to
progress; for every new difficulty quite as well as every new association,
simply means a new bit of light, a new door set open.

We have before us the study of three distinct elements, which must
be coordinated before we are done. These are:
 1. The glyph or character itself, its form, and the origin of that form.
(Our figure 3 is a glyph, or symbol, coming down from the Arabic.)
 2. The meaning attached to that form; also its connections and use
in our various texts. (3 means the triad, or three times one.)
 3. The name, or spoken word used to designate it in the different
later branches, and (inferentially) in the mother Mayance. We cannot
assume which of the modern forms is closest to the ancient, although
Tzeltal and Maya show most reason. (3 is equally called three, trois,
tres, tres, in English, French, Spanish, Latin.)
 This gives us two distinct problems, and two modes of attack: First
on the writing, pictographic or ideographic, a constant incident to the
glyph-form. Second, on the speech, wherein the word used may either
describe the glyph itself, or may again relate the facts, in any one of
many languages. (The **Cimi** glyph is a skull, and talks of death.)

If we knew the meanings of the glyphs, we could correctly translate any passage into English, without knowing a single word of any Mayance language, or the *names* given by the Maya to those glyphs. Just as we can work with a book of mathematical formulae drawn up by a Russian, we not knowing that language. means 'green,' also *verde*.

In the second mode, knowing spoken Russian, we could learn what the formulae were meant to reveal, by reading his textual description of the subject; given this we might then laboriously work out the meanings of the symbols used. Thus we might arrive at knowledge of all three elements—symbol, meaning and name. (The meaning of a passage of unknown glyphs may be indicated by the action in the picture below, as the fire-making; an unfamiliar formula in our mathematical treatise, would be explained by the text.)

Now in our present problem we have scraps, and scraps only, of information about each of the three elements. In a very few cases such bits are found, and agree, in all three classes. In many they are totally divergent, as in the three words for 'moon' in Maya, Kekchí and Quiché: **u, po** and **ik;** or in the case of **Manik** or **Imix.** In such cases we cannot declare a solution reached which ignores or fails to account for all these non-agreeing data. And our whole trouble to date has been due to the fact that would-be interpreters have followed either the line of assigning offhand meanings to the symbols, or of etymologizing their assigned names. Not only this, but they have (in following the first line) failed to tabulate the obvious associations with pictures or other known glyphs, afforded us in the codices; or (in following the second line) they have with negligible exceptions dealt only with Yucatecan Maya words, ignoring the other Mayance languages, as well as the sought-for mother-base. Still further, they have gone on in complete ignorance of even Maya language laws. In our problem we must do the following:

We may cautiously work from pictograph to ideograph.

We may avail ourselves of the known evidence as to the meanings of the day-names associated with the day-signs, including the Aztec.

We must use all the association aids we can find in the texts and their annexed pictures, ignoring none.

We must take into consideration all the Mayance tongues.

We must be sure that we are following the law or methods of Maya and Mayance word-formulation and evolution. Some are superficial (as that **ix-** is a feminine prefix, and not a postfix) ; others are inherent, as the principle of the 'persistence of the Etymon.'

There is a natural law or method prevailing throughout the activity of all organizations, and differing for each. It gives to each what we

call its personality, without which it ceases to be itself as distinct from other organizations, or systems—be they living beings, or types of government or social order, or languages.

This law, method, type, is shown by its persistent repetition, by its constant cropping up as the system functions. And it will only be after extended familiarity that we come to recognize it thus as a distinctive quality. This is as true in physics and ethics, as in sociology and language; it is what the individual *habitually* does. Inability to apprehend it in matters of international psychology, mated with our egocentric belief in our own ' rightness,' is the cause of nine-tenths of international frictions. A similar result follows in studying any kind of system, e. g. another language.

Instances of the ' habit' will come forth in abundance; and the proof of the ' persistence of the Etymon ' will lie in the fact that once recognized and followed, an intelligent and idiomatic use of all Mayance becomes easy and simple; without it, we should constantly stumble and misapprehend the real meaning behind. For Mayance words never get far from, or out of sight of, their ' Etymon '; ours do. That is the great difference; it rules through all word-formation and syntax, and we must perforce assume its presence in the glyph-system syntax as well.

To begin our study along the above lines, we now have the following material. First, the well-known Middle-American series of 20 days, with meanings in substantial accord through the whole region, and in the three main stocks, Aztec, Zapotec and Mayan. For these 20 days we have Aztec pictographs, recognizable as corresponding to the meanings handed down; Sea-monster, Wind, House or Darkness, (Iguana or) Food, Serpent, Death, Deer, Rabbit, Rain, Dog, Monkey, Broom, Reed, Jaguar or Magician, Bird or Wise-one, Owl or Vulture, Force (in Maya Earth), Flint-knife, Storm, Lord (in Aztec Flower).

In Maya we have another set of 20 signs, of which only two—Death and Flint-knife—are obvious; perhaps also that for Lord, a full-face. There are three probably abbreviated pictographs, showing the serpent's markings, the dog's ears, the jaguar's spots. One character, for **Manik**, is clearly a grasping hand, and used as such in glyph compounds with constantly supporting picture evidence; but neither sign nor word in Maya support the idea ' Deer,' that of the corresponding day. Neither is there anything in the remaining thirteen Maya signs to suggest the corresponding names in the above series.

In Maya therefore we have six *pictographs* which fit, and one which does not; then thirteen conventionalized ideographs, which standing alone could mean just anything.

As the next element or factor in our work, we have the above *Meanings* given to the 20 days. (These change in Tzeltal to 20 epony-mous heroes.) In Aztec these meanings both link up with the picto-graphic signs, and are the common dictionary meanings of the day-*names*. Thus in Aztec **Acatl** means Reed, and the sign is the picture of a reed. In Maya this correspondence fails, as we have seen, in 14 of the 20 as to the signs; and it also fails in 15 of the Maya word meanings. Only **Ik, Akbal, Cimi, Caban, Ahau** mean the same as the Aztec signs and words (with even so a change of Flower to Lord, and a somewhat forced parallel between Darkness and House). This shortage of corresponding meanings is partly helped by word-forms in Quiché and Tzeltal, with the needed values, or harking back to a common source; in three of these, be it noted, we have animal signs as the glyphs: serpent, jaguar and monkey for **Chicchan, Ix, Chuen.** In a fourth case the Quiché **Ah** means Reed, as it should, while Maya (and Tzeltal) **Ben** yield no etymological connection. Also, for the very important 19th day, **Cauac,** Storm, while no Maya source assigns that or any other meaning to the word, in Pokonchí, Quiché and Tzeltal, **Cahok, Caok, Chauc** all mean either Rain or Thunder-storm.

Finally, for the most important of all the days, the first, **Imix,** we find the corresponding forms **Imox, Imos** in Quiché and Tzeltal, *defined* in the earliest Quiché dictionaries as meaning *espadarte*, swordfish. We also find **Mox** in Pokonchí, but with no early definition.

In short, we get a nearly complete set of *meanings* for the days, in all Middle America, although built up fragmentarily in the Mayan region. Understand that Landa, who gave us the signs and the *names*, gave us no meanings. Nor does Pío Pérez, or any other Maya dictionary, with the five exceptions first noted, give us an etymology for the Maya names.

This brings us now to our third main element, **the Names, or corre-**sponding *words*. In Aztec all match fully. In Zapotec they fairly match, but with difficulties. In 15 of the 20 in Maya they neither match the sign nor the required day-meaning, save as helped in some six cases, only, by forms and meanings in other Mayance languages. The undeniable value of 'Corn' for the Kan-glyph must be derived solely from association evidence in the codices; the Quiché **C'at,** lizard or iguana, while corre-sponding both to the Aztec and Zapotec, is no help at all, bread and meat to the Maya being wholly distinct concepts, taking two distinct verbs meaning 'eat,'—a common phenomenon in Indian American languages. Both are of course food, but there is a sharply separated distinction in the basic thought—the Etymon; corn seems to be the " staff of life, the sacred

gift," meat something cut or bitten, fruit something different again; we
live by one, devour the other, enjoy the third, may perhaps touch the
distinctions.

Manik, Lamat, Muluc, Oc, Eb, Ben, Cib, Eʒ'nab all have no ety-
mological meaning in Maya or any Mayance language, matching the
meanings of the days in the established general calendar; and every
attempt to force the needed meanings into them has proven in the last
degree unscientific. (Such as Brinton's suggestion connecting Oc, to enter,
with the dog that enters to steal; or mani-ik for the swift, passing wind
of or like the running Deer!!)

In fine, we can by the aid of Comparative *Mayance* Linguistics establish
an almost complete unity of meanings for the whole series, but for nearly
half of our northern *Maya* words, as given by Landa, we can only con-
clude that they are archaic survivals, with their meanings lost. This is
with the possibility, that in cases like Manik, and perhaps Cib, an entire
new meaning as well as name has been introduced. And this probability
is incidentally reduced by the presence of the Oc, the word meaning not
'dog' but 'enter,' while the glyph preserves the idea, showing the
significant dog's ears.

The very confusion thus summarized should be a warning to go slow.

Against this general background of available material let us now take
up individual glyphs; and first Imix. The Aztec sign here shows a kind
of monster, fairly corresponding to the dragon figures so common in Maya.

In the codices we find some 30 primary derivatives under Imix, and
about 60 secondary, plus about 17 compounds where it appears to modify or
be subordinate to another main element. In some of these positions its use
is clearly based on its value as day-sign; thus the form 1.1.1n
stands for " 8 days to tie up the Imix count." As prefixes with
known values it may take on the signs for red, white, black and green.
It combines with at least 20 other main elements, for the full list of
which the student must refer to our Outline Glyph Dictionary. Remem-
ber, too, that when the stone monument glyphs are finally worked into
the list by others hereafter, the total of our known surviving forms will
probably be at least doubled.

This however is not all we have; we still have the pictures in the
codices to help us along. There are about 90 pictures in the Dresden
where the personage or deity is holding out one or another of some 20
different objects: plants alone or in a vase, grains in a vase, food-animal

in a vase, **kan-sign** in a vase, a **yaxkin**, rattle, bag, etc. Also the kan-sign
in his hand 21 times, **kan-imix** once, and **imix** once, where the god is
seated on a maguey plant.

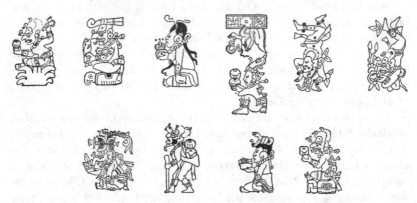

In the Madrid we find six vases with a **kan** and three with **imix**;
(see later, under discussion of vases). Thirteen times the god holds a
kan (usually at the end of a corn-planting tҕolkin series), once an **imix**,
and six times **kan-imix** joined. One is tempted to ask here, why
has this plethora of indicative action-pictures been left all these years
of supposed research, unsorted and unchecked into their corresponding
text-glyphs above the pictures. Surely here is a wider open door than
mere date-glyphs with a side-text lacking all association data save the
numbers incident to mere calendric time or planetary periods.

It is upon the rather ample allowance of actual picture associations
that I ventured to suggest in the OGD two secondary values for the
Imix-sign, apart from its primary calendric value. First, as
based on the Itҕamná, or great dragon of the waters, a possible
value of 'the great green water, the deep'; this with hesita-
tion. Second, on the persistent **kan-imix** compound, a joint
value of 'corn and wine.' (Not if you please, 'corn and
milk.') I must admit an etymological hiatus between the ' great
water' and 'wine'; but the 43 pictures where the god gives
sustenance—the **kan**, and the 200 instances of the compound **kan-imix**
are too many to be ignored. Besides, we have in support the maguey
figure, and the very important fact that the ceremonial drink would be
wine—given us by that great magician. (Itҕ in Maya means 'magician,'
Itҕam-ná the ' house of magic,' Itҕamal, the city, the ' place of the magician,'
or of the Itҕás, the men of magic power; just as Uxmal means 'the place
of Ux,' a protecting mother deity whose name has survived in only one

or two connections.) See also the reference in the *Chumayel*, MSQ for
March, p. 79, to the ceremonial breakfast of bread and wine, in the
olden time.

In the text passages the main element (¯¯¯¯) occurs in the three codices
about 75 times, either alone with affixes, or as the first part of a com-
pound; kan-imix or imix-kan occur about 200 times. (¯¯¯¯) Imix doubled
surmounts the ' monkey-face' head, assumed to belong (¯¯¯¯) to the North.
(Note the reference to the White-Imix-Tree for a sign, after the deluge
that preceded the coming of the present, Indian red-yellow race, MSQ,
p. 81.) Doubled, it also rests on the head of the great dragon, rising
from the waters, in Dres. ฐ. 55 f, page 36—see the illustration above.
In this connection note further the arrival of Itฐamná over the great
waters, seated on the shoulders of Itฐam-kab-ain, the ' whale,' MSQ, p. 83.

As glyph-form 1c (¯¯¯¯) it rests on the head of the plumed serpent,
in the Paris codex, (¯¯¯¯) 4. d. 5. As an affix to the North-star face
(¯¯¯¯) it is found with the ' ben-ik' superfix, and joined to a (¯¯¯¯)
(¯¯¯¯) manik it is used as prefix to a woman's head. With (¯¯¯¯)
' dropping water' beneath it stands as a prefix to God B, and also to a
vulture head. It is also combined with the sky-sign, running water sign,
the ' number 8 glyph,' and with the Oc-glyph with its ' base of honor'
subfix. With the ' woven mat' as superfix, it has the ' dropping water'
prefix. At Dresden, 66. b. 4 it is shown inside a jar.

So much, then, for the glyph and the meaning. Now as to the name,
he *word* itself, Imix. Brinton it was, I think, who first said that the
Imix-glyph looked like, and therefore *represented* a female breast; after
which he proceeded to ' prove' that thesis by splitting up the word into
Yucatecan Maya parts: im-ix. Im in Maya does mean breast, or udder.
In the forms Imox, Imos, Mox the day name reappears in Quiché, Tzeltal
and Pokonchí; the early dictionaries of the first give the meaning as
swordfish, or ' sea-monster'; in all the final vowel is o, and not i.

Now ix- is the universal Mayance feminine *prefix*, meaning ' she,'
and only applied to sentient creatures (the female of the species) plus
a few cases of personification in town names, and in some plant-names.
Cities are indeed treated as feminine in most languages, just as we also
do ships. But Mayance has no formal gender, as Latin and Spanish—only
sex, natural or personified. One simply *cannot* say im-ix as meaning
' female' breast. Besides, the ' she' is always a prefix, in Mayance as
well as in English; we cannot say ' breast-she.' To etymologize im-ix

in this way is false to every Maya, and Mayance, principle; we can neither cut off the -ix as surplus ornament as LePlongeon would have done, nor can we use it to buttress the meaning breast.

Further still, we have our southern form Imox, which we cannot possibly etymologize thus, and where final -ox is clearly not initial -ix. Indeed I much doubt that even Brinton would have devised the im-ix explanation had he not previously decided on the breast pictograph, and then used a variation of his 'ikonomatic' punning to *prove* it. In so doing he ignored every single datum except his two Maya meanings for im and ix, and then combined those in an impossible manner.

I have gone at length into this case of etymologizing Imix as simple Yucatecan Maya, partly because it seems to have used about every wrong and unscientific method possible, and partly to suggest that where our three basic elements—Glyph, Meaning and Name—lack the desired coincidence supplied through what has come down to us, the final linkage will come only through a combination of mythological factors and a science of comparative Mayance linguistics, aided and finally worked out by the same kind of association evidence we would employ in attacking a secret code message.

There is a story that a Japanese code message was worked out during the War in our Secret Service by a man who did not know Japanese, or that the message was in that language. He began by assuming *tentatively* (all research must begin thus) that, *if* a war message it would deal with troops, places, numbers and dates. (We know that much, and more, about most of the ʒolkin texts in both the Dresden and Madrid—their general subject matter.) Next, he guessed that there would be a repeated symbol corresponding to the punctuation 'stop' in our telegrams. I think the story goes that not only did he first de-code the *meaning* (which is our first objective in our glyph-text studies), but then went further to attach words, which finally verified as the proper *Japanese* words.

I believe that this is the proper road, and that it will not only lead to the secret of the Maya writing, but to a far-reaching expanse of mythological fitness lacking in the other. If (possibly) correct, it agrees the archaic mother-tongue of Mayance. We have seen effort after effort, and constant proclaimed 'solutions' failing; Brasseur and LePlongeon (whose type is still extant); Cresson's and Cyrus Thomas' phonetic alphabets (soon to be followed by another—"a true phonetic solution at last," panoplied by the ancient and honorable aegis of the Peabody.) When I began my Maya Study 34 years ago, I tried to learn from all; found none making good. Like the rest of us, I hoped for the desired 'bi-lingual'—Pinart's or other; ran all the leads out on that, and decided

for various reasons that none existed, or ever had. If, as I suspect, some old Maya Indian has preserved the secret, we may be very sure that he will continue not to tell us, his destroyers. Is left then but one possible road—the same as we use for de-coding: Tabulation of the data, association leads, elimination, by parallelisms and variations in the texts themselves.

Before stopping here I must refer to one principle in Mayance—the ' persistence of the Etymon.' I must explain this clearly. To us Etymology is the discussion or science of the derivation of word-forms from their root-*forms*. Here we concentrate upon the forms, spelled out in phonetic letters as we learned them at school. The Maya (who neither knew written phonetic symbols nor thought of words as just ' letters '; who did not see ' letters ' at every turn from rising until sleeping as we do)—dealt in his course of thought with sharply defined and etched ideas, the ' True Base,' the *etymon*, never really lost sight of. He could and did use metaphors; but those too were sharp, concrete, not diffuse—vivid as is all ideographic intercourse. He had separate specific verbs for ' eating ' bread, meat, fruit. The leaning down of a broken branch (an angular phenomenon) was always kept distinct, whether in etymology or metaphor, from the bowing over, in a curved line, as of a bamboo.

As contributions to the beginning of our ' Forum ' two suggestions have come to the writer's desk, touching the glyph for **Imix**. One correspondent, speaking from his past residence in Central America, suggests that it is a symbolic pictograph, derived from certain physical characteristics of the Ceiba-tree; that the semicircle and dots conventionalize the cotton-bolls of the tree, and the lines beneath its pointed, spread-out roots. The suggestion is attractive as bringing in the already known mythological connection of the **Yax-imix-che**, the first (or green) **Imix** tree, and its almost certain relation to the dominant Iʒamná cult of the Maya. The ceiba *is* the sacred tree—even Yggdrasil if you will; as shown by Cornyn, it even links with the rainbow, the divine ladder of the gods from Heaven to Earth. All this does not of course *prove* the pictograph; but it is at least as likely (as pictograph), and it has a mythological fitness *wholly* besides. If (possibly) correct, it agrees with the persistence of the (ideographic) etymon. Between the Ceiba, Iʒamná, and the great Leviathan of the deep, there is a visible connection not only of words and names, but of ideas. With the female breast there is none whatever, nor any evidence either collateral or linguistic.

The second suggestion mentioned, lay in seeing the Ceiba contact as supported by the fact that the tree yields a *milky* sap. To that I cannot agree; it is stretching argument too far. The breast-milk idea is rooted

in the act of suckling, the first care of the mother for the new-born young. The use of ceiba sap, even if milky in color, is for quite other ends, and by other ways; it has to do with a wholly distinct set of ideas, in which it is " etymoned."

I hope that my fellow-students and associate members will not feel that I have taken too much of our Forum space in the above. But I assure them that I have barely scratched the surface of the possibilities of study in the Imix-glyph, in the codices alone. We can still ask twenty ' whys' concerning the associations in the compounds above referred to. But Imix seemed to provide the ground-work for a going in detail into the elements of the problem, as pure research, and yet with great objectives, historical and other, to work for; and also for a review of the utterly false methods that have bogged up and held back our vision.

A detailed study of the day-sign Manik is valuable for two main reasons: First, it breaks away at every point, glyph, meaning and name, from the general calendar. In this the 7th day is Deer, in Quiché, Pokom, Zapotec and Aztec; in Maya and Tzeltal the names are Manik and Moxic, for neither of which words do our sources yield any etymology whatever. Further, and still more important, the Maya character is a clear pictograph, a grasping hand; and that meaning is carried out consistently through the text passages in all the codices, and in their accompanying pictures. We thus have a clear case of a substitution of an entirely different name and meaning, and glyph, from that of Deer. Whatever the archaic day-name was, one or the other of the two groups has broken away from it, and we again find the Maya and Tzeltal together, with the others agreeing in their difference.

It is my strong belief, evidenced by many similar cases, that the Maya-Tzeltal is closest to the archaic; yet we have to note that a day ' Deer' seems more in harmony with the general calendar nomenclature than a day ' grasp.' Also, while the sign is steadily used as meaning ' grasping,' we cannot find that etymological sense in either of the local names, Manik or Moxic.

The second special point of use for our study of the sign for Manik lies in its textual use and compounds. As seen in the reference lists in the OGD, it is persistently a ' repeat-glyph,' occupying an identical place (usually the second) in each clause of a ꜩolkin. It also definitely corresponds to the action, of grasping something, shown in the pictures beneath.

Its glyph-text value being thus clear, and actually translatable, it provides us with valuable opportunities of studying the inter-change of its

affixed minor elements. To illustrate this we here reproduce entire ʒolkin 15 in the Dresden. The action is clearly the use of the fire-drill held by the manik; the fire-drill prefix appears in positions abcd-1; the name and appellative glyphs of the four deities are in the 3rd and 4th places. Position 2 shows a double-manik with changing prefixes. Our immediate question is—why these changes, and what their purport? To find an answer to that here, would help enormously elsewhere; they *must* mean something.

1 **manik, cauac, chuen, akbal, men**

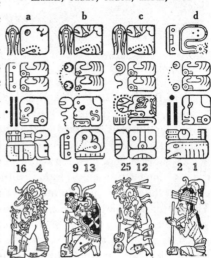

Dresden, ʒolkin 15

Now ʒolkin 15 begins a division of the text which goes on with repeating and shifting changes, to ʒolkin 25. These repeats and shifts are marked by alternating repetitions both of main glyph-elements and pictured activities.

In ʒolkin 16 the initial glyph changes, but the double-manik, with the same prefix as in ʒolkin 15, a.2, continues in the same second position.

In ʒolkins 17, 18, two pairs of gods are seen in conversation, with part of the previous initial glyph in place 1 and the fire-drill prefix in place 2, but the manik absent.

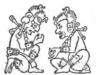

In ʒolkin 19 the manik reappears with two deities of which the first holds a vase with seeds, and the second a growing plant.

In ʒolkin 20 other deities are shown as holding vases of seed or grain (perhaps represented in the

 initial glyph repeated as abcde-1) while the double- manik comes back in the second place with a prefix which apparently represents a hamper.

In t͟zolkin 21 the same initial glyph is seen, with positions 2, 3, 4 all occupied by the name and appellative glyphs of the deities below, with one **kan-imix**; these gods are gesturing, but holding nothing.

In passing, this t͟zolkin 21 shows how close we really are in some cases to a full translation of at least some single sections. Glyphs a. 2, 3 are those of the death god, pictured below; b. 2, 4 are those of the so-called 'young god' or priestess (OGD, glyph 123), with the appellative glyph usually assigned to the Old God, the 'lord of time,' (see OGD, page 54); c. 2, 3 are again the normal pair of glyphs of the death god, pictured below. Glyphs a. 4, c. 4 are the glyphs of ill omen, constantly found with the death god or in destructive clauses, while b. 3 is the **kan-imix**, a beneficent sign, with a beneficent deity. Therefore, assuming for the time that **kan-imix** stands for 'corn and wine,' the gifts of the protective gods (invoked by the ritual chant of which the t͟zolkin text passages most certainly were representative or mnemonic), we have only to determine the specific value of the above 'repeat-glyph' used as the initial through both t͟zolkins 20 and 21, and also that of the above 'ill-omen' sign repeated in clauses ac, to attain a complete *glyph*-translation for the whole of t͟zolkin 21. And that, then, will leave us only the mythological questions involved in the identification of the deity in clause b, why the appellative glyph of the 'old god' is given here; and finally, the symbolic evaluation of the various costume details, as part of the progressive mythological work-out.

6 ahau, eb, kan, cib, lamat Dresden, ♭. 22

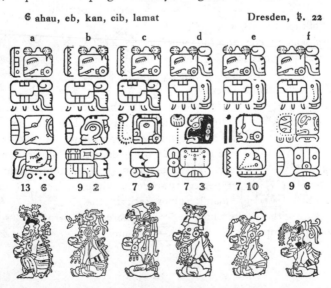

In ʒolkin 22 six deities hold the kan-sign in their hands, the corn, while the affix changes in position 1 and 2 are again interesting. Places abcdef-1 show glyph 23.9 with elements 324 and 601 as prefixes in abc-1, and 609 as postfix in def-1. Places abcdef-2 show a kan-form, 4-3, with the same element 609 as 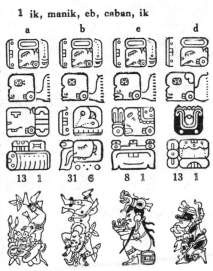 postfix in abc-2, and element 602-a as postfix in def-2.

From a rather extended comparison of its use and positions not only in the codices, but also in the much studied Supplementary Series on the monuments, there seem to me strong grounds for considering the element 609 ⌐⌐⌐ as a sign denoting the end of whatever may be the indicated action—taking, milpa-burning, passage of time or calculation. I am also coming to see in the prefix ⌐⌐⌐ element 324, a possible introductory sign, in a way like the Maya lay: "this now"—etc.

In ʒ. 23 we now again get glyph 23, in the form 23.1.2, showing both above affixes, 324, 609, pre- and post-, with glyph 91.1 in positions abcd-2. The second deity in the pictures is a death-god tumbling head-first, while the other two seem to hold forth the product of the plantings. This ʒolkin ends at the right of page 15, middle division, but the story goes on, returning to the lower division of page 4. Here, in ʒolkin 24, we find glyph 345.8.1 in positions abcd-1 and again our double-manik in place 2; while the four gods seated below hold in their hands this same initial glyph (less the

1 ik, manik, eb, caban, ik

a	b	e	d

13 1 31 6 8 1 13 1

Dresden, ʒolkin 23

prefix, of course). The upper part of this compound 345.8 may perhaps represent a hamper, and the lower part, showing a curved loop, occurs so often on pages 89-102 of the

Madrid codex, where it is matched by the shoots that appear growing and then budding, as to suggest that value for the glyph itself. In the

accompanying pictures death preys, the hatchet and birds attack,
yet the corn grows and finally comes to bearing, by the aid of the magic
ritual and ceremonies, done in those days as we still pray today in the
churches for rain and crops.

 Finally the story comes to
an end with ṭolkin 25, where
we see four gods holding what
may be a vase and pouches, their
special glyphs occupying places
abcd-2, 3, 4; while place abcd-1
shows the well-known kan-imix compound, and which we must
think denotes "food and drink, corn and wine." (The student
may here note that the next ṭolkin clearly begins another subject division,
running to ṭolkin 33, and distinctively marked by a repetition of an
outline of dots about the successive initial glyphs. Query: why the dots?)

In the face of the above evidence it is impossible not to regard the
manik-sign as denoting a grasping or holding; while the play and change
of affixes, initial glyphs, and activities, should surely lead to an evaluation
of these affixes that would go very far toward unraveling a great many
other passages.

Because of its relation to the above suggestions as to glyph-incorpora-
tions, especially in connection with the vase pictures, the glyph and day-
sign **Cib** should here be mentioned, for what little can be said of it.
As a compound-forming glyph it is entirely sterile; as a day-sign it
appears in the three forms above. The day in the general calendar is
either Owl or Vulture; we can surely see neither in the Maya glyph.
But when we turn to the day-name we again find Maya and Tzeltal in
accord, with the correct change in spelling: **ch** for **c.** Thus we find
there **Cib, Chabin,** not untranslatable like **Manik, Moxic,** but each mean-
ing 'wax,' one in Maya, the other Tzeltal. If anyone wants to see a
pictograph for 'wax' in either of the above day-sign forms, he is free
to try; I cannot. But neither can I see the origin of the sign, nor know
its historical form-changes. Yet several points are to be noted: the
presence of the striped band in each case, the fact that the curl may hang
down or rise from the base, be a curl or a double loop like the glyph **345**
we just noted, and that it is always distinct from the **caban-curl,** which
centers in a solid black spot. See further below, the vase signs.

Vessels or Jars, of Food or Otherwise

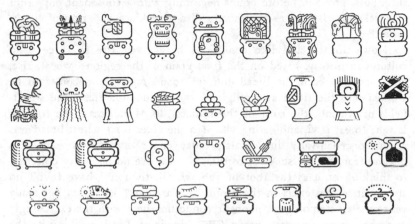

I referred in the earlier part of this article to 'idea-incorporation' as a well-established principle in word formation, in all languages, both in their words, and in compounded characters in Chinese or Egyptian. As suggested by and shown in various examples in the Maya, it seems equally well founded; it certainly appears in pictographs (or in pictures as such), and I am sure it is also found in pure glyphs, such as the thunderbolt sign. This latter is compounded of the cauac storm-sign, with affixed flames and club; the thunderbolt being actually called in Pokonchí rak-cahok, rak-ʒi, the tongue of the storm, or of the (storm-) dog; paralleling the ordinary word for 'flame,' rak-kak, 'tongue of fire.'

In its simplest form this idea-incorporation occurs in *pictures* of food jars or vessels. We have on our pantry shelves pots or cans labeled "sugar, tomatoes, fish"; whatever marks or signs represented like things to the Maya, it is to be expected that they would so mark their jars. One correspondent writes that he has seen such jars, as 'water-jars" marked with the dropping dots 〰. Underneath the day-signs prefacing Dr. ʒ. 64, and also in the picture at the top of page 35, we find the sign here given. The curl here is the same as that of one form of Cib; but is that the explanation? If the meaning is to be transferred from 'wax' to 'honey,' and the dropping dots denote a liquid, what has a 'honey-jar' to do in this text? We might accept an incense-jar as appropriate, but hardly honey.

Above this jar in the picture on page 35 are three pots, marked as nearly all vessels in the pictures are, with the sign 𐋡 apparently the same as that to which Landa gives the phonetic value u. Now this word

u has three wholly distinct meanings in Maya: it serves as the 3rd pers. sing. poss. pronoun before nouns beginning with a consonant only (not a vowel); it also means the moon; also a necklace or string of beads, *sarten*.*

Now, climatic and like conditions have given rise to three main cultures in history, based on the food-grain of the region: wheat, rice, and corn. In each the bread-stuff is 'food' *per se*, and comes to be worked into the ritual and religion: the "honorable rice," the wheat-fields of Amenti, the corn of the Indian. In Maya bread, the tortilla, is vah; to eat is vi, and eating vil. (In the older texts wheat bread was always castellan-vah; in Yucatan today one asks for *pan francés*, as distinct from the far superior tortillas.) I can see no necessary objection to thinking of u as the root of vah, vi, vil, though I have found no statement to that effect in the Motul or elsewhere. But I am not ready yet to see an etymological phonetic connection here with the exceedingly common, almost universal prefix 𓂀 simply on Landa's calling it ' the *letter* U.'

That the mark appears just below the *open top* of a receptacle in nearly every *picture* through the codices, is clear; where it is absent that absence may easily be casual. I do not think it is meaningless; I take no glyphic elements as meaningless, and every time in the past I have started out as doing so, detailed comparisons have shown the contrary. The mark clearly *belongs* in some way, on jars; but its meaning a *food*-vessel is quite doubtful, for concrete reasons. That is, it is used, *added to the jar outline*, in places where food cannot possibly be intended. On page 74, Dresden, the old woman is pouring part of the cataclysmal flood from an upturned jar with this mark; it is wholly contrary both to Maya practice and to the principle of ' idea-incorporation ' to *add* a food-sign in such case. We also might *use* a jar marked " flour " to gather and pour out water, but we would not *label* a water-jar, or reservoir, " food."

* As meaning necklace it has been forcibly expanded, with no support whatever, to au, so as to explain the word Ahau, lord, king, as ' he of the collar.' This violates several facts: u is in Maya a necklace, not a collar; we have no evidence that a necklace or even collar was held by the whole Mayan race as the royal insignia; the prefix ah- is used to give the occupation, status or citizenship, and is not used merely for a thing owned, possessed. While as a fact the root of Ahau is au, av, the general word for milpa, corn-field, farm; a word almost lost in northern Maya, but very common, with many forms, in all the southern branches, including Tzeltal; the ahau is the Planter, land-owner. I have elsewhere commented at length on the false theories that have been raised on a wholly un-Maya derivation of vinal, the 20-day month period, from U, in its meaning ' moon.'

To aid our readers, and in the hope of provoking better suggestions, we have added above a series of the vessels as we find them in the codices. We clearly have different kinds of food shown in jars, and perhaps things that are not food at all; but we certainly must *draw the line between pictures, as such, and glyphs*. A hieroglyphic or ideographic writing develops *from* pictures; but as writing it is conventionalized in form, and has acquired system, linguistic structure, and syntax. It will be bound, as writing, by definite discoverable rules, which pictures have not. Pictures convey ideas, but give us no linguistic information whatever.

Certain Affixes.

In the foregoing we have covered, I think, the chief classes of forms before us to study—save one: that of the affixes. From the very start of my study of the glyphs, I have believed these minor elements to hold the secret of the system, its structure and its syntax. And the commonest affix of all is that which apparently corresponds to Landa's (phonetic) "letter u." To serve the present article I have therefore gone through all glyphs that take this affix, and include herewith all those forms that yield any present points for study.

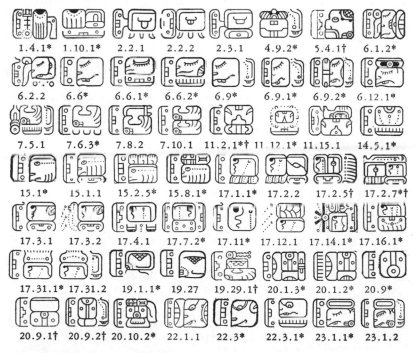

1.4.1* 1.10.1* 2.2.1 2.2.2 2.3.1 4.9.2* 5.4.1† 6.1.2*

6.2.2 6.6* 6.6.1* 6.6.2* 6.9* 6.9.1* 6.9.2* 6.12.1*

7.5.1 7.6.3* 7.8.2 7.10.1 11.2.1*† 11.12.1* 11.15.1 14.5.1*

15.1* 15.1.1 15.2.5* 15.8.1* 17.1.1* 17.2.2 17.2.5† 17.2.7*†

17.3.1 17.3.2 17.4.1 17.7.2* 17.11* 17.12.1 17.14.1* 17.16.1*

17.31.1* 17.31.2 19.1.1* 19.27 19.29.1† 20.1.3* 20.1.2* 20.9*

20.9.1† 20.9.2† 20.10.2* 22.1.1 22.3* 22.3.1* 23.1.1* 23.1.2

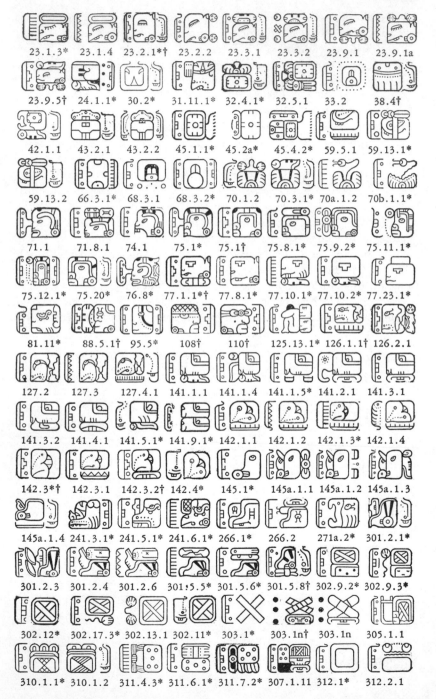

23.1.3* 23.1.4 23.2.1*† 23.2.2 23.3.1 23.3.2 23.9.1 23.9.1a

23.9.5† 24.1.1* 30.2* 31.11.1* 32.4.1* 32.5.1 33.2 38.4†

42.1.1 43.2.1 43.2.2 45.1.1* 45.2a* 45.4.2* 59.5.1 59.13.1*

59.13.2 66.3.1* 68.3.1 68.3.2* 70.1.2 70.3.1* 70a.1.2 70b.1.1*

71.1 71.8.1 74.1 75.1* 75.1† 75.8.1* 75.9.2* 75.11.1*

75.12.1* 75.20* 76.8* 77.1.1*† 77.8.1* 77.10.1* 77.10.2* 77.23.1*

81.11* 88.5.1† 95.5* 108† 110† 125.13.1* 126.1.1† 126.2.1

127.2 127.3 127.4.1 141.1.1 141.1.4 141.1.5* 141.2.1 141.3.1

141.3.2 141.4.1 141.5.1* 141.9.1* 142.1.1 142.1.2 142.1.3* 142.1.4

142.3*† 142.3.1 142.3.2† 142.4* 145.1* 145a.1.1 145a.1.2 145a.1.3

145a.1.4 241.3.1* 241.5.1* 241.6.1* 266.1* 266.2 271a.2* 301.2.1*

301.2.3 301.2.4 301.2.6 301:5.5* 301.5.6* 301.5.8† 302.9.2* 302.9.3*

302.12* 302.17.3* 302.13.1 302.11* 303.1* 303.1n† 303.1n 305.1.1

310.1.1* 310.1.2 311.4.3* 311.6.1* 311.7.2* 307.1.11 312.1* 312.2.1

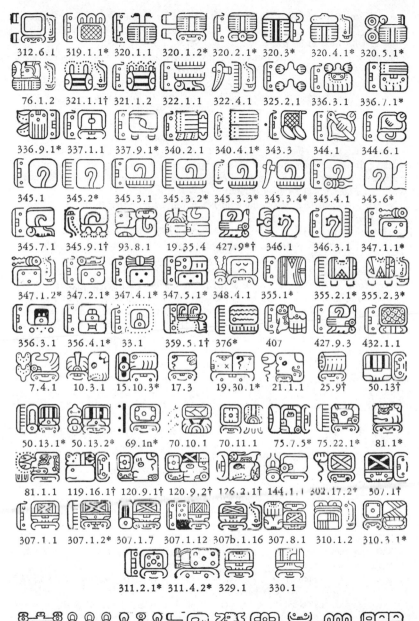

312.6.1 319.1.1* 320.1.1 320.1.2* 320.2.1* 320.3* 320.4.1* 320.5.1*

76.1.2 321.1.1† 321.1.2 322.1.1 322.4.1 325.2.1 336.3.1 336.7.1*

336.9.1* 337.1.1 337.9.1* 340.2.1 340.4.1* 343.3 344.1 344.6.1

345.1 345.2* 345.3.1 345.3.2* 345.3.3* 345.3.4* 345.4.1 345.6*

345.7.1 345.9.1† 93.8.1 19.35.4 427.9*† 346.1 346.3.1 347.1.1*

347.1.2* 347.2.1* 347.4.1* 347.5.1* 348.4.1 355.1* 355.2.1* 355.2.3*

356.3.1 356.4.1* 33.1 359.5.1† 376* 407 427.9.3 432.1.1

7.4.1 10.3.1 15.10.3* 17.3 19.30.1* 21.1.1 25.9† 50.13†

50.13.1* 50.13.2* 69.1n* 70.10.1 70.11.1 75.7.5* 75.22.1* 81.1*

81.1.1 119.16.1† 120.9.1† 120.9.2† 126.2.1† 144.1.1 502.17.2* 507.1†

307.1.1 307.1.2* 307.1.7 307.1.12 307b.1.16 307.8.1 310.1.2 310.3.1*

311.2.1* 311.4.2* 329.1 330.1

324.1 324.1a* 324.1b† 324.2.1 324.3 324.4* 324.4.1* 324.6* 324.6.1*

Above are shown substantially all glyph-compounds in the codices, with prefix or subfix 324; also a considerable number of those with 322, 601, for comparison; also a number with 602, to be paired with 324. See below.

In the Paris codex, alone, form 324c always replaces the Dresden-Madrid form, whether as prefix or subfix. It must be considered a mere scribal variation.

The check-numbers below the glyphs are those of my Outline Glyph Dictionary; an asterisk * denotes that the compound is found only in the Madrid, a dagger † that it occurs only in the Paris. Owing to the difference in subject matter of the codices, a form in the Madrid is more likely to be one connected with farm and planting ceremonies, in the Dresden with astronomical or mythological matters.

The writing in the Madrid is crude, and the position placement in glyph compounds irregular; in the Dresden and Paris affixes have fixed positions, consistently maintained, so that a variation there points to a difference of meaning, which is not the necessary case in the Madrid. The student should note this.

While, as summarized below, the evidence is quite strong that there is a difference in value and meaning between 324 as prefix or subfix, there is one, and only one persistent distinction between the two: that is, as prefix the opening almost invariably faces toward the main element, while as subfix or postfix it is turned away, or outwards.

The above distinction applies to the way the glyph is written; there is one other patent difference, after one studies the compound forms. This is, that the 324abc, or prefix form, is not only used with an immense number of different glyphs, but also seems to stand in free association (about as do adjectives or prepositions in English); the subfix on the contrary, is used with a more limited number of main elements, and with at least half a dozen of these seems to be fixedly attached, the main element seeming to be ' incomplete ' without the subfix. These cases are notably the **Caban, tun, caan** (sky), the similar forms 329, 330, and also the face-glyph of the night-god, gl. 81. The way the above is done seems to me to suggest a syntactic difference, as if the prefix constituted a qualifier or a particle of relation, and the subfix a determinative of class.

The 324d form is also used in the manner of a main element; see the compounds above.

With the above all-too-scanty notes as a preface, we may look at the compounds into which the above affixes enter. We take up first the prefix:

It is used with **Imix** only twice—both times in the Madrid.

With **Ik** in several forms; note the reverse position in 2.2.2.

With **Chicchan** once, doubtful.

With **Cimi, Manik, Men, Caban** and **Ahau** many times.

With **Cauac** only when it is the **tun**-glyph variant; not in the natural meaning of ' rain-storm.'

With both 22 (death) and 23 many times.

With the month or **vinal**-signs only once safely, with **Mol**; perhaps with **Yaxkin**.

With the colors not often.

It is the specific prefix of the North, or the North Star god, whether in form 71.1 or 75.1; without the prefix, it is probable that the face alone does not mean the North. The banded headdress probably means ' Lord, Real Man, Ruler,' a man of position, as distinct from a mere person; I believe it to be the equivalent of the prefix **Ah-**, just as the woman's curl denotes **Ix-**; see at bottom of Dresden pp. 61-62.

It is only used five times out of more than 200, with the glyph of Itzamná, no. 77; and does not appear at all with gl. 120, the woman, or White Lady (? Ixchel).

With the remarkable ' repeat glyph ' **141** persistently.

Also frequently with gl. **142,** a destruction glyph.

Constantly with the action glyphs **145** and **301.2;** note that **301.2.4,** with the cauac superfix denotes to carry, but **301.4,** with ' mat ' superfix represents a covered or thatched building.

The prefix is of frequent use with the ' cross ' glyphs, **302, 303, 310;** also the sky-glyph, **307.**

Also with the firewood glyph, **320; 344; 345** (? the growing plant) ; **347,** the three small dots or circles; and with **355,** the loom.

The glyphs omitted in the above frequency list are almost as interesting, and quite as important as omissions, as are the above occurrences.

It is not found with **Akbal, Kan, Oc, Cauac** when meaning storm.

It is of doubtful use with **Imix, Chicchan, Ix;** the other day signs are of too infrequent occurrence to give ground for study.

It is hardly used at all as a prefix to face glyphs, outside of the sign for the North, and almost never with an animal figure.

The use or non-use of **324** as prefix with astronomical or chronological signs on the one hand, and with agricultural glyphs on the other, should be carefully tabulated and studied.

Its substitution by **322** or **601** is a definite but so far wholly unsolved problem.

There is on the other hand one point where a lead seems to be given by a rather striking use, paired with **602** as a postfix. For this see the pairs **6.9.1, 6.9.2; 17.31.1, 17.31.2; 59.13.1, 59.13.2; 320.1.1** etc.; **345.7.1, 345.9.1; 347.1.1, 347.1.2;** also compare the **kan** and **yax** forms, **4.1.2, 4.9.2,** and then **4.2.1, 4.3.7.** See also cases where both the prefix **324** and postfix **602** are used in one compound, **20.9.2, 23.2.1, 23.3.1.**

Finally note that the postfix **602** is used after four month signs, **Tzec, Yaxkin, Kayab, Cumhu;** after **70.3.1** in the long calendar tzolkin 125, Madrid pp. 65-73; and finally the very important form **426.1.1** repeated across all the Venus pages, and also closing the summation of the lunation terms in the Supplementary Series on the monuments.

Until, then, either confirmed or disproved, the above seems to me to give strong support to a rendering of the postfix **602** as denoting the end of some term or occupation, previously introduced at times by an identical main element, with the prefix **324.** Thus: **4.2,** corn season, **4.2.1,** its end; **4.3.7;** (note **4.3.2**) ; **4.9.1** new corn time, **4.9.2** its end; **6.9.1, 6.9.2,** death ends; **17.31.1-2,** the harvest season, the ' earth producing,' and its close; (note similarity of gl. **17.31** to **Cumhu,** with ' earth' substituted for ' corn ') ; **59.13.1-2,** the tying up of glyph **59** (whether the number 20, or the moon, or whatever it be), and the end of the tying up.

The various forms of **320,** the firewood, on fire in **320.1,** hewn down in **320.3,** and the end of the work in **320.4.1, 76.7.2;** in this case we have the remarkable confirmation of form **320.5.1n,** where the prefix is exactly the same as is used for the initial or zero-day of the vinals—the starting and finishing times of clearing the milpa land.

Glyph **345** may not unlikely denote the growing plant; see its occurrence and the adjoined pictures in Madrid pages 89-102 (see OGD p. 158), where the corn plants grow, are attacked, die, revive and finally bear; thus **345.9.1** may well mark the end of the growing. If then, as I believe from the above and the many other similar

compounds with the **602** affix (in all of which it simply cannot mean ' moon ' as so persistently declared by Morley and his followers) this affix is a ' finishing sign,' its rather remarkable pairing with our **324** prefix should provide a control in our problem as to the actual value of the latter. See also OGD, p. 91.

I believe that the key to the structure of the Maya system lies in these affixes (the written ' particles ' as it were), and that there is no more fruitful field for study.

I had intended to include the above special study in the pages of the Outline Glyph Dictionary, but the work of putting that volume through the press was such that I passed the point for further work. In doing this I classed under one number, 324, both forms, and all three uses which I now feel obliged to separate. There has seemed to me perforce developing a distinct general line between prefixes and subfixes,* the former serving as qualifiers, or particles necessary to the sense, and therewith controlling or modifying the main element; as when we say in-action, re-action, counter-action. The subfixes seem more like determinatives of class, and easier to omit in repetition; there are a number of subfixes that are clearly specific to certain main elements. **Cimi** has its special subfix ⊙∴⊙ So has **Caban**, the earth, [glyph] So **Caan**, the sky, [glyph] and others. The subfix [glyph] appears to mark the major gods, as their distinctive ? honorific; its second constant use, in the pictures, is that of a sort of table for the offerings—two uses close in idea-relationship.

We therefore find the form* [glyph] with its variants, and the points turned toward the main element, used as a very common prefix, with a set number of main elements, and not used with a considerable number of others. We also have the form [glyph] almost identical, save for the short stroke in the opening, and with the opening regularly turned *away* from the main element, as subfix or postfix in a quite different set of associations. The prefix form appears to be more separable from its main element (as a adjective is separable), while the subfix appears in most cases to be integrally united to its main element, as its own special " determining " affix. The main elements which take the prefix either take it or do without it as the context seems to require, and with difference of meaning or construction involved; those which take the subfix form, as the sky-glyph, must have it. This is more or less true of subfixes generally, as just stated.

* Generally speaking the prefix and superfix position may be taken as equivalent; also the postfix and subfix. This is less evident in the second case, where the elements shift position less easily than in the first.

* For convenience in the make-up of the type pages, these small elements are inserted lying flat, instead of upright, as they are to be understood, when used as prefixes or postfixes.

The subfix form is also used apparently as a main element, our glyph 324, for the various compound forms of which see above. That there is a close relation between the two (the prefix and the subfix), in spite of the above distinctions in their use, is confirmed by the fact that the compound forms 324.1, 324.1a, 324.1b, occurring in the three codices, show the Paris codex variant matching the other form here, just as it does in the various cases where the element is a mere affix. We have clearly one single small element, with very varying uses; and, what meaning can be found which will fit all these?

To this we finally add the use of the sign just below the open top of receptacles, as discussed above.

It is these questions which I feel that our purposed "Glyph Studies," with their aroused controversies and discussions, should subserve.

A final brief summary in review of our problem may here aid. We have as facts: A common Middle American calendar system, with 20 day-names, in substantial accord through the whole territory. We have a set of picture-forms for the Aztec, representing the objects themselves, and matching both the names and their meanings. In Zapotec, and modern Quiché and Pokonchí we have sets of day-names, and meanings, quite closely following the Aztec. In the Tzeltal of Chiapas, and the Maya of Yucatan, we have marked variations from the above, and also a long string of names to which we have no known etymological origins or meanings, in either tongue, as spoken from the Sixteenth century down. We must believe these to be so archaic that their meanings have disappeared; in some cases Maya and Tzeltal agree together, and differ from all others.

Then in and for Yucatecan Maya we have from Landa a set of day-*signs*, with their 'proper names,' but no meanings given; some few meanings are provided by the different Maya dictionaries, the Motul and others. A number of these day-*signs* enter as elements into the glyph writings; in some cases their meaning there is clear and consistent, in others obscure or wholly dark.

We have on the stone monuments calendric and other inscriptions, which are in themselves mathematically clear and consistent, but give practically no light on their accompanying texts. On the 216 pages of the three surviving codices we have, however, text sections in great number, with pictures of which they are obviously descriptive, or at least related thereto in a definite way. At times the text and pictures actually translate each other's meaning; leaving us the task of trying to restore the spoken words corresponding. For this we have at our call long and excellent dictionaries and grammars of the languages in the various

Mayance sections—as spoken at the time of the Conquest. And we also know as a fact, that the glyphs could still be read, and were in use then, and until the last years of the 17th century. *But*, these very glyphs are the same as appeared on the oldest stone inscriptions, and the early jadeite figures, with dates close to the beginning of our era. Their use and value was fixed thus at 1500 years before the later above-mentioned dictionaries of the spoken languages were written, by the Spanish missionaries for their purposes; and that is a very long time in language history. In that time Latin had changed to all the modern Romance tongues, and the Gothic of Ulfilas had become modern English; Stoll estimated that at least 2000 years in time was necessary to develop the modern Mayance tongues from the archaic original—*which must have been that of the early monument builders, and wherein* they *read these glyphs*.

To the above day-sign list (to close) we must further add the month-signs, cardinal point signs, colors, and just a few besides, resting on the Landa record, directly or indirectly. A few others (such as the sky-sign, etc.) have been added by different students, on purely association evidence. I believe that in my Outline Glyph Dictionary I showed the values of certain others (both single and compound) on the same kind of evidence; and I also think that certain characteristics of the system itself as a written ideographic script, with its definite syntactic and structural laws, have begun to come into the light. The rest is now for our present and coming students.

A CATALOGUE OF SELECTED DOVER BOOKS
IN ALL FIELDS OF INTEREST

A CATALOGUE OF SELECTED DOVER BOOKS
IN ALL FIELDS OF INTEREST

THE NOTEBOOKS OF LEONARDO DA VINCI, edited by J.P. Richter. Extracts from manuscripts reveal great genius; on painting, sculpture, anatomy, sciences, geography, etc. Both Italian and English. 186 ms. pages reproduced, plus 500 additional drawings, including studies for Last Supper, Sforza monument, etc. 860pp. 7⁷/₈ x 10¾. USO 22572-0, 22573-9 Pa., Two vol. set $15.90

ART NOUVEAU DESIGNS IN COLOR, Alphonse Mucha, Maurice Verneuil, Georges Auriol. Full-color reproduction of Combinaisons ornamentales (c. 1900) by Art Nouveau masters. Floral, animal, geometric, interlacings, swashes — borders, frames, spots — all incredibly beautiful. 60 plates, hundreds of designs. 9³/₈ x 8¹/₁₆ . 22885-1 Pa. $4.00

GRAPHIC WORKS OF ODILON REDON. All great fantastic lithographs, etchings, engravings, drawings, 209 in all. Monsters, Huysmans, still life work, etc. Introduction by Alfred Werner. 209pp. 9¹/₈ x 12¼. 21996-8 Pa. $6.00

EXOTIC FLORAL PATTERNS IN COLOR, E.-A. Seguy. Incredibly beautiful full-color pochoir work by great French designer of 20's. Complete Bouquets et frondaisons, Suggestions pour étoffes. Richness must be seen to be believed. 40 plates containing 120 patterns. 80pp. 9³/₈ x 12¼. 23041-4 Pa. $6.00

SELECTED ETCHINGS OF JAMES A. McN. WHISTLER, James A. McN. Whistler. 149 outstanding etchings by the great American artist, including selections from the Thames set and two Venice sets, the complete French set, and many individual prints. Introduction and explanatory note on each print by Maria Naylor. 157pp. 9³/₈ x 12¼. 23194-1 Pa. $5.00

VISUAL ILLUSIONS: THEIR CAUSES, CHARACTERISTICS, AND APPLICATIONS, Matthew Luckiesh. Thorough description, discussion; shape and size, color, motion; natural illusion. Uses in art and industry. 100 illustrations. 252pp.
 21530-X Pa. $2.50

TEN BOOKS ON ARCHITECTURE, Vitruvius. The most important book ever written on architecture. Early Roman aesthetics, technology, classical orders, site selection, all other aspects. Stands behind everything since. Morgan translation. 331pp.
 20645-9 Pa. $3.50

THE CODEX NUTTALL. A PICTURE MANUSCRIPT FROM ANCIENT MEXICO, as first edited by Zelia Nuttall. Only inexpensive edition, in full color, of a pre-Columbian Mexican (Mixtec) book. 88 color plates show kings, gods, heroes, temples, sacrifices. New explanatory, historical introduction by Arthur G. Miller. 96pp. 11³/₈ x 8½. 23168-2 Pa. $7.50

HOW TO SOLVE CHESS PROBLEMS, Kenneth S. Howard. Practical suggestions on problem solving for very beginners. 58 two-move problems, 46 3-movers, 8 4-movers for practice, plus hints. 171pp. 20748-X Pa. $2.00

A GUIDE TO FAIRY CHESS, Anthony Dickins. 3-D chess, 4-D chess, chess on a cylindrical board, reflecting pieces that bounce off edges, cooperative chess, retrograde chess, maximummers, much more. Most based on work of great Dawson. Full handbook, 100 problems. 66pp. 7⅞ x 10¾. 22687-5 Pa. $2.00

WIN AT BACKGAMMON, Millard Hopper. Best opening moves, running game, blocking game, back game, tables of odds, etc. Hopper makes the game clear enough for anyone to play, and win. 43 diagrams. 111pp. 22894-0 Pa. $1.50

BIDDING A BRIDGE HAND, Terence Reese. Master player "thinks out loud" the binding of 75 hands that defy point count systems. Organized by bidding problem—no-fit situations, overbidding, underbidding, cueing your defense, etc. 254pp. EBE 22830-4 Pa. $3.00

THE PRECISION BIDDING SYSTEM IN BRIDGE, C.C. Wei, edited by Alan Truscott. Inventor of precision bidding presents average hands and hands from actual play, including games from 1969 Bermuda Bowl where system emerged. 114 exercises. 116pp. 21171-1 Pa. $1.75

LEARN MAGIC, Henry Hay. 20 simple, easy-to-follow lessons on magic for the new magician: illusions, card tricks, silks, sleights of hand, coin manipulations, escapes, and more —all with a minimum amount of equipment. Final chapter explains the great stage illusions. 92 illustrations. 285pp. 21238-6 Pa. $2.95

THE NEW MAGICIAN'S MANUAL, Walter B. Gibson. Step-by-step instructions and clear illustrations guide the novice in mastering 36 tricks; much equipment supplied on 16 pages of cut-out materials. 36 additional tricks. 64 illustrations. 159pp. 6⅝ x 10. 23113-5 Pa. $3.00

PROFESSIONAL MAGIC FOR AMATEURS, Walter B. Gibson. 50 easy, effective tricks used by professionals —cards, string, tumblers, handkerchiefs, mental magic, etc. 63 illustrations. 223pp. 23012-0 Pa. $2.50

CARD MANIPULATIONS, Jean Hugard. Very rich collection of manipulations; has taught thousands of fine magicians tricks that are really workable, eye-catching. Easily followed, serious work. Over 200 illustrations. 163pp. 20539-8 Pa. $2.00

ABBOTT'S ENCYCLOPEDIA OF ROPE TRICKS FOR MAGICIANS, Stewart James. Complete reference book for amateur and professional magicians containing more than 150 tricks involving knots, penetrations, cut and restored rope, etc. 510 illustrations. Reprint of 3rd edition. 400pp. 23206-9 Pa. $3.50

THE SECRETS OF HOUDINI, J.C. Cannell. Classic study of Houdini's incredible magic, exposing closely-kept professional secrets and revealing, in general terms, the whole art of stage magic. 67 illustrations. 279pp. 22913-0 Pa. $2.50

EAST O' THE SUN AND WEST O' THE MOON, George W. Dasent. Considered the best of all translations of these Norwegian folk tales, this collection has been enjoyed by generations of children (and folklorists too). Includes True and Untrue, Why the Sea is Salt, East O' the Sun and West O' the Moon, Why the Bear is Stumpy-Tailed, Boots and the Troll, The Cock and the Hen, Rich Peter the Pedlar, and 52 more. The only edition with all 59 tales. 77 illustrations by Erik Werenskiold and Theodor Kittelsen. xv + 418pp. 22521-6 Paperbound $4.00

GOOPS AND HOW TO BE THEM, Gelett Burgess. Classic of tongue-in-cheek humor, masquerading as etiquette book. 87 verses, twice as many cartoons, show mischievous Goops as they demonstrate to children virtues of table manners, neatness, courtesy, etc. Favorite for generations. viii + 88pp. 6½ x 9¼. 22233-0 Paperbound $2.00

ALICE'S ADVENTURES UNDER GROUND, Lewis Carroll. The first version, quite different from the final Alice in Wonderland, printed out by Carroll himself with his own illustrations. Complete facsimile of the "million dollar" manuscript Carroll gave to Alice Liddell in 1864. Introduction by Martin Gardner. viii + 96pp. Title and dedication pages in color. 21482-6 Paperbound $1.50

THE BROWNIES, THEIR BOOK, Palmer Cox. Small as mice, cunning as foxes, exuberant and full of mischief, the Brownies go to the zoo, toy shop, seashore, circus, etc., in 24 verse adventures and 266 illustrations. Long a favorite, since their first appearance in St. Nicholas Magazine. xi + 144pp. 6⅝ x 9¼. 21265-3 Paperbound $2.50

SONGS OF CHILDHOOD, Walter De La Mare. Published (under the pseudonym Walter Ramal) when De La Mare was only 29, this charming collection has long been a favorite children's book. A facsimile of the first edition in paper, the 47 poems capture the simplicity of the nursery rhyme and the ballad, including such lyrics as I Met Eve, Tartary, The Silver Penny. vii + 106pp. (USO) 21972-0 Paperbound $2.00

THE COMPLETE NONSENSE OF EDWARD LEAR, Edward Lear. The finest 19th-century humorist-cartoonist in full: all nonsense limericks, zany alphabets, Owl and Pussycat, songs, nonsense botany, and more than 500 illustrations by Lear himself. Edited by Holbrook Jackson. xxix + 287pp. (USO) 20167-8 Paperbound $3.00

BILLY WHISKERS: THE AUTOBIOGRAPHY OF A GOAT, Frances Trego Montgomery. A favorite of children since the early 20th century, here are the escapades of that rambunctious, irresistible and mischievous goat—Billy Whiskers. Much in the spirit of Peck's Bad Boy, this is a book that children never tire of reading or hearing. All the original familiar illustrations by W. H. Fry are included: 6 color plates, 18 black and white drawings. 159pp. 22345-0 Paperbound $2.75

MOTHER GOOSE MELODIES. Faithful republication of the fabulously rare Munroe and Francis "copyright 1833" Boston edition—the most important Mother Goose collection, usually referred to as the "original." Familiar rhymes plus many rare ones, with wonderful old woodcut illustrations. Edited by E. F. Bleiler. 128pp. 4½ x 6⅜. 22577-1 Paperbound $1.50

EGYPTIAN MAGIC, E.A. Wallis Budge. Foremost Egyptologist, curator at British Museum, on charms, curses, amulets, doll magic, transformations, control of demons, deific appearances, feats of great magicians. Many texts cited. 19 illustrations. 234pp. USO 22681-6 Pa. $2.50

THE LEYDEN PAPYRUS: AN EGYPTIAN MAGICAL BOOK, edited by F. Ll. Griffith, Herbert Thompson. Egyptian sorcerer's manual contains scores of spells: sex magic of various sorts, occult information, evoking visions, removing evil magic, etc. Transliteration faces translation. 207pp. 22994-7 Pa. $2.50

THE MALLEUS MALEFICARUM OF KRAMER AND SPRENGER, translated, edited by Montague Summers. Full text of most important witchhunter's "Bible," used by both Catholics and Protestants. Theory of witches, manifestations, remedies, etc. Indispensable to serious student. 278pp. 6⅝ x 10. USO 22802-9 Pa. $3.95

LOST CONTINENTS, L. Sprague de Camp. Great science-fiction author, finest, fullest study: Atlantis, Lemuria, Mu, Hyperborea, etc. Lost Tribes, Irish in pre-Columbian America, root races; in history, literature, art, occultism. Necessary to everyone concerned with theme. 17 illustrations. 348pp. 22668-9 Pa. $3.50

THE COMPLETE BOOKS OF CHARLES FORT, Charles Fort. Book of the Damned, Lo!, Wild Talents, New Lands. Greatest compilation of data: celestial appearances, flying saucers, falls of frogs, strange disappearances, inexplicable data not recognized by science. Inexhaustible, painstakingly documented. Do not confuse with modern charlatanry. Introduction by Damon Knight. Total of 1126pp.
23094-5 Clothbd. $15.00

FADS AND FALLACIES IN THE NAME OF SCIENCE, Martin Gardner. Fair, witty appraisal of cranks and quacks of science: Atlantis, Lemuria, flat earth, Velikovsky, orgone energy, Bridey Murphy, medical fads, etc. 373pp. 20394-8 Pa. $3.50

HOAXES, Curtis D. MacDougall. Unbelievably rich account of great hoaxes: Locke's moon hoax, Shakespearean forgeries, Loch Ness monster, Disumbrationist school of art, dozens more; also psychology of hoaxing. 54 illustrations. 338pp. 20465-0 Pa. $3.50

THE GENTLE ART OF MAKING ENEMIES, James A.M. Whistler. Greatest wit of his day deflates Wilde, Ruskin, Swinburne; strikes back at inane critics, exhibitions. Highly readable classic of impressionist revolution by great painter. Introduction by Alfred Werner. 334pp. 21875-9 Pa. $4.00

THE BOOK OF TEA, Kakuzo Okakura. Minor classic of the Orient: entertaining, charming explanation, interpretation of traditional Japanese culture in terms of tea ceremony. Edited by E.F. Bleiler. Total of 94pp. 20070-1 Pa. $1.25

Prices subject to change without notice.
Available at your book dealer or write for free catalogue to Dept. GI, Dover Publications, Inc., 180 Varick St., N.Y., N.Y. 10014. Dover publishes more than 150 books each year on science, elementary and advanced mathematics, biology, music, art, literary history, social sciences and other areas.